LEONARDO DA VINCI

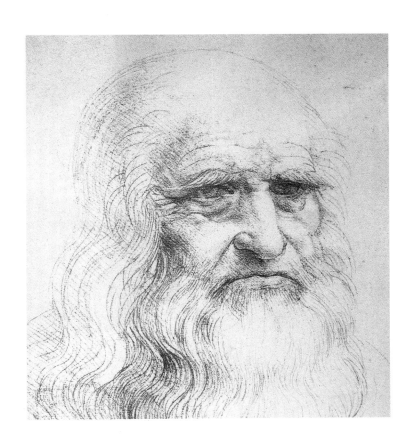

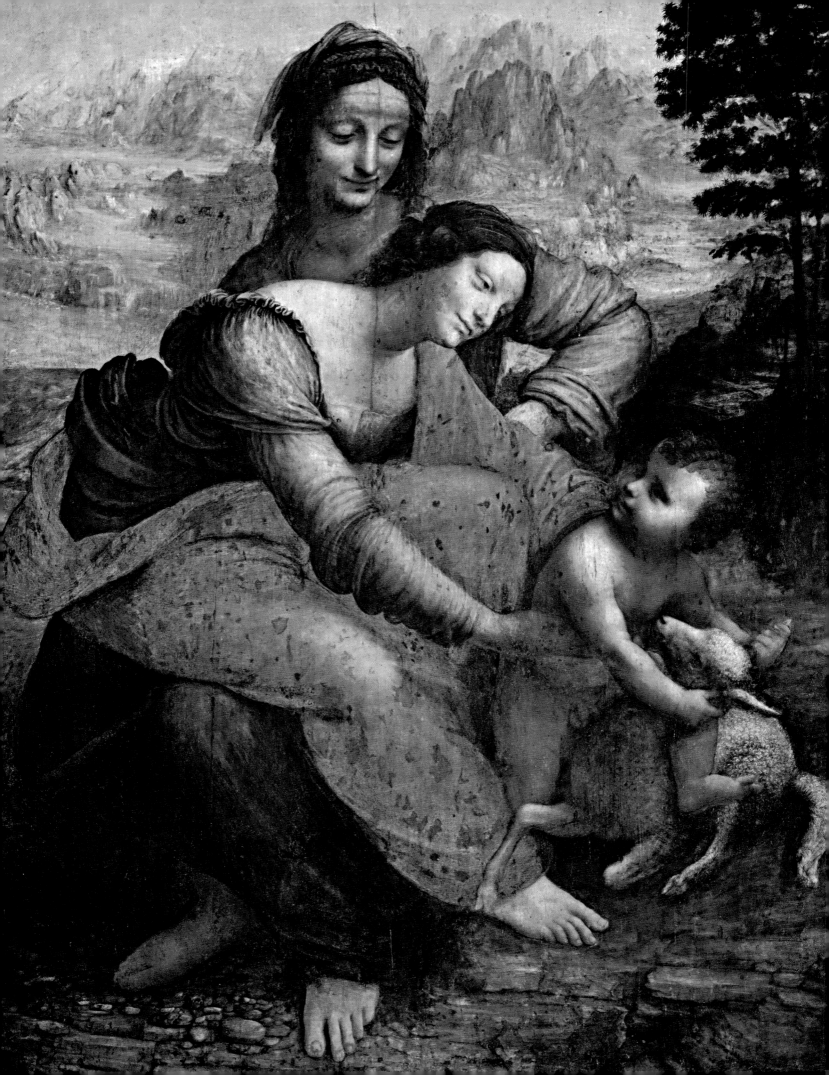

LEONARDO DA VINCI

HIS LIFE AND WORKS IN 500 IMAGES

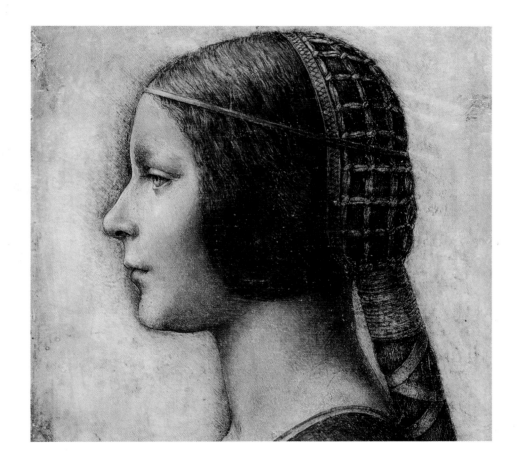

AN ILLUSTRATED EXPLORATION OF THE ARTIST, HIS LIFE AND
CONTEXT, WITH A GALLERY OF 300 OF HIS GREATEST WORKS

ROSALIND ORMISTON

LORENZ BOOKS

This edition is published by Lorenz Books,
an imprint of Anness Publishing Ltd, Blaby Road,
Wigston, Leicestershire LE18 4SE

Email: info@anness.com

Web: www.lorenzbooks.com;
www.annesspublishing.com

Anness Publishing has a new picture agency outlet
for images for publishing, promotions or advertising.
Please visit our website www.practicalpictures.com
for more information.

Publisher: Joanna Lorenz
Editors: Amy Christian and Anne Hildyard
Proofreading Manager: Lindsay Zamponi
Designer: Sarah Rock
Production Controller: Mai-Ling Collyer

ETHICAL TRADING POLICY

At Anness Publishing we believe that business
should be conducted in an ethical and
ecologically sustainable way, with respect for the
environment and a proper regard to the
replacement of the natural resources we employ.

As a publisher, we use a lot of wood pulp to
make high-quality paper for printing, and that
wood commonly comes from spruce trees. We
are therefore currently growing more than
750,000 trees in three Scottish forest plantations:
Berrymoss (130 hectares/320 acres), West
Touxhill (125 hectares/305 acres) and Deveron
Forest (75 hectares/185 acres). The forests we
manage contain more than 3.5 times the number
of trees employed each year in making paper for
the books we manufacture.

Because of this ongoing ecological investment
programme, you, as our customer, can have the
pleasure and reassurance of knowing that a tree
is being cultivated on your behalf to naturally
replace the materials used to make the book you
are holding.

Our forestry programme is run in accordance
with the UK Woodland Assurance Scheme
(UKWAS) and will be certified by the
internationally recognized Forest Stewardship
Council (FSC). The FSC is a non-government
organization dedicated to promoting responsible
management of the world's forests.
Certification ensures forests are managed in an
environmentally sustainable and socially
responsible way. For further information about
this scheme, go to ww.annesspublishing.com/trees

PUBLISHER'S NOTE

Although the information in this book is
believed to be accurate and true at the time
of going to press, neither the author nor the
publisher can accept any legal responsibility
or liability for any errors or omissions that
may have been made.

PICTURE ACKNOWLEDGEMENTS

l=left, r=right, t=top, b=bottom, m=middle

AKG: 1, 66t, 69bl, 69t, 82, 117t, 128b, 137t, 137b, 185b, 198, 202t, 206t, 208t, 212b, 214t, 222, 233b, 236t; /© De Agostini Pict.Lib.: 87b; /© Album/Oronoz: 47b, 177t; /© Pietro Baguzzi: 52b, 187t, 187b; Cameraphoto: 205b; /© Catherine Biboilet: 87t; /© Herve Champollion: 89b; /© Electa: 67tl, 130t, 208b, 210b, 222b, 224t, 224b; /© Rupert Hansen: 85t; INTERFOTO: 66br; /© Erich Lessing: 2, 68tl, 68tr, 104b, 108t, 165t, 177b, 196; /© Pirozzi: 57t; /© Rabatti – Domingie: 166b.

Alamy: /© The Art Gallery Collection: 111t; /© Ian Dagnall Commercial Collection: 52t; /© Diana Bier Florence: 62b; /© Gaertner: 65tr; Dennis Hallinan: 4, 12br, 23br, 30, 38, 37tr, 37tl, 37b, 40b, 55, 61, 67tr, 69br, 103, 112t, 116b, 119t, 123b, 131t, 154b, 159t, 159b, 176, 184b, 186b, 188t, 188b, 201, 207b, 214m, 215, 216b, 216t, 219b, 223t, 226t, 226m, 232t, 233t, 234t, 234b, 236b, 237b, 238t, 238b, 239t, 240t, 240b, 242t, 242b, 243t; /© Hemis: 213t; /© Iconotec: 12bl; /© INTERFOTO: 218b; /© Ilene MacDonald: 48bl; /© medicalpicture: p232b; /© David Pearson: 51t; /© photomadnz: 97b; /© The Print Collector: 190t, 190m, 190b; /© Lourens Smak: 206m; /© Travel Division Images: 16b; /© World History Archive: 226b.

Art Archive: /© Biblioteca Nacional Madrid: 49; /© Bodleian Library Oxford: 45b; /© Château d'Amboise France/Gianni Dagli Orti: 93t, 93b; Gallerie dell'Accademia, Venice: 230b; /© Manoir du Clos-Lucé /Gianni Dagli Orti: 87m, 92t; /© Musée des Beaux Arts Lyon/Gianni Dagli Orti: p46b; /© Musée du Louvre Paris; /© National Gallery London/Eileen Tweedy: 31br, 33t, 153m, 153b, 195b; /Alfredo Dagli Orti: 57b; /© Alfredo Dagli Orti: 7b, 38t; /Gianni Dagli Orti: 62t; /© Gianni Dagli Orti: 84t; /© Palazzo Chigi Siena/Gianni Dagli Orti: 71t; /© Private Collection Italy/Gianni Dagli Orti: 205t, 241t.

Bridgeman: 20br, 58bl, 66bl, 74t, 169m, 247b, 249b; /© Gallerie dell'Accademia, Venice, Italy: 10, 28br, 44, 118t, 118b, 123t, 138b, 139t, 146b, 173t, 184t, 194t, 195t, 204b, 228, 230b, 250b; /Alinari: 17t, 22, 27b, 60t, 60bl, 63tr, 104t, 173b, 175b, 197m; /© Alinari: 85b; /© Ashmolean Museum, University of Oxford, UK: 72t, 100, 107b, 108b, 137m; /© Baptistery, Florence, Italy: 79t, /© Biblioteca Ambrosiana, Milan, Italy: 8, 146t, 207t, 217t, 218t, 219t, 220t, 220m, 221t, 223b; /© Biblioteca Nacional, Madrid, Spain: 125b, 126t, 126b; /© Biblioteca Nazionale, Turin, Italy: 229t, 229b; /© Biblioteca Reale, Turin, Italy: 90; /© Biblioteque des Arts Decoratifs, Paris, France, Archives Charmet: 235t, 237t; Bibliothèque de l'Institut de France, Paris, France: 25bl, 213b, 220b, 249t; /© Bibliothèque Mazarine, Paris, France/Archives Charmet: 245m; /© Bibliothèque Nationale, Paris, France/Giraudon: 53tl, 91t, 245t, 245b; /© British Library: 221b; /© British Library Board. All Rights Reserved: 46t, 200; /© British Museum, London, UK: 25br, 105b, 106t, 109t, 111m, 111b, 138t, 161m, 161b, 167b, 194b; /© Casa Buonarroti, Florence, Italy: 73tr; Cameraphoto Arte Venezia: 15b, 79b, 113t, 127b, 130b, 139t, 168t, 168b, 230b; /© Cameraphoto Arte Venezia: 56t; /© Christie's Images: 3, 117b, 246t, 247t; /© Collegio del Cambio, Perugia, Italy/Alinari: 20l; /© Samuel Courtauld Trust, The Courtauld Gallery, London, UK: 110b; /© Duomo, Florence, Italy: 17b; /© Fitzwilliam Museum, University of Cambridge, UK: 122, 169b, 169t; /© Fondazione Contini-Bonacossi, Florence, Italy: 29m; /Giraudon: 58t, 73br; /© Gabinetto dei Disegni e Stampe, Uffizi, Florence, Italy: 16t, 31t, 105t, 146m, 239t; /© Galleria Nazionale, Parma, Italy: 81b; /Giraudon: 73tl; /© Graphische Sammlung Albertina, Vienna, Austria: 185m; /© Hamburger Kunsthalle, Hamburg, Germany: 106b, 165b; /© Hermitage, St Petersburg, Russia: 12t, 160, 161t, 162, 162t; /© Collection of the Earl of Leicester, Holkham Hall, Norfolk: 75t; /© Kunsthistorisches Museum, Vienna, Austria: 18t; /© /Lauros/Giraudon: p64, p89t, 211t, 212b; /© Lindenau Museum, Alternburg, Germany/ Bildarchiv Foto Marburg: 77, 83bl; /© Louvre, Paris, France: 23tl, 34, 42, 75b, 78, 83t, 171, 172t, 172b, 175m, 193, 199b, 231r; /Louvre/Giraudon: 54, 70, 128t, 151, 163b, 243b; Louvre/Peter Willi: 35b, 96t, 199t; /© Musée Bonnat, Bayonne, France/Giraudon: 26, 36b, 107t, 124t, 124m,

124b, 165m; /© Musée Condé, Chantilly, France/Giraudon: 71br; /© Musée Fesch, Ajaccio, Corsica, France: 23bl; /© Musée Jourdain, Morez, France, Lauros, Giraudon: p88t; /© Musée de la Ville de Paris, Musée du Petit-Palais, France: 92b; /© Musée des Beaux-Arts, Caen, France/ Lauros/ Giraudon: 15t, 95br; /© Museo Archeologico Nazionale, Naples, Italy: 63b; /© Museo de Firenze Com'era, Florence, Italy: 59tl; /© Museo di San Marco dell'Angelico, Florence, Italy: 50b; /© Museo e Gallerie Nazionale di Capodimonte, Naples, Italy: 53tr; /© Museo Nazionale del Bargello, Florence, Italy: 19t, 19br, 19bl, 37br; /© National Gallery of Art, Washington DC, USA: 5tr, 37t, 155; /© National Gallery, London, UK: 5tl, 35m, 43, 63tl, 150, 153t, 174, 175t; /© National Gallery of Scotland, Edinburgh, Scotland: 23tr; /© Old Sacristy, San Lorenzo, Florence, Italy: 18bl; /© Orsanmichele, Florence, Italy: 18br; /© Palazzo Medici-Riccardi, Florence, Italy: 7b, 36t; /© Palazzo Pitti, Florence, Italy: 29r; /© Palazzo Reale, Turin, Italy/Alinari: 136b; /© Palazzo Vecchio, Florence, Italy: 20t; /Alinari: 75m; /© Pinacoteca di Brera, Milan, Italy: 41tl, 47t; /© Royal Library, Windsor, UK: 5tm; /© Royal Library, Windsor, Berkshire, UK/Alinari: 134t; /© Santa Corona, Vicenza, Italy: 32b; /© Santa Maria della Grazie, Milan, Italy: 51b, 51m, 98, 178, 179, 180, 181, 182, 183; /© Santa Maria Novella, Florence, Italy: 28t; /© Santa Trintà, Florence, Italy: 58br; /© Sarah Quill: 21; /© The Stapleton Collection: 41b, 84b; /© Galleria degli Uffizi, Florence, Italy: 1, 27t, 28bl, 3ll, 32, 35t, 41tr, 83br, 156t, 156b, 157, 158t, 158b, 164, 166t; /© Upton House, Oxfordshire, UK: 86; /© Victoria & Albert Museum, London, UK: 37bl; /© Vatican Museums and Galleries, Vatican City, Italy: 29l, 80, 170; /© Ken Walsh: 53b; /© Ken Welsh: 94; /© Collection of the Earl of Pembroke, Wilton House, Wilts, UK: 81t, 191.

Corbis: /© Alinari Archives: 13, 14, 24, 25t, 40tl, 40tr, 45t, 48t, 48br, 60br, 65br, 65bl, 67b, 9ll, 91m, 95bl, 101, 02, 109t, 110t, 112b, 113b, 114, 115, 116t, 119m, 119b, 20t, 120b, 121t, 121b, 125t, 127t, 129t, 129b, 131b, 32, 33, 134b, 135t, 135m, 135b, 136t, 140t, 140b, 141t, 41m, 141b, 142t, 142b, 143, 144t, 144b, 145t, 145b, 47t, 147b, 148t, 148m, 148b, 149t, 149b, 167t, 185t, 86t, 186m, 189t, 189b, 192t, 192b, 197t, 197b, 203t, 203b, 204t, 206b, 207m, 208m, 209t, 209b, 213m, 214b, 217b, 225t, 225b, 229t, 231l, 244t, 244b, 248, 250t, 251t, 251b, 252m, 252t, 252b, 253t, 253m, 253b; /© James L. Amos: 76t, 95tl; /© Arte & Immagini srl: 154t. /© Bettman: 235b, 241b; /© Seth Joel: 246b; Francis G. Mayer: 52; /© PoodlesRock: 210t, 212m, 227; /© Baldwin H. Ward & Kathryn C. Ward: 202b.

Getty Images: 6t; /© AFP 96b, 97tl, 97tr; /© Time & Life Pictures: 6b.

Istockphoto: 50t, 56b, 65tl, 72b, 74b, 76b.

Mary Evans Picture Library: 68b, 212t. /ASIA Media, 95tr.

Superstock: /©. Hemis.fr: 88; Royal Library, Windsor Castle: 231b, 236c, 245c.

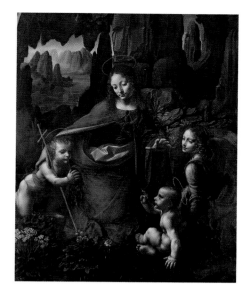
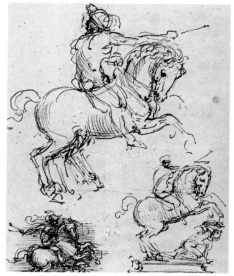
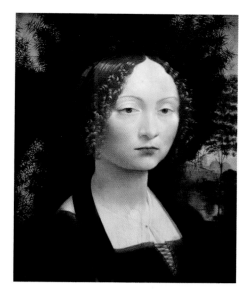

CONTENTS

INTRODUCTION

Regarded by many as the greatest artist who ever lived, and even in his own lifetime revered as a multi-talented genius, Leonardo da Vinci left only a small number of completed paintings, together with quantities of drawings and notes on many aspects of science.

We know relatively little about the artist Leonardo da Vinci, his family or his personal life, but his humanity shines out through his works.

WHO WAS LEONARDO DA VINCI?

Leonardo da Vinci is best known as a painter and sculptor. His work as an architect and engineer complements his astute observations as an anatomist and naturalist. It is a legacy that his contemporaries found hard to match. Leonardo's fervent desire for knowledge on practically every subject led him to make copious notes, all tied together in loosely bound notebooks, on a wide range of subjects, from an early age. Yet his written accounts tell us little about Leonardo, the man.

ARTISTIC TALENT

Leonardo's talent as a painter was recognized during his apprenticeship in the workshop of the sculptor and goldsmith Andrea del Verrocchio in Florence, but he did not, like many of his contemporaries, remain part of the artistic culture of Florence and its rich patrons. At the first opportunity he moved to Milan to work at the court of the Sforza family, leaving behind unfinished works, his studio and his assistants. Personal letters to Duke Ludovico Sforza are perhaps the clue to his true ambitions. In these letters he positively promotes his engineering skills far more than his artistic ability. This is the clue to how he wanted to spend his professional life. He thought of himself as an architect or engineer, not an artist, yet not one of his architectural designs, warfare machines or practical gadgets was completed. If they had been made, we might today recognize Leonardo as a designer more than a painter. His patrons were most illustrious: from the court of the Milanese Sforza to the Florentine Medici and the King of France, they wanted him for all his attributes. For Leonardo, patronage was vital.

FAMILY AND FRIENDS

Leonardo benefited from being nurtured by a family that appreciated his talent for art. He spent his formative years living in the countryside around Vinci, in Tuscany, attentive to nature and at one with his environment. As a youth, he was a likeable person, tall, very handsome and athletic. His strength was noted, as were

Above: Vitruvian Man, *larger than life-size sculpture, metal, Museo Ideale di Leonardo da Vinci, Vinci, Italy, scaled from Leonardo's drawing,* Proportions of the Human Figure (Vitruvian Man), *c.1490.*

his patience and kindness. He is said to have been an adventurous dresser, wearing bright colours, even in older age. He was not a follower of fashion, but perhaps more a maker of it: he favoured long hair when the fashion was for short, and in middle age he wore shorter tunics when the style for the older generation was long. He spoke his mind, and was known to be a fair and loyal friend; his friendships lasted a lifetime.

PROFESSION

Leonardo was a prolific writer, jotting down ideas and plans in note form. Giorgio Vasari records that 'he wrote backward, in rude characters, and with the left hand, so that anyone who is not practised in reading them, cannot understand them'. It was a personal note-making style, not designed to confuse, for he planned to have his

Left: The hillside village of Vinci, near Florence, Italy. Today a museum dedicated to Leonardo's life and works welcomes visitors to lectures and exhibitions.

notes published as treatises. As a polymath Leonardo had interests spanning many fields, allowing him to work on diverse projects, from science-based anatomical dissection to canal engineering, from city fortification to portrait painting. His flair for engineering and architectural design is perhaps the reason why he produced only 28 paintings during his professional life. Of these, 22 remain extant. The other works are known to us through copies of the original, or through his notes.

Below: Map of Tuscany from Theatrum orbis terrarum, *Abraham Ortelius, 1570.*

LEONARDO THE ENIGMA

Favoured by the nobility, Leonardo da Vinci spent the majority of his adult years living at royal courts. To his patrons and perhaps to Leonardo himself, he was *l'uomo universale* (universal man), through his ability to achieve on many levels; an extraordinarily gifted man who personified the remarkable Renaissance in Italy. But why does Leonardo have such an exceptional reputation with so few paintings completed? Looking at his artworks, this reputation rests on the beauty of the depictions and his astonishing skill in rendering reality, from the glancing look in the eyes of

Cecilia Gallerani in *Lady with an Ermine*, 1489–90, to the stunning landscape glimpsed through the windows in *Madonna and Child with a Carnation*, c.1473–6, and the enigmatic smile of the *Mona Lisa*, 1503–6. Standing in front of a Leonardo da Vinci painting, it is possible to feel present with him at the moment he painted it. From Leonardo's history, it is easy to discover how much time he spent working on each painting, and how long he spent designing objects, from canals and bridges to war machines. His art, design and writing should be considered as a united body of work.

Below left: The Journey of the Magi to Bethlehem *(detail), by Benozzo Gozzoli, c.1460. On the walls of the chapel of Palazzo Medici-Riccardi, Gozzoli painted the Medici as princely travellers en route to Bethlehem to worship the newborn Jesus.*

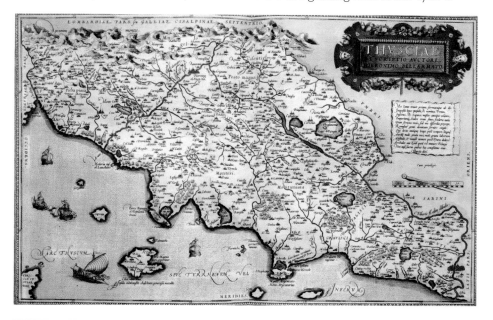

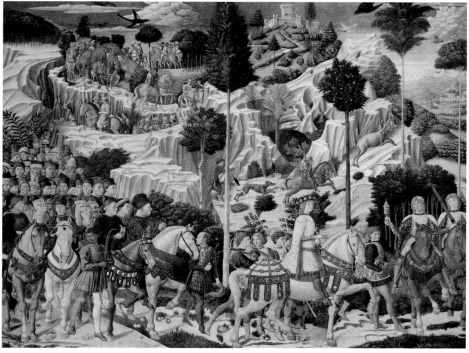

FLORENCE IN 1452

Leonardo da Vinci was born at a pivotal moment during the Italian Renaissance. Unrest in Constantinople in 1451, as Sultan Mehmet II planned to besiege the city, came to a violent conclusion in 1453 when the city fell to the Ottoman Turks. Greek academics, including philosophers, monks and teachers, fled Constantinople. Many made their way to Florence and stayed as guests of the noble families, acting as tutors. The Greeks brought ancient texts and their knowledge of ancient Greece and Rome. They inspired the Florentine families to immerse themselves in the works of Plato, Aristotle and Virgil and to study Humanism and Neo-Platonism. The result was a widespread interest in the city's Roman past, with the creation of buildings based on the classical language of architecture, and sculptures created using Roman methods. Painting a Humanist view of man as a reflection rather than a servant of God promoted the status of rich patrons and their artists.

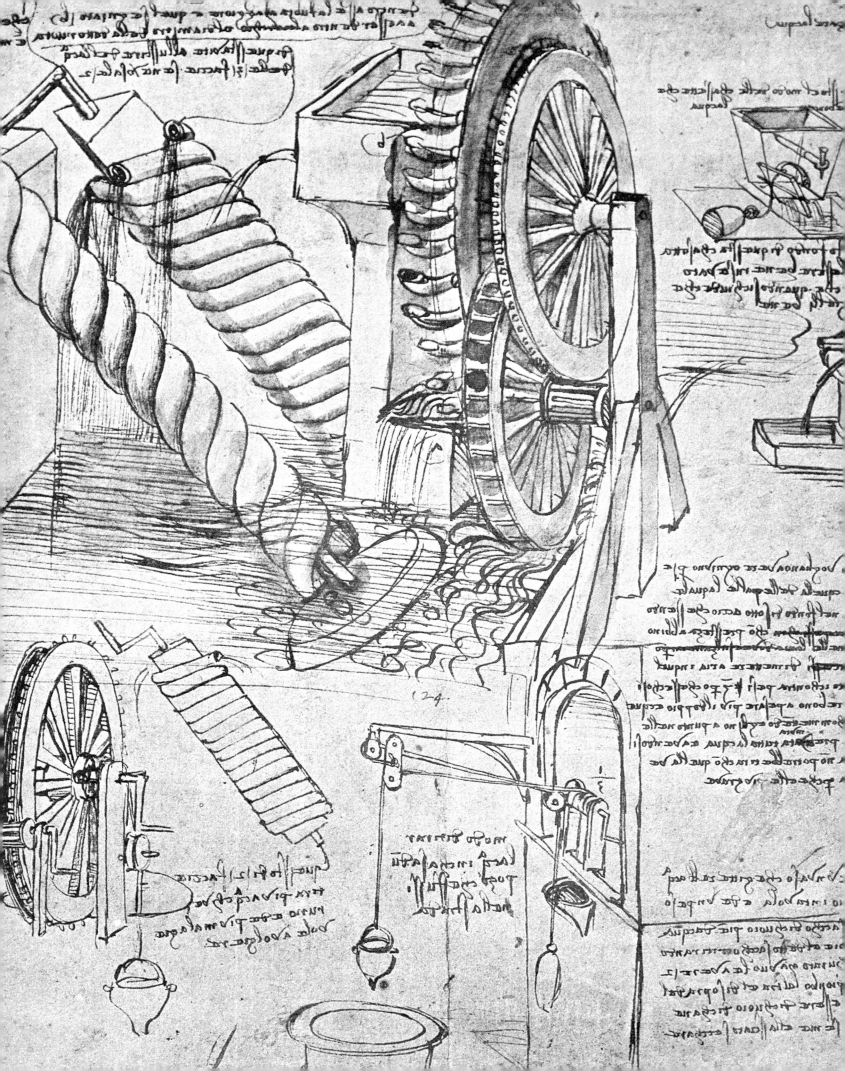

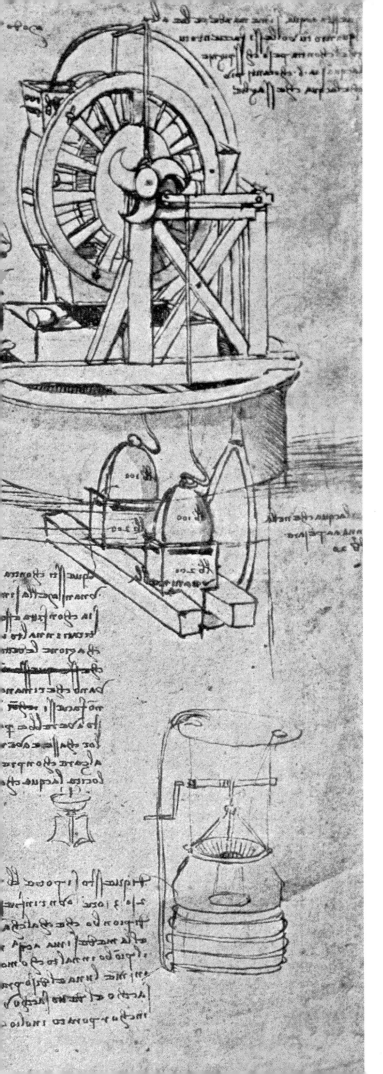

Leonardo: His Life and Times

The personal and professional life of Leonardo da Vinci can be pieced together from a variety of sources. At the very beginning, Leonardo's paternal grandfather joyfully noted down the time, date and location of his first grandson's birth, and Leonardo's death was relayed to his family in words of deep regret at his passing. Leonardo left paintings, money, property and around 13,000 pages of notes, drawings and manuscripts, of which about 6,500 pages survive today. His notebooks record details concerning works in progress, orders for materials, expenditure and other accounts. Further aids are two *Lives* of Leonardo, which were written soon after his death. One of these, *Leonardo Vincii Vita*, written *c.*1520–7 by the philosopher, physician and historian, Paolo Giovio (1483–1552), was a brief one-page eulogy. We look to Giorgio Vasari's *Lives of the Artists* for a fuller account of Leonardo's life.

Left: Archimedes screws and waterwheels, 1478–1515.
A sheet of pen and ink drawings from Leonardo's notebooks
(Codex Atlanticus, fol. 36r).

Vinci and Florence

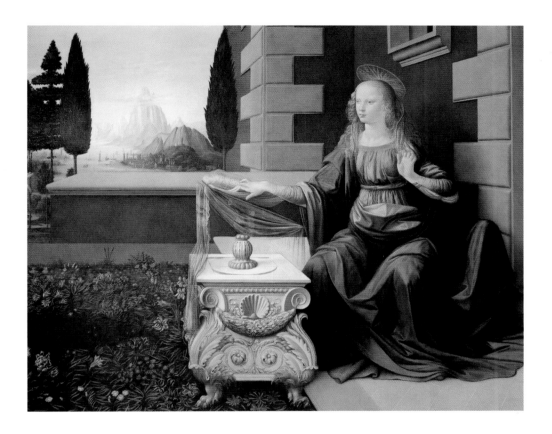

Leonardo da Vinci was born in Vinci, a Tuscan hillside village, close
to Florence. As the illegitimate son of a notary, he grew up in the care of
his paternal grandfather and uncle. In Vinci his interest in nature and the
countryside flourished. He drew sketches, observing nature in all its forms,
from wild animals to insects, flowers and trees, and noting different species.
A permanent move to Florence, the home of his father, came about
through an apprenticeship to the respected artist and sculptor, Andrea del
Verrocchio. In the city, he observed and studied the architecture, paintings
and sculptures of Florence's most respected artists. Learning much from
Verrocchio, Leonardo began a remarkable career.

Above: Virgin Mary *(detail), from the* Annunciation, *1472–5. An early painting by Leonardo, possibly created on
completion of his apprenticeship to Andrea del Verrocchio.* Left: Proportions of the Human Figure ('Vitruvian Man'),
c.1490. Leonardo's drawing of 'Vitruvian Man' encapsulates the Humanist ideals of the Italian Renaissance.

LEONARDO: A SPECIAL CHILD

Born the illegitimate child of Ser Piero di Antonio da Vinci and Caterina, a young peasant girl, Leonardo da Vinci lived with his grandfather in the small village of Vinci on the outskirts of the city of Florence.

Because he was born into a paternal family of notaries and judges and a maternal family of peasants and labourers, Leonardo da Vinci (1452–1519) was burdened with the stigma of illegitimacy, which may have restricted his professional prospects.

BIRTH OF A GENIUS

Leonardo da Vinci was born on 15 April 1452 to Caterina, a peasant girl, and Ser Piero di Antonio da Vinci (1426–1504), a young notary. The birth took place in Anchio, a small hamlet near Vinci, 46km (29 miles) west of the city of Florence. Historians claim a terracotta-tiled, two-storey house, situated one and a half miles above Vinci, as the da Vinci farm. The foundations of a smaller house in the grounds might possibly be the site of the house where Leonardo's birth took place. Leonardo was an illegitimate child, but in Italy it was accepted practice that such a child could be welcomed into the family and brought up alongside legitimate offspring.

AN OFFICIAL RECORD

Ser Piero da Vinci and Caterina did not have a permanent relationship. Historians believe that Caterina was possibly a servant in Leonardo's grandfather's house, or in the house of a family friend in Florence. Ser Antonio, Leonardo's grandfather, made a record of his baptism. A priest named Piero di Bartolomeo di Pagneca conducted the service, probably at the Chiesa di Santa Croce in Vinci. Records show that five male and five female witnesses were present, but Caterina's name does not appear on Leonardo's baptismal certificate. At a later date, Ser Antonio recorded at the Land Office that 'Leonardo son of the aforesaid Ser Piero, not legitimate, born of him and of Caterina' resided at his house. The statement acknowledges the circumstances of Leonardo's birth, but where the infant lived in the first few years is still disputed.

Below: Vinci, Italy. Leonardo was born in Anchio, a tiny hamlet of Vinci. As a child he lived in the house of his grandfather.

Above: Madonna Litta (detail), c.1481–97, attributed to Leonardo da Vinci. The unseen presence of the viewer during an intimate moment between mother and child is captured in the intuitive gaze of the infant Christ.

Below: Study of a lily, attributed to Leonardo, c.1475. One of many drawings revealing close observation of plant structure.

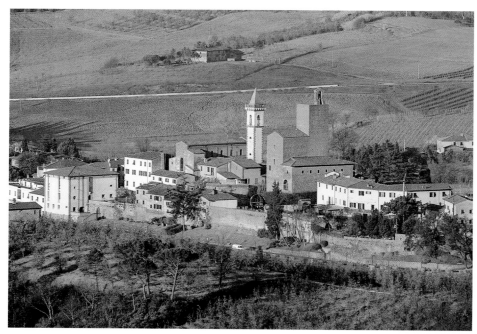

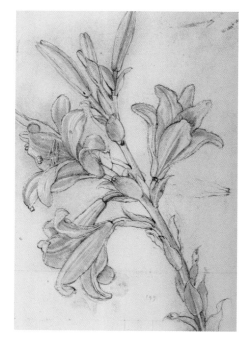

Right: Clouds over a Hilly Landscape, Francesco Melzi, after 1517. Melzi's drawing connects to Leonardo's lifelong interest in cloud formation, originating at the age of four, observing a storm over Florence in 1456. Melzi was an assistant of Leonardo.

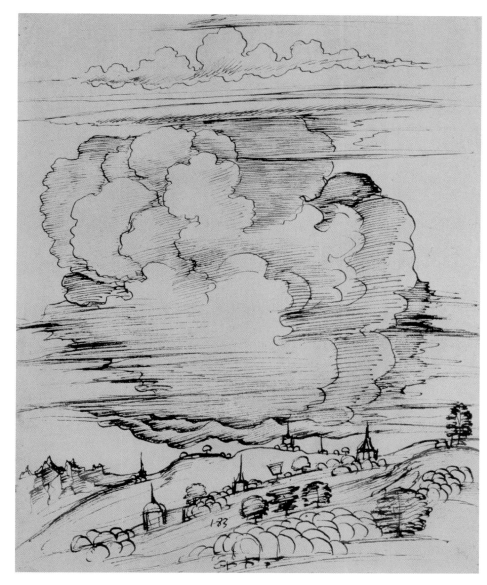

LEONARDO'S *LIFE*

In 1511, eight years before the death of Leonardo da Vinci, the painter and biographer Giorgio Vasari (1511–74) was born in Arezzo. He spent his adult life in Florence mixing with the families that Leonardo knew, particularly the Medici. Vasari wrote the first modern art-history book, published in 1550, *Vite de' più eccellenti architetti, pittori, et scultori* (*The Lives of the Most Eminent Painters, Sculptors and Architects*). He published an enlarged and revised edition in 1568. In this history of the lives of Italian artists, Vasari is the first to use the term *rinascita* (Renaissance). In the *Life* of 'Leonardo da Vinci: Painter and Sculptor of Florence', we can accept that much of what Vasari narrates is based on elements of historical fact, first-hand recollections and official records. He, like Leonardo, was a Florentine, and the artists of the city and region were much favoured in his book. In the opening paragraphs on Leonardo's life, Vasari informs us that Leonardo had the celestial gifts of 'beauty, grace and talent', each rained on him in full measure. Vasari refers to Leonardo's 'great genius' and 'divine actions'. These are terms which show the gracious respect in which he was still held 30 years after his death. Vasari points out that Leonardo set himself to achieve many things but often had to abandon projects unsolved or unfinished because he did not easily focus on one objective. Such was the nature of his genius.

Some accounts imply that initially Leonardo may have stayed with his mother, which would be a natural assumption for a newborn child, but we know from official documents that by the age of five years Leonardo was living permanently in the da Vinci household in Anchio. He is listed on his grandfather's tax return dated 28 February 1457 as a *bocco* (mouth to feed), a tax-deductable dependant.

SER PIERO MARRIES

Caterina was probably welcome in the house, if not actually living in the Vinci household. However, soon after the birth, according to the Florentine biographer Giorgio Vasari, Ser Piero di Antonio married Albiera di Giovanni Amadori (1436–64), a 16-year-old girl from a wealthy Florentine family, who

Piero and his family considered had a higher social status than Leonardo's birth mother. In 1453, Caterina married Accattabriga di Piero del Vacca (dates unknown), a lime-burner and manual labourer, who is recorded as living in Vinci from March 1449 until August 1453. It was perhaps on this marriage that Leonardo moved permanently to his grandfather's residence.

The village of Vinci, situated on the slopes of Montalbano was a lush landscape of olive groves and vineyards. Growing up, Leonardo enjoyed living in the Vinci household and particularly appreciated the company of his grandfather and his uncle Francesco, who encouraged Leonardo to study the world around him, from the stunning landscape to the flora and fauna on the estate.

FROM VINCI TO FLORENCE

A childhood in the countryside of Vinci and an education at home allowed Leonardo the freedom to pursue an interest in art. This led his father to consider trying to find him an apprenticeship in Florence.

The biographer Vasari tells us that in his youth Leonardo already showed an exceptional intellect. This was obvious to his family members and his tutors, and to everyone who met him, yet he found it difficult to settle on one subject, often abandoning studies or tasks.

BREAKING A FAMILY TRADITION

Illegitimacy was not always a constraint to a profession, but Leonardo's status at birth would hamper the possibility of taking up his father's respected position of *notaio*, a profession that was a family tradition. Leonardo's great-grandfather, Ser Piero da Vinci (d.1417), had been a distinguished notary of the Signoria in Florence. While his grandfather, Ser Antonio, and his Uncle Francesco had chosen to live as country gentlemen in Vinci, Leonardo's father, Ser Piero di Antonio, was an ambitious man and would successfully continue the da Vinci tradition as a prominent notary and judge in Florence. It is perhaps because of his illegitimacy that Leonardo was encouraged by his family to consider a different profession, to study literature and practise art, which he loved.

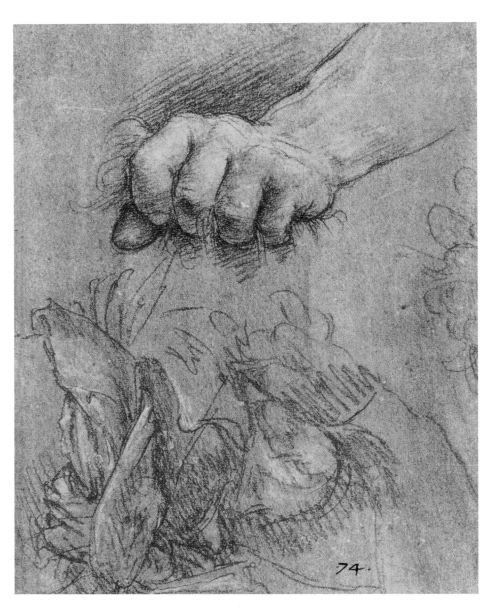

Above: Drawing of a closed fist (detail), c.1480–1515. A preparatory study for a larger work, this is attributed to Leonardo.

A FUTURE FORETOLD

In a notebook, Leonardo relates the first memory of his infancy as an encounter with a large bird. 'I lay in the cradle and it seemed as though a Kite descended on me. It opened my mouth with its tail feathers and moved them about my lips.' Leonardo deduced this to be an omen for his future, a type of 'baptism' of nature that was leading him toward his destiny.

A TALENT TO INSPIRE

Leonardo was a beautiful child, growing into a handsome youth with a powerful physique, able, according to Vasari, to bend a horseshoe with his hands. He was also said to have a kind nature. His likeable personality attracted attention, leading his family and tutors to indulge him and become interested in his future. Growing up, he challenged his tutors with his probing questions and enquiring mind. He was taught to read and write. He used his left hand to draw and write, creating his own mirror-image writing technique that is difficult to decipher. Later in life, the many notes he would make, gleaned from close observation and all dutifully recorded in his mirror-writing style, show that everything in his world was of interest to him.

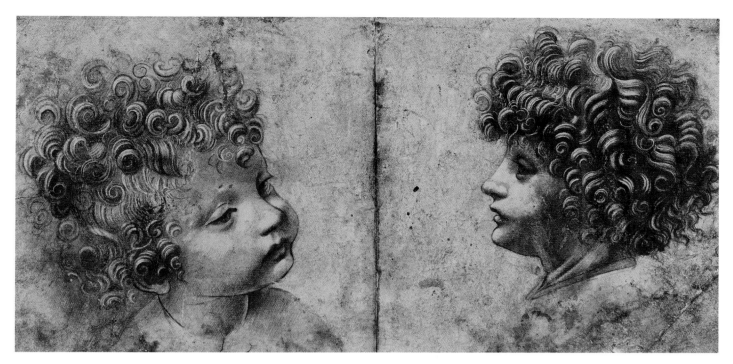

Above: Study of a child's head, c.1498–9.
Attributed to Leonardo, this three-quarter
right profile and left profile of a young
child are linked with preparatory studies for
the infants pictured in Virgin and Child
with St Anne and Infant St John, c.1508.

AN IMPATIENT STUDENT

Leonardo's interests were wide: they
spanned natural history, music and the
arts and sciences. He cross-examined
his tutors, often exasperating them with
countless questions, and was a
determined person interested in diverse
pursuits, including playing the lyre,
which he learned in order to play
improvisations to accompany his own
singing. As a youth he moved rapidly
from one pursuit to another, impatient
and keen to learn something new.
This depiction of the gifted, impetuous
young Leonardo, who had a talent
for learning but was too impatient
to stay the course, is one that is
reflected in his later life, when he
would often leave projects unfinished
without explanation.

Right: Part of a page of notes showing
a design for a church, 1478–1519.
Leonardo's notes, which later comprised
bound notebooks, contain many pages
of text with small sketches in the margins
or interspersed between sentences,
to illustrate different points.

A BUDDING ARTIST

Soon after Leonardo's birth, his father
married the young Florentine girl,
Albiera, but Leonardo did not live with
them; no children were born to them
during their 12-year marriage, cut short
by Alberia's death in 1464. However, at
Vinci, Leonardo was indulged as Ser
Piero's first grandson. His interest in
natural history was nurtured, prompted
by his fascination for lizards, glow
worms and the other wild creatures
that resided in the fields and vineyards
around his home, which he would

carefully observe and then draw.
His tuition, particularly in the basics
of reading, writing and arithmetic,
was given by respected tutors, but
there is no reference to formal
schooling in Florence. In later life he
taught himself Latin. Perhaps Leonardo
could have chosen a profession that
enjoyed a much higher status than the
perceived manual tasks of painting or
sculpture, but this was what he
excelled in, and for this reason his
father looked to secure Leonardo an
apprenticeship in Florence.

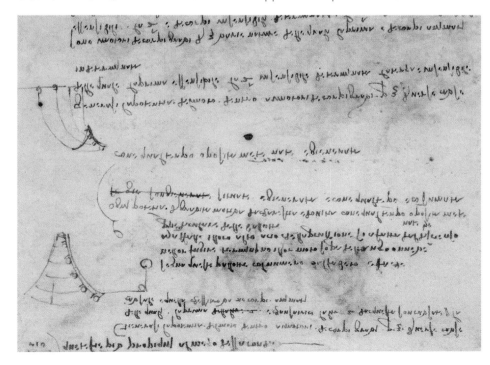

1469: APPRENTICESHIP

In the city of Florence, Leonardo's father worked as a notary at the Palagio del Podestà (also known as the Bargello), the seat of the chief law officer, where he was ideally placed to support Leonardo in his choice of career as an artist.

Ser Piero da Vinci's decision to secure his son an apprenticeship with Andrea del Verrocchio was the key to Leonardo's progress as a painter, sculptor and architect.

A KEY MEETING

Leonardo created many drawings and sketches while living at Vinci. His accomplished artworks led his father to take a portfolio of them to a friend of the family, the sculptor, goldsmith, painter and draughtsman, Andrea di Michele Cione, better known as Andrea del Verrocchio (c.1435–88), who ran the most notable art workshop in Florence. Vasari relates that 'Ser Piero… took some of his [Leonardo's] drawings to Andrea del Verrocchio… and besought him straitly [sic] to tell him whether Leonardo, by devoting himself to drawing, would make any proficience.' The response, Vasari tells us, was clear: Verrocchio was astonished at Leonardo's skills. He 'urged Ser Piero that he should make him study it'. Thus it was arranged that Leonardo would enter Verrocchio's workshop, much to his delight.

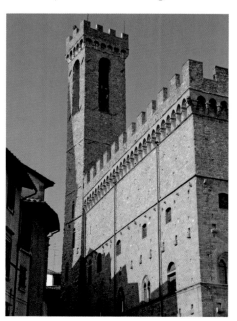

Left: Palazzo del Bargello, Florence. In the 15th century the building was the official residence of the Podestà, the governing magistrate of the city, and the workplace of Leonardo's father.

Above: Head of an angel, Andrea del Verrocchio, c.1470s. Possibly a study for the archangel Gabriel, in Tobias and the Angel, c.1470–5, by Verrocchio and his workshop, which included Leonardo.

A MASTER CRAFTSMAN

The exact year that the apprenticeship began is hard to pinpoint. Historians' opinions vary from 1464 to 1469, with the majority in favour of 1468–9. Leonardo's presence in Florence relies on evidence that his grandfather died in 1464 and Leonardo probably moved to Florence to live with his father. His first stepmother also died in 1464, and his father soon remarried. Leonardo's presence in the city is verified from 1469, when his name appears on his

father's tax return. His father had rented a house in the Via delle Prestanze (now Via dei Gondi) the same year. For Leonardo, his father's choice of the Verrocchio workshop was perfect; he was interested in every aspect of artistic accomplishment, whether painting, sculpture or architecture. Unlike his later rival, the Florentine artist, sculptor and architect Michelangelo Buonarroti (1475–1564), whose wish was to work as a sculptor, not a painter, Leonardo was keen to embrace many art forms.

AN ACCOMPLISHED APPRENTICE

We learn more about the progression of Leonardo's career as an apprentice from Vasari. He writes: '… he was an excellent geometrician, he not only worked in sculpture making, in his youth, in clay, some heads of women that are smiling, of which plaster casts are still taken, and likewise some heads of boys which appeared to have issued from the hand of a master; but [also] in architecture… and painting.'

Vasari's factual account of Leonardo's involvement at the workshop brings together the attributes for which the artist was known in later life. He tells us that Leonardo was involved in the making of plaster casts; he drew up ground plans and designs for buildings; he was the first to suggest the idea, and make a plan, for reducing the river Arno to a navigable canal; he made 'designs of flour mills, fulling mills, and engines' that could be powered by water. Vasari lists a phenomenal variety of tasks that Leonardo was given, and accomplished, during his apprenticeship.

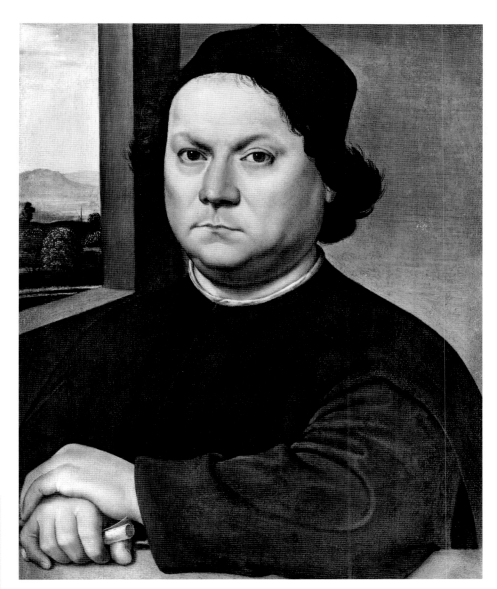

THE STATUS OF THE ARTIST

In 15th-century Italy, picture painting and sculpture were considered manual skills – trades rather than professions. However, in Florence, signs could be seen of the gradual elevation of the status of the artist. This began in the 14th century with the first great artist of the Italian Renaissance, Giotto di Bondone (c.1267–1337). His style of painting was the prototype for the 'new sweet style' of naturalism in art. In the early 15th century, recognition of the artist continued, notably with the work of Florentine artists such as Tommaso di Masaccio (1401–c.1428), and it reached a peak at the beginning of the 16th century in the art of Leonardo, Michelangelo and Raphael, (Raffaello Sanzio, 1485–1520).

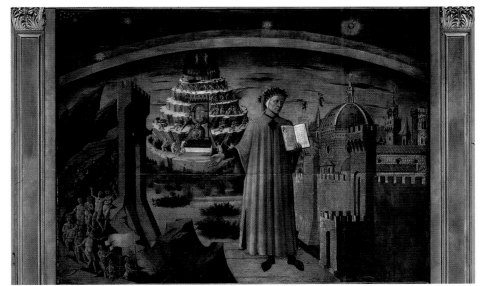

Top: Portrait of Andrea del Verrocchio(?), Lorenzo di Credi, c.1500. Lorenzo di Credi (1459–1537) and Leonardo were apprentices to Verrocchio at the same time.

Above: Dante Reading from the 'Divine Comedy', Domenico di Michelino, 1465. To Dante's left is Florence at the time that Leonardo commenced his apprenticeship.

A MASTER CRAFTSMAN

Giorgio Vasari writes that Leonardo da Vinci practised all forms of art in the workshop of Verrocchio, where bronze and marble sculptures, paintings and frescoes were commissioned by the wealthy patrons of Florence.

Today, Andrea del Verrocchio's name is synonymous with his famous apprentices, Leonardo da Vinci being just one of his many pupils. His contribution to the progress of new art forms in Florence is immeasurable.

LEARNING SKILLS IN BRONZE

Andrea del Verrocchio was a Florentine by birth. In his early teens the death of his father propelled him toward attaining a skilled profession, in order to support his mother and siblings. A talented draughtsman, he was at one time apprenticed to the remarkable Florentine sculptor Donatello (Donato di Niccolò di Betto Bardi, c.1386–1466), from whom he learned much about sculpture. These were skills he would teach his own apprentices. From the outset, Leonardo was involved in the preparation of clay models for bronze sculptures, like those that his master had made for Donatello. In 1470, Verrocchio was renowned for his sculptural works

Below: Tomb of Piero and Giovanni de' Medici, Verrocchio, 1469–72. In marble, bronze, porphyry, serpentine, and pietra serena, church of San Lorenzo, Florence.

on display in the city of Florence. One commission was for a bronze freestanding statue of *David* for Piero di Cosimo de' Medici (1416–69). From 1464 until his death in 1469, Piero was the de facto ruler of Florence, which may explain his desire to order a bronze sculpture of the city's patron, the biblical figure of *David*. A link between this statue, Verrocchio and Leonardo is the possibility that Leonardo was the model for this *David*. Leonardo may also have been involved in the creation of a life-size bronze niche sculpture of *Christ and St Thomas*, commissioned by the Mercantazia in 1467 for Orsanmichele. At the same time, from 1469 to 1472, Verrocchio and his team designed and created the tomb of Piero and Giovanni de' Medici, in a combination of precious materials: marble, porphyry, serpentine, bronze and pietra serena. It was placed in the church of San Lorenzo, the Medici parish church in Florence.

Below: Christ and St Thomas, Andrea del Verrocchio, 1467–83. A sculpture for Orsanmichele, Florence. Leonardo may have been involved in its creation.

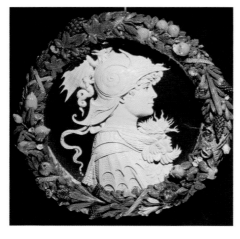

Above: Profile portrait of Alexander the Great, Andrea del Verrocchio and Andrea della Robbia, c.1480. Combined talents produced this superb terracotta polychrome-glaze roundel.

FOLLOWING A TRADITION

Verrocchio was working for the most influential families in Florence, including the Medici and the Tornabuoni. In the workshop, apprentices were taught how to prepare colour pigments for paint by grinding and mixing the raw ingredients. Verrocchio would also teach apprentices the techniques of fresco painting and oil painting. They would learn on-site, wherever Verrocchio was working: whether it was in a chapel or a palace, he gave his apprentices every opportunity to improve and advance their own techniques and emergent skills.

When an apprentice was considered skilled enough, he would complete whole sections of larger works. An example of one combined contribution from Andrea del Verrocchio and his workshop is the oil on canvas painting, *Tobias and the Angel* of 1470–5 in the National Gallery in London, which was created by the artist and his assistants. Specific parts of the painting are attributed to Leonardo.

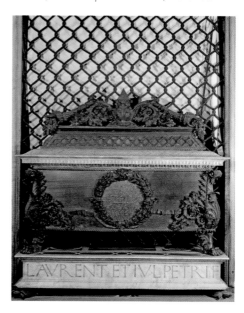

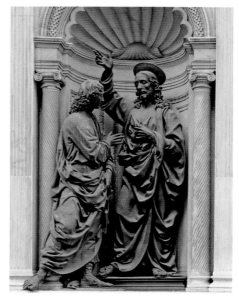

Right: David *(detail), Andrea del Verrocchio, c.1470. The features of the bronze freestanding sculpture were possibly modelled on an apprentice.*

Below left: David, *Donatello, c.1412. Life-size marble sculpture. An inscription at the base (in Latin) reads: 'To those who fight bravely for the fatherland the gods lend aid even against the most terrible foes.'*

Below right: David, *Donatello, c.1440–2. The first nude bronze freestanding sculpture since antiquity was created as a private commission for the Medici family.*

DAVID

David was a biblical hero (1 Samuel 17:12–54), a young shepherd who slew Goliath, a Philistine enemy of gargantuan size, using only a slingshot and a stone. David was chosen by Florentines to symbolize the Republic of Florence and its fortitude against enemies greater in number and size than the city itself. Two versions of *David* by the sculptor Donatello show quite different characters. A marble *David*, 6ft 3in (1m 90cm) tall, c.1412, looks straight ahead after the fight. Wearing a long robe, he stands astride the head of the decapitated Goliath. Donatello's bronze *David*, c.1440–2, a private commission for the Medici, was the first male nude bronze since antiquity. It visualizes the boy David wearing only his shepherd's hat and some armorial greaves (knee-to-ankle armour). The plumage from the helmet of the decapitated Goliath gently caresses the interior of David's thigh. Andrea del Verrocchio's bronze *David* is a young boy. He stands astride the head of Goliath, and the features of David's face are said to be those of the young Leonardo da Vinci. A later version, by Michelangelo (1501–4), explores David as a symbol of man's perfection.

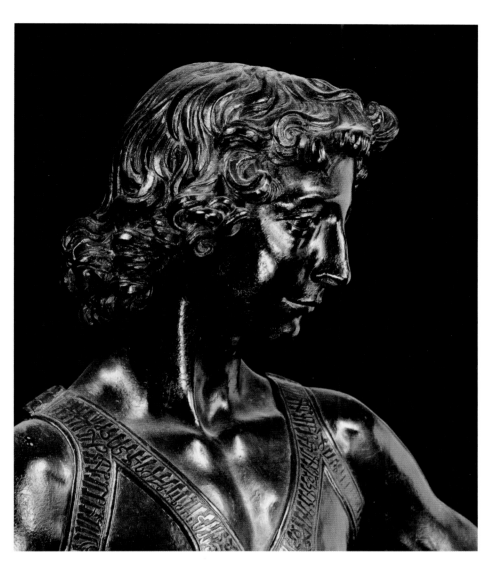

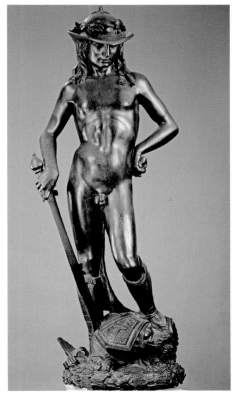

LIVING *ALL'ANTICA*

Since the Florentine revival of interest in ancient Greece and Rome, wealthy patrons wanted to live *all'antica*, 'like the ancients', aspiring to commission houses, chapels or sculptures based on their illustrious forebears' own designs.

At the time of Leonardo's apprenticeship, the workshop of Verrocchio had an order book full of commissions for sculptures in bronze. Leonardo learned techniques for making large-scale works, including equestrian statues, in the antique style.

BRONZE SCULPTURES

Verrocchio ran an industrious workshop that produced many talented artists, such as Pietro Perugino (1446–1524) and Domenico Ghirlandaio (1449–94). In his own apprenticeship years, Andrea had trained for some time as a goldsmith under the supervision of Francesco di Luca Verrocchio, a successful Florentine goldsmith. (During the apprenticeship Andrea changed his surname from Cioni to Verrocchio.) In Florence he was the first choice for works commissioned in bronze. Like many other artists, he used the people he employed as models for faces and figures in his work, such as *Head of an Angel*, c.1460s, a life study of one of his apprentices.

Below: Self-portrait, *Pietro Perugino, c.1497–1500. According to Vasari, Perugino was an apprentice alongside Leonardo.*

AN ART INDUSTRY

For rich patrons, the main interest lay in emulating the art and architecture of the past, and Verrocchio and his team of artists were favoured to accomplish commissions based on antique prototypes. Although self-taught, Verrocchio had a good library of books, including Greek texts translated into Latin, which he could read. Verrocchio and Leonardo were aware of the works of Leon Battista Alberti (1404–72) and his treatise on classical architecture *De re aedificatoria* (1450). Alberti was active in Florence with a design for a new façade for the church of Santa Maria Novella (1458–70) and the prominent *all'antica* façade of Palazzo Rucellai (1452–70), based on the ancient façade of the Colosseum (AD70–82), in Rome.

Below: The church of Santa Maria Novella, Florence. The façade, built 1458–70, was designed by architect Leon Battista Alberti, author of De re aedificatoria, *1450.*

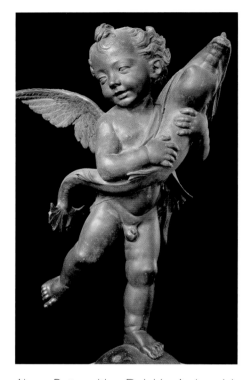

Above: Putto with a Dolphin, *Andrea del Verrocchio, c.1470s. The bronze freestanding sculpture emulates the style of classical antiquity.*

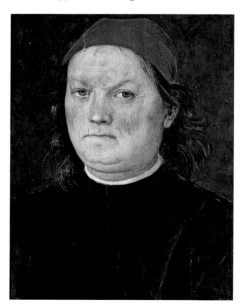

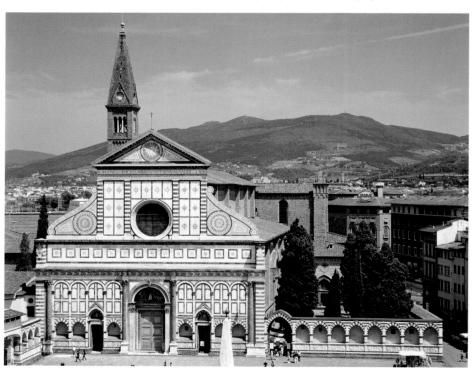

EQUESTRIAN STATUES

A return to the ancient 'lost wax' method of bronze casting allowed sculptors to create larger than life-size equestrian monuments. Antique precedents included the bronze equestrian statue of the Roman Emperor Marcus Aurelius (AD121–80), which stood outside the Roman Basilica of San Giovanni in Laterano in Rome, and four antique bronze horses placed on the pediment of the Basilica of San Marco in Venice, which had been stolen from Constantinople *c.*1204. In Italy the first equestrian statue for nearly 1,000 years had been created by Donatello in 1446–50. The bare-headed bronze equestrian statue of Condottiere 'Gattemelata' Erasmo da Narni (*c.*1370–1443) enthralled all who saw it in Piazza del Santo, Padua. Verrocchio and Leonardo were familiar with this work.

LOST WAX METHOD

To create a sculpture in bronze, a method of casting known as the *cire-perdue* or 'lost wax' process was employed by artists in Florence. Its history dates back to ancient Egypt. The method was perfected by the ancient Greeks, particularly from the 5th century BC, and was also used in Roman foundries. For larger sculptures, bronze casting was produced from a hollow clay or plaster mould, which would include all the fine detail required for the finished object. The mould was covered in a thick layer of wax, and the wax covered with a thicker layer of clay. On completion the mould was heated to a temperature which allowed the wax to melt and drain away from specially placed holes in the sculpture (hence 'lost wax' method). Molten bronze would be poured into the space left vacant by the melted wax, and once it had set, the clay exterior would be broken and removed to reveal the sculpture in bronze.

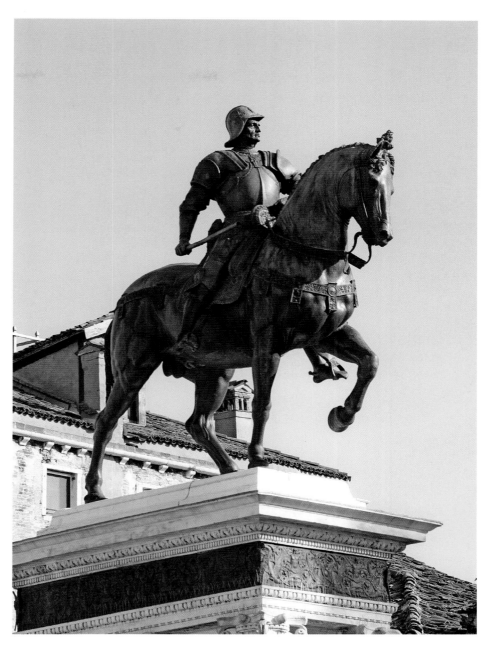

CONDOTTIERE BARTOLOMMEO COLLEONI

One of the most remarkable ventures for the Verrocchio workshop came at the end of Leonardo's apprenticeship: a commission *c.*1478 from the Senate of the Republic of Venice for an equestrian statue of Condottiere Bartolommeo Colleoni (1400–75). Colleoni had bequeathed 100,000 ducats to the Senate to ensure it was made. The plan was to portray the Condottiere astride his horse. The horse's left foreleg would be raised, a new venture in bronze-making. Leonardo, a keen horseman, created many drawings of horses in movement, including sketches for equestrian

Above: Bronze equestrian monument of Condottiere Bartolomeo Colleoni, Andrea del Verrocchio, c.1480, Venice. Leonardo may have participated in the design stages of this project.

monuments of this type. Leonardo may have travelled to Venice with Verrocchio to visit the patrons. A drawing he created *c.*1475–80, *Portrait of a Warrior* (British Museum, London), bears a strong likeness to Verrocchio's head of Colleoni. Verrocchio created the design in Florence and worked on the statue in Venice from 1482. His sudden death in 1488 left the casting process to the Venetian goldsmith Alessandro Leopardi (1466–c.1512).

A SIGNATURE STYLE

In 1472, Leonardo da Vinci completed the requirements of apprenticeship and joined the confraternity of the Florentine guild of painters, the Compagnia di San Luca, a confident action to encourage patronage.

The years that Leonardo had spent working hard at studying the techniques of drawing and painting, the art of clay sculpture and bronze pouring, resulted in a standard of proficiency that was recognized by the guilds in Florence. Leonardo was now able to progress from being an apprentice and work as a professional artist for Verrocchio.

FROM APPRENTICE TO MASTER

In Florence, the frescoes of Giotto di Bondone in Santa Croce and Tommaso di Masaccio in the Carmine church and Santa Maria Novella were most copied by other artists for their naturalism. Paintings by Giotto were among Leonardo's favourites.

At the Verrocchio workshop, all the apprentices lived together and worked together. In addition to training Leonardo to be a professional artist, Verrocchio passed on a diversity of skills, including playing the lute, a favourite with Leonardo, who aspired to improve his musical proficiency.

COMPAGNIA DI SAN LUCA

The first documentation we have of Leonardo da Vinci as a professional artist is in records kept by the Compagnia di San Luca (Guild of St Luke), a fraternity of painters based in Florence. In the record book for 1472 is Leonardo's name, written as a member of the guild of artists with a confirmation of his subscription.

Leonardo, at the age of 20, was now officially part of the artists' confraternity and recognized as such in Florence. Membership of this guild would have allowed him to accept independent commissions.

An apprentice such as Leonardo, on completion of his apprenticeship, would often continue to work as a professional artist for the same master, and in the same workshop.

Below: Santa Maria delle Nevi, addì 5 d'aghossto, 1473 ([On the day of] St Mary of the Snow Miracle, 5 August 1473). The earliest extant drawing by Leonardo, familiarly known as Landscape drawing of the Arno Valley, *is signed and dated by the artist.*

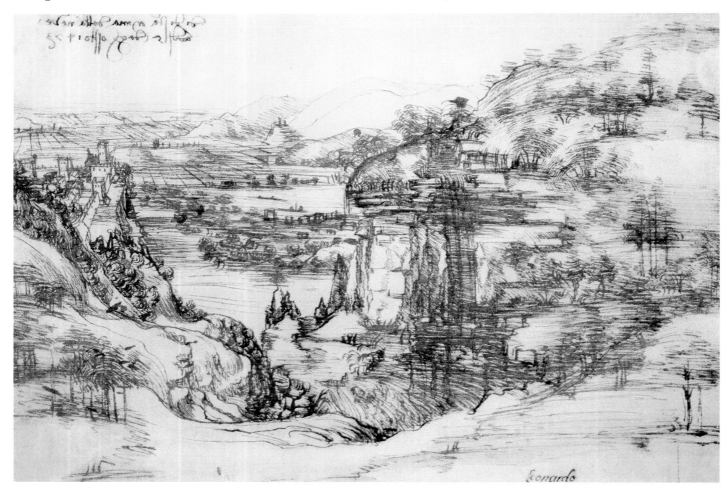

MIRROR WRITING AND SIGNATURE DRAWINGS

To highlight Leonardo's progress after his admission to the guild of painters, one drawing in particular stands out. It is the earliest signed drawing by Leonardo. In the top left-hand corner, written in his left-handed signature style of mirror writing, from right to left and back to front, it reads *di Santa Maria delle Nevi, addì 5 d'aghossto 1473* (on the day of St Mary of the Snow Miracle, 5 August 1473), a reference to a feast day. It is now more familiarly known as *Landscape*

Drawing of the Arno Valley. The Florentine landscape is completed in pen and ink over a preparatory pencil sketch. The scene is a long stretch of a Tuscan valley protected by hills. To the left, in the far distance, is a fortified hilltop castle. Today it is thought to be a view of Montevettolini Monsummano drawn from the slopes of Montalbano, 16km (10 miles) from Vinci. The drawing may have been a

preparatory sketch for a background landscape to a painting, possibly *Madonna and Child with a Carnation*, c.1473–6. There are similar scenes in both Verrocchio's and Leonardo's portraits, which favoured a backdrop of windows through which the landscape beyond can be seen. The technique added perspective to the depiction, placing the sitter and the viewer in a realistic setting.

Below: Madonna and Child with Two Angels (*also known as* Madonna of the Pomegranate), *Filippino Lippi, c.1472–5.*

Below: Madonna and Child, *Andrea del Verrocchio, c.1470. A classical building provides the backdrop.*

AN INDEPENDENT COMMISSION

Madonna and Child with a Carnation was one of the first religious works painted by Leonardo as an independent artist. It reveals his 'signature' distant landscape through the arched windows behind the sitter and his close attention to detail. Vasari, writing of a Leonardo painting referred to as the *Madonna of the Carafe*, may well have meant this painting by a different name. In his discussion of Leonardo's Madonna and Child portrait, Vasari writes that 'among other things painted there, he counterfeited a glass vase full of water, containing some flowers … besides the marvellous naturalness, he had imitated the dew drops of water on the flowers so well that it seemed more real than reality'. A carafe of water with flowers in it appears to the bottom right in *Madonna and Child with a Carnation*. The painting is known to have been in the possession of Pope Clement VII. The sweet face of the Madonna and the naturalness of the pose mirrors works by Leonardo's contemporaries, for example *Madonna and Child with Two Angels (Madonna of the Pomegranate)*, c.1475, by Filippino Lippi, and *Madonna and Child*, 1475, by Giovanni Bellini.

Above: Madonna and Child, *Giovanni Bellini, c.1475. The artist delicately captures the infant Christ touching his mother's face.*

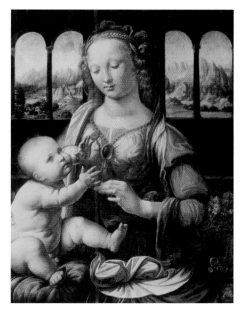

Above: Madonna and Child with a Carnation, *c.1473–6, an early work attributed to Leonardo da Vinci.*

A TALENTED DRAUGHTSMAN

Primary drawings and sketches by Leonardo illustrate his working method, highlighting how he planned artworks. Whatever the commission, from large altarpieces to private portraits, each work started with a simple sketched outline.

Leonardo's skill as a draughtsman, illustrated in the thousands of pages of drawings comprising his vast collection, were created over many years. They show his method of creating an image.

LEONARDO'S DRAWING METHOD

Leonardo drew with his left hand. He used a variety of media, including pencil, pen, chalk and charcoal, to sketch an outline or a detailed cartoon. He favoured a silverpoint technique, using a thin silver wire held in a clutch pen or other holder. This method left an indelible mark on specially prepared paper. It was used by the professional artist, after years of drawing in pencil. Leonardo used large pieces of paper for his drawings, which were normally

32 × 44.6cm (12 × 17in). This allowed him to create many sketches and outlines on one sheet. This was called a 'theme sheet' by the Leonardo scholar, Carlo Pedretti (b.1928). On the 'theme sheet' Leonardo created sketches of his ideas: perhaps the head of a man alongside a design for battlements or a hand or arm, all related to work in progress and other projects. The number of Leonardo's sketches and drafts that have been lost is subject of debate, and historians' opinions vary, but it is probably between half and four-fifths of his output.

AN ACCUSATION

Through an unfortunate incident we know that Leonardo was still resident at Verrocchio's workshop in 1476.

In April Leonardo came close to having his promising career curtailed. He and three others, Bartolomeo Pasquino (a goldsmith), Baccino (a doublet maker) and Lionardo Tornabuoni, son of a patrician, were accused anonymously of homosexual practices (*sodomia*) with 17-year-old Jacopo Saltarelli, a goldsmith's apprentice. In Florence a person or persons unknown had posted the accusation in one of the Bocca della Verità (Mouth of Truth) boxes. Without evidence nothing was done,

Below: Sketches of nude figures, and siphons, c.1500–19. A page of Leonardo's notes interspersed with sketches of apparatuses and nude figures.

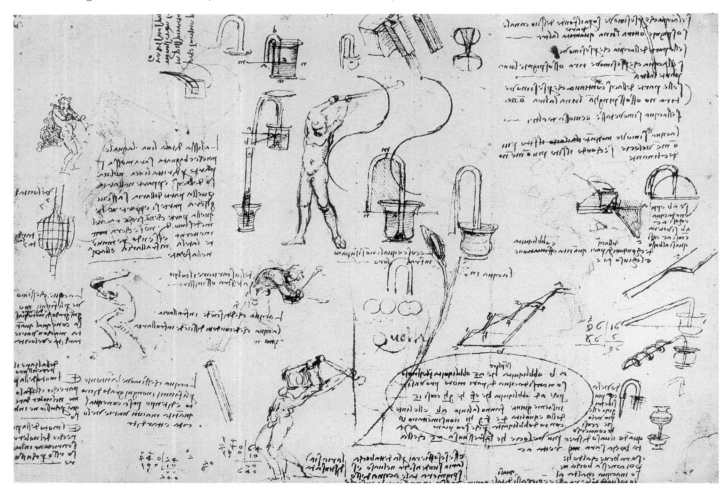

but the accusation was repeated in June. Fortunately for Leonardo the charge was dropped, possibly through the intervention of Tornabuoni's influential family. Leonardo's name was cleared. This traumatic experience may be the reason we know nothing more of Leonardo's personal relationships. Florence had a reputation for homosexual practices. Authorities in the city introduced Officers of the Night to patrol the streets to curtail the activity. If a man was caught and prosecuted the ultimate sentence was death, normally commuted to a prison sentence or banishment from the city.

NEW CLIENTS

With the threat of a court case dropped, Leonardo continued to work for Verrocchio, and with the help of his father he concentrated on the task of promoting his career as an artist. Leonardo needed to look for patrons and commissions. An opportunity was given on 10 January 1478, with a commission to paint an altarpiece for the chapel of San Bernardo in the Palazzo della Signoria (Palazzo Vecchio). The commission may have come through the influence of his father, who worked in the government offices. An initial fee of 25 florins was

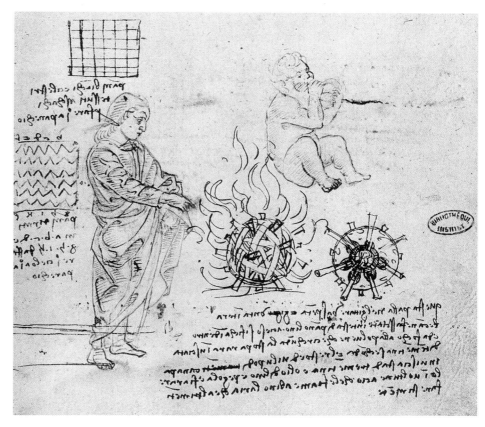

paid to Leonardo on 16 March. He began the work but did not complete the task. It was the first commission Leonardo left unfinished. His father's annoyance can only be imagined. The task eventually went to the talented Filippino Lippi (c.1457–1504), who completed the work in 1485.

Above: A sheet of notes with sketches of two figures, and exploding bombs (Codex B). The quickly drawn sketches, typical of Leonardo, are interspersed with his mirror-writing, right to left across the page.

LEONARDO'S STYLE

Vasari states that Leonardo, during his childhood, 'never ceased drawing and working in relief'. Unfortunately these works have not survived to show us his pre-apprenticeship approach to drawing. Looking at later works, a study for *Madonna and Child with Cat*, c.1478, shows Leonardo playing with the image layout, moving the head of the Madonna to create a more pleasing framework. Details of the child and cat are outlines in Leonardo's favoured medium, pen and ink on paper. In a drapery study for a seated figure, c.1475–8, which is reminiscent of Giotto, a section of the clothed figure is drawn and then painted in detail, the *chiaroscuro* technique accentuating the soft folds of the garment and the shape of the body beneath.

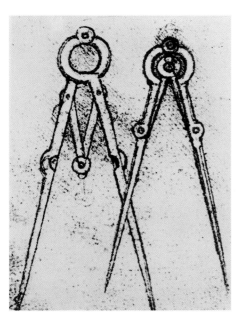

Above: Drawing of two types of adjustable-opening compass (Paris Manuscript H, fol. 108r), 1493–4. A pen and ink sketch, possibly of Leonardo's own compasses.

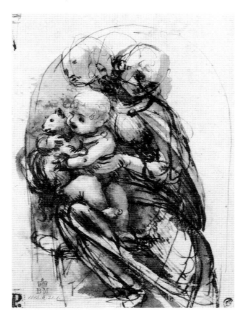

Above: Study for a Madonna with a cat, c.1478–80. Leonardo reworks the image, to find the best position for the head of the Madonna.

ADORATION OF THE MAGI

Leonardo was offered a second commission, to paint an altarpiece depicting the Adoration of the Magi, requested by the monks of San Donato a Scopeto, a church attached to a monastery near Florence.

The contractual default of his first commission did not stop another request for a painting. It is likely that Ser Piero da Vinci may have had a hand in procuring the second commission as he was also notary for the San Donato monastery.

AN UNUSUAL PAYMENT

The recorded memorandum of the contract for the *Adoration of the Magi* shows that it was acceptable for artists to agree to payment in kind. The money for the altarpiece was donated in 1479 by a saddle manufacturer. The main 'payment' to Leonardo in return for the work being completed in 24 to 30 months was an offer of one-third of a property in

Right: Figural studies for the Adoration of the Magi, *c.1481. A preparatory outline sketch of figure positions.*

Valdelsa (between Florence and Siena), which the monks record as given to them by 'Simone, father of Brother Francesco'. Included in the memorandum is the opportunity for the monks to reclaim this share of the property in three years for 300 florins. The oddity of the 'contract' is the inclusion of the clause that Leonardo would pay 150 florins to provide a dowry for 'the daughter of Salvestro di Giovanni', granddaughter of the patron.

As the work was not completed, the conditions were nullified, but the memorandum shows that payments were not only cash contracts. Other records show Leonardo receiving 'payments' of wine, wood and corn.

HIDDEN MEANING

Historians have debated for many years over Leonardo's illustrative plan for the *Adoration of the Magi* painting. Several sketches for the layout, plus individual

SCIENTIFIC ANALYSIS

Today, with the advantage of infra-red technology, it has been possible to see what lies beneath the rather gloomy translucent brown paint that covers the surface of the *Adoration of the Magi*. Recent scientific analysis by the respected Florentine scientist and art historian Professor Maurizio Seracini, a scholar who has studied the paintings of Leonardo for many years, has proven that the under-drawings created by Leonardo were later covered in a brownish-coloured paint. The style of the over-painting suggests that this addition is not by the hand of Leonardo. The reason for it was perhaps to unify the many different scenes in the background and to eliminate any republican overtones associated with the iconography.

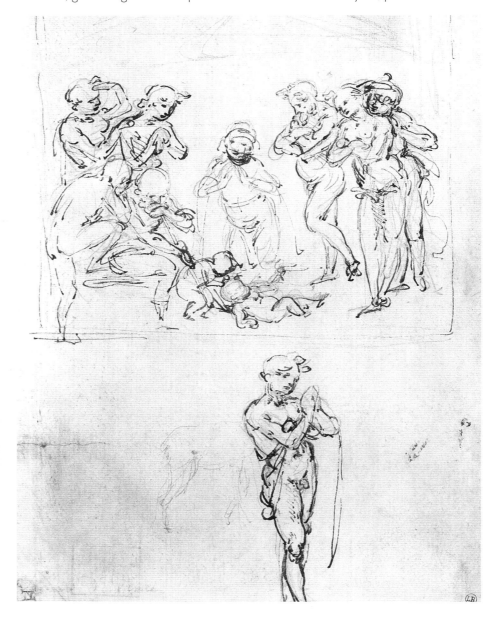

Right: Adoration of the Magi, *1481–2, Galleria degli Uffizi, Florence. Leonardo left the oil on panel painting unfinished when he left the city of Florence to work in Milan.*

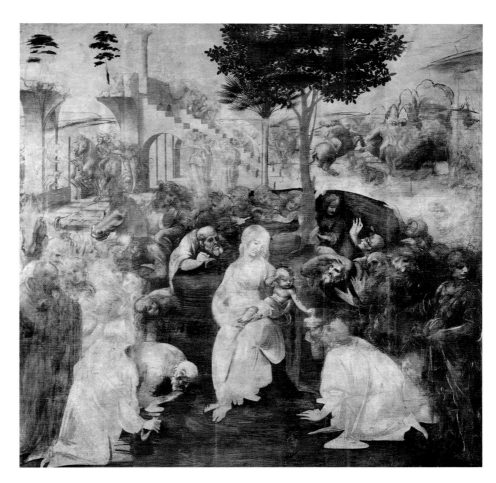

figures, show Leonardo working out the scheme with subtle differences in each study. Central to the picture is the traditional scene (Matthew 2:1–12) of the Madonna and Child receiving the Magi, the 'wise men', who gather around and kneel at their feet. Leonardo's intention for the imagery was perhaps to explore the coming together of the three world powers of Asia, Africa and Europe, united through the birth of Christ and Christianity. As a young, inspired artist, a different version of the traditional scene would be of interest to him. In the background, a conflict can be seen. Does this symbolize the pagan world being superseded by the Christian world? What the painting does explore is Leonardo's use of emotion in the faces of the Holy Family and the Magi, linked to the rhythm of movement in the background.

A SECOND UNFINISHED PROJECT

Leonardo's preparatory work for the 'Adoration' took from March to September 1481, but remained unfinished when he left for Milan. Of the original drawings, Vasari commented, 'He [Leonardo] began a panel with the *Adoration of the Magi* on which are many beautiful things, especially the heads… which too remained imperfect like his other things.' Leonardo left the work unfinished, along with a painting of St Hieronymus, which he had begun earlier. Years later, long after the monks had given up hope of Leonardo ever completing the work, Filippino Lippi was commissioned to create a new altarpiece of the *Adoration of the Magi*, 1496 (Uffizi, Florence). The setting, the landscape and the placement of figures bear a close resemblance to Leonardo's own version.

Right: Adoration of the Magi, *Filippino Lippi, c.1496. Lippi accepted the commission for a new Adoration of the Magi altar painting. It is similar in format to Leonardo's unfinished original.*

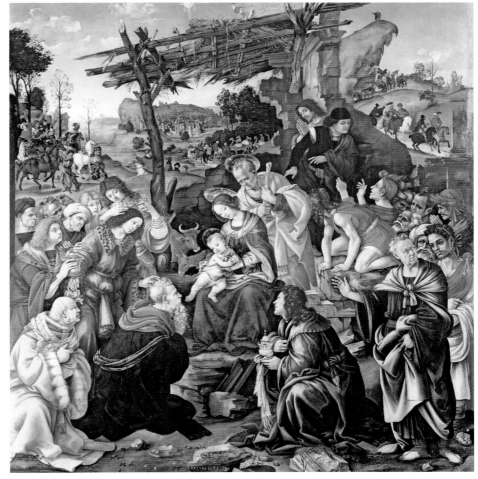

LEONARDO'S CONTEMPORARIES

Leonardo da Vinci was an amiable man, liked by his peer group and known to be sociable, kind and patient. In his youth he formed good friendships with Lorenzo di Credi, Sandro Botticelli and Pietro Perugino.

During the 15th century, artists who can be compared to Leonardo flourished in Florence and Venice. In style, Florentine artists focused on perspective and geometrical proportion; Venetian artists accentuated light and colour.

WORKSHOP LIFE

Apprentices lived and worked together in a close community, often sharing cramped quarters, living on site at their master's workshop. They learned from each other and shared the work. Many friendships were formed, lasting lifetimes. The workshops of 15th-century Florence were the key to the flourishing art and architecture of the city. Florentine apprentice painters followed in the footsteps of Masaccio, revering and copying his remarkable painting *Holy Trinity, with the Virgin and John*

and Donors (Santa Trinità), 1426–8. It was an exercise in geometrical proportion, painted as a funerary monument in Santa Maria Novella. Masaccio's use of perspective and foreshortening, and his reference to Roman antiquity in the triumphal arch and barrel vaulted ceiling, captured the attention of artists such as Leonardo, Bramante and Michelangelo.

FROM FLORENCE TO ROME

Florentine artists, such as Perugino, Sandro Botticelli, Domenico Ghirlandaio and Cosimo Rosselli (1439–1507), were aided by the patronage of Lorenzo

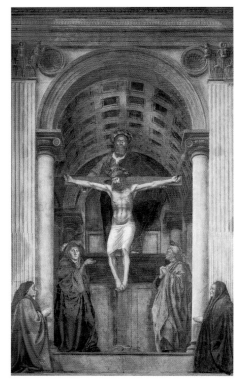

Right: Holy Trinity, with the Virgin and John and Donors, *Masaccio, c.1426–8. The groundbreaking style of the painter was an inspiration to Leonardo.*

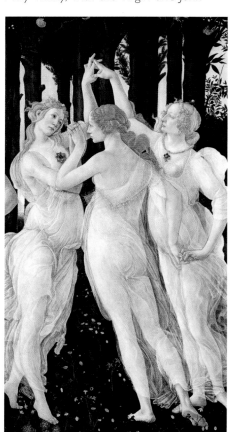

Left: Primavera *(detail), Sandro Botticelli, c.1478. In Florence, patrons commissioned paintings and sculptures based on antique prototypes to decorate their private homes.*

Below: Study of three dancing figures (detail), c.1513–15. Leonardo captures the quick movements of dancers, in this sepia and black ink sketch.

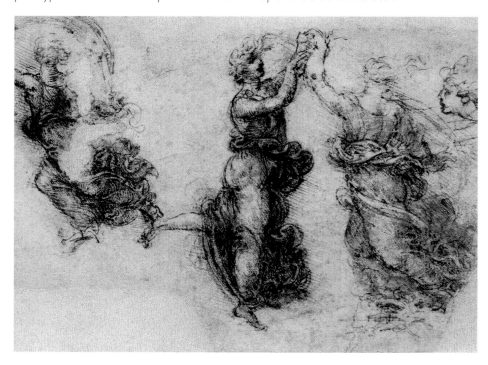

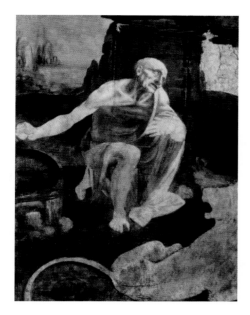

Above: St Jerome Praying in the Wilderness, c.1480–2. Leonardo's unfinished painting is comparable in style to the painters Giovanni Bellini and Antonio Pollaiuolo.

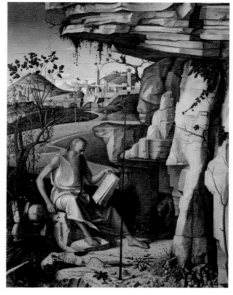

Above: St Jerome in the Desert, 1480–7, Giovanni Bellini. Leonardo also favoured rock formations and the Tuscan landscape as a backdrop to his paintings.

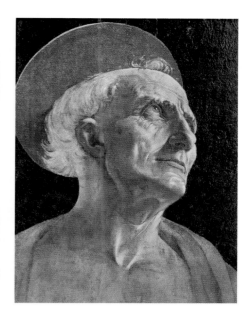

Above right: St Jerome, *attributed to Antonio Pollaiuolo, c.1432–98, Palazzo Pitti, Florence. St Jerome is pictured in the portrait style of Roman antiquity.*

de' Medici and the arts culture that flourished in Florence. This brought Florentine artists to the attention of Rome. In 1471, Pope Sixtus IV delle Rovere (1414–84) invited some of them to work at the Vatican during his papacy (1471–84). They were summoned to paint frescoes in the Pope's new Sistine Chapel from 1477 to 1480. Their style of painting used perspective, symmetry, proportion and naturalism, all clearly present in the large frescoes that they created in the chapel. This style was passed on to their apprentices, for example in the sublime paintings of Filippino Lippi, who was apprenticed to Botticelli in 1472.

EXCHANGING IDEAS

In the close-knit art community of Florence, artists and apprentices were familiar with each other's works; it was easy to exchange ideas. A detail of Botticelli's *Primavera* depicts the Three Graces, mythological daughters of Zeus. The same vibrant sense of movement can be seen in Leonardo's sketch *Three Dancing Figures and a Study of a Head* (c.1515). In his paintings Leonardo incorporated perspective, light and rich colour, a combination of Florentine and Venetian style. Like

Leonardo, Antonio Pollaiuolo (1432–98) had the ability to depict figures in action. One of his works, *Battle of the Nude Men*, 1475, may have been an inspiration to Leonardo for the *Battle of Anghiari* (from 1503), and to Michelangelo for the *Battle of Cascina* (from 1504). Comparisons can be made between *St Jerome*, attributed to Antonio Pollaiuolo, *St Jerome in the Desert*, 1480–1, by the gifted Venetian painter Giovanni Bellini (c.1430–1516), and the unfinished painting *St Jerome*, 1480–2 (in the Vatican Museum), by Leonardo. Venetian painters were noted for their use of rich colour, compared to the Florentine focus on perspective. The outstanding Pollaiuolo brothers, Antonio and Piero (1443–96), preceded Leonardo and Michelangelo in dissecting human corpses to understand anatomy, which was evident in their work.

For the figure of St Jerome, it is possible that Leonardo made a maquete (a three-dimensional small scale model) to work from. The head, similar in pose to the Pollaiuolo *St Jerome*, is in the style of Roman portrait busts of antiquity.

HIGH RENAISSANCE

The city of Florence was at the heart of the Early Renaissance. A new style of painting was introduced in the early 1300s by Giotto di Bondone. Vasari wrote that Giotto '...made a decisive break with the Byzantine style...introducing the technique of drawing accurately from life, which had been neglected for more than two hundred years'. The Early Renaissance was interrupted by the devastating effects of the Black Death, which swept Europe in 1348. The 1400s in Florence brought the Renaissance in art, which looked to ancient Rome for inspiration. This was illustrated by the works of the goldsmith and architect Brunelleschi, the painter Masaccio and the sculptor Donatello. Artists such as Andrea del Verrocchio, Pietro Perugino, Filippino Lippi, Sandro Botticelli and Leonardo da Vinci perfected and elevated this rebirth, leading to the High Renaissance in Rome in the early 16th century, which lasted until the Sack of Rome in 1527. This period was exemplified by the design for the new Basilica of St Peter by Bramante and the works of Michelangelo, Raphael and Giuliano Sangallo.

ANGELS AND DRAGONS

Leonardo, now at work as a professional artist in Andrea del Verrocchio's workshop, created what would become a 'signature' style of drawing and painting, which could be readily identified, whether depicting angels, dragons, mistresses or the Madonna.

A factor of Leonardo's signature style is the ability to create portraits which capture the personality of the sitter and lead observers to feel part of the creation of the work, as if they were actually present at the sitting.

A GRAPHIC DEMON

One particular episode of Leonardo's creative ingenuity is related by Vasari. He writes that Leonardo's father had been asked by a peasant worker at his villa to have a wooden shield, which he had made from fig wood, painted with an illustration. The man was useful to Ser Piero as a birdcatcher and fisherman, so he took it to Leonardo's workshop, where it was planed and then primed for painting. Vasari relates that Leonardo 'began to think what he could paint on it, that might be able to terrify all who should come upon it, producing 'the same effect he had once with the head of a Medusa'. Vasari adds that Leonardo 'carried to a room…lizards great and small, crickets, serpents, butterflies, grasshoppers, bats and other strange kinds of suchlike animals….' Painting in chiaroscuro — a use of light and dark shadow to heighten the illusion of depth — he depicted a strikingly muscular dragon emerging from craggy rocks, its wide-open mouth issuing steaming breath.

A PROFITABLE EXERCISE

Vasari describes the illustration as 'a great ugly creature, most horrible and terrifying… belching forth venom from its open throat….' It would seem from Vasari's account that the stench of the dead animals in Leonardo's room only added to the realism of the work. Even Ser Piero was shocked and surprised by its realism.

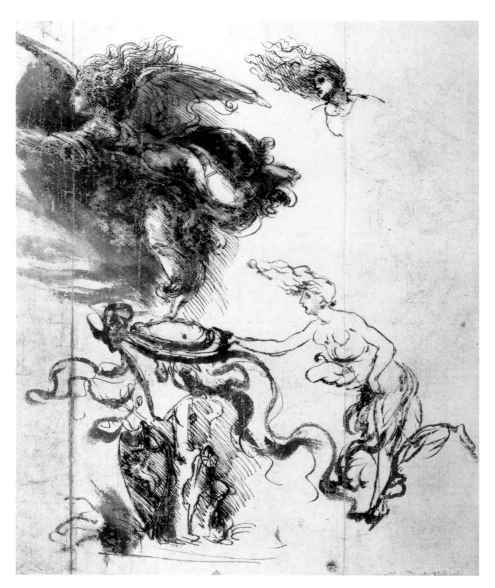

Above: Allegory of Victory and Fortune, *c.1480–1. In a tiny pen and ink sketch, Leonardo portrays a winged Victory above a shield held by a wind-blown Fortune.*

He kept the shield to sell while giving the farmer a more conventional one painted with a heart shot through with an arrow. It is reported that the dragon shield was sold to a merchant for 100 ducats and then sold on again, for 300 ducats, to the Duke of Milan. The work's success was due to the realism of the fabulously demonic illustration, not Leonardo's name. Vasari's narration is difficult to trace to an actual work, but chiaroscuro was a favourite technique of Leonardo, and his love of dragon-like creatures is evident in his drawings.

MEDUSA

Leonardo's love of dragons and demons is demonstrated in his own drawings. He advised that to create a realistic image, the artist should 'use the head of a bird and exaggerate its features'. Vasari records an unfinished painting of Medusa, in the possession of Cosimo de' Medici, 'with the head attired in a

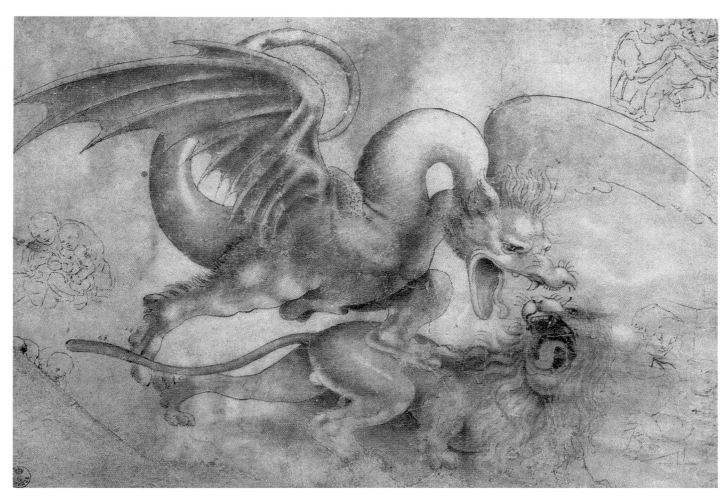

Above: Fight between a dragon and a lion, c.1480–1516. Attributed to Leonardo, this drawing highlights an interest in the depiction of fantasy creatures.

coil of snakes, the most strange and extravagant invention'. In Greek mythology, Medusa was a Gorgon, a monster with snakes entwining her head. To look directly at her would turn the onlooker to stone. From Caravaggio's copy of Leonardo's original, we can see that he had captured the grisly head and manic stare. The work is now lost.

Vasari notes that Cosimo's collection included an angel painted by Leonardo, depicted with one arm raised in the air and the other raised to the breast.

Below: Tobias and the Angel, workshop of Andrea del Verrocchio, c.1473. An example of a combined contribution by Verrocchio and his assistants.

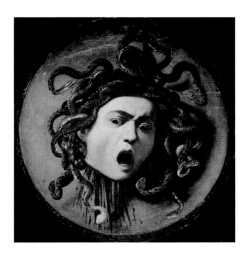

Above: Medusa, Michelangelo di Merisi Caravaggio, c.1596–8. This painting is a copy of Leonardo's unfinished original.

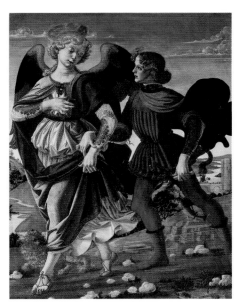

TOBIAS AND THE ANGEL

The constant demand for artworks created in the workshops in Florence meant that quite often a painting would be completed by more than one hand. A small panel painting, Tobias and the Angel, c.1473 (National Gallery, London), that was produced in Verrocchio's workshop, is identified as possibly the work of Pietro Perugino, with Leonardo contributing the small, lively dog walking at the side of the Angel, and the realistic portrayal of the fish that Tobias carries. This was painted in a busy workshop where experienced artists would each contribute to a work in progress.

BAPTISM OF CHRIST

Leonardo's contribution to the altarpiece painting, *Baptism of Christ,* stands out as an early indication of his potential as a painter. His artistic dexterity outclassed both his peer group and his tutor, Andrea del Verrocchio, who acknowledged the ability of his gifted assistant.

This work, *Baptism of Christ,* painted c.1470–2 and 1475–8, was a commission contracted to Verrocchio by the monastery of San Salvi in Florence, possibly for the Villambrose church close to Florence.

LEONARDO AND VERROCCHIO

This artwork unites the hands of Verrocchio and of Leonardo in one painting. On completion of the work the monastery itemized it in its accounts by its formal name, *Baptism of Christ.* The summary includes 'An Angel by Leonardo da Vinci'.

The angel referred to is the one that enters the picture space to the far left. The young angel, kneeling, with back half turned and head in profile, looks toward the figure of Christ. Could it be a self-portrait of Leonardo? The upturned face of the angel 'leads' the viewer to witness the scene of Christ's baptism. The angel holds the garments of Christ in readiness for him to step out of the river. In workshops it was expected that the leading artist, in this case Verrocchio, would paint the major figures, Christ and St John the Baptist, leaving the landscape and

minor figures to be completed by accomplished apprentices. It is understood that the second angel, close to Christ's right side, may have been painted by Sandro Botticelli. On the basis of stylistic traits, parts of the landscape may be the work of Leonardo, too; however, no official record exists to confirm this.

Below: Baptism of Christ, *Andrea del Verrocchio and Leonardo da Vinci, c.1470–2 and 1475–8. The altarpiece painting includes a kneeling angel to the far left painted by Leonardo.*

VERROCCHIO'S BAPTISM OF CHRIST

Verrocchio depicts Christ baptized in the waters of the river Jordan by John the Baptist, the last of the Old Testament prophets, and a forerunner of Christ. The Bible relates that John the Baptist wore 'a garment of camel's hair, and a leather girdle around his waist' (Matthew 3:4). Painters used artistic licence to recreate the image of John. The Bible narrates that '… when Jesus was baptized, he went up immediately from the water, and behold the heavens opened'. At the moment of baptism '… the Spirit of God descending like a dove, and alighting on him' (Matthew 3:16) was accompanied by a voice from heaven saying, 'This is my beloved Son, with whom I am well pleased' (Matthew 3:17). In Verrocchio's painting the angels kneeling at Christ's feet are holding his garments, an event not included in the Bible but part of a traditional Christian depiction of the scene.

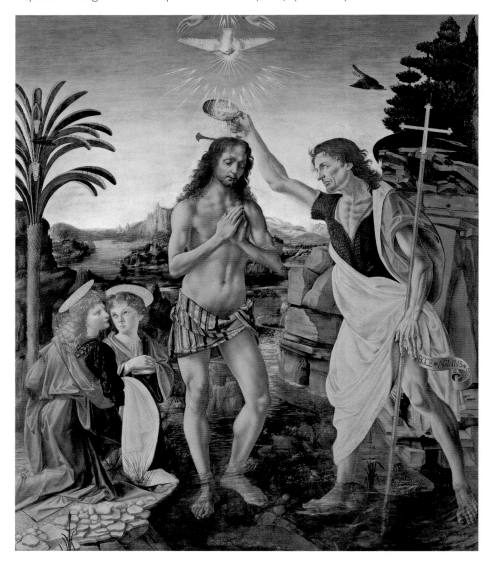

Right: Baptism of Christ, *Piero della Francesca, 1450. The altarpiece painting is based on geometric proportion, a constant characteristic of della Francesca's works.*

VERROCCHIO RECOGNIZES LEONARDO'S GENIUS

In reference to this painting Vasari relates an apocryphal account of Verrocchio's workshop during the creation of the *Baptism of Christ*. He states that Verrocchio had been away from the workshop and returned to see Leonardo's superb painting of the angel. He immediately recognized that Leonardo was a vastly superior artist to himself and vowed from that day to give up painting. Verrocchio did continue to paint after the date of the painting's completion, which may disprove the tale, but from this time he focused more on sculpture. Looking at the painting of the *Baptism of Christ*, it is possible to see similarities between it and the design of Verrocchio's bronze sculpture *Christ and St Thomas*, for Orsanmichele. Carlo Pedretti (*Leonardo*, 1973) points out that the angel, as a peripheral figure, with body turned away from the viewer, performs the same function as the figure of

Below: Baptism of Christ, *Giovanni Bellini, 1501–2. An altarpiece painting that relates to the earlier paintings by Piero della Francesca and Verrocchio.*

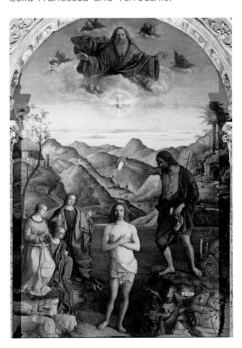

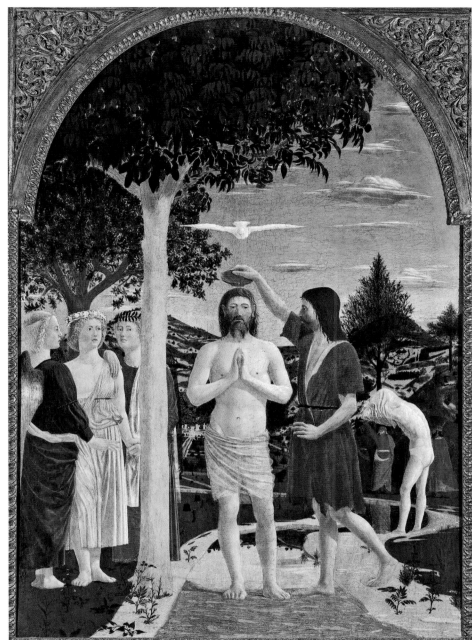

St Thomas, that of bringing the viewer in as part of the scene to become a participant at the baptism. Pedretti highlights the fact that the face of Leonardo's angel bears the subtlety of the antique model of classical beauty.

SYMMETRICAL PROPORTIONS

In Leonardo's era, the 'Baptism of Christ' was a popular subject for public and private devotional paintings. One particular painting stands out above others, the *Baptism of Christ*, 1450 (National Gallery, London), by the Tuscan-born artist Piero della Francesca (1415–92). Before turning to painting professionally, Piero della

Francesca was trained as a mathematician. His mathematical knowledge is transferred to the painting, which demonstrates certain symmetrical proportions. The figure of the flying dove and the figure of Christ divide the canvas into two, while the clouds mirror the shape of the bird, which represents the Holy Spirit. The tree to the left of the painting forms a third of the canvas section. In Piero della Francesca's painting, three angels, symbolizing the Trinity stand to the left, witnessing the scene. There are many similarities between this painting and Verrocchio's version, which was painted 20 years later.

LEONARDO'S *ANNUNCIATION*

One of the first religious works to be designed and painted solely by Leonardo is the *Annunciation*, *c*.1472–5. Historians agree that the work, a serene study of the subject, originally attributed to the eminent Florentine painter Domenico Ghirlandaio, is by the hand of Leonardo.

In Florence, Leonardo da Vinci's pleasant manner, combined with a consummate skill in his chosen profession, quickly won him friends, patrons and work.

PROVENANCE

An unknown patron may have commissioned the *Annunciation*, which was painted *c*.1472–5. Leonardo does not mention the painting in any extant note or letter, but many of his papers have been lost. In a formal contract the date of commencement and date of expected completion would appear. A description of the work and how many figures were to be drawn would be included, and an account of the paint pigments needed. Without any formal claim to its origins, it is possible that the *Annunciation* was painted by Leonardo at the Verrocchio workshop after he had 'graduated' from apprentice to professional artist. Historians believe it was probably painted as an altarpiece for a church being built or restructured *c*.1472–3, in the convent of San Bartolommeo a Monte Oliveto, close to Florence. The painting remained there until 1867, when it was removed to the Uffizi Gallery in Florence.

A label on the back confirms that it had hung in the Sacristy; other documents confirm that at one time it was placed on a wall in the monks' refectory. The rectangular shape 78 x 219cm (31 x 86in,) suggests that it may have hung directly above an altar, or above a piece of furniture.

GEOMETRICAL PRECISION AND OPTICAL ILLUSION

The painting illustrates Leonardo's use of geometrical perspective. The diagonal grid of the floor tiles to the right of the figure of the Virgin leads the eye to the landscape in the middle and far distance beyond the building. Leonardo made light of his command of linear perspective: 'Perspective is nothing else than the seeing of an object behind a sheet of glass… these things approach the point of the eye in pyramids, and these pyramids are cut by the said glass.' At the time of this painting, he was still in the process of perfecting the craft.

SIMILARITIES TO VERROCCHIO

The painting includes several mannerisms of style which characteristically belong to Verrocchio, and perhaps show that this piece was painted by Leonardo while he was at the workshop. For example, the hand movement of the Virgin and the sculptural element of her clothing can be attributed to the influence of Verrocchio. The base of the lectern relates to Verrocchio's sculptural work on the tomb of Piero de' Medici (church of San Lorenzo, Florence), which he was completing at this time.

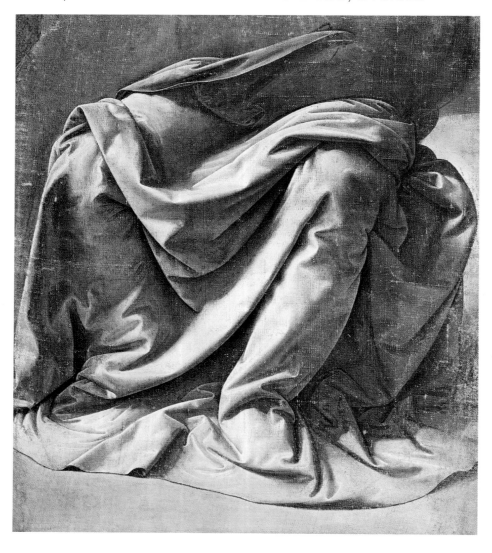

Left: Drapery study for a seated figure, 1470–80. Leonardo drew many studies of drapery. This painted example, in oil on canvas, highlights the dramatic effects of shading.

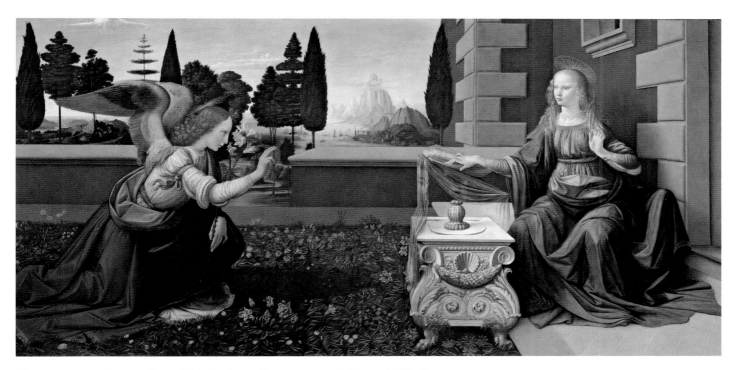

There are several anomalies, which lead to the conclusion that it was a practice piece, perhaps for a 'graduation' work. Distractions included the ornate stand of the lectern, which dominates the central space, and has led art historians to confirm that this was a newly qualified pupil's early attempt at a solo work, with some defects in presentation. This would explain a lack of documentation, as no patron would have commissioned it, and would further explain its placement in the monastery, to which it was perhaps given purely as a gift.

Above: Annunciation, c.1472–5. *Leonardo's first solo painting is possibly a 'graduation' piece, painted on completion of his apprenticeship with Verrocchio.*

Below: Annunciation, *Fra Filippo Lippi, c.1450–3. Lippi's superb egg tempera on panel painting predates Leonardo's depiction of the biblical scene.*

Bottom: Annunciation, *Lorenzo di Credi, 1478–85. This work is similar in layout to Leonardo's* Annunciation. *Credi was also apprenticed to Verrocchio.*

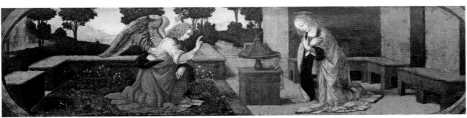

THE ANNUNCIATION

The Bible text of the Annunciation to the Virgin Mary is found in Luke 1:26–38. The narrative relates that in the sixth month after the conception of St John the Baptist by Elizabeth, the Angel Gabriel was sent from God to the Virgin Mary, who resided at Nazareth in Galilee. Mary was betrothed to Joseph. The angel, taking the form of a young man, approached Mary in the house. He announced, 'Hail, O favoured one, the Lord is with you!' Mary was greatly worried. The angel calmed her, 'Do not be afraid Mary, for you have found favour with God... Behold, you will conceive in your womb and bear a son, and you shall call his name Jesus.' Mary enquired how this could be possible when she had never yet had a relationship with a man. The Angel Gabriel explained to her, 'The Holy Spirit will come upon you, and the power of the most high will overshadow you; therefore the child to be born will be called holy, the Son of God.'

COURT OF THE MEDICI

At the time of Leonardo's birth the Medici were established as the wealthiest family in Florence and possibly in the whole of Europe. Their presence in Florence dominated city life for its citizens, particularly the artists, who sought their approval.

The Medici family were the uncrowned princes of Florence and artists looked to them for prestigious commissions to beautify palaces and villas, churches and chapels with new art.

A CONSPIRACY TO MURDER

Lorenzo de' Medici (1449–92), known as 'Il Magnifico', or 'the Magnificent', was a cultured man and an enthusiastic contributor to the flourishing arts circle in Florence. Ser Piero da Vinci worked at the Palazzo della Signoria, effectively Lorenzo's court, and Leonardo was known to the Medici. In 1478, on Easter Sunday, 26 April, the citizens of Florence were shocked by the murder of Giuliano de' Medici (1453–78), Lorenzo's brother,

in the Duomo during Mass. The plot to kill the brothers was supported by Pope Sixtus IV delle Rovere, the Archbishop of Pisa, and the King of Naples. All of these, as well as the Pazzi, a Florentine banking family, wanted to be rid of the Medici and to take control of Florence. The murder attempt was on both brothers, but Lorenzo managed to escape with minor injuries.

SKETCH OF THE MURDERER

Over the following months the conspirators, as many as 80 of them, were hunted down and killed. Their bodies were displayed hanging from the Palagio del Podestà (Bargello). At one time it was speculated that a

Above: Portrait of Lorenzo de' Medici 'the Magnificent', *Italian School, c.15th century. The wealth of Lorenzo de' Medici kept the artistic fraternity of Florence amply supported through commissions.*

painting of the dead conspirators would be commissioned, and Leonardo and other artists in Florence knew this. However, there is no mention of this in Leonardo's papers. In the autumn he merely wrote, '[…] 1478 I began the two Virgin Marys [paintings]' (Uffizi, 446Er). These may be the *Benois Madonna* and *Madonna and Child with a Carnation*. We do know that Leonardo now had his own studio and employed at least one, probably two assistants. One official record of a homosexual misdemeanour by an assistant, Paolo, was dated 4 February 1479; it was sent to Lorenzo de' Medici, to inform him that 'Paulo de Leonardo di Fiorenze' had served six months in a Bolognese

Left: Hanging body of Bernardo di Bandino Baroncelli, 1479. Baroncelli's body was suspended from the Palagio del Podestà, Florence. Leonardo sketched it.

THE MEDICI DYNASTY

Giovanni di Bicci de' Medici (1360–1429) had created the family's fortune through banking and commerce. His son Cosimo de' Medici (1389–1464), 'Il Vecchio', consolidated it. As a bibliophile, he accumulated ancient texts, particularly Greek, and possessed the largest private library in Europe. Cosimo was a cultured man who initiated a Platonic Academy, encouraging the study of Humanism. One friend was Marsilio Ficino (1433–99), the president of the Medici Academy, who translated the complete works of Plato from Greek into Latin for Cosimo. On the death of Cosimo in 1464 the Medici 'crown' was passed to his son Piero de' Medici, and then within a few years to Lorenzo, his 21-year-old son, in 1469, at about the time of Leonardo's apprenticeship.

Right: Portrait of Ginevra de' Benci, c.1474–8. An oil on panel painting by Leonardo, depicting Ginevra de' Benci in three-quarter profile.

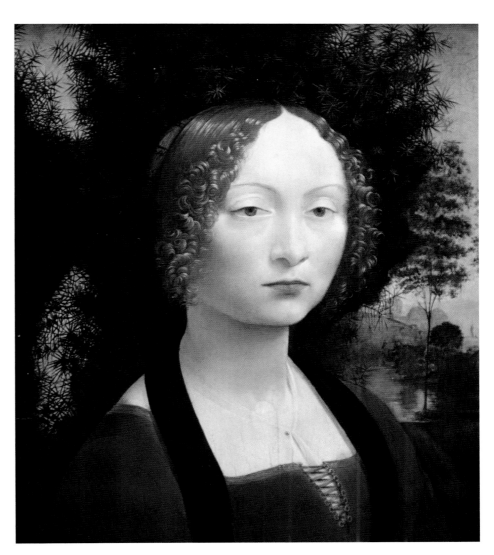

prison for the offence. In the same year a more serious felon was caught in Constantinople. Bernardino di Bandino Baroncelli, the chief assassin who stabbed Giuliano de' Medici 19 times, was captured. He was in disguise, wearing Turkish dress. Baroncelli was repatriated to Florence and hanged on 29 December. Leonardo made a sketch of his body hanging outside the Palagio del Podestà, and to the side of the sketch an itemized list of what the man was wearing. The list may have been linked to a possible commission for a painting of the event.

LEONARDO USES HIS CONTACTS

A portrait of Ginevra de' Benci (b.1457), a member of Lorenzo de' Medici's circle of friends, is the first of Leonardo's portraits to show his ability to capture likeness and character. The portrait shows that Leonardo had studied the works of Flemish painters, using three-quarter profile to engage the subject's eyes with the viewer; this was a portrait style that had been favoured by Flemish artists since the 1430s. This radically new form was used by Sandro Botticelli in *Woman at a Window* (c.1470–5, Victoria and Albert Museum, London). Leonardo's depiction bears similarities to Verrocchio's sculpture *Lady with a Bunch of Violets* (Museo Nazionale del Bargello, Florence), a half-length portrayal, possibly also of Ginevra de' Benci, that includes the arms and hands.

Leonardo's *Portrait of Ginevra de' Benci*, painted c.1474–8, raises more questions than answers about the sitter and the patron. The commission may have been instigated because of Leonardo's brilliant reputation as a painter, which was known in court circles. His association with the Benci family increased his visibility at court, and Ginevra was the daughter of his friend Amerigo di Giovanni Benci. However, Leonardo reveals nothing about the commission in his notes or letters.

Below: Woman at a Window (Portrait of a Lady), *Sandro Botticelli, c.1470–5. The artist draws on the Flemish portrait-style of three-quarter profile, possibly the first example in Florentine painting.*

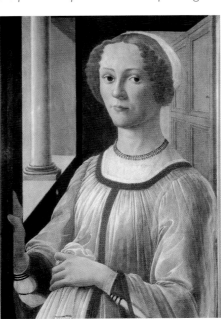

Below: Lady with a Bunch of Violets, *Andrea del Verrocchio, c.1475–8. This marble portrait sculpture is possibly another depiction of Ginevra de' Benci.*

PRINCELY PATRONAGE

In Florence, Leonardo's father helped draw up legal contracts for patrons wanting to commission his talented son. However, Leonardo's ambition was to leave the city and find a patron who would commission him to work as an innovative design engineer.

Leonardo had the talent to succeed in whichever field he chose, whether that was art, architecture or engineering, and his letters reveal a desire to design much more than a pleasing portrait.

AN ARTIST OR AN ENGINEER?
Perhaps Leonardo felt stifled in Florence. While he made useful contacts through his father, his lack of knowledge of Greek and Latin distanced him from the Humanist inner circle of the Florentine elite, such as the Medici, Pitti or Tornabuoni families. Artists did not need to be highly educated, but Leonardo was more than a painter; and, mixing with patrons, he was aware of the shortcomings of his own education. Many of his notes comment on this. However, Leonardo's ability to think

Below: Bombards or mortars, c.1485. This drawing illustrates bombards or mortars, showing the mechanism for adjusting the firing range. The cannonballs emit small pellets when they fall to the ground.

beyond the everyday, to express new ideas, made him an energetic and innovative theorist. His mind was focused on engineering and landscape projects, which would challenge his intellect. He needed a patron who was looking for an engineer.

A DIPLOMATIC MOVE
A Florentine author of a fragmented history of 13th- to 16th-century Florentine artists, Anonimo Gaddiano (*fl.* 1537–42), also known as Anonimo Magliabechiano, relates the story that Lorenzo de' Medici sent Leonardo to Milan with Atalante Miggliori, a musician. Gaddiano states that Leonardo carried with him an impressive silver lyre in the shape of a horse's head. Who it was made by is not told, but Verrocchio had been working on the Colleoni equestrian statue and Leonardo had a great interest in horses, raising the possibility that the Verrocchio workshop or Leonardo himself may have made it. The Sforza family

Above: Double gold ducat (obverse) of Ludovico Sforza, 1494–9. The heraldic emblem of the Sforza family is shown on the reverse side of the coin.

symbol was the horse, and this would have been a very impressive diplomatic gift. The Medici sending Leonardo to Milan could be seen as a diplomatic move to maintain good relations, but letters show that Leonardo wanted to work for Ludovico 'Il Moro' Sforza.

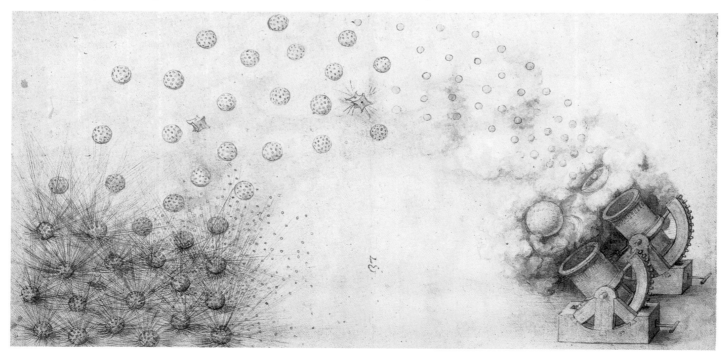

PETITION TO LUDOVICO SFORZA

Leonardo called himself 'a man without letters' in reference to scientific rather than Humanistic interests, but his invitation to the Court of the Sforza in Milan was a result of a cultured and persuasive petition he sent to Ludovico Sforza, 'Il Moro' (The Moor). The draft letter (*Codex Atlanticus*, fol. 391r-a) is written left to right, which offers the possibility that it was dictated by Leonardo to another person, or that the original was copied by a scribe. The letter highlights his technical knowledge, from architecture to military warfare. He lists ten services he can offer. Only the last one relates to art. In the letter Leonardo describes his expertise, particularly in his ability to design and build war machines:

Most illustrious Lord, Having now sufficiently considered the specimens of all those who proclaim themselves skilled contrivers of instruments of war, and that the invention and operation of the said instruments are nothing different to those in common use: I shall endeavour, without prejudice to anyone else, to explain myself to your Excellency showing your Lordship my secrets… (Codex Atlanticus, fol. 391r-a)

Leonardo follows with a list of his abilities, including the creation of bridges that can be carried, removing water from trenches, designing machines for the defence of war at sea, mines, chariots, big guns and mortars, as well as methods of burning to destroy an enemy. The list is formidable. The letter then turns the attention of Ludovico to Leonardo's qualities in time of peace:

I believe I can give perfect satisfaction and to the equal of any other in architecture and the composition of buildings public and private; and in guiding water from one place to another… I can carry out sculpture in marble, bronze or clay, and also in painting whatever may be done, and as well as any other, be he whom he may.'

In the draft Leonardo refers to a bronze horse, which must have been discussed during earlier correspondence: '… the bronze horse may be taken in hand, which is to be to the immortal glory and

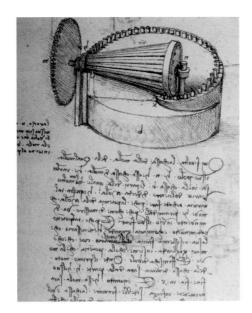

Above: Study of the diminishing power of the spring, 1493–7. A sheet of Leonardo's design notes on the power of the spring, with illustration.

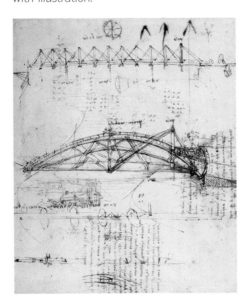

Above: Swing bridge, 1478–1518. A pen and ink sketch with explanatory notes.

eternal honour of the prince your father of happy memory, and of the illustrious house of Sforza'. Reading this draft, it is obvious why Leonardo wanted the challenge of working for the Sforza, to broaden his field of interests and work. Here was the 'universal man', capable of intelligent thought and creativity in design, whether for war machines or bronze horses. At the same age, and with the same drive to succeed, Ludovico and Leonardo were ideally suited.

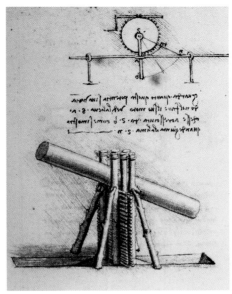

Above: Studies of power transmission and lifting a beam, 1493–7. One of a series of studies that contemplate the transmission of power through gears.

LETTERS TO ARMENIA

It has been conjectured that extant draft letters from Leonardo da Vinci to 'The Devatdar of Syria, Lieutenant of the Sacred Sultan of Babylon [Syria]' may have been written c.1481, or possibly later, during Leonardo's residence in Rome. The informal prose and form of address suggests that Leonardo and the Devatdar were known to each other. Armenia had recently experienced a vast earthquake and a great deal of building work was needed.

Had Leonardo perhaps thought to offer his services to the Armenians as an engineer? His movements between 1481 and 1482 are unclear; he could have been in Florence or Milan, or elsewhere. From the letters it would seem that he planned to leave Italy and journey to Syria. An alternative theory has been proposed, that Leonardo was perhaps writing a romance and that the draft letters were part of his text.

1482: A MOVE TO MILAN

After the last recorded payment in September 1481 by the monks of San Donato a Scopeto for the still unfinished *Adoration of the Magi*, Leonardo left Florence to take up a new position at the court of Ludovico Sforza in Milan.

Leonardo's stay in Milan, from *c.*1482, lasted 17 years, only ending in 1499 when his patron Ludovico, 'Il Moro', fled the city to avoid the approaching troops of the French army.

A MILITARY ENGINEER ON PAPER

The tyrant Ludovico Sforza might be considered a strange choice of patron, were it not for the fact that Leonardo desired to be much more than an artist. His all-round skills, and the possibility of what he could achieve for 'Il Moro', far outweighed the desire to paint artworks. It would seem that painting was what he was known for and what he was expected to do, but his heart was in science, architecture and engineering. We pay great attention to Leonardo da Vinci's extant paintings, studying them closely to reveal his methodology and materials. The engineering feats that were undertaken by him are studied less by admirers of his art, even though they often advance the understanding of key engineering and scientific concepts. During a 17-year period, under the patronage of Ludovico, he designed war craft, studied aeronautics and planned fortifications. Perhaps Ludovico, recognizing Leonardo's supreme skill as a painter, humoured him in regard to his inventions, for none ever materialized.

SALAÌ, THE 'LITTLE DEMON'

Setting up his studio in Milan, Leonardo took on the services of a Milanese assistant, Gian Giacomo Caprotti (*c.*1480–1524), a boy from

Right: Studies of a fortified castle (detail), c.1500–5. An interest in architectural designs for castles and fortifications began when Leonardo moved to Milan in the early 1480s.

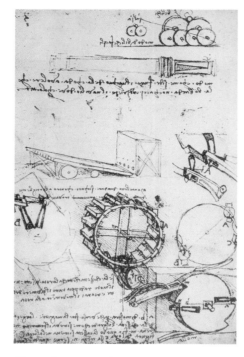

Above: Drawings of a bombard and a water mechanism, c.1493–1505. This relates to the operation of the warfare equipment.

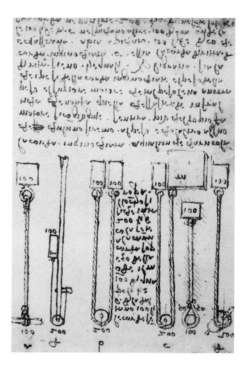

Above: Drawings of weights and pulleys, c.1493–1505. Designs for weights and pulleys illustrate a text of explanatory notes.

an impoverished farming family. Caprotti was ten years old, and a good-looking lad with curly hair. Vasari states that, 'while in Milan he took for his servant Salaì, a Milanese, who was most comely in grace and beauty, having fair locks abundant and curly, in which Leonardo much delighted'. Leonardo recorded the exact date that Giacomo joined his household.

Giacomo came to live with me on St Mary Magdalene's day [22 July] 1490, aged ten years. The second day I had two shirts cut out for him, a pair of hose and a doublet, and when I put aside some money to pay for these things he stole it [4 lire] out of my purse; and I could never make him confess although I was quite certain of the fact.

In the margins of Leonardo's diary of this event he lists: 'ladro [thief], bugiardo [liar], ostinato [obstinate], ghiotto [glutton]'.

AN ENDEARING SERVANT

Despite his young servant's aberrant ways, Leonardo remained charmed by him and continued to write about Giacomo Caprotti. 'The following day I went to dine with Giacomo Andrea [da Ferara], and the said Giacomo ate

Above: Virgin and Child with Saints Peter and Paul, *Gian Giacomo Caprotti di Oreno, 1520. A painting by Leonardo's long-term assistant 'Salaì'.*

enough for two and did mischief for four, for he broke three cruets and spilled the wine.' Leonardo nicknamed him 'Salaì', a term meaning 'little unclean one' or 'demon'. It referred to Salaì's obstinacy, greed and aptitude for petty theft. However, Leonardo

Above: Head of an old man and a youth in profile, *c.1495–9. The studies are not directly linked with each other, but contrasts of old age and youth fascinated Leonardo.*

liked him and treated him well, and continued to buy him fine clothes. In spite of the many times he was caught thieving, Salaì was to remain his favourite pupil, and he was a constant companion to Leonardo throughout the rest of his life.

Left: 'Map of Milan', from Civitates orbis terrarum, *Georg Braun and Frans Hogenburg, published c.1572.*

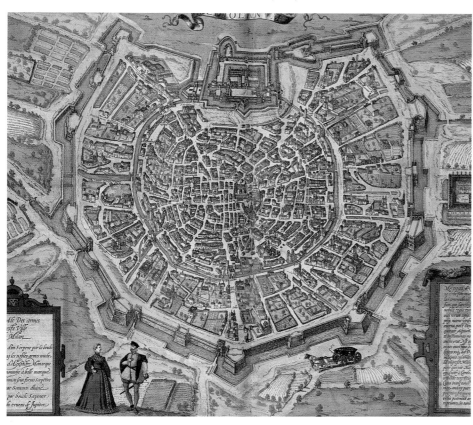

THE DUCHY OF MILAN

In the 15th century, the city of Milan and the Lombardy region was dominated by the Sforza family. The Antendolli family, prosperous agriculturalists of the Romagna, founded the dynasty, the 'Sforza' ('force') that ruled Milan for a century. The founder, Condottiere Muzio Antendolli (1369–1424), was succeeded by his illegitimate son Francesco Sforza (1401–66), who became Duke of Milan in 1450 through marriage to the daughter of Duke Filippo Maria Visconti.

1483: *VIRGIN OF THE ROCKS*

Two paintings of the same subject, in the same format, were painted at different times and are accredited with the same title, *Virgin of the Rocks*, owing to the near-identical portrayal of the subject matter. A dispute over payment led to the creation of the second painting.

In April 1483, Leonardo signed a contract for an altarpiece panel depicting the *Virgin of the Rocks* (also known as *Madonna of the Rocks*).

THE CONFRATERNITY OF THE IMMACULATE CONCEPTION

In 1480 a sculptured altarpiece for the oratory of San Francesco Grande in Milan was commissioned by the Confraternity of the Immaculate Conception, who had use of the chapel (now destroyed). The carved and decorated wooden frame by Giacomo del Maino (*fl.* 1469–1503) was designed to hold several panels. The whole work was devised as a combination of painting and sculpture. On 25 April 1483, with the frame complete, a subsidiary formal contract, in Latin, was drawn up by the Confraternity to commission three panels for the altarpiece: a central panel and two side panels. The document was signed by Giovanni Ambrogio de Predis (*c.*1455–1517), his brother Evangelista (d. after 1499) and Leonardo da Vinci. It was to be a collaborative effort. The de Predis brothers were contracted to assist Leonardo in painting and gilding the work. Leonardo would paint the central panel; Ambrogio, the two smaller side panels; and Evangelista would paint and gild the carvings on the frame. The time allowed was about seven months, with completion of the work expected by 8 December the same year.

LEONARDO'S *VIRGIN OF THE ROCKS*

The Confraternity would perhaps have expected a depiction of the Virgin relating to the Immaculate Conception, but there is no documentary evidence to suggest this, only a request to portray 'Our Lady'. For the large panel, Leonardo chose to depict a shaded

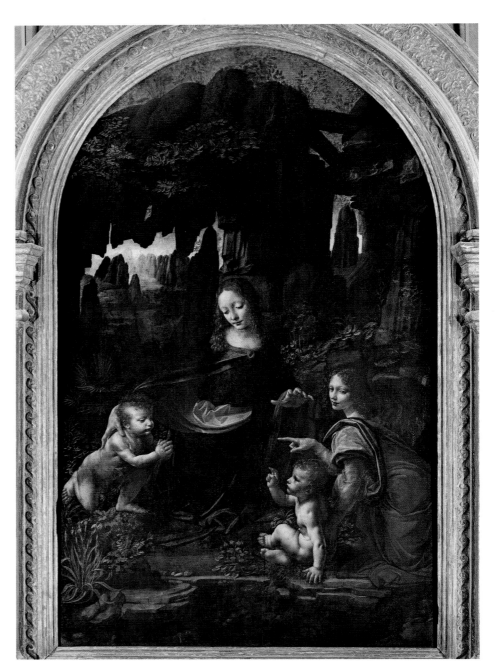

grotto with a stream running through to a mountainous landscape beyond. The Virgin is seated at the centre of the picture, with the infant St John the Baptist kneeling by her right knee, and the infant Christ seated on the ground to her near left, holding up his fingers toward John in blessing. The Angel Gabriel is seated next to him and

Above: Virgin of the Rocks, 1483–1484/5, oil on wood (transferred to canvas), Musée du Louvre, Paris. This is the first version of the altarpiece painting.

supports the infant with his left hand. He points the index finger of his right hand toward John. The Virgin's left hand is raised above the head of the infant

Christ. All are depicted in a shadowy, rocky grotto. The face of the Angel Gabriel is turned toward the viewer, leading the spectator into the scene. Looking at the painting, it should be considered in situ, above an altar. The dark grotto would create an intensely atmospheric scenario when lit by flickering candles from below, allowing the observer to enter the space as witness and participant at an intimate, private gathering. Leonardo created a one-to-one communication between spectator and subject.

A PROBLEM OF PAYMENT

Work began on the panel painting. A letter addressed to 'Most Illustrious and Excellent Lord', written by Leonardo and Ambrogio, pleads for help in resolving a problem of payment for paint pigments and materials: '… the blind cannot judge colours' was a vexed plea to the cultured eye of Ludovico. It is known that the deadline was not met and the painting was still unfinished when Leonardo left Milan in 1499. A letter written by Ambrogio de Predis, requesting payment, is dated as late as 1503. He points out that he and his (now deceased) brother had complied with their part of the contract. It was Leonardo's part which remained unfinished. This same document reveals that the reason for the initial

delay partly lay in the artists' expenditure overrunning the agreed fee. By 1506 the Confraternity offered a new solution. A new contract with fees covering earlier expenditure would be drawn up if Leonardo agreed to come back to Milan to complete the *Virgin of the Rocks* painting.

Leonardo possibly sold the first painting to a private client when the Confraternity did not pay for the extra materials. A second version

must have been agreed when the first version was no longer an option. Underdrawings of the second version reveal that Leonardo considered changing the figure of Mary to a profile pose but then reverted to his original plan.

Below: Virgin of the Rocks, *c.1495–1508, oil on wood (parqueted), National Gallery, London. This is the second version of the altarpiece painting.*

TWO PAINTINGS

Two versions of the *Virgin of the Rocks* painting are in existence. One, 1483–1484/5, is at the Louvre in Paris and the second, dated *c.*1495–1508, is in the National Gallery in London. For many years there was speculation over which painting was the first version; the Louvre painting is now recognized as the first one. A copy of the original work was made by Ambrogio di Predi, with Leonardo overseeing it. There is a note of a request to remove the original panel from its frame for this purpose.

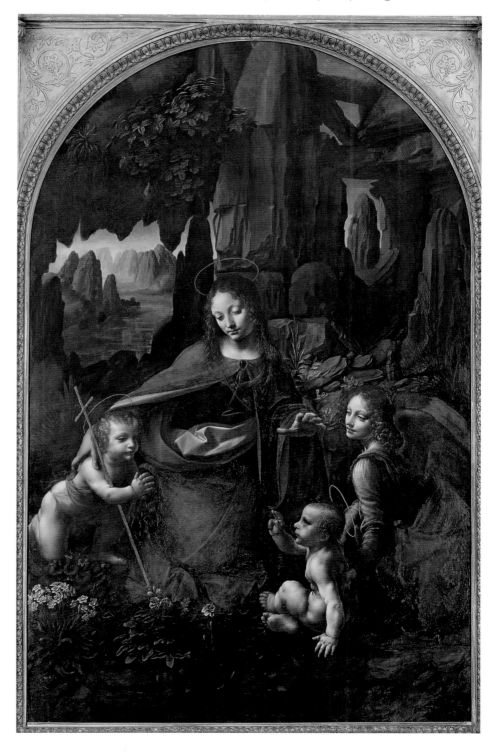

VITRUVIAN MAN

Drawings have the power to be icons of a historic era. One such is *Proportions of the Human Figure* ('*Vitruvian Man*'), *c*.1490, a pen-and-ink drawing with accompanying explanatory text, created by Leonardo da Vinci.

'Vitruvius while measuring the mile… did not recognize that that was the means of finding the square equal to the circle.' (Leonardo da Vinci, *c*.1490.)

ICON OF AN ERA

Leonardo's study of human proportion illustrates each part of the body as a fraction of the whole. It was a visual interpretation of the Roman architect Vitruvius's explanation of the relation of the geometric proportion of the classical Orders to the proportion of the human body. Vitruvius discussed it in *Ten Books on Architecture* (*c*.30BC), the only extant treatise on architecture from antiquity. Leonardo's drawing transcended its original purpose as a visual representation of Vitruvius's commentary to become a representation of Italian Humanist and Neo-Platonic thought evolving in 15th-century Italy: the embodiment of man, a microcosm, placed at the centre of the cosmos, the macrocosm.

MILAN: HOTHOUSE OF ARCHITECTURAL TALENT

In 1490, when Leonardo was creating an illustration of Vitruvian theory on 'the body as architecture', he may have had access to a copy manuscript of Vitruvius's treatise, which belonged to the Sforza family. He did not read Greek but was teaching himself Latin, and this text may have been a reason for him to do so. At the same time, in 1490, the Sienese architect, sculptor, painter and military theorist, Francesco di Giorgio Martini (1439–1501), visited Milan at the invitation of Ludovico Sforza. His accomplishments rank him as the 'Sienese Leonardo'. He was a renowned architect, and went to Milan to advise on the construction of the lantern for Milan cathedral. Leonardo is known to have read Martini's

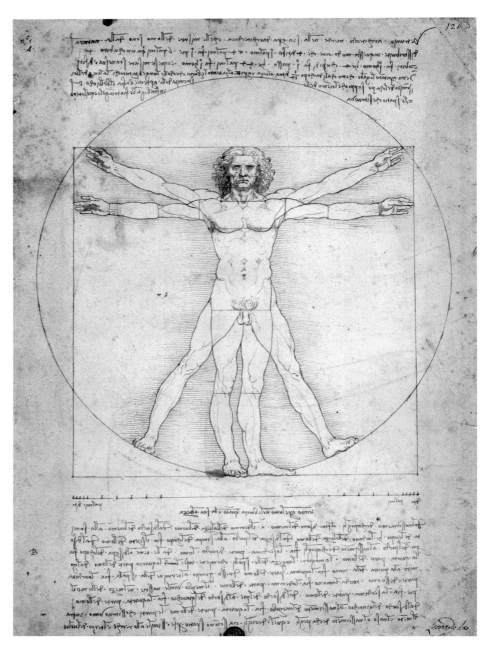

treatise on architecture and military engineering, *Trattato di architettura, ingegneria e arte militare* (from 1482), containing 19 chapters on military engineering, plus weaponry, civil and mechanical engineering, hydraulics and city planning. It informed Leonardo's own writing. The text was continuously updated by Martini, both before and after his visit to Milan.

Above: Proportions of the Human Figure *(after Vitruvius), c.1490, pen and ink with accompanying text. The drawing is familiarly known as* 'Vitruvian Man'.

Leonardo's interest in Giorgio is easy to understand, as he recognized not only his intellect but also his reputation in the field of architecture as much as in painting.

Above: Studies of male nudes (detail),
c.1503–4. Leonardo was fascinated
by proportion, and created a series
of proportional studies of male nudes,
horses and dogs.

VITRUVIUS: PROPORTION OF THE HUMAN BODY

The circle and the square are perfect forms; Vitruvius placed man at the centre, a symbol of perfection and harmony. Leonardo's drawing included a frame of these perfect forms of circle and square, in which stands an outstretched figure in two positions: standing, and in motion. Underneath the illustration he wrote, 'The span of a man's open arms is equal to his height.' He spent much time considering how to 'square the circle', forming each from the same area of measurement. His exploration of the problem anticipated modern mathematics. In a text entitled

Below: Graded drawing of male figure,
Leon Battista Alberti, c.1450. Alberti was
the first historian of the modern era to
explore the proportions of the human
figure in relation to architectural design.

'Of squaring the circle and who it was who first happened to discover it' he wrote his own analysis.

Around 1490 Leonardo created a series of life drawings using male models. We know the names of two of the models: Caravaggio and Trezzo. For his studies he measured and drew them, in standing positions, from head to toe, focusing on each part of the body in anatomical detail. From this he then measured and drew figures in sitting and standing positions. At the same time, he was also working on the anatomical measurements of horses. The proposed equestrian statue of Francesco Sforza was uppermost in his mind.

VITRUVIUS

In the 1st century BC, a Roman architect and engineer, Marcus Vitruvius Pollio (c.80–15BC), who was in the military service of Julius Caesar, wrote a treatise on architecture, *De architectura libri decem* (Ten Books on Architecture), c.30BC. The text discussed the history and practice of Greek and Roman architecture and was possibly intended as a handbook for architects in the expanding Roman Empire. Vitruvius discussed the geometry of symmetry and proportion, and in Book Three he identified a modular ratio of the human body in relation to architectural design. In the 15th century, as it was the only ancient treatise on architecture to survive, manuscript copies of the text were in demand in Florence and Rome. Cultured patrons desired to recreate 'living *all'antica*', like the ancients, but the text was in a mixture of Latin and Hellenistic Greek, and parts of it were hard to follow, with no illustrations. It left architects free to interpret the meaning of the text as they wished, and artists free to create drawings based on their own understanding of Vitruvian theory.

COURT ARTIST TO THE SFORZA

At the court of the Sforza, Leonardo put his technological and artistic expertise to use as a wedding party organizer, concocting fabulous displays to commemorate official occasions while continuing to paint portraits.

In 1488 the marriage of Gian Galeazzo II Maria Sforza (1469–94), the Duke of Milan (although his uncle, Ludovico Sforza, was de facto ruler), to his first cousin Isabella of Aragon, Princess of Naples (1470–1524), prompted a 'paradise festival' at Castello Sforzesco.

SFORZA–ARAGON WEDDING
Gian Galeazzo Sforza was the sixth Duke of Milan. He attained the title at the age of seven when his father, Galeazzo Maria Sforza (1444–76), was assassinated. His uncle, Ludovico 'Il Moro' Sforza, Leonardo's patron, acted as ruler, in practice rather than by law, for his young nephew – a role he was unwilling to renounce when his nephew came of age. For the

sumptuous marriage celebrations for Gian Galeazzo and Isabella, the plan was for Leonardo to create the stage set for *La Festa del Paradiso* (The Feast of Paradise), created by the poet and Sforza courtier Bernardo Bellincioni (1452–92), which was performed in the Castello Sforzesco. He was commissioned to design the pavilions, stage sets, scenery and costumes for the theatrical production.

SFORZA–ESTE DOUBLE WEDDING
Following the outstanding success of *La Festa del Paradiso*, in 1491, Leonardo was involved in a double Sforza–Este wedding celebration, combining the marriages of Ludovico Sforza (1452–1508) to Beatrice d'Este (1475–97), and Beatrice's brother

Above: Frontispiece to Giovanni Simonetta's Sforziada (The Life of Francesco Sforza)*, Giovan Pietro Birago, 1490. At lower right, Ludovico Sforza is symbolized as a mulberry tree.*

Alfonso d'Este (1476–1534) to Anna Sforza (1476–97), the sister of Gian Galeazzo Sforza. He organized a special tournament requested by Gian Galeazzo Sanseverino, Ludovico's son-in-law. In addition, a portrait of Beatrice, perhaps a wedding gift, was commissioned from Leonardo da Vinci, aided by Giovanni Ambrogio de' Predis. It reveals the chaste beauty of the 15-year-old bride. Leonardo chose to portray her wearing precious jewels, a symbol of Ludovico Sforza's intense love for his bride. Her death, seven years later, in 1497, at the age of 22, utterly devastated Ludovico. The contemporary Italian poet

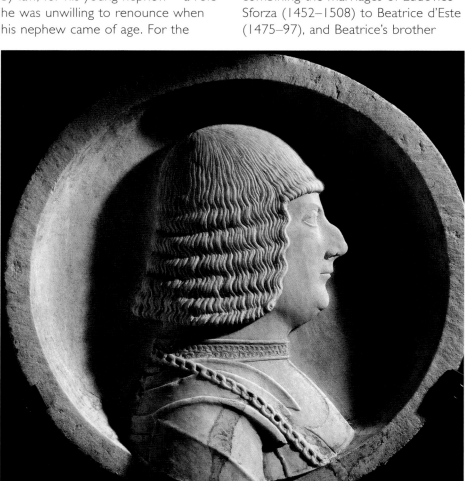

Left: Portrait of Ludovico Sforza, Italian, late 15th century. A marble medallion depicting a profile of 'Il Moro'.

Right: Sforza Altarpiece, *Master of the Pala Sforzesca, (fl. 1480–1520), c.1495 (Madonna and Child Enthroned with the Doctors of the Church and the Family of Ludovico il Moro).*

Vincenzo Calmeta wrote of the effect her death had at court, '...when Duchess Beatrice died everything fell into ruin, and that court, which had been a joyous paradise, was changed into a black Inferno'.

A FLEETING PORTRAYAL

Prior to Ludovico's marriage to Beatrice, Cecilia Gallerani (1473–1536) had been Ludovico Sforza's mistress. Leonardo's portrait of her, *Lady with an Ermine*, 1489–90, was probably commissioned by Ludovico soon after he received the Order of the Ermine in 1488. Its completion date was most likely before the birth of her son Cesare Sforza in January 1491, an illegitimate child born to Ludovico in the same year as his marriage to Beatrice d'Este in May 1491. The painting portrays the young woman holding a pet ermine in her arms. Leonardo significantly illustrates a fleeting moment in time as Cecilia turns her head to the left and the ermine's head follows her gaze. The lifelike spontaneity of the movement remarkably captures the sitter, who seems to have been momentarily distracted by something or someone, turning her head in that direction. Historians point to Leonardo's portrayal of Cecilia as the first modern portrait painting. The brilliance of the lifelike quality of the work is accentuated in the finely painted detail of the soft furry ermine, and the sweet face of the young woman, with hair drawn fashionably around her face to frame her features. The inclusion of the ermine plays on her name, Gallerani: the Greek word for ermine is pronounced *gallay*.

Right: Portrait of Cecilia Gallerani (Lady with an Ermine), *c.1490, Leonardo's portrait of a mistress of Ludovico Sforza, Duke of Milan.*

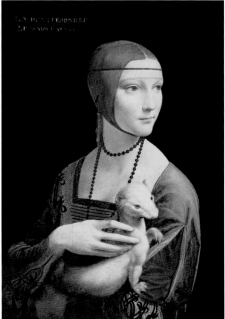

A SONNET FOR CECILIA GALLERANI

The perfection of Leonardo's portrait of Cecilia Gallerani was praised in a sonnet, published in 1493, by Italian poet and courtier Bernardo Bellincioni.

Whom do you envy, O Nature?
Only Vinci, who has painted a
portrait of one of your stars
... He has made her seem that she
appears to be listening...
Now therefore thank Ludovico
And the genius and hand of Leonardo
...to comprehend now which is
nature and which is art.

THE SFORZA EQUESTRIAN STATUE

The horse was an important symbol of the Sforza dynasty. The family wished to commemorate the life of Francesco Sforza, the deceased Duke of Milan, with a larger than life-size equestrian statue in bronze. This was one of the reasons Leonardo was invited to Milan.

A bronze equestrian statue was commissioned by Gian Galeazzo and Ludovico Sforza as a tribute to their revered grandfather and father, Francesco Sforza, Duke of Milan.

A BEAUTIFUL HEAD

Comments written in Leonardo's notebook for 16 July 1493 relate to his need to find the right horse to model for the statue. He noted, 'Messer Mariolo's Morel the Florentine has a big horse with a fine neck and a beautiful head… The white stallion belonging to the falconer has fine hind quarters; it is behind the Comasina Gate… The big horse of Cermonino, of Signor Giulio'. Leonardo was observing the largest and finest horses in the neighbourhood. In November 1493 an equestrian effigy of Francesco Sforza, based on Leonardo's design for the Sforza horse, was placed inside Milan Cathedral for the wedding of Bianca Maria Sforza (Ludovico's niece) to the Emperor Maximilian I of Habsburg. The placing of the effigy under a triumphal arch of the cathedral shows the extent to which Francesco was revered, and Leonardo's sculpture was eagerly anticipated. Soon afterward, in December of that year, Leonardo made the decision to cast the giant horse on its side. The tail would be added later.

ANTIQUE STYLE

As well as understanding the techniques of making a vast sculpture, learned in Verrocchio's workshop, Leonardo was a keen horseman. His close observation of the anatomy of the horse is visible in his drawings and notes. However, though he worked from life, he also believed that it was better to copy from the antique than to follow modern works.

Right: Recreation of the Sforza horse, Frederik Meijer Gardens, Grand Rapids, MI, USA, based on Leonardo's design.

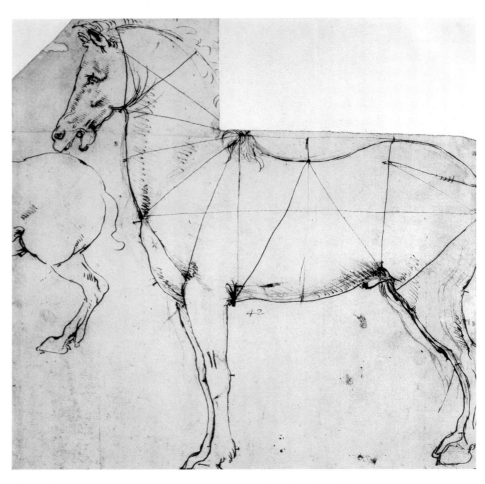

Above: Study of the proportions of a horse, c.1480, illustrating Leonardo's attention to accurate proportion representation.

Below: Studies of the hind quarters of horses, c.1490, for the monument to Francesco Sforza.

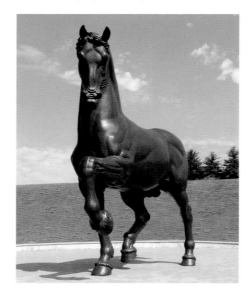

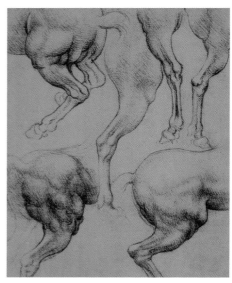

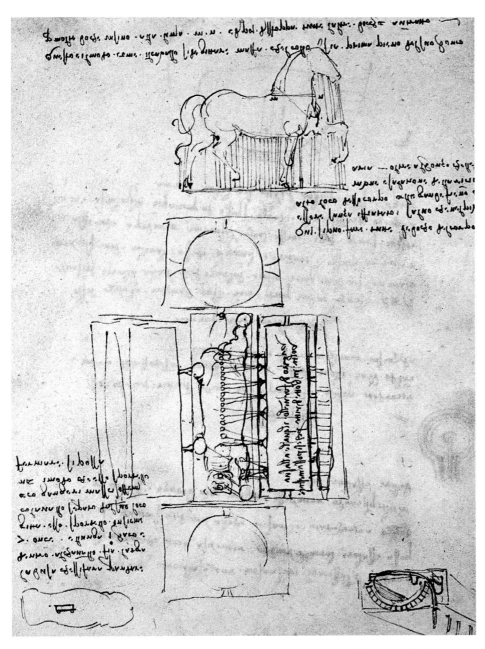

Above: Sketch of the casting pit for the Sforza horse, c.1493. This sketch, with explanatory notes, shows the pit from above (top); and from the side (bottom).

The ancient bronze equestrian statue of Marcus Aurelius in Rome was a magnificent example. In addition, Leonardo wrote in praise of the antique equestrian bronze statue of Odoacer, King of the Goths (AD435–93), who became King of Italy in AD476. It was situated in the Piazza del Duomo in Pavia, after its removal from Ravenna by Charlemagne. In Leonardo's time it was nicknamed 'Regisole' (Sun King) owing to the stunning reflection of the sun's rays on the bronze metal. On seeing it,

Leonardo wrote, 'Of that at Pavia the movement more than anything else is deserving of praise.' His own design for Sforza was to be of a horse in movement too.

A MONUMENTAL FIGURE

The Sforza horse was to be the largest monument ever to be cast in bronze. The size was to be 12 *braccia* (7.32m (24ft) from the horse's nape to the ground, and it would weigh a staggering 200,000 *libbre* (67,800 kg, 150,000 lbs). Seven tonnes of bronze were allocated to create it. It is possible that Leonardo travelled to Venice in 1492, when he had completed the vast clay model. The Verrocchio equestrian statue of the

Condottiere Bartolommeo Colleoni was about to be cast in bronze by the Venetian bronze-founder Alessandro Leopardi. Leonardo may have visited him to discuss the Sforza casting, or simply in order to view the method Leopardi employed. Unfortunately for Leonardo and the Sforza family, at the end of 1494 Ludovico had to send the bronze allocated for the sculpture to his father-in-law, the Duke of Ferrara, Ercole d'Este. It had been requisitioned to make a cannon.

By 1495, Leonardo had completed the clay model, a magnificent sculpture of a lifelike horse, which was destined never to be cast in bronze. The clay model was destroyed by the invading French armies in 1499. It was used as target practice; cannons were fired at it, breaking it into thousands of pieces. This was a sad conclusion to what would probably have been Leonardo's finest work. Today only sketches and notes remain to give an indication of the grandiose plan for this giant equestrian statue.

CATERINA – MOTHER OR SERVANT?

Throughout his adult life Leonardo remained in contact with his birth mother. While he was living in Milan, he recorded in his notebook, 'Caterina came on 16 July 1493'. However, there is conjecture that this Caterina is in fact a servant, not his birth mother. Six months later, his account book of expenses for 29 January 1494 includes two entries for the name Caterina, each receiving ten *soldi*. It may be two payments to a servant or one to a servant and one to his mother. On the death of his mother, in 1495, he records 'expenses for Caterina's funeral', listing everything from 27 *soldi* for 'three pounds of wax' for candles, to four *soldi* for 'carrying and setting up of cross'. The doctor's fees are listed at five *soldi* and the gravedigger's at 16 *soldi*. However, Leonardo does not make any comment on Caterina's death.

THE *LAST SUPPER*

Ludovico Sforza is thought to be the patron behind the commissioning of the *Last Supper*. The Dominican monks of the Convent of Santa Maria delle Grazie, in Milan, became the beneficiaries of his generous gift.

In 1495, the unexpected end to Leonardo's rigorous preparations for the casting of the Sforza bronze equestrian statue left him free for new commissions.

SANTA MARIA DELLE GRAZIE

Perhaps Ludovico offered Leonardo the commission of the *Last Supper* (*L'Ultima Cena*, 1495–7) as a consolation for the disappointment he must have felt after making the massive clay equestrian model without the possibility of completing it in bronze. The convent of Santa Maria delle Grazie was undergoing restoration and expansion. In 1492 the first stones for a new choir were laid. The patron was Ludovico Sforza, who planned to build a family mausoleum in the church. The subject of the refectory painting is thought to have been chosen by Ludovico; however, it was traditional for a painting of the Last Supper to be present, in some form, in the refectories of convents and monasteries. Verrocchio's former pupil Domenico Ghirlandaio's fresco of the Last Supper, c.1486, in the convent of San Marco, Florence, is a contemporary example.

A VAST PAINTING

The enormous size of Leonardo's *Last Supper* painting, 460 × 880cm (181 × 346.5in), was planned to fill the inner north wall. This was a narrow side of the rectangular space. Leonardo planned the optical illusion of the visitor being part of the Last Supper; walking into the room was to step into the painting. The placement of painted monastery cell doors behind the sitters with a landscape view beyond the painted windows created an illusion of an extension to the refectory, where Christ and his followers were seated in conversation at the supper table. Leonardo's work progressed at a slow pace. The Italian author Matteo

Above: Church of Santa Maria delle Grazie, Milan. Leonardo's Last Supper *mural was painted on a wall in a refectory of the church's adjoining Dominican convent.*

Bandello (1485–1561), writing in 1554, recorded that Leonardo would spend '… two, three or four days without touching it; and yet he always stayed there, sometimes for one or two hours, and he only contemplated, considered and criticized, as he debated with himself and the figures he had made'. The instructions from Ludovico Sforza, written on 29 June 1497, sent via his courtier Marchesino Stanga, were more specific: '... to urge Leonardo the Florentine to finish the work on the Refectory of the Grazie, which he has begun… and that articles to which he has subscribed by his hand be executed, which shall oblige him to finish the work within the time agreed upon with him'.

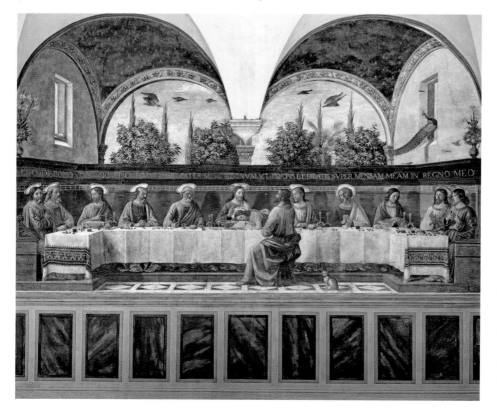

Left: Last Supper, *Domenico Ghirlandaio, 1476–80. The subject was traditional for the refectories of convents. This fresco is in the small refectory of the convent of San Marco, Florence.*

RECOGNITION OF A GENIUS

Even before Leonardo completed the *Last Supper* in 1497, it was called 'miraculous', and his finest work, elevating his reputation. He had chosen not to paint in fresco, the normal medium for a wall painting, but in a combination of oils and pigments, made to his own recipe. At court the painting was hailed as a masterpiece by the mathematician and Franciscan friar, Luca Bartolomeo Pacioli (1445–1517). Pacioli took the opportunity to praise the *Last Supper* in his publication, *Di divina proportione* (1509), a collaboration with Leonardo.

Left: The ex-Dominican convent of the church of Santa Maria delle Grazie receives a constant stream of visitors, to view Leonardo's painting of the Last Supper.

A FEAST OF EEL AND ORANGES

Prior to the cleaning of the painting of the *Last Supper* in 1978–97, the food Leonardo had included for the last meal of Christ and his followers was debatable. Tradition stipulates a symbolic meal of lamb, bread and wine. The poor state of the painting made recognition of specific foods difficult. Now the cleaned artwork reveals that Leonardo chose to depict grilled eel and sliced oranges. Leonardo was known to own a copy of the recipe book *De honesta voluptate et valetudine* (*On Right Pleasure and Good Health*), c.1465, published 1474, by the Italian author Bartolomeo Platina (1421–81). Recipes include apricots, grilled eel and peppery bread. Much like his fellow Florentine, Michelangelo Buonarroti, Leonardo often wrote a shopping list on the side of a sketch. Research has identified similarities between his own eating habits and the food content of the *Last Supper*, and, despite speculation, little evidence exists to support a theory that he was a vegetarian.

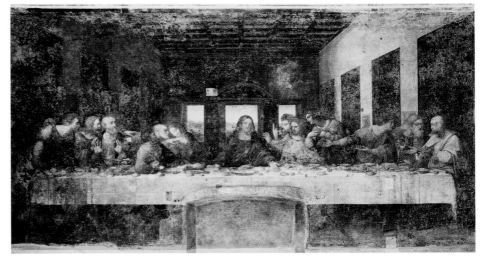

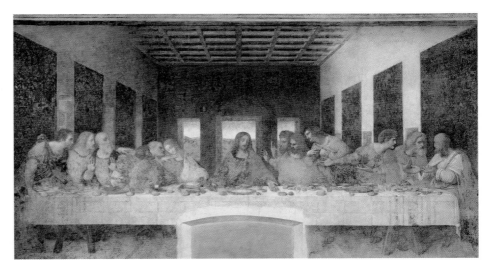

Top: Last Supper (pre-1978–97 restoration). Leonardo places the figure of Judas, normally seated opposite Christ and his apostles, on the same side of the table.

Above: Last Supper (post-restoration). An analysis of the perspective structure of Leonardo's trompe l'oeil room setting is possible in the post-restoration painting.

WORK AND FRIENDS

At Castello Sforzesco friendships with Leonardo flourished, and his opinion was sought on many matters. This created opportunities for him to be an adviser on several projects, some of which were more successful than others.

Residence at court brought Leonardo commissions from the Sforza family, and contact with like-minded people such as Donato Bramante and Luca di Pacioli. He pursued architectural projects, but art still dominated his schedule.

MILAN CATHEDRAL

In the field of architecture, Leonardo was moderately successful as a consultant on the new work planned for Milan cathedral. A letter, c.1487, to the 'Signori padri diputati', gives his reasons for being the right man to design a *tiburio* (domed crossing tower) for the cathedral. Using the analogy that only a doctor knows his patient well enough to cure him, 'a doctor-architect who well understands what a building is… will leave you satisfied both with his theory and his practice'. His rhetoric succeeded and two of his designs were translated into large wooden models by Bernardo de' Madis, a carpenter's assistant. Records show payments received for the work from July to September. In January and May 1490, Leonardo received further payments for the *tiburio* model but by

June they were withdrawn. The competition was won by Giovanni Antonio Amadeo (c.1447–1522) of Pavia, and Giovanni Giacomo Dolcebuono (c.1445–1504) of the Solari family of Milan. Local architects were given preference on this occasion. Leonardo was frustrated and disappointed, having considered the job to be his.

Above: Piazza Ducale, Vigevano, near Milan. In 1492–4, Leonardo possibly assisted Donato Bramante in the design of a spectacular rectangular piazza, in Vigevano, for Ludovico Sforza.

PIACENZA CATHEDRAL

Leonardo's powers of persuasion still had not brought results by 1496. On hearing that a commission for bronze doors for Piacenza cathedral might go ahead, Leonardo wrote to put himself forward: '… the city of the Florentines [has] grand works in bronze; amongst which are the doors of the baptistery in blue… I can assure you from this region [Milan, Lombardy] you will only get cheap and coarse masters… Here there is no man of merit, believe me, except Leonardo da Vinci.' He did not get the commission. A further disappointment was a lost commission to create ground plans and building designs for a palace for a member of the Milanese court, but again it did not materialize.

Left: Sala delle Asse, Castello Sforzesco, Milan. The scenic forest fresco decoration was designed by Leonardo c.1496–8.

Above: Truncated icosahedron, engraving. One of a series of geometric illustrations by Leonardo, for Luca Pacioli's De divina proportione, *published 1509.*

Right: Portrait of Luca Pacioli (c.1445–c.1514), Jacopo de' Barbari, 1495. The Franciscan monk stands at his table with geometrical tools, to illustrate a theorem from Euclid.

SALA DELLE ASSE

The same year Leonardo received an unusual art commission to decorate the Sala delle Asse (room of pikes), a plainly vaulted ground-floor hall in Castello Sforzesco. He was to paint a scenic forest with a pergola, shrubs and fruit, depicting an ancient grove brought to life. It was to be the last commission given to Leonardo by Ludovico Sforza. Leonardo chose to depict a forest of mulberry trees in reference to 'Il Moro' (the Italian word for mulberry is

Above: Portrait of Donato Bramante, artist unknown, c.1500. Bramante and Leonardo were possibly involved in the design of Piazza Ducale, in Vigevano, c.1492–4.

gelsomoro). The room displays the ambient lifestyle of the court at Castello Sforzesco, and at its centre the underlying political message of a family tree. The task was an unusual one for Leonardo, and one that stretched his patience. At one point he left the job and letters refer to the work being given to another artist, but Leonardo returned.

BRAMANTE AND LEONARDO

At the time of Leonardo's involvement with the Sala delle Asse, the aspiring architect and painter Donato Bramante (1444–1514) was also in Milan. He was one of the eminent artist-architect-engineers in the employ of Ludovico Sforza, alongside Leonardo da Vinci and Francesco di Giorgio. Born near Urbino in the Marche region, he moved to Milan in 1474. His architectural works identify his focus on pure classicism, evident in the church of Santa Maria presso San Satiro, Milan; he designed the choir there c.1480. In 1488 Bramante and Leonardo were asked by Cardinal Ascanio Sforza, brother of Ludovico Sforza and Bishop of Pavia, to draw up a new plan for the cathedral of Pavia. The closeness in age of Bramante and Leonardo and their mutual interest in architecture, particularly in Vitruvian theory, was

destined to produce a close friendship. Leonardo and Bramante were interested in many things which drew them together, from architecture to painting and from sculpture to philosophy. Bramante is known to have written a book of poetry dedicated to Leonardo.

DE DIVINA PROPORTIONE

Leonardo always wanted to improve his knowledge of mathematics, and the opportunity arose for him to take tuition from Luca Bartolomeo de Pacioli, a Franciscan friar resident at the Sforza court in Milan. Pacioli had spent much of his adult life travelling from city to city teaching; he was respected as the foremost mathematician in Italy. In 1497, Pacioli joined Ludovico's court and there met Leonardo. They became good friends. Pacioli was at this time preparing a book on geometrical proportion entitled *De divina proportione.* They collaborated on the book, with Leonardo contributing the accurately drawn geometric illustrations. When Leonardo left Milan, Luca de Pacioli travelled with him to Florence.

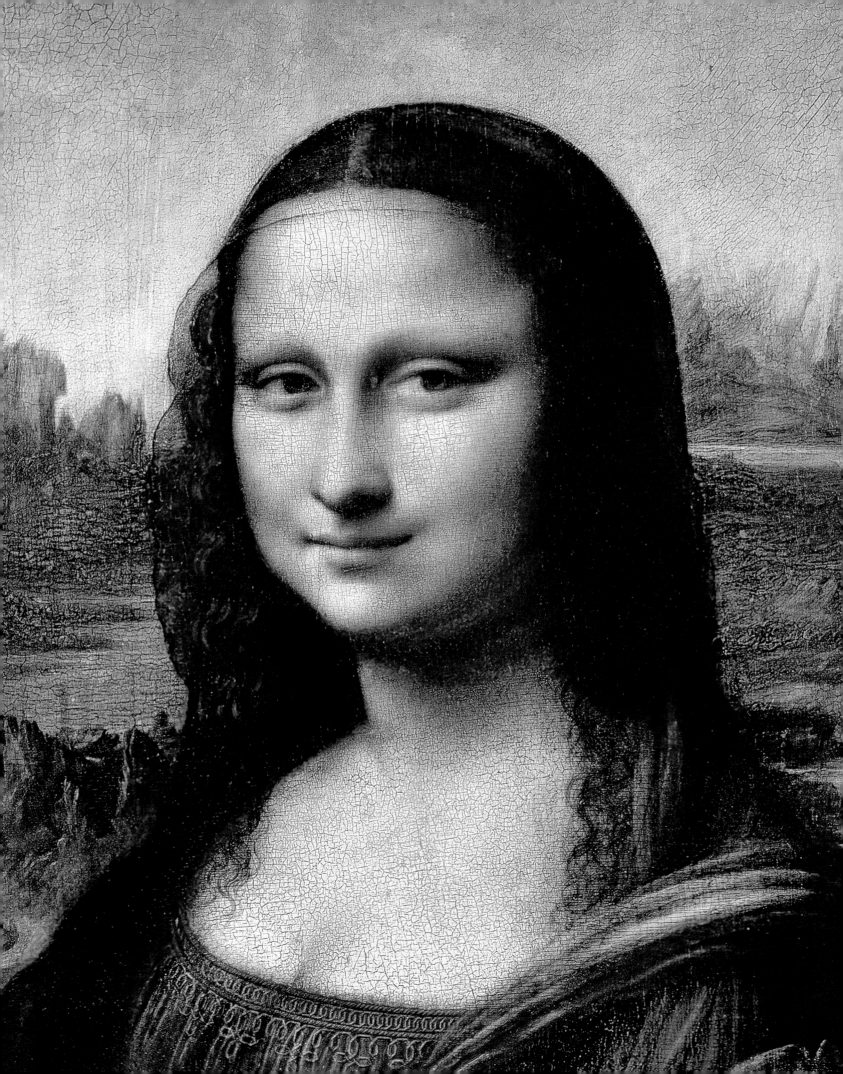

L'Uomo Universale

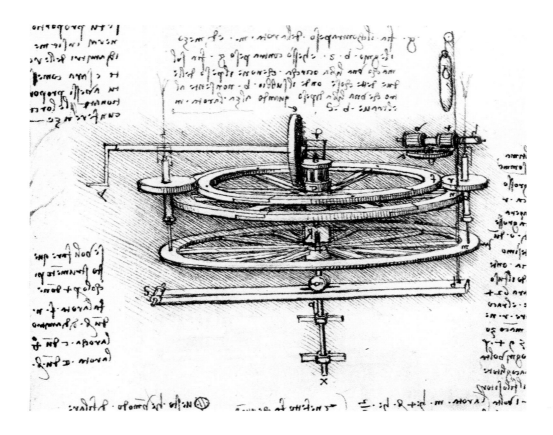

Leonardo's 17-year residence in Milan witnessed a maturity of his artistic skills, observed in altarpieces and portraits, the *Last Supper*, and the Sforza equestrian monument. Added to his ingenuity as a painter and sculptor, his drawings reveal a vast range of interests: from human bodies and animals to mathematics and geometry, engineering and architecture. In 1499, by the time of his departure from Milan, he well deserved the Humanist title *l'uomo universale* (universal man). From 1500, Leonardo moved from city to city, wherever patronage took him. In 1516–17, he accepted an offer from King Francis I, to move to the Château du Clos Lucé (also called Cloux), next to the king's royal residence at Château d'Amboise. Here he spent his remaining years.

Above: Study for a waterwheel, 1493–7. One of several studies on the design of water mechanisms.
Left: Portrait of Lisa del Giocondo (Mona Lisa) (detail), c.1502–6. Possibly the world's most recognized portrait, the Mona Lisa remained in Leonardo's possession until his death.

MILAN, MANTUA AND VENICE

In 1499, Ludovico Sforza, Duke of Milan, fled from the city to save himself from the invading army of the French king Louis XII. Leonardo, like many others, prepared to leave the city too. After visiting friends in the nearby cities of Mantua and Venice, he returned to Florence.

Seventeen years of patronage at the court of the Sforza was at an end and Leonardo needed a new patron, a new place to live, and commissions that would interest his polymath intellect.

MONETARY MATTERS

Leonardo packed some of his belongings to send on to Florence, and counted his money. His notebook for April states: 'On the first of April 1499 I find myself with 218 lire.' He records that his money is wrapped in different coloured papers and is hoarded in different parts of his study. Prior to leaving the city, on 14 December 1499, through the services of Francesco di Roma and Company in Milan and Piero Capponi and Company in Florence, Leonardo deposited 300 large florins to open an account at Santa Maria Nuova in Florence. The account received a further 300 florins through Salvestro di Dino in Milan, via Taddeo Ghaddi and Company in Florence. On this he could live comfortably for two or possibly three years, withdrawing funds as necessary.

Below: The city of Mantua. After leaving Milan, Leonardo resided for a short time at the home of Isabella d'Este in Mantua.

END OF AN ERA

Leaving Milan in December, accompanied by Fra Luca de Pacioli, his assistants and servants, Leonardo first travelled to Mantua, where he stayed in the city as a guest of Isabella d'Este (1474–1539), the young Marchioness of Mantua and wife of Francesco Gonzaga. Isabella's sister Beatrice had married Ludovico Sforza in 1491. Leonardo was treated as a special guest. In Mantua Leonardo spent time with Isabella, a cultured woman of great intellect and one of the greatest patrons of the arts. During their time together he drew her portrait. She fervently hoped that Leonardo would use it as a template to create an oil painting of her, yet he must have been reluctant to do so, for in spite of her entreaties, he did not give time to this. He made promises to do so but it remained a future project when he left her to travel to Venice.

VENICE

Records place Leonardo in Venice in March 1500. Here he would have taken time to view Verrocchio's bronze equestrian statue of Bartolomeo Colleoni (1478–9), erected in the Campo SS Giovanni e Paolo in 1494. In addition, he

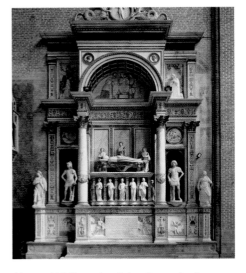

Above: Wall tomb of the Doge Andrea Vendramin, Tullio Lombardo (c.1455–1532) and Pietro Lombardo (1435–1515), c.1480–95.

would have wanted to see the recently completed wall tomb of Doge Andrea Vendramin (1393–1478), a marble classical 'triumphal arch' monument, c.1480–95, by the sculptor Tullio Lombardo (c.1455–1532) and his father Pietro (1435–1515). Historians consider that this work by Tullio, demonstrating his interest in Graeco-Roman sculpture, may have influenced Leonardo.

Above: *Castel Sant'Angelo, Rome. In 1501, Leonardo and Bramante may have liaised on a modification of the fortified Castel Sant'Angelo, Rome, for Pope Alexander VI.*

Right: Portrait of Isabella d'Este, *by Giovanni-Francesco Caroto, 1505–10. Possibly commissioned after Leonardo rejected an offer to paint Isabella's portrait.*

PORTRAIT OF A LADY

In 1498, Isabella d'Este wrote to Cecilia Gallerani, asking her to send her Leonardo's portrait of Cecilia, so that Isabella might compare it to one painted by Giovanni Bellini, the renowned Venetian artist. Cecilia did so, pointing out that it was a true likeness of her at the time it was painted. Clearly Isabella wanted Leonardo to paint her portrait, and his temporary stay with her in 1499 was her opportunity. It resulted in a cartoon drawing, created in preparation for a portrait. However, the portrait itself was never painted. In 1501, Isabella d'Este wrote to Fra Pietro de Novellara, the Vicar-General of the Carmelite order in Florence, enquiring '… if Leonardo the Florentine painter is to be found there…' and asking what work, if any, Leonardo was undertaking. Fra Pietro replied, 'as far as I can learn... he has done only one sketch since he arrived in Florence'.

FLORENCE, ROME OR NAPLES?

Following a brief stay in Venice, Leonardo's notes suggest that he planned to journey to Rome or Naples to meet the Count of Luxembourg, Louis de Ligny, an adviser to the French king. A note dated 10 March 1500, on the obverse side of a Leonardo drawing of Hadrian's mausoleum in Tivoli, simply states, 'A Roma. A Tivoli Vecchio, casa d'Adriano' (*Codex Atlanticus*, fol. 618v). The date is more probably 10 March 1501, in line with the Florentine calendar. The drawing is of Hadrian's circular mausoleum (AD 135–9) at Castel Sant'Angelo on the banks of the River Tiber in Rome. Leonardo scholar Pietro Marani (*Leonardo da Vinci: The Complete Paintings*, 2003) suggests that in 1501 Leonardo and Bramante may have been working together on a modification of Castel Sant'Angelo for Pope Alexander VI (pontiff 1492–1503). Bramante had been made under-architect to the Pope in 1500.

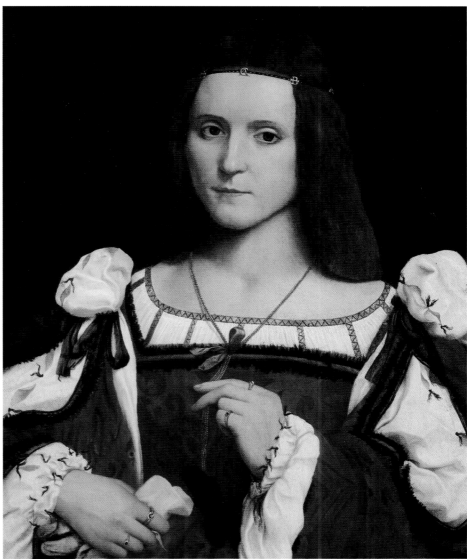

1500: A RETURN TO FLORENCE

For Leonardo, the Sforza era of patronage and life at court had come to an abrupt end. It was time to seek new patronage, and Leonardo returned to his home city of Florence. In the aftermath of Savonarola's demise, Florentine patrons were willing to commission new works.

Florence in 1500 was under Republican rule, with the Medici in exile. This was the second year after the death of a self-appointed ruler of Florence, the strictly religious Girolamo Savonarola.

CULTURAL PATRONAGE RENEWED

Since the death of the repressive Savonarola, Florentine cultural interests, particularly patronage of the arts, had revived. Patrons, both public and private, once again felt comfortable indulging in cultural pursuits such as the decoration of churches, chapels and private homes. Artists including Leonardo and Michelangelo returned to the city. Others, such as Pietro Perugino, who moved back and forth between Florence and Perugia, and the Florentine Sandro Botticelli, were in demand. Botticelli, renowned for his mythical paintings, such as *Primavera* (c.1482) and *Birth of Venus* (1485), both painted for the Medici, had his work denounced as decadent by Savonarola. From 1494–8 he received no commissions in Florence. Artists such as Filippino Lippi and

Above: Birth of Venus, *Sandro Botticelli, 1485. Botticelli, a popular artist in Florence, found that his artworks were denounced as decadent by Girolamo Savonarola.*

Below: Self-portrait, *Domenico Ghirlandaio, 1485. A detail from* Nativity and Adoration of the Shepherds, *Sassetti chapel, Santa Trinità, Florence.*

Domenico Ghirlandaio had gained Savonarola's approval of their religious paintings but now found themselves in competition with the most talented artists once again.

SANTISSIMA ANNUNZIATA

Leonardo had returned to Florence in April of 1500. Giorgio Vasari writes that soon after Leonardo's arrival he was offered a commission to create an altarpiece of the 'Virgin and Child' for the Servite monks of the Basilica della Santissima Annunziata (Basilica of the Most Holy Annunciation), which he gladly accepted. It gave him and his assistants a place to stay. He is recorded as living with the Servite monks, and having his studio at the monastery, until 1501. Recent renovations at the monastery have uncovered the studio, complete with walls decorated with frescoes.

A NEW *DAVID* FOR FLORENCE

Following Michelangelo's creation of a spectacular marble *Pietà*, 1499–1500, for Cardinal Jean Bilhères de Lagraulas, the French ambassador of King Charles VIII at the papal court in Rome,

Above: Portrait of Filippino Lippi, *Pietro Pezzati, 19th century. Detail from a fresco in the Palazzo Comunale, Prato.*

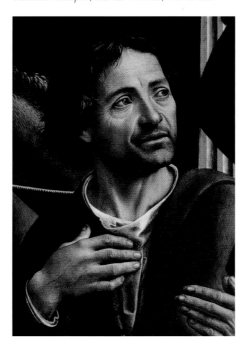

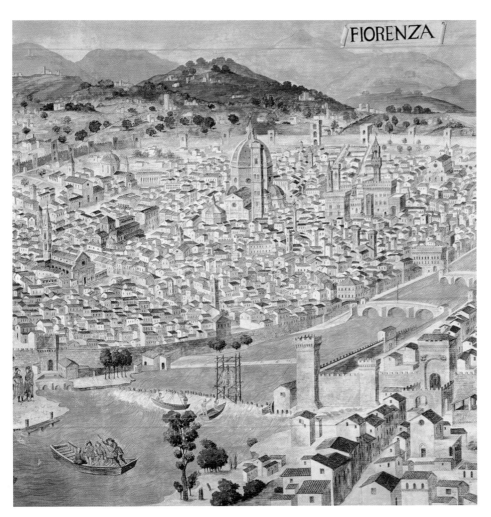

Above: Carta della Catena *(detail), Italian School, 1490. A panorama of Florence in the late 15th century.*

Above right: The 19th-century stone figure of Savonarola stands in Piazza Savonarola, in Ferrara, his birthplace.

Michelangelo returned to Florence, greatly respected as a sculptural genius. Eager to keep him in the city, the committee of the Operai dell'Opera del Duomo – the Order of the Works of the Cathedral of Santa Maria del Fiore – agreed to offer Michelangelo a commission to create a giant sculpture of 'David' for one of the buttresses of the apses of the cathedral. The sculpture would be placed high up, and viewed from below. In spite of the inferior block of marble he was given to work with, Michelangelo accepted the challenge. After completing a private commission, he began work in 1501.

COMPETITION WITH ROME

From the beginning of the pontificate of Pope Sixtus IV (pontiff 1471–84), the aggrandizement of the papal state was a priority. Rome began a transformation from a medieval to a Renaissance city, as buildings were demolished to widen the streets. Through painting, sculpture and architecture, a gradual resurgence of the city's power, and one to rival Florence, can be seen. In the Sistine Chapel, built by Sixtus, the walls were decorated with sensational paintings by Botticelli, Perugino, Domenico Ghirlandaio and Cosimo Rosselli. Perhaps the papal election of Pope Julius II, in 1503, who was known to have grand plans for the Vatican and St Peter's basilica, caused the Republican commune of Florence to consider further commissions for Michelangelo, and for Leonardo, in order to have their most respected artists work for the city of Florence, not Rome.

GIROLAMO SAVONAROLA

In 1494, during an invasion of Italy by King Charles VIII of France, Piero de' Medici had been expelled from the Republic of Florence. Following his departure, Girolamo Savonarola (1452–98), a Dominican monk and vicar-general of the convent of San Marco, seized power. As a religious and political reformer he was initially welcomed by the populace, but his strict moral code led to the public burning of private collections of books and paintings and the destruction of fine objects, to scourge the city and its inhabitants of the culture of materiality. His zealous sermons singled out for damnation the immoral, the rich and pleasure-seekers. Outward extravagance, particularly in dress, was forbidden. Stricter rules on what could and could not be painted saw a decline in commissions for artworks and many artists left the city owing to the lack of patronage. The Republic of Florence remained under Savonarola's control until Pope Alexander VI excommunicated him in 1497. On 23 May 1498 Savonarola was hanged and burnt at the stake outside the Palazzo della Signoria in Florence.

DRAWING FROM LIFE

Leonardo drew the things that he saw around him, including people, and animals, birds and insects in their natural habitat, and from 1489 to 1515 he closely observed and drew the anatomical formation of the human body.

Contemporary histories of Leonardo da Vinci comment on his sketches, which reveal a close awareness of nature. In his youth he spent time studying birds, insects and animals. As an adult he learned about the human body by dissecting corpses.

LIFE CLASS

Leonardo's detailed drawings of cadavers reveal his ideas on how the body, muscles and brain co-ordinate; they formulate his views on the living human condition. Anatomical dissections of human bodies were normally prohibited to all except the medical profession in Florence, yet Leonardo found a way to probe beneath the skin of many cadavers, in order to inform his understanding of the human body. In Florence he was given access to corpses at the

Below: Head of a woman, Master of the Pala Sforzesca (fl. c.1490–1500). The Master of the Pala Sforzesca closely followed Leonardo's drawing style, with the exception that he drew with his right hand.

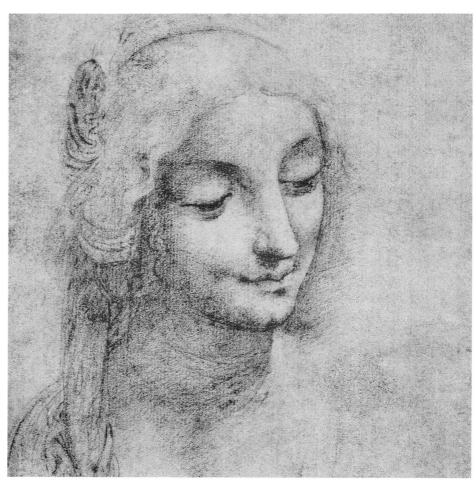

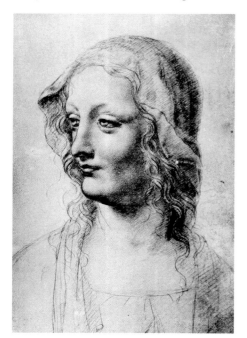

Below: Drawing of two crabs, c.1481–2. Leonardo questioned why the shells of oysters and other creatures such as crabs and sea snails were found within the strata of mountains that bordered the sea.

Above: Head of a woman, c.1480–99. Attributed to Leonardo, possibly a study for a larger work. Leonardo enjoyed sketching the people around him, as well as animals, insects and plants.

Ospedale di Santa Maria Nuova, which also happened to be his bank. Leonardo's anatomical drawings show the extent to which he observed and learned from the dead. In the first contemporary history of Leonardo's life, titled *Leonardi Vincii vita*, written soon after the artist's death, c.1520, the author Paolo Giovi wrote:

...in the medical faculty he learned to dissect the cadavers of criminals under inhuman, disgusting conditions... because he wanted [to examine and]

to draw the different deflections and reflections of limbs and their dependence upon the nerves and the joints. This is why he paid attention to the forms of even very small organs, capillaries and hidden parts of the skeleton.

The written observations that accompany Leonardo's drawings show the meticulous detail of his dissections. He wrote, 'Would that it might please our Creator that I were able to reveal the nature of man and his customs even as I describe his figure.' (MacCurdy, vol. I, p.90.)

Below: Anatomical study of the muscles of the thighs, c.1507–10. One in a series of anatomical studies of the muscles of the legs.

DISSECTING THE DEAD

In around 1507–8, Leonardo carried out a dissection of the corpse of a man who was 100 years old at his death. He wrote a detailed account of the experience:

And this old man, a few hours before he died, told me he was over a hundred years and that he felt no pain in his body, only great weakness.
And so, sitting up in bed in the hospital of Santa Maria Nuova of Florence, without any movement or sign of any mishap, he passed away. And I conducted anatomy on him, to find the cause of such a gentle death: the which I found to consist of a lack of blood in the arteries that nourish the heart and the other lower members, which I found
very arid, worn and dry. I described this anatomy very diligently and easily, since the body had no fat nor humours, which severely hinder recognition of the parts. The other dissection was that of a child of two, in which I found everything the opposite of the old man. (fol. 19027r.)

One other dissection Leonardo made included a complete and thorough examination of all parts of the body, from which he made drawings and copious notes. In the dissections that Leonardo carried out from 1489 to 1515, he performed many experiments: for example, injecting blood vessels with wax for preservation, thus discovering and naming the capillaries.

BIRD LOVER

One of Leonardo da Vinci's many cryptic notes written after 1500 reads, 'The great bird will take its first flight, on the back of his great swan, filling the universe with wonders; filling all writings with his fame and bringing eternal glory to his birthplace.' The symbolism of the comment connects Leonardo to his birthplace, and his aspirations for fame as an artist and a writer. It accords with the man who, according to Vasari, had an empathy with animals, birds and insects. Vasari tells us that Leonardo could not hurt or permit injury to any creature. Passing a market stall of caged birds, he would buy them and release them from their cages. A reference to Leonardo's concern for birds and animals appears in a letter (1515), sent by Andrea Corsali to Giuliano de' Medici, which gives an account of an overseas voyage. Corsali discusses an Indian race named the Gujerats 'who never ate anything which had blood, or permitted any injury to living creatures, like our Leonardo da Vinci'. Leonardo's kindness to animals is universally recognized, however, his shopping lists did include meat.

SUBLIME PORTRAITURE

Living at the monastery of Santissima Annunziata, his new residence in Florence, suited Leonardo. He and his assistants would live and work on site to paint a new altarpiece, and establish his presence in the city once again.

Vasari tells us that the Servite monks of the Basilica della Santissima Annunziata 'took [Leonardo] into their house, meeting the expenses of both himself and all of his household; and thus he kept them in expectation a long time'.

A THEME OF ST ANNE

Vasari informs us how Leonardo came to receive this commission. He writes that the monks of Santissima Annunziata had entrusted the painting of a panel for the high altar to Filippino Lippi, but as soon as Leonardo professed that he would have painted it for them, Filippino graciously gave way. This is an example of the desire of Florentines to commission prestigious artists who were returning to the city.

Leonardo started by making several drawings. In each he worked on the central figures of the Virgin and St Anne, continuously changing the format, aiming to create the right balance between the characters. In what can be called a signature theme developing over several drawings and cartoons, the inclusion of

Above: Virgin and Child with St Anne *(detail), c.1502–16. A detail of the face of the Virgin Mary elucidates Leonardo's tender portrayal of a young mother.*

St Anne was central to Leonardo's depictions of the Virgin and Child. Leonardo reworked this theme for many years. Vasari records that the drawing was one 'which not only caused all the craftsmen to marvel, but, when it was finished, men and women, young and old, continued for two days to flock for a sight of it to the room where it was'.

ISABELLA D'ESTE WRITES

While Leonardo was working on the cartoon, Isabella d'Este wrote again to Fra Pietro de Novellara to enquire about Leonardo's work schedule. Isabella keenly wanted Leonardo to make a painting of her from his drawing. The friar reported back, in a letter dated 3 April 1501, that Leonardo was at work on 'a little

Left: Piazza Santa Annunziata, Florence. Leonardo set up his studio in the monastery of the Basilica della Santissima Annunziata.

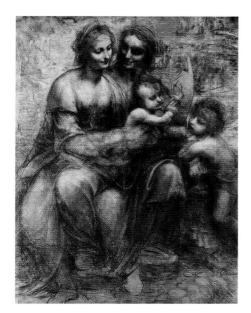

Left: Head of a woman, c.1500. *This red chalk drawing is probably a preparatory sketch for the painting* Virgin and Child with St Anne and the Infant St John, *c.1500.*

and the cartoon had been pricked out in readiness for transference to canvas, but he had been contracted to the king of France, and therefore asked to be released from this promise. This may link one of the cartoons to a work for Charles d'Amboise, the French Governor in Milan. Did Leonardo consider that his new patrons, the council of Florence and the French king Louis XII, would be displeased by any links to his former patrons, the Sforza family? It is possible Leonardo did not have time to paint the portrait. A contractual obligation for the second *Virgin of the Rocks* painting was active. Whatever the reason, by May 1502, Leonardo was working for Cesare Borgia in a quite different capacity.

Below: Crouching Venus with Cupid, *Roman, after Hellenistic original, 3rd century* BC. *We know that Leonardo was familiar with works of Roman antiquity.*

Above: Virgin and Child with St Anne and the Infant St John *(Burlington House cartoon), c.1500. The drawing affirms Leonardo's superb draughtsmanship.*

cartoon… not yet finished'. This may refer either to a smaller picture of the *Virgin and Child with St Anne and the Young St John,* or to the Santissima Annunziata commission. In frequent correspondence between Isabella and Fra Pietro, he informs her of the content of Leonardo's other drawings and works in progress. Fra Pietro writes of one sketch where 'the mother [Virgin] half rising from St Anne's lap, is taking the Child to draw it from the lamb…'. Here we have evidence of what Leonardo was creating at this time. Isabella's persistence led Leonardo to inform her that he would have been delighted to have created the portrait,

INTERPRETING THE ANTIQUE

For the Santissima Annunziata altarpiece Leonardo eventually decided on a portrayal of the *Virgin and Child with St Anne and St John the Baptist.* The shape and stance of the figures in the drawing may relate to antique sculptures. If, as has been suggested, Leonardo visited Rome in 1501, he could have seen the start of the excavation of Emperor Hadrian's villa at Tivoli (built c.AD118), and possibly the statues of Muses that were found in the ancient gardens (Marani, 2003). In Rome many ancient sculptures were being discovered, for example the *Apollo Belvedere,* a Roman marble copy of a Hellenistic bronze original, dating to 320BC, discovered in Rome c.1499–1500. The figures in Leonardo's drawing do have an antique quality to them.

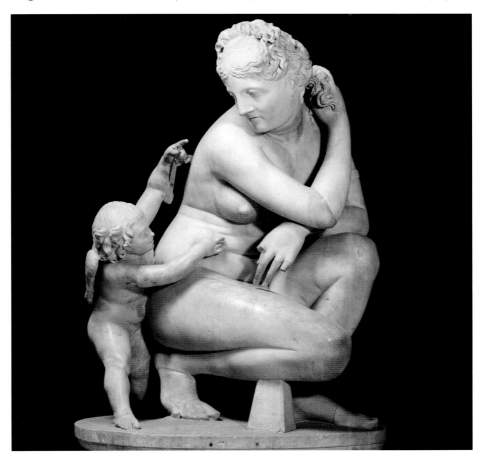

LEARNING FROM THE ANTIQUE

In Florence the resurgence of interest in Greek and Roman antiquity through literature, philosophy, art and architecture was reaching its peak in the early 1500s. Leonardo, interested in the buildings of classical antiquity, experimented with designs for centrally planned churches.

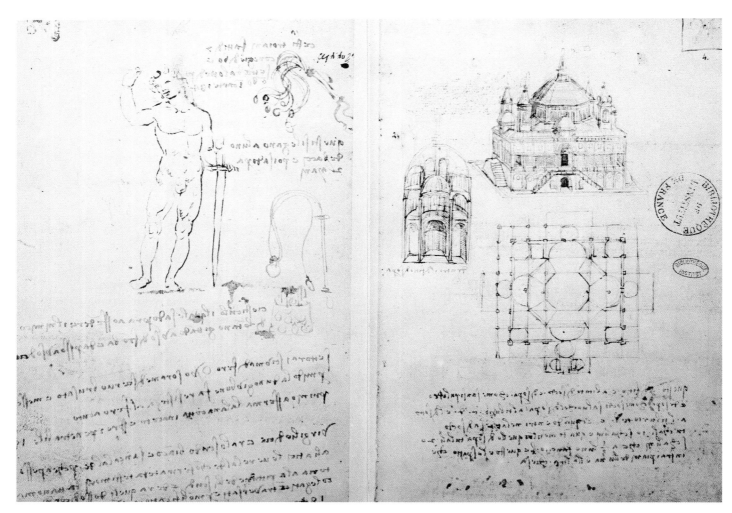

As an apprentice in Florence, Leonardo had been exposed to the 'new sweet style' inspired by the naturalism inherent in the ancient sculptures and artworks of Greece and Rome. Now he utilized this in his own works.

ROMAN ORIGINS

In reference to Leonardo's cartoon for the *Virgin and Child with St Anne and the Infant St John*, the art historian Kenneth Clark (1903–83), who was Director of the National Gallery, London, where the drawing is exhibited, from 1933 to 1945, stated that this work may prove that Leonardo visited Rome before 1503. The classical outlines of the figures bear a similarity to antique statues in the city.

In another of Leonardo's preparatory drawings, this time for *Leda and the Swan*, the shape and style of the body of Leda is informed by classical sculpture. In 1502, Leonardo's knowledge of the antique style led to him being asked to evaluate a series of drawings of antique vases in the collection of Lorenzo de' Medici, that were possibly changing ownership to Isabella d'Este.

THE ANTIQUITIES OF ROME

Leonardo recognized that he had been born at an intensively active moment for the arts in Florence. From the beginning of the 1400s, Florentine painters, sculptors and architects spent time in Rome whenever possible, to study the

Above: Figure sketch and plan and elevation of a church, 1487–90. To the left, a figure stands with a sword. To the right, a centralized plan and elevation of a church, with notes.

architectural ruins of the ancient city and any artefacts, particularly sculptures or ceramics, from the Roman period. Leonardo was no different from other artists in researching the origins of antiquity. Dominating any visit would be a tour of the Colosseum, the elliptical amphitheatre commissioned by Emperor Vespasian (AD9–79) in AD70 and completed by Emperor Titus (AD39–81) in AD80. In Leonardo's time it was partly buried under hilly mounds. The circular

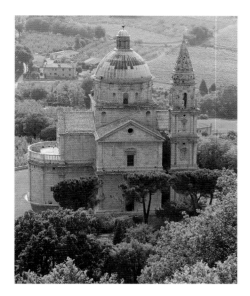

Above: Church of Madonna di San Biagio, Montepulciano, Tuscany, Antonio da Sangallo, 1518–40. This church resembles Leonardo's designs for centrally planned churches.

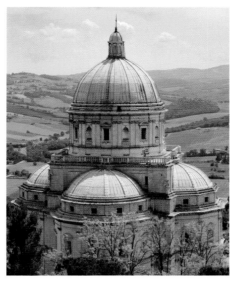

Above: Church of Santa Maria della Consolazione, Todi, Tuscany, Cola di Matteuccio da Caprarola, 1502–12. The design of this church can also be compared to Leonardo's drawings.

being unearthed in Rome. On sculpture, Leonardo noted, 'It is better to copy the antique than a modern work.'

ROMAN TEMPLES

Leonardo's drawings show his interest in Roman temples and their revival, particularly as centrally planned churches. The ideal building and city are based on symmetry, harmony and proportion, which in turn produce beauty, and Leonardo, in his sketches, could be seen planning symmetrical buildings based on the theories of Vitruvius and Alberti. Although there are no extant buildings designed by Leonardo, contemporary architects may have used his ideas. Based on the perfect forms of the circle and the square, his plans and sketches may have been utilized for the architectural design of two churches with a domed Greek Cross plan. The church of Santa Maria della Consolazione (1508–12) by Cola di Matteuccio da Caprarola (*fl.* 1494–1518), at Todi, and the church of Madonna di San Biagio (1518–40) by the Florentine architect Antonio di Sangallo (*c.*1455–1534), in Montepulciano, both closely resemble Leonardo's designs, *c.*1492. From his own plans, the most erudite are those for the palace at Romorantin, one of his later works for King Francis I of France.

Pantheon (AD118), a pagan temple converted into the church of Santa Maria ad Martyres in AD609, was considered to be an architectural marvel. Other

centrally planned churches and temples were in evidence, and influenced the work of Brunelleschi, Alberti and Bramante, just three of the notable Italian architects of the 15th century. The 2nd century AD bronze equestrian statue of Emperor Marcus Aurelius, placed outside the Lateran church, was a must-see for sculptors and goldsmiths; so too were the ancient marble statues that were

DE RE AEDIFICATORIA

A publication that was influential to generations of architects from the 15th to the 19th century was produced in Leonardo's lifetime. A treatise on architecture, *De re aedificatoria* (1450) by the Italian writer and architect Leon Battista Alberti, was the first modern treatise on the theory and practice of architecture. The book, loosely based on the ancient treatise *De architectura* by the Roman architect and engineer Vitruvius, explores the architecture of the ancients and, more importantly, discusses what the architecture of the modern city should be, based on classical precedents. The first version of the treatise was written in Latin. Alberti wanted to appeal to the most cultured audience, including wealthy patrons and the papacy. The second edition was produced in Italian, so that it would be easily understood by builders and artisans.

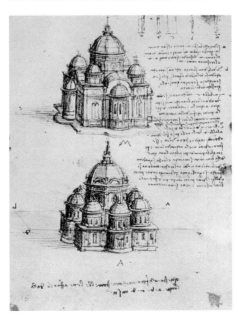

Above: Studies and notes for a centrally planned building. One of a series of architectural designs that work from the plan of the circle and square.

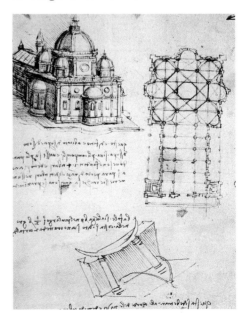

Above: Ground plan and perspective elevation of a centrally planned building, c.1487–90. Design outlines for central plan buildings, based on the antique.

THE SCIENCE OF MAN

From 1480 until his death in 1519, Leonardo da Vinci's notebooks are filled with remarkable designs for practical devices, from self-propelled carts to armoured cars, scythed chariots and flying machines.

Leonardo's engineering inventions were groundbreaking in their time. His plans for hydraulics and flight pushed boundaries and explored innovatory ideas, some of which are still in use today.

FROM CARTS TO WAR CHARIOTS

Leonardo da Vinci's inventive intellect is illustrated by just a few of his remarkable designs, which show his vast capacity to think beyond the everyday in order to produce plans for revolutionary pieces of equipment. One of Leonardo's earliest technical drawings, dated 1478–80 (*Codex Atlanticus*, fol. 812r), shows a multi-purpose self-propelled cart, ideal for either warfare or farming. The simplicity of the design hides the technical knowledge required in order to make it work. A design for an armoured car (Biblioteca Reale, fol. 1030), dated 1485, which looks like a fantasy spaceship, was one of Leonardo's war machine plans created for Ludovico Sforza. Neither design was taken to completion; however, it has been

Above: Design for an armoured car (detail), c.1485–8. An inventive idea for a mobile circular armoured wagon with firing holes, an early type of tank.

Below: Reconstruction model of Leonardo's design for an automobile.

Below: Technical study for an automobile machine, c.1478–80, drawn from above and the side. A reconstruction model of the automobile machine is pictured left.

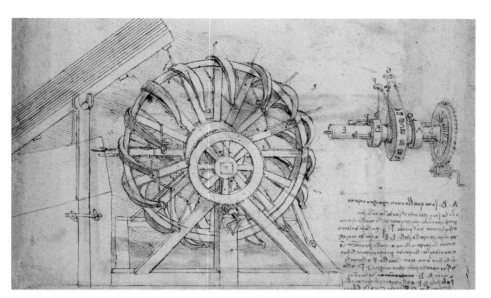

Above: War machine with 16 crossbows, c.1485. A detailed study of the mechanism of an innovative machine, which could fire crossbows.

proven that each would have worked. In the same year Leonardo produced a design for a scythed chariot (Biblioteca Reale, fol. 1030), which looks much like the chariots of Roman antiquity and is perhaps based on them. The rotating blades, mounted horizontally on spiked wheels, would stop an enemy and anything else approaching the vehicle. The drawing was illustrated with corpses surrounding it to emphasize its lethal capacity. However, Ludovico Sforza did not respond. In hindsight, considering his demise at the hands of the French king in 1499, he might have been wiser to listen to Leonardo.

MITRE BRIDGE

In 1497, Leonardo perfected a double-gated canal lock bridge for the newly constructed San Marco canal in Milan, to aid the flow of boats between different water levels. A release of water at too steep an angle via the lock gates could make a boat roll and sink. Leonardo devised a two-lock system, known as a mitre bridge; the shape follows that of a bishop's mitre headdress. The simple system allowed a boat through the mitre gates, whereupon the closed compartment either filled or emptied of water in order for the vessel to continue at the new water level. The mitre gate superseded the portcullis bridge system.

FROM BRIDGES TO MORTAR BALLS

Leonardo's notebooks are filled with design exploration. It is clear that he spent his time constantly considering the flight of birds, the trajectory of wind-blown objects, or the strength of warfare missiles. It was as though he had a store cupboard of plans, waiting for the next patron to need a warfare strategy, a bridge built, a map drawn.

One drawing from 1504 shows a shower of mortar balls being fired from a series of mortars spaced evenly along a pathway, just beneath vast castellated walls. The mortar balls easily fly over the walls in an artistic arch of gunfire,

Above: Drawing of a wing mechanism, 1487–90. Illustrates a mechanical wing undergoing wind tolerance testing.

Above: Design for a dredger and various hydraulic machines (detail), from Paris Manuscript E, 1513–14.

to land on their target, a courtyard within the walls. Drawing his intention and making it happen were both within his grasp. His knowledge of geometry, engineering and logistics created the perfect military architect for warfare. This may have been lost on Ludovico Sforza, but it was not lost on Cesare Borgia. Leonardo's delight in his ability to design a new invention and see it in use outweighed, it would seem, his allegiance to one city, one country.

FLYING MACHINE

Leonardo's design for a flying machine was a work in progress over many years. The first sketches appeared during the years he spent in Milan, from 1482 to 1499. The studio at Santissima Annunziata, Florence, where he lived intermittently from 1501 to 1506, has walls decorated with sketches of birds in flight. It was an idea that obsessed him, and his technical drawings show the integrity of his grasp of bird flight, and how he was using this knowledge to try to make a mechanical flying machine (Ms B, fol. 74v–75r). Here, the plan depends on his observation of the kite in particular. He called his machine the 'great bird'.

WORKING FOR THE BORGIA

In 1502, Leonardo da Vinci and Niccolò Machiavelli worked together at the travelling court of the ruthless mercenary leader Cesare Borgia, the Duke of Valentinois and Romagna, Captain General of the Papal armies.

Cesare Borgia (1476–1507), the second son of Pope Alexander VI, employed Leonardo as his design engineer. Cesare Borgia had a formidable reputation as a mercenary soldier, a real opportunist, and also as the murderer of his own brother, Giovanni, Duke of Gandia.

BORGIA'S TRAVELLING COURT

On 18 May 1502, Leonardo was listed in Borgia's retinue as 'familiar architect and general engineer'. He had been hired as chief military engineer, in charge of the design of machines, warfare equipment and fortifications. For Leonardo this must have been an exciting position to hold, in spite of having to work for a murderous man. For the first time in his life, Leonardo was not engaged primarily for his skill as a painter, but as an architect

Right: Pope Alexander VI (Rodrigo Borgia) and his Son Cesare Allegedly Poisoned while Dining with Cardinal Corneto, 1503, *artist unknown, 19th century.*

Above: Portrait of Cesare Borgia, *Altobello del Meloni, (fl. 1497–1530). Leonardo travelled with Cesare Borgia's court, as 'familiar architect and general engineer'.*

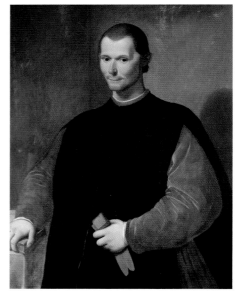

Above: Portrait of Niccolò Machiavelli, *Santi di Tito, 16th century. Machiavelli joined Cesare Borgia's travelling court for several months.*

A BRIDGE ACROSS THE BOSPHORUS

In January 1503, during his service with Cesare Borgia, Leonardo wrote to Sultan Bajazet II regarding a proposal to build a 100m (220ft) bridge over the Bosphorus Sea in Istanbul. He had sent a design for the bridge to the sultan in 1502; it would have been the largest bridge ever to be built. The plan was to create a bridge of three arches supporting a walkway. Leonardo offered to oversee the construction, but the scheme was rejected by the sultan as impossible to create. In 2001, the bridge was built in Norway, to Leonardo's precise specifications, proving that his engineering skills were sound.

Right: Mechanism for repelling scaling ladders, c.1480–7. Leonardo's innovative designs, created in Milan, could now be used for Cesare Borgia's military skirmishes.

and engineer. Just like the Roman Vitruvius, he would design maps, roads, bridges, machines and battlements.

NICCOLÒ MACHIAVELLI

At Cesare Borgia's travelling court Leonardo was joined for several months by the Florentine courtier Niccolò Machiavelli (1469–1527), who was later to write a semi-fictional book, *The Prince* (1513), based on the oligarchy of Cesare Borgia. From July to September 1502, Leonardo travelled to Le Marche and Romagna, visiting Urbino, Cesena, Porto Cesenatico, Pesara and Rimini. At the same time, Machiavelli's aim was to discover, using his charm and intellect, the military intentions of Cesare Borgia. Leonardo was in a perfect position to tell Machiavelli about Borgia's military ambitions. During his service for Borgia, Leonardo created maps and plans related to the campaign. Notes alongside the drawings he created during this period point to a problematic equation for Leonardo: balancing his own moral code with the possible military intervention by Borgia in Florence. Leonardo did inform Machiavelli, and Borgia did not march on Florence. The extent of Borgia's strategy was only known after his death. In 1507 he was killed in battle in Viana.

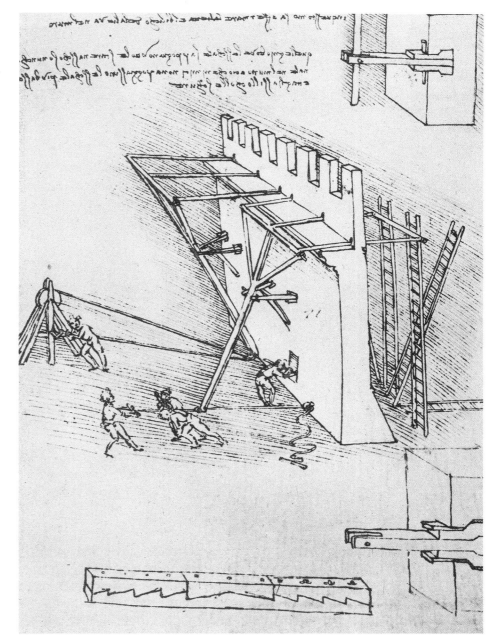

Below: Machine for hurling bombs, c.1485. Planned for Ludovico Sforza, Leonardo could reuse his war machine design for his new patron, Cesare Borgia.

Right: Design for a drill, 1487–90. The design illustrates the working mechanism of the drill, alongside notes on its construction.

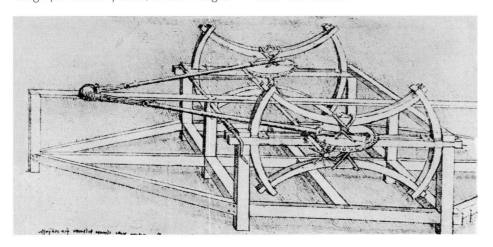

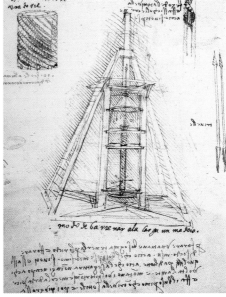

MONA LISA

Giorgio Vasari records that the painting of 'Monna Lissa del Giocondo' was carried out when Leonardo returned to Florence. Of all his portraits, this one stands out as his masterpiece.

Vasari states that Leonardo 'undertook to execute for Francesco del Giocondo, the portrait of Monna Lissa, his wife; and toiling over it for four years, he left it unfinished…'

MONNA LISSA DEL GIOCONDO

Vasari goes on to inform us that Leonardo employed minstrels to play and sing to Monna Lissa while he painted. It is a detail of Leonardo's working environment that brings us a little closer to the man, knowing that he liked to relax his sitters with the accompaniment of music, creating an ambience that would both please the client and produce a good portrait. At some point Vasari must have viewed the work at close quarters, for he points out that the head was an example for 'whomsoever wished to see how closely art could imitate nature…' His final comment brought attention again to Monna Lissa's mouth, '… in this work of Leonardo's there was a smile so pleasing that it was a thing more divine than human to behold…' From Vasari's description and our own eyes, we have come to recognize this as the enigmatic smile of 'La Gioconda', the *Mona Lisa*.

ARTISTIC DEBATE

The exact history of the *Mona Lisa* painting is difficult to ascertain. The work is thought to have been initiated in Florence, c.1502–3, after Leonardo returned from his expedition with Cesare Borgia and just before he began his preparation in October 1503 for the *Battle of Anghiari* wall painting. The actual painting of the *Mona Lisa* probably took place between 1503 and 1506. Sketches of the work may have been initiated at an earlier time when Leonardo was travelling from Milan via Mantua and Venice. The debate centres not on the timing as much as on the identity of the sitter, who commissioned the painting, and for what reason. Art historians identify the sitter as Lisa Gherardini del Giocondo (1479–1551), who had married a rich Florentine silk merchant, Francesco del Giocondo (1465–1539) in 1495. There is evidence to suggest that the Leonardo family knew members of the Gherardini and del Giocondo families; their acquaintance was renewed during Leonardo's residence at Santissima Annunziata, where the del Giocondo family had a chapel in the church.

AN ENIGMATIC SMILE

Several theories for the commission have emerged. The first relates to Monna Lissa's clothing, and the possibility

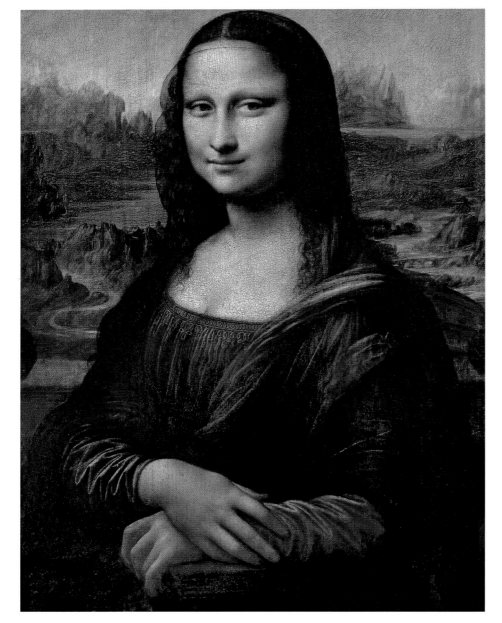

Left: Portrait of Lisa del Giocondo (Mona Lisa), c.1502–6. 'Mona Lisa', in three-quarter profile, is set against a landscape of mountains and streams.

that it was made from cloth that Francesco del Giocondo supplied. Secondly, the veil Lissa wears may have been a mourning veil, worn in memory of her daughter who died in 1499. However, the veil was typical dress and not necessarily for mourning. Other theories include that the painting may have been commissioned to mark the birth of Monna Lissa's second son Andrea in December 1502 (she gave birth to five children), or that the work was intended as a commemorative painting for a house purchased in 1503. One further theory, which is a distinct possibility, is that Leonardo's depiction of her smile may represent a play on her name, Giocondo, the 'cheerful one'.

Above: Leonardo da Vinci painting the 'Mona Lisa', *Cesare Maccari, 19th century. The work prompted artists to copy its style; others have visualized its creation.*

Right: La Gioconda Nude, *Leonardo School, c.1513. A charcoal study of Leonardo's lost drawing.*

PROVENANCE

After 'lingering over it', as Vasari puts it, Leonardo left the *Mona Lisa* unfinished. The work stayed with him for the rest of his life. There are no clues as to why it was unclaimed or why Leonardo chose not to part with it. When he travelled to France in the winter of 1516, the *Mona Lisa* travelled with him. On his death, in 1519, it was bequeathed to his assistant Salaì, and it remained with the Salaì household until his death, in 1524. The painting, inherited by Salaì's sisters, was sold in 1525. The valuation of the painting at this time was 505 lire, a princely sum. How it later came to be in the collection of the French king Francis I is unknown. Salaì had bequeathed this painting and other works to his sisters. The king may have asked if he could purchase it from them, but the exact chain of events remains a mystery.

MICHELANGELO – A RIVAL

Florence once more contained a wealth of talented artists living and working in the city. The most famous were Michelangelo Buonarroti and Leonardo da Vinci, who were destined to become artistic rivals.

Leonardo had returned to Florence with a prestigious reputation but little to show for his 17-year absence; Michelangelo was a favoured son of the city, famous for his ego and remarkable talent.

DIFFERENT PATHS
In 1502, Leonardo da Vinci was 50 years old, with over 30 years' experience as a professional artist; Michelangelo was 27 years of age, having worked as a professional sculptor for nine years. The patronage of the Sforza had allowed Leonardo the opportunity to paint his masterpiece, the *Last Supper* (1495–7), for which he was recognized as an artistic genius. From an early age Michelangelo had decided to make sculpture his profession, considering painting pictures to be of little skill and even less value. His reputation rested on remarkable works in marble such as *Sleeping Cupid* (1496), *Bacchus* (1496–7) and the *Pietà* (1499–1500). His ego matched his sculptural dexterity. It was notably visible on the sash across the figure of the Madonna of the *Pietà*, where he carved in Latin, *Michelangelus Buonarrotus Fiorentius Faciebat* (Michelangelo Buonarroti, Florentine, made this).

A SIMILAR UPBRINGING
Leonardo and Michelangelo were both Florentines, both born in small country villages on the outskirts of the city: Leonardo in Vinci, and Michelangelo in Caprese. At the time of their births both fathers held civic positions: one was a notary, the other a mayor. One difference was Leonardo's illegitimate birth, while Michelangelo was the second son of a close-knit family. Leonardo's mother was absent

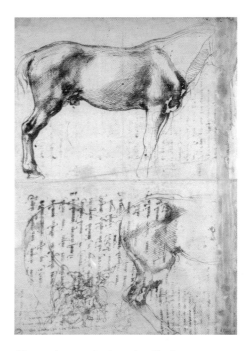

Above: Anatomical study of a horse, Michelangelo, 1504. A pen and ink study with notes.

from his life; Michelangelo's mother died when he was five years old. Each benefited from a country childhood: Leonardo had time to study the natural world; Michelangelo learned from the family of sculptors to whom he was sent initially to be wet-nursed in his first years. Both boys were educated at home, but Michelangelo had been given a formal education in Florence too.

A DIFFERENCE OF OPINION
Leonardo da Vinci was a respected member of the Florentine community and one of 30 council members, including Sandro Botticelli, who met on 25 January 1504 to discuss where to place Michelangelo's 4.09m (13.5ft)

Left: David, 1501–4, Michelangelo. Leonardo was part of the committee who decided that the entrance to the Palazzo della Signoria was the best location for the larger than life-size marble sculpture.

ARTISTIC EDUCATION

Leonardo and Michelangelo were both fortunate to have been apprenticed to notable masters: Leonardo to Andrea del Verrocchio, and Michelangelo to Domenico Ghirlandaio (although Michelangelo later tried to deny it). Leonardo initially found patronage through his father. Michelangelo's aspirations for a career as a sculptor were advanced when he was offered a place at Lorenzo de' Medici's newly formed sculpture school. He had the good fortune to be invited to live in the house of the Medici too, and was treated as a family member. He was introduced to the study of Humanism and Neo-Platonism and had the opportunity to meet philosophers, linguists, historians, scientists, artists and architects.

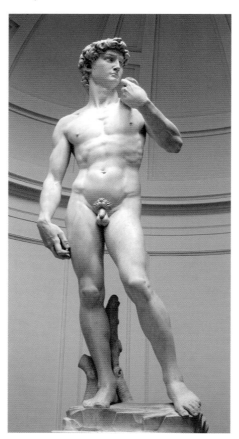

Above: Portrait of Michelangelo Buonarroti, *Jacopino del Conte, c.1535. Michelangelo at about 60 years of age.*

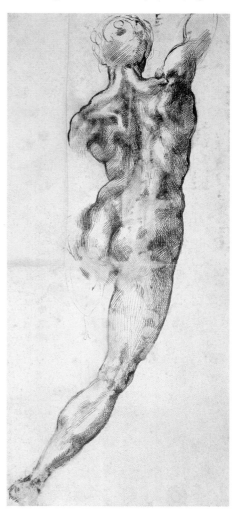

marble sculpture *David*. It was obvious, not only in the light of Michelangelo's increasing fame but also because of the beauty of the statue, that an insignificant position on a buttress of the Duomo was now unacceptable. Michelangelo's known animosity toward Leonardo may stem from this meeting, when Leonardo may have suggested placing the sculpture in the Loggia del Lanzi, close to the Palazzo Vecchio. For Michelangelo, there was only one place for his sublime *David*, and that was in front of the most important civic building in Florence, the Palazzo della Signoria. According to Vasari, it was placed there on 8 September 1504.

Above: Ideal head, known as the Damned Soul (Il dannato), *Michelangelo, c.1534. An expressive drawing, possibly a preparatory work for the* Battle of Cascina.

From this time Leonardo makes reference to Michelangelo slighting him in the street and making abusive remarks about Leonardo's failure to complete the Sforza equestrian statue. It was a difficult situation, for Leonardo was at work on the *Battle of Anghiari* and Michelangelo was about to begin his preparations for the *Battle of Cascina*, both works destined for the Palazzo della Signoria.

Above: Nude study, Michelangelo, c.1504, possibly a preparatory drawing for the Battle of Cascina *painting.*

BATTLE OF ANGHIARI

In the Salone dei Cinquecento of the Palazzo della Signoria, two painted battle scenes depicting the Battle of Cascina (1364) and the Battle of Anghiari (1440), both victories for the Florentine Republic, were chosen to decorate the walls.

The Salone dei Cinquecento, the 'Hall of the Five Hundred', where a council of 500 Florentine citizens met, had been redesigned and decorated in 1495 by the Florentine architect, 'Il Cronaca', Simone del Pollaiuolo (1457–1508).

BATTLE COMMENCES

According to Vasari, 'It was ordained by public decree that Leonardo should be employed to paint some fine work… In 1503, the hall was allotted to him by Piero Soderini, the Gonfaloniere of the city… Leonardo began by drawing a cartoon…' Leonardo chose to paint the 1440 *Battle of Anghiari*. He was to be paid a regular salary. A document drawn up on 4 May 1504 by the secretary of the Second Chancery, Niccolò Machiavelli, records a fee of 25 florins per month with a completion date set for February 1505 and a proviso that money could be claimed back if the work was incomplete. Apart from his team of assistants, Leonardo's outlay included vast

Right: The commune of Florence employed two of the most exciting artists of the era, Michelangelo and Leonardo, to adorn the walls of the Salone dei Cinquecento.

Above: The Salone dei Cinquecento in the Palazzo della Signoria (now Palazzo Vecchio), Florence.

quantities of paper and materials plus a movable scaffold, invented by him to create the large cartoon and painting.

A PLACE TO WORK

On 24 October 1503, in order to create the cartoons and preparatory sketches for the vast painting of the battle scene, Leonardo was given the keys to the Sala del Papa, adjacent to the Church of

Santa Maria Novella in Florence. Here he set up a workshop to house himself and his assistants. Records show that the figures in the cartoon and subsequent painting were one and a half times life-size. The finished painting would need 25m (82ft) of wood to frame it. Leonardo began to paint the *Battle of Anghiari* in 1505. His diary informs us:

On the 6th day of June, 1505, Friday, at the stroke of the 13th hour I began to paint in the palace [Palazzo della Signoria]. At that moment the weather became bad, and the bell tolled, calling the men to assemble. The cartoon ripped. The water spilled and the vessel containing it broke. And suddenly the weather worsened and it rained so much that the waters were great. And the weather was dark as night.

Leonardo completed the central part, the *Fight for the Standard*, before leaving for Milan. His experimentation with paint pigments and formulas led to some of the paint 'sliding' off the canvas, but the mural remained in place until at least 1549. The large cartoon was cut up and sold but a mystery still surrounds the whereabouts of the *Battle of Anghiari* painting. It may be behind Giorgio Vasari's mural *Battle of Marciano in Val di Chiana*, 1563. Vasari had reconstructed

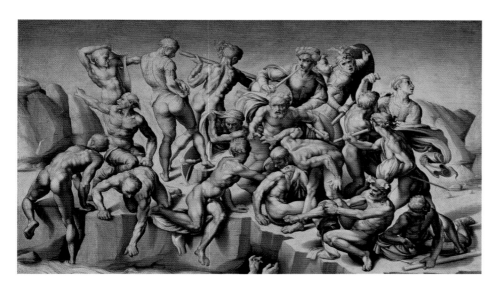

Above: Battle of Cascina, *or* Bathers, *Aristotile da Sangallo, 1542. A copy of the central section of the cartoon by Michelangelo's* Battle of Cascina. *It is through copies that the work is known.*

Below right: Episode of the Standard (Battle of Anghiari), *after Leonardo da Vinci, Peter Paul Rubens, c.1603. Rubens' painting confirms the composition of the original work by Leonardo.*

1440: THE BATTLE OF ANGHIARI

On 29 June 1440, the Battle of Anghiari was fought on land between Anghiari and San Sepolcro, with the Florentines fighting men from Lombardy and the Milanese. The Italian League included the League of Pope Eugenius IV, and the Republic of Florence and Venice. It was led by Condottiere Micheletto Attendolo (*fl.*1411–63) and Pietro Giampaolo Orsini (*fl.*1414–43). The Milanese troops were led by the mercenary soldier Condottiere Niccolò Piccinino (1386–1444) fighting for the Milanese Sforza. The Italian League was successful, defeating the Sforza and Piccinino. Leonardo's Florentine origins, followed by 17 years of Sforza patronage in Milan, must have led to divided loyalties when he was asked to produce a partisan illustration for the council of Florence.

the hall for Cosimo de' Medici. However, many historians believe that Vasari would not have destroyed Leonardo's work. The respected art diagnostician Professor Maurizio Seracini believes that Vasari built a thin wall in front of Leonardo's work and applied his own painting to a screen in front of it.

BATTLE OF CASCINA

On completion of his sculpture of *David* in the summer of 1504, Michelangelo was commissioned to start preparatory sketches and cartoons for the *Battle of Cascina*, a battle fought against Pisa in 1364 and a subject, according to Vasari, of Michelangelo's own choosing. The artwork, still at the cartoon stage, was left unfinished in 1505 when the artist was summoned to Rome to work for Pope Julius II.

Below: Battle of Anghiari, *artist unknown, 16th century (after 1506). This is a copy after Leonardo da Vinci's painting. Here the artist portrays part of the battle scene.*

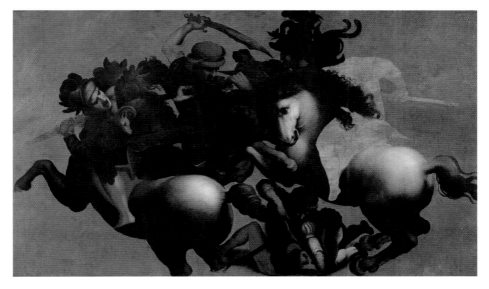

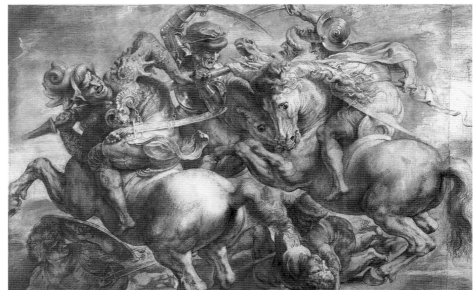

FAMILY MATTERS

Letters relating to his family are a rarity in Leonardo's papers, which are notable for business rather than personal memoranda. His private family life is more often revealed through official papers and law court records.

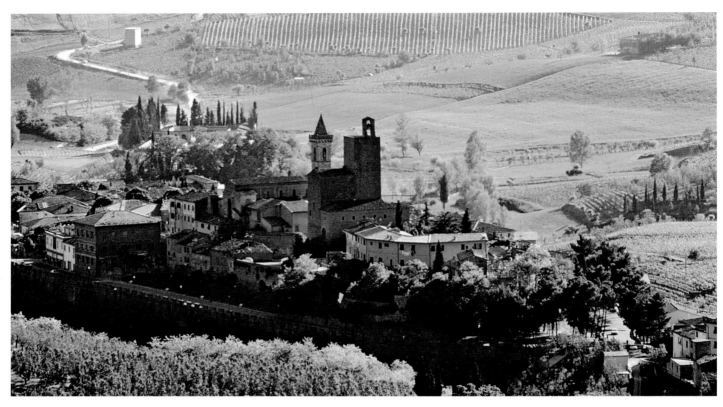

At the time of Leonardo's involvement with the cartoon for the *Battle of Anghiari* in Florence, his elderly father died, leaving a divisive will that created much bitterness between Leonardo and his father's other children, an estrangement resolved much later, in 1514.

THE DA VINCI FAMILY

Because of his illegitimacy, Leonardo had a complex relationship with his legitimate da Vinci half-siblings, the first of whom was born when Leonardo was 24 years of age. Leonardo's own father, Ser Piero (1426–1504), had been one of four children. He had two brothers, Giuliano (b. 1427), who died in infancy, and Francesco (c.1435–1507), who was Leonardo's loving uncle. He also had one sister, Violante (b. 1432). Following Leonardo's birth, Piero was married four times, over a 50-year period.

DEATH OF SER PIERO DA VINCI

In his diary Leonardo noted: 'On Wednesday, 9 July 1504, my father Ser Piero da Vinci, notary at the Palazzo del Podestà, died; he was eighty years old; left ten sons and two daughters.' It was a sparse, simple statement. It hid the complexity of his father's life, from the birth of his illegitimate son Leonardo, to his marriage to four different women and the birth of eleven legitimate children, Ser Piero's offspring by two of his four wives. After his father's death the legal wrangling between Leonardo and his half-brothers over his father's estate stretched on for years, causing anger and acrimony. Adding to the disagreement over his father's will, Leonardo's uncle Francesco, who was like a second father to him, chose to bequeath his Vinci property solely to Leonardo. Francesco's will was drawn up in 1504, after the death of Ser Piero. Perhaps this decision was planned by Francesco with his

Above: View of Vinci, Tuscany. On his death, Leonardo's uncle, Francesco da Vinci (c.1435–1507), bequeathed property in Vinci to his favourite nephew.

Below: Palazzo Vecchio (formerly Palazzo della Signoria), Florence, the seat of the Florentine commune.

brother Ser Piero's knowledge, and was the reason that Leonardo was not included in his own father's will. Or perhaps it was an act to soothe Leonardo's anger toward his siblings, who had benefited from his father's will.

FRANCESCO'S BEQUEST

The problem with Francesco's generous gift to Leonardo was that it ignored an earlier bequest to share the estate between the legitimate children of Ser Piero. One of those children, Ser Giuliano da Vinci, continuing the da Vinci family profession of notary, challenged the bequest in around June 1507. Leonardo, working in Milan at this time, was successful in the first round of challenges, securing the backing of the French king, in a letter to the Signoria in Florence, to ascertain that the bequest was legal. The king's ambassador in Milan, Charles d'Amboise, also wrote to the Signoria, in August 1507, reluctantly allowing Leonardo to return to Florence to settle the matter. He added that he expected Leonardo to return soon to Milan, to complete paintings for the king. One of Leonardo's letters on the matter, dated 18 September, to Cardinal Ippolito d'Este, gives the arguments of the case and asks his help for it to be expedited as soon as possible. A conclusion was expected by All Saints' Day (1 November 1507). Other letters written by Leonardo, extant in draft form, state his estrangement from the legitimate sons of Ser Piero and their hatred of Francesco. Part of Francesco's extended property had been bought with a sum of money loaned to him by Leonardo, and in effect, became his on the death of his uncle, but Ser Piero's children considered Leonardo a stranger, not a family member.

RECONCILIATION IN ROME

Estrangement between Leonardo and his half-brothers in the years between the initial family challenge to Francesco's bequest in 1507–8, and Leonardo's residence in Rome in 1513–16, continued. However, in 1514, a favour needed by notary Ser Giuliano da Vinci, second son of Ser Piero, found him in Rome, seeking Leonardo's help to gain the attention of the papal advisor Niccolò Michelozzo, to obtain a benefice. Leonardo wrote on his behalf and relationships thawed. Ser Giuliano's lengthy stay prompted his wife Alessandra, at home in Florence, to write to say she was missing him, and she added a postscript that sent good wishes to Leonardo, 'remember me to your brother Lionardo, a most excellent and singular man'. It is a positive sign that family acrimony had dissipated. This letter, given to Leonardo by Ser Giuliano, remained with him until death, possibly an outward sign that it meant much to have his half-brothers and their family thinking kindly of him.

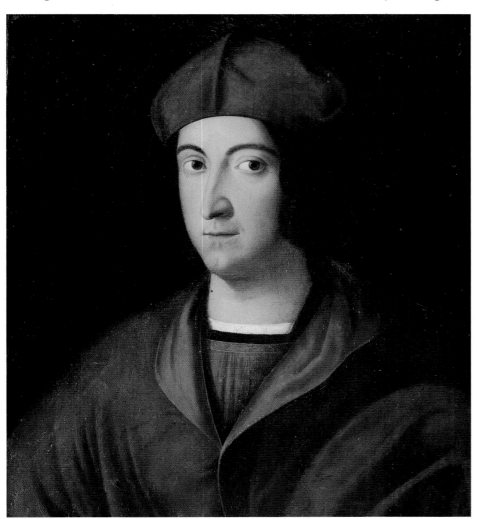

Left: Portrait of a Cardinal *(possibly Ippolito d'Este, after Raphael), Italian School, 16th century. Leonardo wrote to the cardinal regarding the lawsuit brought by Ser Piero da Vinci's legitimate children.*

LEONARDO'S HALF-SIBLINGS

In 1452, at the age of 26, Ser Piero married Albiera di Giovanni Amadori, in the year of Leonardo's birth. The marriage was childless and she died in 1464. Soon after her death Ser Piero married 15-year-old Francesca di Ser Giovanni Lanfredini, the daughter of a fellow notary in Florence. This marriage too was childless, and she also died at an early age. His third marriage, to Margherita (1458–c.1480), the daughter of Francesco di Gacopo di Guglielmo, produced two sons, Antonio and Giulian. Margherita died soon after the birth of her second son. Ser Piero's final marriage, to Lucrezia di Guglielmo Cortigiani, produced a large family of seven sons and two daughters.

A RETURN TO MILAN

A request to Leonardo from Charles d'Amboise, the French governor of Milan, to return to the city, left the city council of Florence in a difficult position. For the sake of good relations Leonardo was given a three-month leave of absence from the *Battle of Anghiari* contract.

In 1506, Leonardo received a firm order from Charles d'Amboise, the French Governor of Milan, to return to the city. The council of the Signoria in Florence had no choice but to acquiesce, however reluctantly.

ABSENT WITHOUT LEAVE

The Signoria let Leonardo go, allowing him three months' leave of absence from the contract, with the *Battle of Anghiari* still unfinished. Leonardo's last monetary withdrawal from Santa Maria Nuova, on 20 May 1506, left 150 florins in his account. It was held as a bond by the director of Santa Maria Nuova, as a guarantee that Leonardo would return to Florence to finish the *Battle of Anghiari* mural. After three months' absence, a personal plea from Louis XII, King of France, allowed Leonardo to stay in Milan, but as the new deadline passed, the Florentine council relieved the artist of his obligations. The money was forfeited to the Signoria when he failed to return. He remained in Milan, except for a short period in Florence to help the sculptor Giovanni Francesco Rustici (1474–1554). He stayed with him over the winter months of 1507–8, to assist Rustici with the creation of a large bronze group of figures of *St John Preaching*, which were destined to stand above the north door of the Baptistry.

NOTES AND NOTEBOOKS

At the same time we find Leonardo trying to organize all the notebooks he had compiled. His notes were written on large pieces of paper, usually on both sides. They were folded and folded again, and kept in a pile until thick enough to be bound together in a sheaf. For one stack he wrote, 'I am fully conscious, not being a literary man, that certain presumptuous persons will think that they may reasonably blame me; alleging that I am not a man of letters…but they

Above: Portrait of Charles d'Amboise, *Antonio da Solario, c.1508. Charles d'Amboise, French governor of Milan, painted by an assistant to Leonardo.*

do not know that my subjects are to be dealt with by experience rather than by words…'. He accuses himself of repetition because of the length of time between the earliest and latest, which causes him to forget what he has written. 'O reader, blame me not, because the subjects are many, and the memory cannot retain them…' (B.M.l.r).

AN APOLOGY

A draft letter to Charles d'Amboise, *c.*1508, reveals that Leonardo had continued to delay his return to Milan. He wrote, 'I am wondering whether the slight return I have made for the great benefits I have received from

Your Excellency may not have made you somewhat angry with me.' In Florence, at this time, and four years after the death of his father, he was still in legal dispute with his half-brothers over the family inheritance. He needed to consult lawyers. Leonardo explained to the French ambassador that he was sending his assistant Salaì to explain; the litigation against his half-brothers had taken longer than he expected.

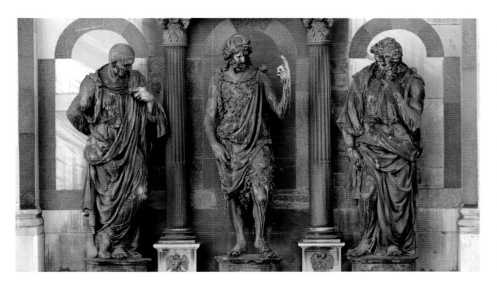

Left: Bronze sculptures of the Preaching of St John the Baptist and the Pharisee, Giovanni Francesco Rustici, 1506. Leonardo returned briefly to Florence, to aid Rustici with this group of sculptures, destined for the north door of the Baptistry.

YOUR HUMBLE SERVANT, LEONARDO DA VINCI, PAINTER

In a letter to the Cardinal d'Este at Ferrare Leonardo entreats, 'Most Illustrious and most Reverend Lord, I arrived from Milan but a few days since and finding that my elder brother refuses to carry into effect a will, made three years ago when my father died…' With his apology written, he goes on to ask for the Cardinal's help:

> … *a matter I esteem most important – I… crave of your most Reverend Highness a letter of recommendation and favour to Ser Raphaello Hieronymo, at present*

one of the illustrious members of the Signoria before whom my cause is being argued and more particularly it has been laid by his Excellency the Gonfaloniere into the hands of the said Ser Raphaello, that his Worship may have to decide and end it before the festival of All Saints.

The tone of this letter clearly shows Leonardo's despair at the legal dispute dragging on through the courts for years.

Below: Designs for equipment, 1483–1516. A page of Leonardo's notes is interspersed with drawings of equipment.

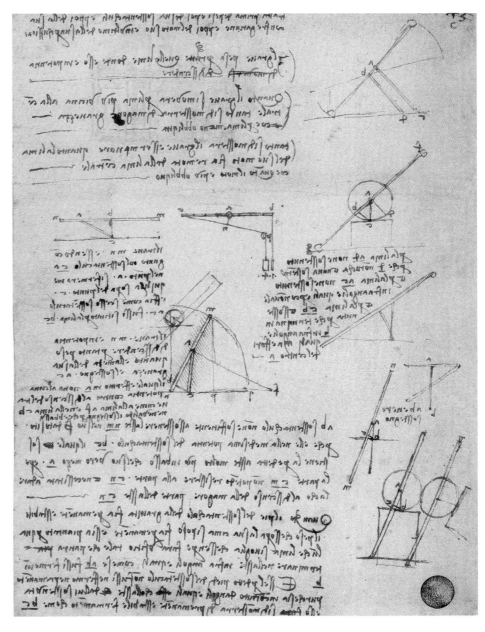

'ACADEMIA LEONARDI VINCI'

A long-standing debate between Renaissance scholars surrounds the possibility that Leonardo da Vinci had a school, 'Academia Leonardi Vinci', in Milan. Evidence for it is scant but some reports indicate the existence of an intellectual circle of Humanists, artists and musicians, which included Marsilio Ficino, Donato Bramante and Leonardo da Vinci. New evidence based on Henri Boscano's text *Isola beata* (c.1513) points to its membership being taken from Leonardo's circle, closely associated with the court of Ludovico Sforza. However, it is still debatable.

A TREATISE ON PAINTING

Trattato della pittura (Treatise on Painting) by Leonardo da Vinci was created from hundreds of notes written by him over several years. It was his intention to publish the treatise but it remained incomplete. The notes were bequeathed to Francesco Melzi.

Leonardo's *Treatise on Painting* was a work comprising pages of notes, which related to the art of drawing and painting.

PUTTING THE TREATISE TOGETHER

The *Trattato della pittura (Treatise on Painting)* was formulated by Leonardo da Vinci between 1492 and 1510, and first published in 1651. The assembly of the manuscript began in Florence in 1508. Leonardo writes, 'Begun at Florence, in the house of Piero di Braccio Martelli [Commissario della Signoria, a writer and mathematician] on the 22nd day of March 1508. And this is to be a collection without order, taken from many papers which I have copied here, hoping to arrange them later each in its place, according to the subjects of which they may treat.'

READER BEWARE

A stark warning was given to readers, with Leonardo paraphrasing Aristotle's command, found written over the door of his 'academia', 'Let no man enter who knows no geometry.' Leonardo commanded, 'Let no man who is not a Mathematician read the elements of my work.' Having had tuition in mathematics from Fra Luca Pacioli, Leonardo could write confidently on the subject: 'Among all the studies of natural causes and reasons Light chiefly delights the beholder; and among the great features of Mathematics the certainty of its demonstrations is what pre-eminently [tends to] elevate the mind of the investigator.'

These are the opening words with which Leonardo proposed to discuss the mathematical approach to painting, using scientific analysis and explanation. His method was not to follow other treatises. Many writers and artists published treatises on painting. Two of the most notable were the Italian Humanist, architect, antiquarian, mathematician and

art theorist Leon Battista Alberti, in his 1435 treatise *De pictura (On Painting)*, written in Latin and translated into Italian the following year as *Della pittura*; and the Florentine painter Cennino Cennini (1370–1440), in his manual of artists' techniques and methods, *Il libro dell'arte (The Craftsman's Handbook)*, from 1437. Both works were known to Leonardo.

PERSPECTIVE

Leonardo's explanation of perspective, which he divided into three 'branches', led to a discussion of the laws of

Above: Detail of 'Plato and Aristotle', from the fresco School of Athens *(Stanza della Segnatura Vatican, Rome), Raphael, 1510–11. The figure of Plato (left) is modelled on Leonardo da Vinci.*

diminishing perspective. He wrote: '*There are three branches of perspective; the first deals with the reasons of the [apparent] diminution of objects as they recede from the eye, and is known as Diminishing Perspective. The second contains the way in which colours vary as they recede from the eye. The third and*

last is concerned with the explanation of how the objects [in a picture] ought to be less finished in proportion as they are remote: [and the names are] Linear Perspective; The Perspective of Colour; The Perspective of Disappearance.'

COLOUR THEORY

Leonardo's treatise was not the first to consider a scientific explanation of colour theory and how it relates to painting, but his knowledge of classical literature would have led him to consider the theoretical analysis of Aristotle (384–322BC), who wrote *On Sense and Sensible Objects* (c.350BC) and *On Colour* (c.350BC). He may also have considered the colour theories of Plato (429–347BC) in *Timaeus* (360BC). It is not by accident that Raphael chose to use a likeness of Leonardo da Vinci to represent Plato in his fresco of the *School of Athens,* 1508–11, on the wall of Pope Julius II's private apartments in the Vatican.

A PAINTERLY DEMONSTRATION

During the years that he was writing the text of *Trattato della pittura,* Leonardo had several works of art in progress. It is probable that his explanation of certain techniques, such as *chiaroscuro* and *sfumato,* would be in relation to his own works. One Leonardo painting known only through copies is *Leda and the Swan,* which may have been used as an example of Leonardo's discussion of landscape, with its use of the *sfumato* technique, whereby a hazy, realistic depiction of light and colour blurs the distant landscape.

For portraiture, such as the drawing of Leda, Leonardo advised artists: '…always go slowly to work in your drawing; and discriminate in the lights, which have the highest degree of brightness… likewise in the shadows… those that are darker than the others. …and finally, that your light and shade blend without strokes and borders like smoke [*sfumato*].'

Right: Head of a young woman with tousled hair *(or Leda),* c.1508. *This exquisite drawing in gouache on wood is possibly one of Leonardo's preparatory studies for the head of Leda.*

Above: Leda and the Swan, *possibly by Francesco Melzi, c.1505–15. The oil on wood panel is a copy of Leonardo's* Leda and the Swan *painting, now lost.*

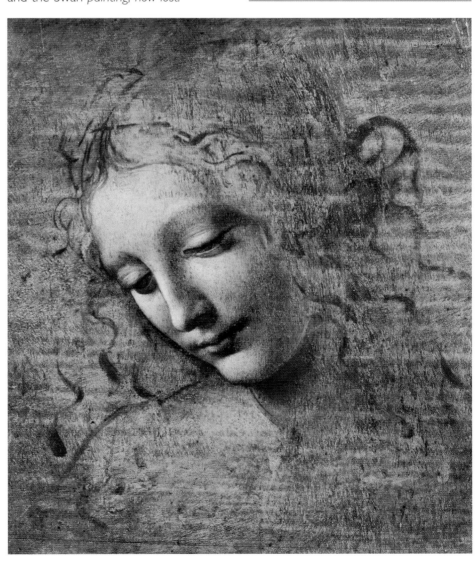

1513: A COMMISSION IN ROME

Leonardo was called to Rome in September 1513 at the request of Giuliano de' Medici, the brother of Giovanni de' Medici, Pope Leo X, who had been elected pontiff in March 1513. During his residence Leonardo may have painted a John the Baptist portrait.

Leonardo and his assistants travelled from Milan to Rome via Florence. On 10 October 1513, Leonardo deposited 289 florins in his bank at the Ospedale Santa Maria Nuova in Florence. The money was bequeathed to his father's family in his will.

A NEW ROME

The group reached the papal city on 1 December 1513. Leonardo wrote in his diary that he left Milan on 24 September with 'Giovan Francesco, Salaì, Lorenzo [a pupil who joined Leonardo in 1505] and Il Fanfoia [perhaps a nickname for his pupil Cesare da Sesto, or the sculptor Agostino Busti]'. On his arrival he was given rooms in the Belvedere

A PAPAL COMMISSION

Pope Leo X, eager to use the skill of Leonardo da Vinci, allotted a work to him but was exasperated when he saw Leonardo preparing varnish for the work not yet started, saying, 'Alas! This man will never do anything, for he begins by thinking of the end of the work, before the beginning.'

Leonardo's growing reputation for pushing the boundaries in his experimentation with oils, herbs and colour pigments, at times resulting in poor paint surfaces and deteriorating canvases, had obviously reached the ear of the pope. However, Leonardo's *sfumato* technique required layers of oils and paint, leading one to surmise that the painting for Leo X may have been *St John the Baptist*, a work that serves to highlight the maturity of Leonardo's *sfumato* application.

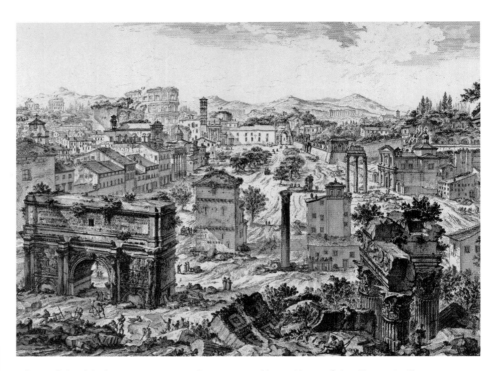

wing of the Vatican, courtesy of his patron Giuliano de' Medici (1479–1516). Leonardo was one of many artists lured to Rome by possible lucrative contracts. His friend, Donato Bramante, whom he had met in Milan and with whom he was in regular correspondence, had arrived in Rome from Milan in 1499. He had designed the circular Tempietto, c.1502–10, a commemorative martyrium on the site where St Peter was said to have been crucified. At the time of Leonardo's arrival Bramante was the chief architect rebuilding St Peter's basilica, replacing parts of the ancient building, which was in disrepair. Other notable artists were in Rome, too: Raphael had recently completed the frescoes for the apartments of Pope Julius II, and Michelangelo had completed the Sistine Chapel ceiling and was once more working on sculptures for Pope Julius's tomb, with agreement from the new pope, Leo X, Giovanni de' Medici.

Above: View of the Forum in Rome. 'Veduta di Campo Vaccino', page 15 of the series: Vedute di Roma, *Giovanni Battista Piranesi, c.1750.*

LEONARDO IN ROME

The evidence we have of Leonardo's three-year stay in Rome is fragmentary. Vasari gives an outline of how his time was spent. At first, we are told, he focused on philosophy and alchemy. Vasari writes, 'forming a paste of a certain kind of wax he shaped animals very thin and full of wind, and by blowing into them, made them fly through the air'. The scientific exploration behind Leonardo's experiment was lost on Vasari, and perhaps also on the court of Pope Leo X. Apart from an occasional visit to other cities, Leonardo remained in Rome under the patronage of Giuliano de' Medici. One architectural exercise entailed taking precise measurements of the church of San Paulo Fuori le Mura (St Paul Outside the Walls).

Right: St John the Baptist, *c.1513–16 (or 1508–10). Leonardo possibly created this painting during his stay in Rome.*

MADONNA WITH CHRIST CHILD

Vasari tells us that Baldassare Turini da Pescia, the datary (a special officer) of Pope Leo X, commissioned from Leonardo a small painting of a 'Madonna with the Christ Child in her arms', but the finished artwork, although beautiful, had not been properly primed with gesso and it deteriorated. Leonardo was still experimenting with paint techniques. Vasari points out that it may have been the fault of an assistant, or perhaps more likely it was due to Leonardo's experimentation with 'capricious mixtures of grounds and colours'.

ST JOHN THE BAPTIST

Many scholars consider that during his time in Rome, Leonardo painted a half-length *St John the Baptist*, in oil on walnut panel, dated 1513–16, and possibly another portrayal of St John, set in a landscape. Raphael created a similar work, showing a young St John, in a landscape, with his index finger pointing toward the heavenly light which shone on him, an indicator of the coming of Christ. On stylistic grounds some scholars choose a date for Leonardo's painting of *c.1508–10*, to coincide with the painting period of the *Mona Lisa*, due to the similar enigmatic facial expression of St John. However, on 8 October 1514, Leonardo was inscribed in the confraternity of San Giovanni dei Fiorentini in Rome, which may link to a portrait of St John the Baptist. He was asked to leave due to non-payment of fees, and both the *Mona Lisa* and *St John the Baptist* paintings were with Leonardo when he moved to France after 1516. At the time, King Francis I of France was so taken with the portrayal of John the Baptist that he commissioned his own portrait in similar pose, created by the French painter, Jean Clouet (1480–1541), *Francis I as St John the Baptist, c.*1518 (Musée du Louvre, Paris).

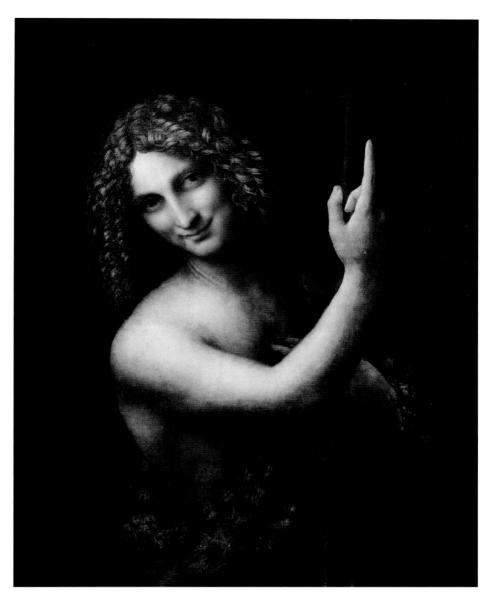

Below: St John the Baptist, *Italian School, 16th century. The index finger of John the Baptist, pointing upward, symbolized the coming of Christ, and was a popular representational device for artists.*

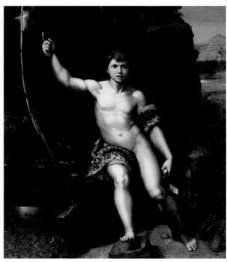

Below: Young St John, *Raphael and Giulio Romano, 1517–20. The painting shows the young St John, naked but for animal skins, again with an index finger raised to herald the coming of Christ.*

PARMA TO CIVITAVECCHIA

Working under the patronage of Giuliano de' Medici and Pope Leo X, Leonardo became involved in a variety of commissions. One that particularly interested him was an architectural inspection and studied observation of the towns of Parma and Civitavecchia.

In July 1514, Leonardo wrote: 'finished on 7 July [a geometrical challenge] at the 23rd hour at the Belvedere, in the studio made for me by Il Magnifico'. Intriguingly we are told no more, but soon after Leonardo left Rome, 'on tour'.

A MILITARY INSPECTION?

Leonardo's note is evidence that he worked under the patronage of Pope Leo X and his brother, Il Magnifico, Giuliano de' Medici. By the end of September Leonardo is to be found in Parma 'on the banks of the Po' river, probably working as a military engineer for Giuliano de' Medici, the Captain General of the papal militia. He travels on to Civitavecchia, an ancient city on the outskirts of Rome, to make a study of the harbour. His plan was to measure the ancient port in order to reconstruct it. Leonardo toured the ancient Roman ruins, much in the manner of Leon Battista Alberti some 70 years before him.

Above: Cathedral porch with lions, Giambono da Bissone, 1281, Parma. Leonardo carried out a survey of the architecture of Parma in 1514.

Left: Maps of Parma, Siena, Palermo and Drepanum, from Civitates Orbis Terrarum, *Georg Braun and Frans Hogenberg, c.1572.*

It is here that a grand fort was commissioned from Bramante by Pope Julius II to defend the port of Rome. Leonardo was possibly studying the area, in order to take over Bramante's commission to reconstruct the port. Pope Julius II had died in 1513, and Bramante in 1514. Giuliano Leno and Antonio da Sangallo the Younger (1484–1546), under the supervision of Pope Paul III (1468–1550), pontiff from 1534 to 1549, completed the fort, now known as Fort Michelangelo, owing to Michelangelo's input, in 1535.

Little is known about Leonardo's involvement with the project. He may have been required only to take measurements, and to make maps and drawings. However, one map is of the Pontine Marshes, south of Rome.

Under Giuliano's direction Leonardo may have worked to devise a scheme to drain the Pontine Marshes, to remove the malaria-infested waters.

DIFFICULT RELATIONSHIPS

Records show that in October 1514, Leonardo joined the confraternity of San Giovanni dei Fiorentini, in Rome, as a 'novizzo'. However, by December of the same year, he was ousted because he had not paid his fees. In many respects it was a difficult time for Leonardo, highlighted by arguments with a German assistant, Giorgio Tedesco. In 1514, stretching into 1515, Leonardo wrote several drafts of angry letters to his patron Giuliano de' Medici, describing his difficulties. Giorgio, influenced by a fellow German, Giovanni degli Specchi, a mirror maker working in the Belvedere workshops, had demanded more money from Leonardo, yet was found to be working for other artists, and was not following Leonardo's designs, which resulted in inadequate models. Leonardo complained that Giorgio had failed

Above: Fort Michelangelo and the port of Civitavecchia, Lazio, near Rome. Leonardo is believed to have been involved in the fort project in some capacity.

DEATH OF GIULIANO DE' MEDICI

In early January 1515, Leonardo's patron Giuliano de' Medici left Rome to travel to Savoy, where he was to marry Filiberta (1498–1524), a princess of the House of Savoy, in February of the same year. She was the aunt of the new king of France, Francis I, and therefore a useful family connection for the Medici. It was the plan of Giuliano's elder brother, Leo X, to create a kingdom of Ferrara, Parma, Piacenza and Urbino for them. On 17 March 1516, Giuliano died prematurely at the age of 37. On hearing the news Leonardo wrote, 'The Medici made me and destroyed me.' The loss of his major patron was a blow to him. He decided to take up a long-standing invitation to join the court of King Francis I, in Amboise, France.

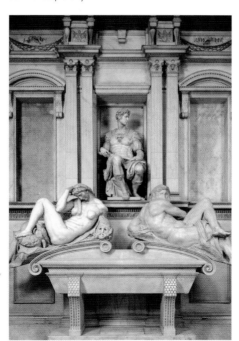

Above: New Sacristy, Cappella de Medici, Florence, Michelangelo, c.1530 (detail of the tomb of Giuliano de' Medici). The premature death of Leonardo's patron provoked his decision to accept the patronage of Francis I, King of France.

to try to learn Italian, and was not competent. The sour situation escalated and led Specchi to inform the pope that Leonardo was performing anatomical dissections of corpses, which Pope Leo X abruptly stopped. Leonardo's relationship with Michelangelo was strained too. Each was a gifted genius, yet both had become mere employees of the Medici in Florence and Rome; it was hard to tell who was the more dismayed about this. Vasari tells us that Michelangelo left Rome in 1514 and moved back to Florence to design a façade for San Lorenzo, the family church of the Medici in Florence, thus leaving Leonardo with the Pope in Rome.

A MEETING IN BOLOGNA

In December 1515, Francis I, King of France, and Pope Leo X, held a meeting in Bologna, to discuss papal matters and a military expedition against the Turks. Leonardo and Giuliano de' Medici both attended, possibly in a military capacity. Soon afterward, on Giuliano's death in March 1516, Leonardo promptly left Medici patronage to work for Francis I.

1516: FROM ITALY TO FRANCE

In 1516, Francis I, King of France, offered Leonardo a permanent retreat near Amboise,
France, and the high-ranking position of 'First Painter, Engineer and Architect of the King'.
He accepted the king's invitation and travelled to France with his assistants.

Leonardo enjoyed courtly life but he wrote that he was unconcerned about the material wealth surrounding him. 'Pray, hold me not in scorn. I am not poor. Poor rather is the man who desires many things'.

STATELY HOME

Leonardo and his entourage took three weeks in the winter of 1516 to travel from Rome to the residence of King Francis I (1494–1547) at Château d'Amboise. It must have been a difficult journey to make, not only owing to the physical demands of travelling but also because Leonardo realized he might not see his native Italy again. However, on his arrival Leonardo was warmly welcomed. At the court of the young king, Leonardo was given the grand title of 'First Painter, Engineer and Architect of the King'. Francis I supplied Leonardo with his own manor house at Cloux, where he could live with his assistants, surrounded by courtiers appreciative of his reputation. The estate was approximately 225km (140 miles) south-west of Paris. The house, which belonged to the Queen Mother, was close to King Francis's residence, the Château d'Amboise on the Loire, and linked to it by an underground passage. The arrangement suited both men perfectly.

AN ACCOMMODATING KING

To make the residence suitable, the ground floor was converted into a large studio with two floors above accommodating Leonardo, his assistants and servants. As he was a permanent resident, and chief engineer and architect to the king, a generous salary was provided. From 1517, Leonardo received the yearly sum of 1,000 *scudi* (1,000 *écus soleil*); Melzi, referred to in the accounts as 'the Italian nobleman who is with Master Leonardo', received a generous 400 *scudi* (400 standard *écus*); Salaì,

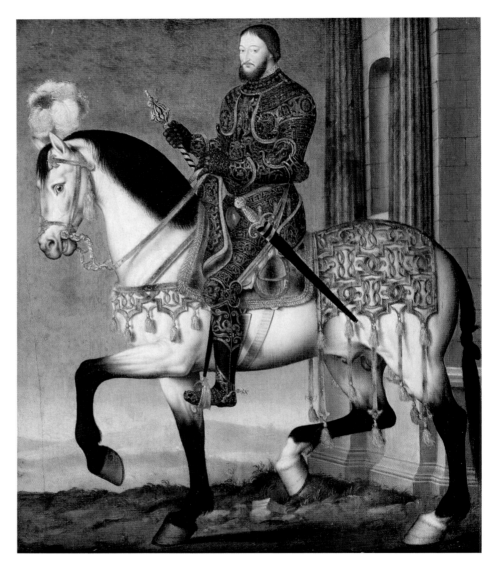

Above: Equestrian Portrait of Francis I, King of France, *François Clouet and workshop,* c.*1540.*

referred to as a 'servant' in the accounts, received a one-off payment of 100 *scudi* (100 standard *écus*).

A NOTABLE VISITOR

In 1517, Cardinal Luigi of Aragon paid a visit to Leonardo, accompanied by his secretary Don Antonio de Beatis (fl.1517–21). We do not have records of the event from Leonardo's memoranda, but de Beatis kept a diary,

Voyage du cardinal d'Aragon (printed and published in 1893). He recorded that on 10 October 1517, he and the Cardinal met Leonardo in his studio.

He showed the Cardinal three pictures, one of a certain Florentine woman portrayed from life at the request of the late Magnificent Giuliano de' Medici, another of the young John the Baptist as a young man [now in the Louvre], and one of the Madonna and Child set in the lap of St Anne [also in the Louvre]. All three works are quite perfect, though nothing good can be expected of his brush as he suffers from paralysis of the right hand.

Right: Le Manoir du Clos-Lucé, near Chenonceaux Loire, the residence of Leonardo while living and working in France.

He has successfully trained a Milanese pupil [Melzi] who works extremely well. And although Messer Leonardo cannot colour with his former softness, yet he can still draw and teach.

The diary entry for 11 October amended an oversight of one work: 'there is also a picture in which a certain lady from Lombardy is painted in oil, from life, quite beautiful…'

ANATOMICAL DRAWINGS AND DELIGHTFUL BOOKS

De Beatis continued his record of the afternoon spent with Leonardo: 'This gentleman has written on anatomy in a manner never yet attempted by anyone else; quite exhaustively with painted illustrations not only of limbs but of the muscles, tendons, veins, joints, intestines, and every other feature of the human body, both male and female.' Leonardo showed his notebooks to the Cardinal and de Beatis. De Beatis commented, '… he has also written (or so he said) innumerable volumes, all in the vernacular, on hydraulics, on various machines and on other subjects, which, if published, will be useful and most delightful books'.

Right: Leonardo's bedchamber at Le Manoir du Clos-Lucé.

Right: The kitchen used by Leonardo at Le Manoir du Clos-Lucé.

THE *LAST SUPPER* DETERIORATES

The Cardinal and de Beatis visited Milan on 29 December 1517 and viewed Leonardo's *Last Supper* in Santa Maria delle Grazie. De Beatis commented, 'This is most excellent, though it is starting to deteriorate: whether because of dampness of the wall or because of some oversight, I do not know.' It was only 20 years since Leonardo had completed the work.

AT THE COURT OF KING FRANCIS I

A close rapport with the young king of France allowed Leonardo to enjoy his final days as an advisor to Francis I. He devoted time to a favourite subject, philosophy, playing the role of tutor 'Aristotle' to the king's role as pupil 'Alexander'.

In one of Leonardo's notebooks, dating to about 1518, he wrote of the ancient Greek philosopher Aristotle and his young student Alexander, son of King Philip of Macedon, possibly drawing a comparison with his own relationship with King Francis I.

ROYAL ADMIRATION

In an autobiography, written 1558–62, the Florentine sculptor Benvenuto Cellini (1500–71), who was in the employ of King Francis I, recalled that 'King Francis, being enamoured to such an extraordinary degree of Leonardo's great virtue, took so much pleasure in hearing him talk that he would only on a few days deprive himself of his company'. Cellini related that when he was in the company of the king of Navarre and the cardinal of Lorraine, King Francis had remarked that, 'he did not believe that a man had ever been born who knew as much as Leonardo', highlighting 'not only his spheres of painting, sculpture and architecture but that he was a very great philosopher'.

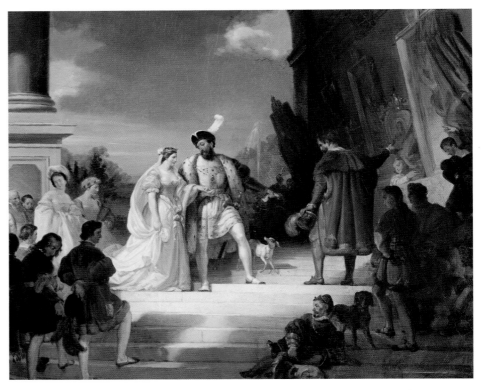

Above: King Francis I with Leonardo da Vinci, *Alexandre Evariste Fragonard, 19th century. An idealized depiction of a meeting between Leonardo and the young king of France. The classical setting is an indication of the interests of both men.*

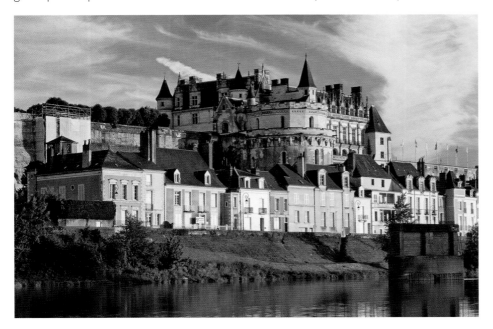

Left: A view of Château d'Amboise, Loire Valley, France. Leonardo spent his final years at the château.

INTELLECT AND PHILOSOPHY

During his short time with Francis I, Leonardo and the king spent many hours 'long into the night' discussing philosophy. Leonardo wrote in his notes, 'Alexander and Aristotle were teachers of one another... Alexander possessed a power that allowed him to conquer the world. Aristotle had great learning which enabled him to embrace all the learning acquired by other philosophers.' King Francis enjoyed Leonardo's company. The physical disability of arthritis in Leonardo's right hand and the paralysis of his right side did not prevent his desire to continue working. His notes doggedly confirm his strong will: 'I will continue... iron rusts when it is not in use... stagnant water loses its purity... inactivity saps the vigour of the mind.' (*Codex Atlanticus*, fol. 249r/289vc.)

SALAÌ AT COURT

Once the urchin thief employed by Leonardo when a young boy, Salaì was now in his thirties and still looking for monetary opportunities. He was often rebuked by Leonardo for his misdemeanours. At court, Leonardo recorded in his notebook that he observed Salaì stealing money from the wallet of a French footman who had undressed to put on a festival costume as part of the king's entertainment.

Leonardo must have forgiven Salaì many times. One drawing, *Portrait of an Old Man and a Youth*, is thought to be Leonardo's portrait of them both. Salaì was obviously an entrepreneurial man. Records kept by the French court list payments to him, amounting to a substantial amount, 6,250 imperial lire, in return for acquiring several works on behalf of the king. Historians are unsure which works Salaì procured. Some people suggest that several of the

Leonardo works left to Salaì on the artist's death were then to be left to the French king on Salaì's death. Soon after arriving at Cloux, Salaì left for Milan, possibly as an agent for the king. Melzi now became the closest person to Leonardo; he was his scribe, his assistant artist and his carer. In addition, Salaì, as an artist using his given name, Gian Giacomo Caprotti, received commissions for artworks, painted in a style reflective of the years spent as Leonardo's assistant.

Left: Notes and drawings. Left page: a falconer releasing a bird with a dog in pursuit is Leonardo's allegory of 'short liberty'. Right page: the viscosity of water in various whirlpool forms.

Below left: The interior staircase of Château de Chambord, a residence of Francis I, King of France.

ROMORANTIN

A project close to the hearts of Francis I and Leonardo was the creation of a new royal palace, to be built at Romorantin, 81km (50 miles) east of Amboise, which was to incorporate an older château. Architectural plans were drawn up by Leonardo in 1517. Until January 1518, Leonardo frequently visited Romorantin; he was there to plan new canals and oversee the building preparation. His building brief extended to a successful canal project in the Sologne (south of the Loire between Orléans and Amboise). His notes explain how local villagers can help. 'The river at Villefranche may be led to Romorantin, and this may be done by the people who live there, and the timbers which form their houses may be taken on boats to Romorantin...' His notes and accompanying drawings show his understanding of the Loire river and its tributaries. The Romorantin palace was partly built before the plan was dropped in favour of a new location.

LAST WORKS

During 1517 and 1518, Leonardo continued to work on scientific experiments, architectural plans and designs for festive celebrations. One major project was to arrange his collection of notebooks, in preparation for publication.

Leonardo looked to Melzi to organize his 'library' of notes, with a plan to publish books on painting, anatomy, architecture and engineering from these sources. Meanwhile he pressed on with his architectural project at Romorantin.

FESTIVE EXTRAVAGANZAS

Leonardo's physical disability left the completion of unfinished works to his assistants, using his expertise to guide them. However, he was still able to draw, and drawings from this late period include costumes and room decoration, designed for court festivities. One object presumed to be made by Leonardo was mentioned on 1 October 1517 in the diary of the Mantuan ambassador to France, Rinaldo Ariosto. During a festival in Argentan, a town 193km (120 miles) west of Paris, a mechanical lion walked several steps, when its chest opened to reveal lilies, a symbol of France.

The following year was filled with many projects; at the back of Leonardo's mind was the desire to publish his treatises, but new commissions took his attention. On 19 June *The Feast of Paradise*, a stage-set fantasy originally devised by Leonardo in 1490 for the Sforza family in Milan, was recreated at Cloux, to celebrate the wedding of Francis I's niece Maddalena de la Tour d'Auvergne to Lorenzo de' Medici. It was performed complete with mechanical scenery, designed by Leonardo.

1519: LEONARDO'S LAST YEAR

At the age of 67, Leonardo had become frail. Vasari gives an account of Leonardo's final days. 'Finally, being old, he lay sick for many months. When he found himself near death he made every effort to acquaint himself with the doctrine of Catholic ritual; and then with many moans, confessed and was penitent; and although he could not raise himself on his feet, supporting himself on the arms of his friends and servants,

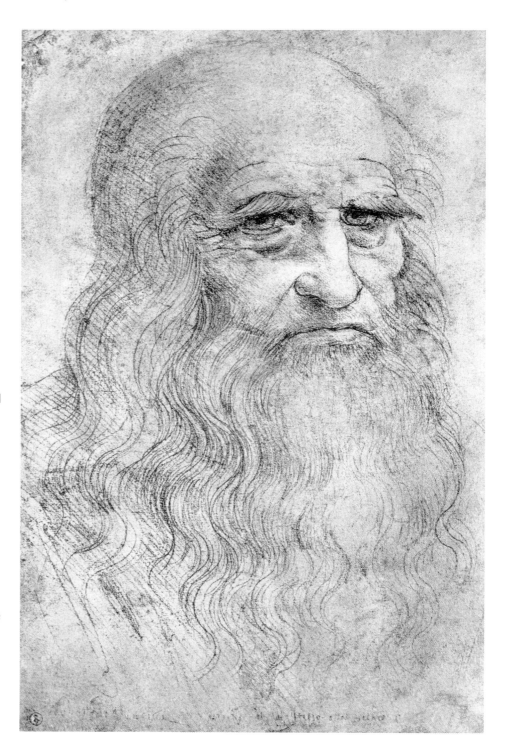

Above: Leonardo da Vinci, c.1510–15. This drawing, a refined study of a head in red chalk, reveals a quiet, pensive face, attributed to Leonardo as a self-portrait.

he was pleased to take devoutly the Holy Sacrament, out of his bed.' Vasari's narration of these events informs us that Leonardo accepted the last rites, performed by a Catholic priest, in preparation for death, insisting on getting up from his bed to do so.

DEATH IN THE ARMS OF THE KING

Vasari records that in Leonardo's last moments, 'he was seized by a paroxysm, the messenger of death'. The king, according to Vasari, moved forward and took Leonardo's head, and moments later, in the arms of the king, Leonardo died. His passing led to many tributes. Vasari records how the 'loss of Leonardo saddened beyond all measure everyone who had known him, for no one who had ever lived brought such honour to painting'.

His eulogy included mention of Leonardo's handsome physique, and the ability the artist had to listen to both sides of a debate and then 'sway the most hardened mind to either side of a question'. It is easy to imagine the sadness with which the news was received in Florence, perhaps more so as Leonardo did not want his body to be repatriated to the city, unlike Michelangelo, who died in 1564. (His body was stealthily removed from Rome, under the cover of darkness, to commence a long journey back to Florence). From Florence, Giovanni Strozzi of the noble Strozzi family wrote a verse in praise, on which note Vasari ended his *Life* of the artist:

> Alone he vanquished
> All others; he vanquished
> Phidias and Apelles,
> And all their victorious band...

In Italian it reads: *Vince costui pur solo/ Tutti altri; e vince Fidia e vince Apelle/ E tutto il lor vittorioso stuolo.* This is a play on the Vinci name combined with the verb 'vincere', to win or to vanquish.

Below: Study of a man with a turban, c.1510–19. This drawing, in red and black chalk on pale red prepared paper, was among those that were bequeathed to Francesco Melzi.

Above: King Francis I as a Composite Deity, *Niccolò Bellin da Modena, 1545. The king and his court enjoyed festive extravaganzas. This work relates to the king's interest in emblematic portraiture.*

Above: A caricature of a lawyer or an academic, c.1495–1519. This drawing of an old man was bequeathed to Francesco Melzi.

AT PEACE WITH GOD

In his last days Leonardo stated that he was remorseful that he had offended God and mankind for not 'having worked at his art as he should have done'. In his prime Leonardo believed in God as a higher being, and also in the human soul, but as well as being an artist, he was also a scientist, and the nature of his geological and astronomical observations led him to question man's existence on Earth and how humans had evolved.

As with many others before him, the knowledge of his own approaching death found him wishing to reconcile himself with God, and preparing his funeral service in church.

LAST WILL AND TESTAMENT

The last will and testament of Leonardo da Vinci was written at the French court, and the king of France was present at his death, a lifetime away from Leonardo's illegitimate birth in Anchio, the tiny hamlet near Vinci in Italy.

Leonardo da Vinci's will, drawn up before the royal court at Amboise on 23 April 1519, nine days before the artist's death, reveals the people and confraternities who mattered most in his life.

ALMS FOR THE POOR

To the poor of the hospitals of Saint Lazaire and Amboise, Leonardo da Vinci left 70 *soldi tornesi* (coins made of silver and copper) as alms for the inhabitants. Leonardo, a recognized and revered public figure, having reached a pinnacle of cultural celebrity, and mixing freely with princes, kings and nobility, found time to remember the poorer members of the community, perhaps in memory of his peasant mother.

FAMILY

It was left to the Milanese nobleman Francesco Melzi, Leonardo's assistant and companion, to give news to the da Vinci family of the contents of Leonardo's will. In a letter written on 1 June 1519 to the 'honourable Giuliano and his brothers', Melzi informed the seven half-brothers

Below: King Francis I Receives the Last Breaths of Leonardo da Vinci, *Jean Auguste Dominique Ingres, 1818. Historical accounts state that Francis I visited Leonardo on his deathbed.*

Above: A closer view of the bed and bedroom of Leonardo at Le Manoir du Clos-Lucé. King Francis I supplied Leonardo and his assistants with sumptuous accommodation, and a workshop studio.

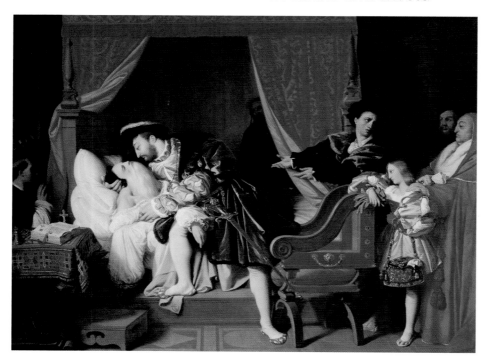

that 400 *scudi del sole* in certificated bonds, held on deposit by Leonardo with the bursar of the hospital of Santa Maria Nuova in Florence, was theirs. To them Leonardo had also bequeathed a smallholding in Fiesole. The bequest perhaps showed that there had been a reconciliation between himself and his father's family, but this is not definitely known. Melzi does not enlighten Giuliano da Vinci with a list of what was gifted to friends and servants of the artist.

TO HIS SERVANTS

To his maidservant Maturina, Leonardo bequeathed a garment of 'good black cloth lined with skin', a woollen dress and two gold ducats. To his servant Battista de Vilanis, Leonardo bequeathed all the furnishings and household effects from his

Right: The tomb of Leonardo da Vinci at Château d'Amboise, Cloux. Leonardo requested burial in the cloister of the church of Saint-Florentin in Amboise.

manorial home at Cloux. In addition he bequeathed to de Vilanis a stretch of water for his use on the canal of San Cristoforo in Milan, and half of a garden Leonardo owned on the outskirts of the city of Milan. It was given in perpetuity for his loyal service. The other half of this garden and the house on it, built by his former assistant Salaì, was left to Salaì and his family and successors in perpetuity. In addition he bequeathed to Salaì the *Mona Lisa*, *St Jerome* and *Madonna, Child and St Anne*. On Salaì's death from an arrow wound in 1524, he left these works to his two sisters, plus a *St John the Baptist*, *Leda and the Swan*, now missing, and other smaller paintings.

FRANCESCO MELZI

His assistant Francesco Melzi, who had joined Leonardo in 1507, received a bequest of all the books in Leonardo's possession at the time of his death, and all tools and depictions (*portracti*) in relation to his art and profession. These comprised a substantial collection of Leonardo manuscripts and drawings. From Melzi's letter to Leonardo's father's family, bringing news of the contents of the will and testament, it is easy to see how much Melzi revered Leonardo. 'I believe you have been informed of the death of Master

Leonardo your brother, who was also a brother and the best of fathers to me.' This short summation tells us much of the deep understanding between Melzi and Leonardo, and perhaps why he was bequeathed the most personal belongings of his father-figure, Leonardo.

FUNERAL ARRANGEMENTS

For the funeral service Leonardo had requested that he be buried within the cloister of the church of Saint-Florentin in Amboise with his body borne there by the church chaplains. In his will he left money for 60 tapers for the funeral service, to be carried by 60 poor men who would be paid by Melzi. From the chaplains and rectors of the diocese churches he requested three high masses and 30 low Gregorian masses to be held. For this, each of the four churches of the diocese was bequeathed 4.5kg (10lb) of thick wax candles to be lit. On 12 August 1519, Leonardo da Vinci, one of Italy's most illustrious men, was buried in Amboise, on French soil.

Left: This simple slab stone marks Leonardo's final resting place in a quiet corner of the church of Saint-Florentin, Amboise.

THE LEGACY OF LEONARDO

Leonardo stated that he planned to collate many of his papers into notebooks for publication. However, many of his notes were still in draft stage at his death and it was left to others to assemble his library of notes in good order.

Of the 13,000 documents and papers bequeathed to Francesco Melzi, only around 6,500 are known today. Melzi tried to create order among the thousands of loose pages and fragments of notes in his possession.

A DIFFICULT TASK

One sentence that Leonardo repeatedly wrote down throughout his lifetime began, '*Di mi se mai fu fatta alcuna cosa*' (Tell me if anything was ever done). It is fitting, for the legacy Leonardo had wanted to leave for posterity was the

publication of his many notebooks in which he had compiled his research, anatomical observations, notes and sketches. The painstaking task of formulating complete works from thousands of papers was left to others. Melzi did what he could to produce the *Treatise on Painting*. On Melzi's death c.1570, his son Orazio, who had little interest in Leonardo or the papers, gave away or sold parts of books and loose pages to the many 'Leonardo seekers' who visited his home in Vaprio. These items might still be discovered in the

future. Today the 22 codices of Leonardo's papers include the earliest, *Codex Trivulzianus* (c.1487–90), which contains word lists in Italian and Latin (which Leonardo taught himself), and the *Codex Madrid* (1503–4), which includes coloured map drawings and detailed notes on the Sforza horse.

SCIENCE, ARCHITECTURE AND TOWN PLANNING

The *Codex Atlanticus* (1478–c.1518) is the largest collection, consisting of 1,119 sheets set in a formal arrangement by the Italian sculptor Pompeo Leoni (1533–1608). It brings together a collection of Leonardo's papers relating to science, architecture and town planning, plus personal memoranda and biographical information. To achieve this, Leoni took apart previously made notebooks to create a methodical order in Leonardo's papers. Other bound manuscripts include the *Codex Arundel* (c.1490–1518), a notebook containing 238 pages of various sizes. Leonardo described the contents as 'a collection of notes without order, composed of many pages which I have copied, hoping then to put them in their appropriate place, according to the topics that they treat'. The notebook focuses on a variety of inventions from underwater breathing cylinders to designs and applications for weights. It also includes papers on geometry and architectural plans for the palace of King Francis I, at Romorantin, created during Leonardo's last years in Amboise.

ON PAINTING

The death of Leonardo might have been expected to cause a surge of interest in acquiring his paintings, or

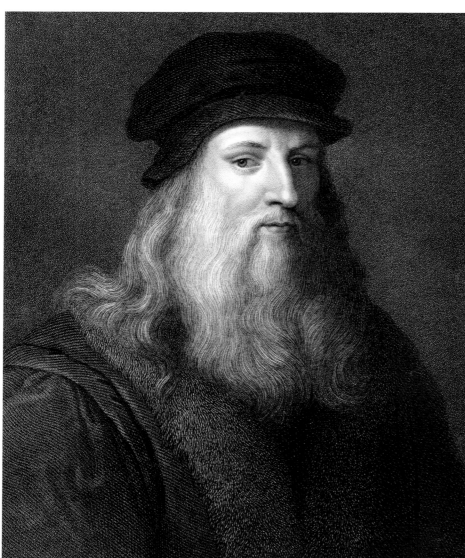

Left: Portrait of Leonardo da Vinci, *English School, 19th century.*

Above: A page from De divina proportione, *Luca Pacioli, published in 1509, with illustrations drawn by Leonardo.*

Above: Life of Leonardo da Vinci, Raphael Trichet du Fresne (1611–61), published in the 17th century.

those that were left to his assistants. This was not the case. There is no record of Salaì, who received the majority of the paintings in Leonardo's possession at his death, selling the works. They were passed on to his sisters when he died in 1524, although there is conjecture that Salaì made an arrangement with the French court that it should have the paintings after his death. Historians point out that Leonardo was 'forgotten' as a major painter until his reputation was revived

by 18th-century 'Grand Tourists' of Europe. A renewed interest in the art and architecture of Italy saw thousands of wealthy men (and some women) making journeys across Europe, to spend months in Venice, Florence and Rome. Naples became popular too in about 1745, owing to the rediscovery of the buried towns of Pompeii and

Herculaneum. Eventually the works once owned by Salaì and Melzi passed into the hands of major collectors, and then to museums. The scenario is different for sculpture and architecture, as not one of Leonardo's sculptural works or architectural plans was completed and only his design drawings remain.

Below: Virgin of the Rocks, *copy after Leonardo, artist unknown, early 16th century, Musée des Beaux-Arts, Caen.*

MODERN INTERPRETATIONS OF LEONARDO

One of Leonardo's most famous works, the *Mona Lisa*, was appropriated by the French 'ready-made' artist Marcel Duchamp (1887–1968) in 1919. Using a cheap postcard of the *Mona Lisa*, Duchamp altered the work by drawing a moustache and goatee beard on the face. He renamed the work *L.H.O.O.Q.*, thus forcing observers to view the painting from a new perspective. The title, when said in French very quickly, sounds like 'elle a chaud au cul', which translates colloquially as 'she is hot in the ass'.

Above: The signature of Leonardo da Vinci.

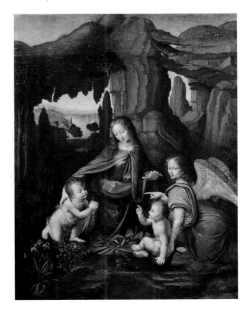

LEONARDO TODAY

Leonardo da Vinci is known through his paintings and his notebooks. Art experts are now using modern techniques, such as X-rays and neutron analysis, to gain more information about his drawings and possibly hidden paintings.

In the immediate aftermath of his death, some artists took up the challenge of emulating Leonardo. The gifted Raphael had already copied or 'paraphrased' some of Leonardo's most famed works, although we find nothing from Michelangelo.

RECOGNITION BY ASSOCIATION

At the time of Leonardo's death Vasari, in the final sentence of his *Life* of Leonardo, refers to two worthy pupils of the artist who had learned from him and epitomized his style of painting: Giovanni Antonio Boltraffio (1467–1516), who predeceased Leonardo, and Marco d'Oggiono (c. 1477–1530). His inclusion of their names added lustre to their reputation by association.

NEW DISCOVERIES

In January 2005, researchers uncovered a hidden sealed room at the basilica of Santissima Annunziata, revealing exploratory works on the study of flight by Leonardo da Vinci. In addition, research into Leonardo's time spent in the Sala del Papa in Florence in 1503–6 continues to intrigue historians looking for the lost cartoons of the *Battle of Anghiari*. The mystery of the original painting, which is possibly hidden behind Vasari's mural in the Salone dei

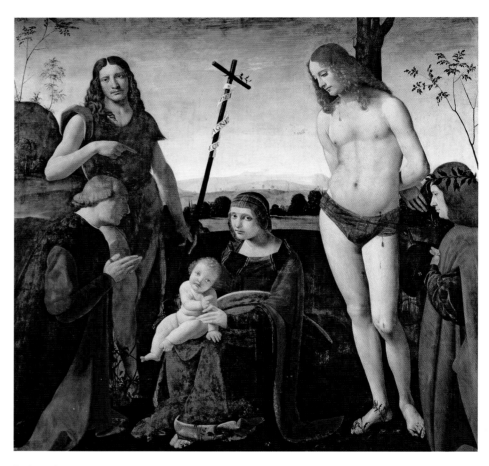

Below: A scaled copy of Leonardo's Sforza equestrian monument, Milan. The fabulous but unrealized Sforza horse remains a key sculpture in Leonardo's catalogue of work from the period that he spent in Milan.

Above: Madonna and Child with SS John the Baptist and Sebastian between Two Kneeling Donors (Pala Cassio) Giovanni Antonio Boltraffio, 1500. Boltraffio, one of Leonardo's assistants, painted in a Leonardesque style.

Cinquecento in the Palazzo Vecchio, Florence, may eventually be solved, if the Florentine authorities will allow exploration into the void between Vasari's painting and the wall of the hall. The Florentine art diagnostician, Professor Maurizio Seracini, confirms this. 'I am sure that Vasari could not bring himself to destroy Leonardo's finest work.' He has pointed out the words written on a small flag in the top right-hand corner of Vasari's mural, which state *Cerca Trova* (he who seeks shall find), which Professor Seracini considers to be

Above: X-ray of a drawing of the head of an old woman (see right). The sketch was sold to industrialist Giancarlo Ligabue. Scientific examinations later confirmed that it is by Leonardo.

a clue to finding the work. At the present time he is using neutron analysis to bounce back information on any paint colour that lies behind the current work.

NEW THEORIES ON FAMILY

Historians continue to research the family background of Leonardo. Particular interest has been shown in his mother, the little-known 'Caterina'. In 2008, Francesco Cianchi, the Italian author of a study into Caterina's background, stated that the only Caterina officially known to Ser Piero da Vinci was a slave girl living at the house of a banker, Vanni di Niccolo di Ser Vann, a wealthy friend of the family. Cianchi traced all known records of the inhabitants of the area and could not find her, contradicting accepted history that Caterina was from Vinci or its vicinity. From records he found that on the death of Vann in 1451, he bequeathed the slave Caterina to his wife, but left the house in Florence to Ser Piero, the executor of his will. Cianchi's theory includes the possibility that Caterina received her freedom in return for Vann's widow being allowed to stay in the house until her death.

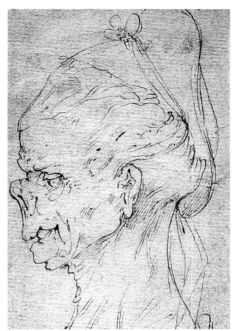

Above: Study for the head of an old woman. The sketch, bought in Venice in the 1970s, was later attributed to Leonardo after it was X-rayed, and unveiled in Venice on 15 June 2006.

WAS CATERINA A SLAVE?

In 2009, documents discovered and edited by Leonardo scholars Alessandro Vezzosi, Director of the Museo Ideale Leonardo da Vinci in the town of Vinci, and Agnese Sabato, have helped to supplement Leonardo's family tree. 'Was Leonardo's Mother a Slave?' and 'Leonardo's Family Tree', support the

Above: A design for a mitre bridge locking system, created by Leonardo c.1497, is utilized today, for example, at the Panama Canal.

proposal that Leonardo's mother was a Russian 'slave'. Vezzosi tells us that in Florence, 'A lot of well-to-do and prominent families bought women from Eastern Europe and the Middle East.' Foreign 'slave' workers – persons who were the property of a family and 'owned' by them – were baptized and given new Italian names, often Caterina, Maria or Marta. Vezzosi proposes that Leonardo may have been of Arabic descent, based on the fingerprint found on one of his paintings. Other research suggests Leonardo's 'slave' mother had Jewish ancestors. New research, based on unpublished documents, proposes that Leonardo had 21 half-siblings. Included in this number are five children of his mother Caterina, and possibly two further illegitimate children of Ser Piero. If the facts are sustained, Leonardo's written statement of the exact number of siblings in his family shows a need to clarify whom he recognized as his father's children.

FROM FACT TO FACTION

In the 21st century, interest in Leonardo abounds. Informative 'faction', a synthesis of fact and fiction, such as Dan Brown's novel *The Da Vinci Code* (2003), has increased public interest in the genius of Leonardo da Vinci, a man who, more than any other, deserves the epithet *l'uomo universale*.

A BRIDGE ACROSS THE CENTURIES

Leonardo's engineering designs continue to be utilized beyond his death. The extraordinary mitre-bridge lock system, known today as the pound lock system, was devised by Leonardo in 1497 and is still in use today. In Britain, use of the mitre bridge spread rapidly during the 18th century when the canal system of waterways was introduced, with water-based traffic increasing until the advent of the railway in 1834. Most canal locks around the world use the principles of Leonardo's design, including the vast locks on the Panama Canal, opened in 1914.

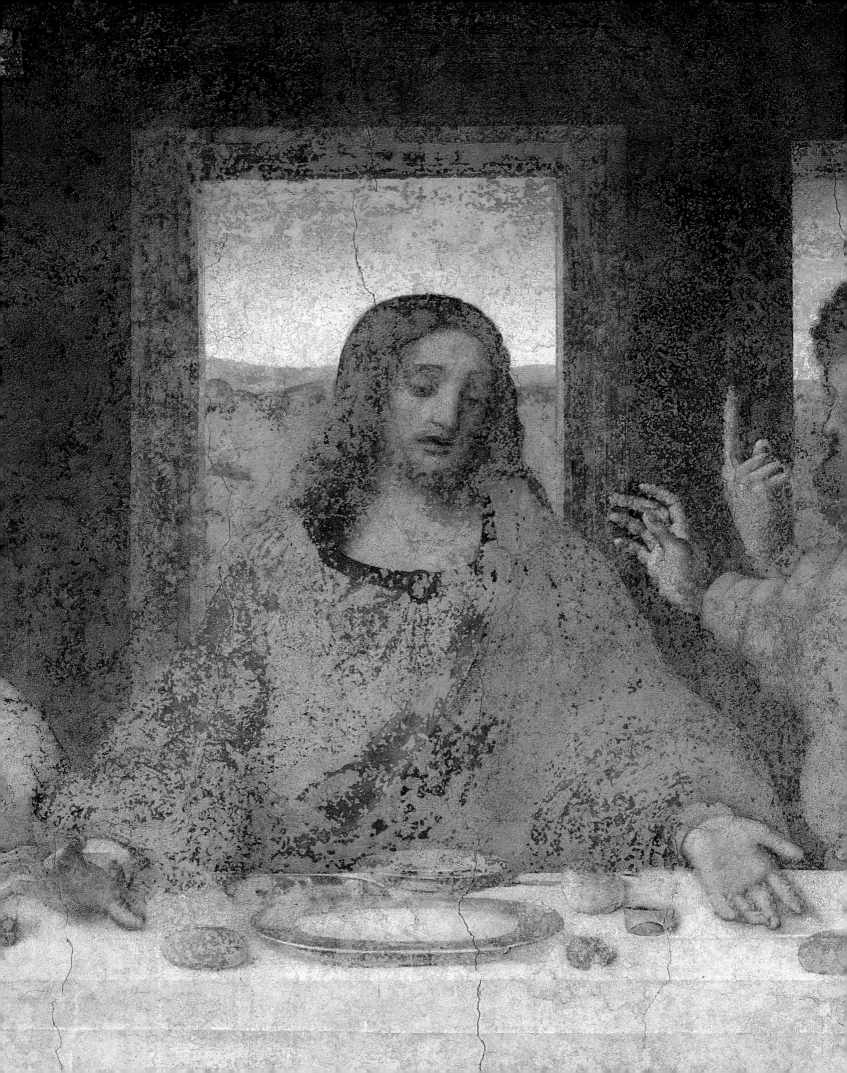

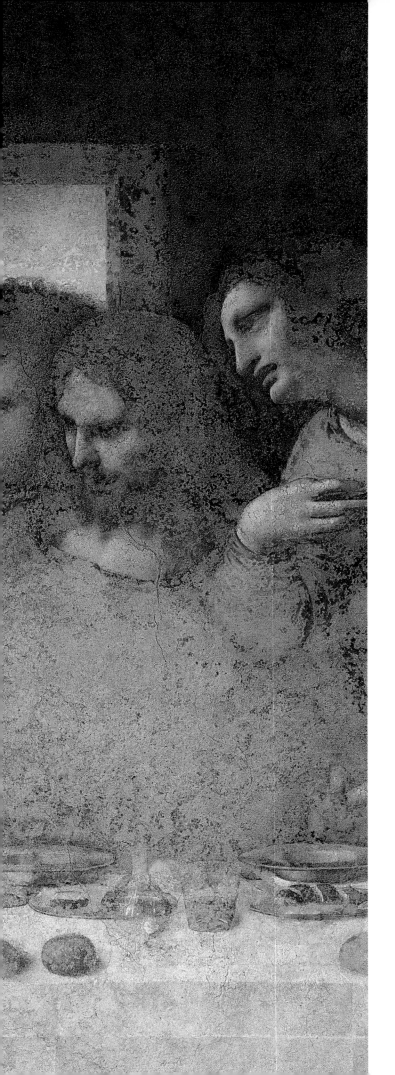

The Gallery

To explore the life of Leonardo we look to historical records and his catalogue of works. Equal to the artist's paintings are an astonishing number of drawings, many used to illustrate Leonardo's notebooks. These works show the combined interests of this extraordinary man, who was respected as a genius in his own lifetime and who remains at the forefront of any discussion of the Italian Renaissance. Leonardo's paintings and drawings demonstrate the diversity and remarkable productivity of the artist. From his earliest known drawing, *Arno Landscape*, created while he was an apprentice to Andrea del Verrocchio in Florence, to those he produced during his final years at Cloux, living as a permanent guest of the king of France, the inventiveness of Leonardo is always present. An exploration of Leonardo's paintings reveals facets of his technique, and his approach to portraiture and landscape. In addition, notebooks disclose Leonardo's wide knowledge of human anatomy, architecture and engineering.

Left: Last Supper, *1495–7 (detail). The focal point of this notable painting of the Last Supper is the seated figure of Jesus Christ. His calm demeanour is in striking contrast to the animated gesticulations of his followers, Thomas, James the Greater, and Philip, pictured to his left.*

Drawings

Observing Leonardo da Vinci's drawings, the prolificacy of the artist's output and the diversity of its content is astonishing. In this section, that diversity is explored, through selected portraits, detailed preparatory studies, quick outline sketches, caricatures, landscapes and plant studies. These drawings hold a spontaneity that encapsulates a moment in time. Small studies, like those of the Virgin and Child with a cat, really take us to the heart of Leonardo's work – an intimate scene adeptly captured with a few strokes of his pen.

Above: Two willow trees on the bank of a stream, c.1511–13. In his treatise on painting, Leonardo discussed each stage of tree growth, to encourage greater accuracy of depiction. Left: Maiden with a unicorn (Young woman seated in a landscape with a unicorn), c.1480–1. Possibly a preparatory sketch for a painting, Leonardo depicts a seated young woman, in three-quarter profile.

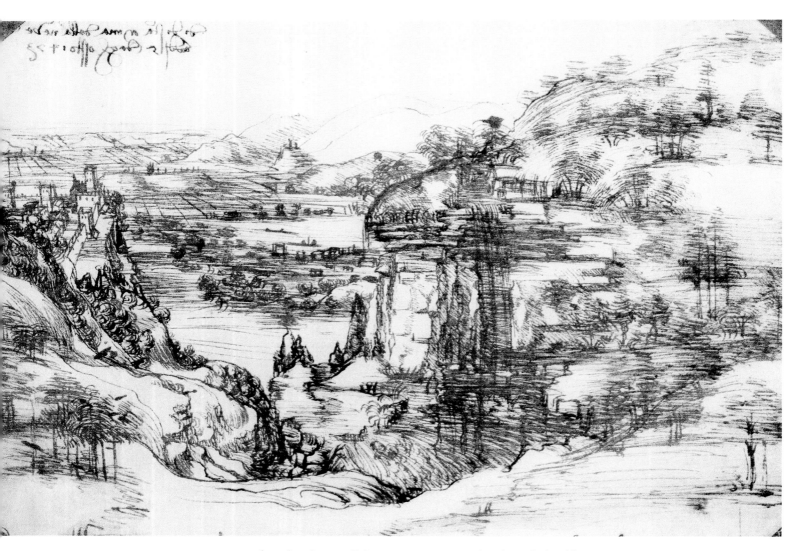

Arno Landscape, 5 August 1473, 1473, pen and ink over pencil, Gabinetto dei Disegni e delle Stampe, Galleria degli Uffizi, Florence, Italy, 19 x 28.5cm (7.5 x 11.2in)

This pen and ink drawing of the river Arno landscape is the earliest extant work known to be by the hand of Leonardo. He produced many drawings during his childhood and before his apprenticeship in the Verrocchio workshop, but those works are now lost. In this drawing the hills and valley resemble land near to Leonardo's birthplace in Vinci. The date of the drawing coincides with a visit he made to his grandfather's home in 1473.

Warrior with helmet and breastplate in profile, *c.*1475, silverpoint on cream prepared paper, British Museum, London, UK, 28.7 x 21.1cm (11.3 x 8.3in)

The fabulous bust of a warrior, in left profile looking right, is wearing a winged helmet and armour, bearing the head of a lion on the breastplate. This detailed drawing, which in some respects has the facial features of Andrea del Verrocchio's equestrian sculpture of the Venetian *condottiere* Bartolomeo Colleoni (1400–75), illustrates Leonardo's attention to Verrocchio's style of drawing, observed during his apprenticeship.

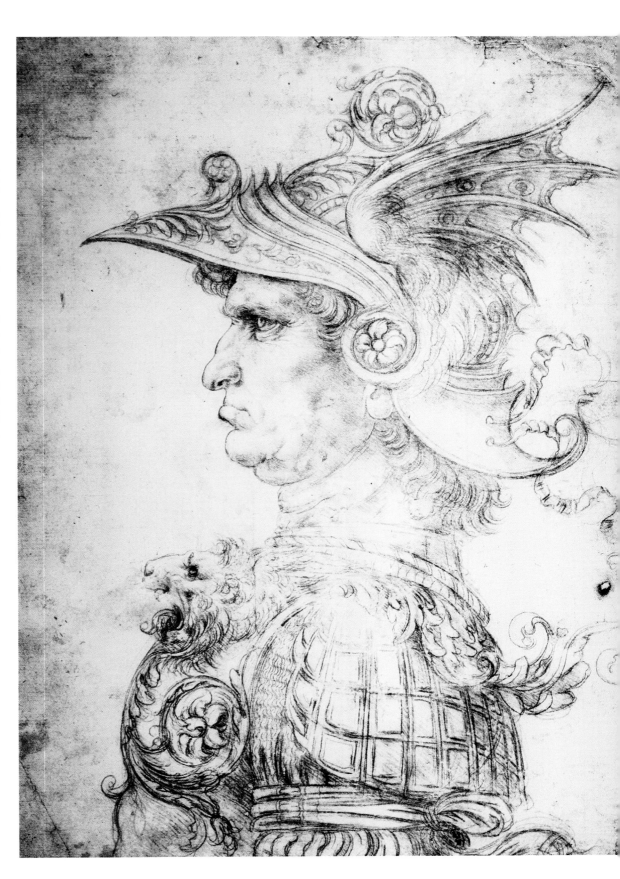

Drapery study for a kneeling figure in profile to right, *c.*1472–5, brush and grey tempera with white heightening on canvas, Galleria degli Uffizi, Florence, Italy, 16.4 x 16.8cm (6.5 x 6.6in)

This is one of several early studies for drapery created by Leonardo da Vinci. Giorgio Vasari, in *Lives of the Painters, Sculptors and Architects* (1550;1568), relates that Leonardo often made clay figure models and then, dipping a piece of fabric in wet plaster, draped it in naturalistic folds on the figure in order to copy it on to canvas.

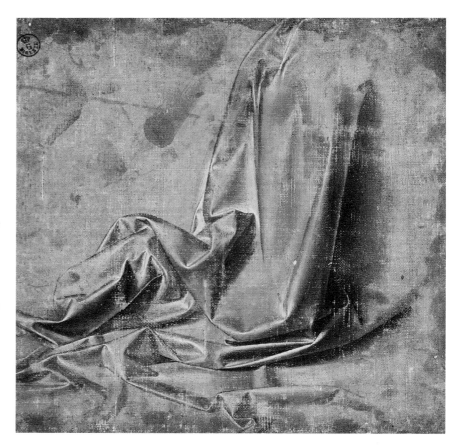

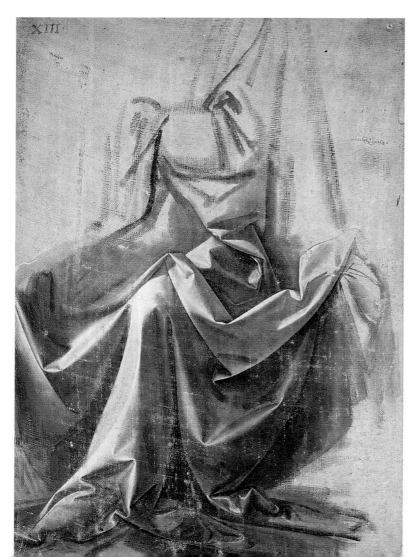

Drapery study for a seated figure, *c.*1475–6, brush and greyish brown tempera with white heightening on prepared canvas, Musée du Louvre, Paris, France, 22 x 13.9cm (8.7 x 5.5in)

An intricately detailed oil on canvas study of drapery for a seated figure viewed in three-quarter profile to the left.

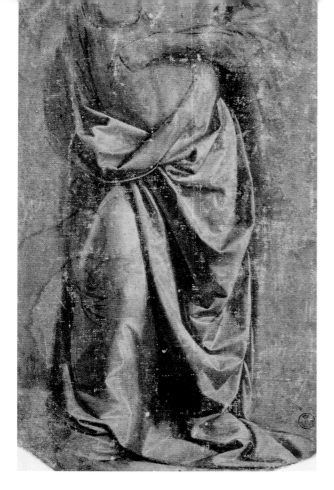

Drapery study for a standing figure seen from the front, c.1478–80, tempera and white on canvas, Galleria degli Uffizi, Florence, Italy, 28.2 x 15.8cm (11.1 x 6.2in)

One of several depictions of drapery painted on to canvas, possibly preparatory work in relation to an Andrea del Verrocchio workshop commission, or an independent work by Leonardo.

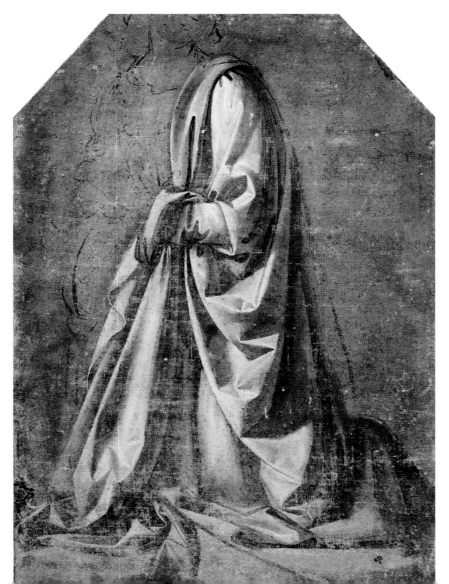

Drapery study for a kneeling figure in three-quarter profile to the left, c.1475, brush and grey-brown tempera with white on prepared canvas, British Museum, London, UK, 28.3 x 19.3cm (11.1 x 7.6in)

A study of a kneeling figure in three-quarter profile. Careful attention has been paid to the folds of the drapery. White heightening accentuates the fall of light on to the fabric. The figure is a possible study for a 'Nativity' or 'Annunciation'.

Two studies of a cat, and one of a dog, *c.*1480–5, metalpoint on prepared paper, British Museum, London, UK, 13.9 x 10.4cm (5.5 x 4.1in)

Leonardo was known to be an animal lover and spent his childhood studying and sketching small lizards, insects and birds around his home and the domestic animals too. This study of a dog and two studies of a cat capture the personality of both animals. The work is considered to have been created during his early Florentine period or first Milanese period, *c.*1480–5.

Aristotle and Phyllis (or *Campaspe*), *c.*1480, pen and dark brown ink over metalpoint on pale blue-grey paper, traces of framing outlines in pen and dark brown ink, Hamburger Kunsthalle, Germany, 9.6 x 13.5cm (3.8 x 5.3in)

This drawing relates to the tale of Alexander the Great's tutor, Aristotle, the revered philosopher, and Alexander's lover, Phyllis. It depicts Alexander and Aristotle just after the philosopher has been caught in a compromising situation with Phyllis. Phyllis, a beautiful woman, annoyed that Aristotle kept Alexander from her through his studies, seduced Aristotle with the promise of love if she could first ride on the philosopher's back. Phyllis arranged for Alexander to watch. Aristotle, caught in the act by Alexander, warned that if a woman could seduce such a wise man as himself, lesser men should take care.

Sketch of a roaring lion, *c.*1515–17, red chalk on paper, Musée Bonnat, Bayonne, France, 10 x 17.7cm (3.9 x 7in)

Attributed to Leonardo da Vinci. On 1 October 1517 the Mantuan ambassador to France, Rinaldo Ariosto, reported the following in his diary: during a festival in Argentan, a town 193km (120 miles) west of Paris, a mechanical lion, designed by Leonardo, walked several steps. The lion's chest then opened to reveal lilies, a symbol of France. This sketch may be from that period.

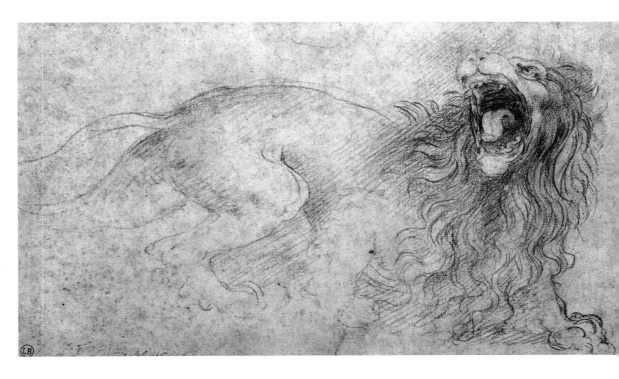

Study of a unicorn dipping its horn into a pool of water, *c.*1481, pen and dark brown ink with metalpoint on white paper, Ashmolean Museum, University of Oxford, UK, 9.4 x 8.1cm (3.7 x 3.2in)

Here Leonardo depicts a mythical unicorn. The tiny drawing conveys the actions of the crouching unicorn as it lowers its single, central horn, to dip it into a pool of water. The artist's portfolio of drawings includes many of fantastical creatures, primarily dragons fighting other animals, or in combat with a horseman.

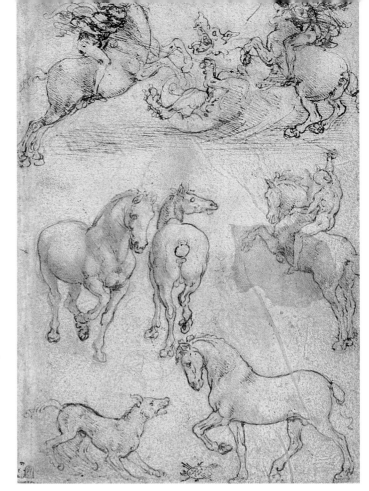

Two horsemen fighting a dragon and studies of horses, *c.*1480s, pen and ink and brush on paper, Cabinet des Dessins, Musée du Louvre, Paris, France 19 x 11.9cm (7.5 x 4.5in).

In the upper half of this page, Leonardo captures the ferocity of two horsemen in combat with a dragon. In the middle, a horseman, with sword arm raised, is seated on a rearing horse. To his left are detailed drawings of two horses, illustrated from the front and the rear. At the bottom of the page, a horse is depicted facing right, challenged by a dog. The attribution of this drawing is given to Leonardo.

A horseman in combat with a griffin, *c.*1482–3, silverpoint on pinkish-cream prepared paper, Ashmolean Museum, University of Oxford, UK, 8.8 x 13.9cm (3.5 x 5.5in)

To the left the horse with rider rears up to engage in combat with a griffin. A griffin (or gryphon) is a mythical beast, a winged four-legged creature with the head and talons of an eagle and the body of a lion. A griffin was reputed to have the combined strength of a lion and an eagle. Leonardo created several drawings of a horse and rider in combat with wild animals. His interest lay in medieval bestiaries (books of beasts) and the animal symbolism in *Physiologus*, an ancient Greek text (2nd century AD), by an unknown author, which discussed the physiology of animals and birds including mythical creatures.

Study of a man blowing a trumpet into the ear of a nude man, and two seated men, c.1480–2, pen and brown ink over stylus sketch, British Museum, London, UK, 25.8 x 19.3cm (10.2 x 7.6in)

A page of quick sketches includes a depiction of a man in profile blowing a long trumpet into the ear of a naked man, who turns away. Beneath this drawing two figures are seated facing each other in conversation. Often, artists would use a nude figure to create the right body movements within the pictorial space, adding clothing in the final piece of work.

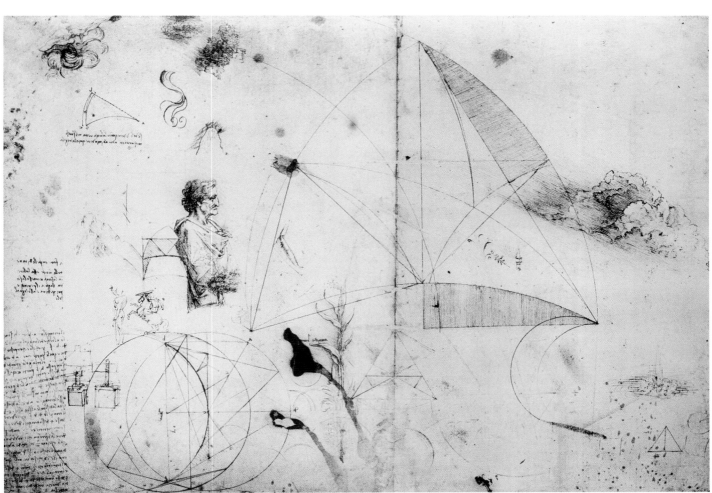

Study of an old man and geometric diagrams, c.1490, pen and ink, Royal Library, Windsor Castle, UK, 32 x 44.6cm (12.6 x 17.6in)

A carefully defined study of an old man in profile is central to a sheet of unrelated geometrical drawings. In addition, there are smaller figure drawings, including a horse and rider. In his notes (later published in *On Painting*), Leonardo advised, 'When you have to draw a face from memory, carry with you a little notebook, in which you have jotted down […] features. I shall not speak of monstrous faces because they are easily kept in the mind.'

Designs for a Nativity or Adoration of the Christ Child, *c.*1480–5, metalpoint partly reworked with pen and dark brown ink on pink prepared paper; lines ruled with metalpoint, Metropolitan Museum of Art, New York, USA, 19.4 x 16.3cm (7.6 x 6.4in)

These small sketches relate to a Nativity scene depicting the Virgin worshipping the infant Christ Child. The multiplicity of different poses for the Virgin reveals Leonardo's ability to create a variety of intimate scenes depicting mother and infant. In the central image, the Virgin stretches out her arms to encompass the infant Christ Child and St John, in the traditional 'Madonna della Misericordia' pose. The sketches are possibly preparatory drawings for the *Virgin of the Rocks* painting.

Studies for a St Mary Magdalene, *c.*1480–3, pen and ink on paper, Samuel Courtauld Trust, Courtauld Institute of Art Gallery, London, UK, 13.7 x 7.9cm (5.4 x 3.1in)

A pen and ink sketch showing two depictions of St Mary Magdalene holding an object, possibly a jar of anointing oil. Her action relates to the biblical narrative, whereby after the crucifixion of Christ, Mary Magdalene visits the tomb where the body of Christ was laid in order to anoint his body (Mark 16:l).

Studies for the Virgin and Child with a cat, c.1478–80, pen and ink, Musée Bonnat, Bayonne, France, 22.8 x 16.5cm (8.9 x 6.5in)

One of a series of studies, which depict a continuation of Leonardo's theme of the Virgin and Child with a cat. Other sketches show a lamb in place of the cat. He captures the determination of the infant to hold on to the cat and the inquisitiveness of the cat that turns to look toward something or someone unseen.

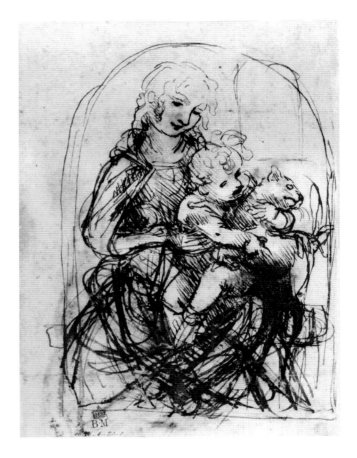

Study of the Virgin and Child with a cat, c.1478–80, pen and brown ink over stylus underdrawing, British Museum, London, UK, 13 x 9.4cm (5.1 x 3.7in)

This drawing is one of a series of six studies depicting the Virgin and the infant Christ, who holds on to, or plays with a cat. Leonardo captures the natural attempts of a cat to escape when in the embrace of a young child. This study is a double version, the other study is on the obverse of this drawing. Both are outlined in an arched space.

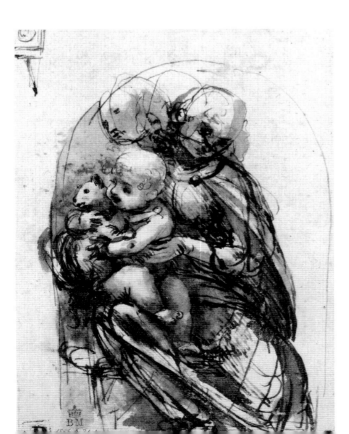

Study for a Madonna with a cat, c. 1478–80, pen and brown ink, brown wash, over stylus underdrawing, British Museum, London, UK, 13 x 9.4cm (5.1 x 3.7in)

One side of a double drawing of the Virgin and Christ Child with a cat, depicting a reverse portrait of its counterpart. Here, the infant and cat are placed on the Virgin's lap to the viewer's left. The cat and the infant both look to the left as if something or someone unseen has momentarily taken their attention. Leonardo perfected this technique of capturing a moment in time in his portrait of Cecilia Gallerani.

Study for a Virgin and
Christ Child with a cat,
c.1478–80, pen and ink,
Gabinetto dei Disegni e
delle Stampe, Galleria degli
Uffizi, Florence, Italy,
12.5 x 10.5cm (4.9 x 4.1in)

This is a particularly beautiful
study of mother and child.
Leonardo captures the
intimate bond as their faces
turn toward each other in a
loving gaze. The Madonna's
right hand firmly holds the
upraised foot of the Christ
Child. To the right of the
picture frame a cat with its
head turned away from the
infant struggles to be
released from his hold.

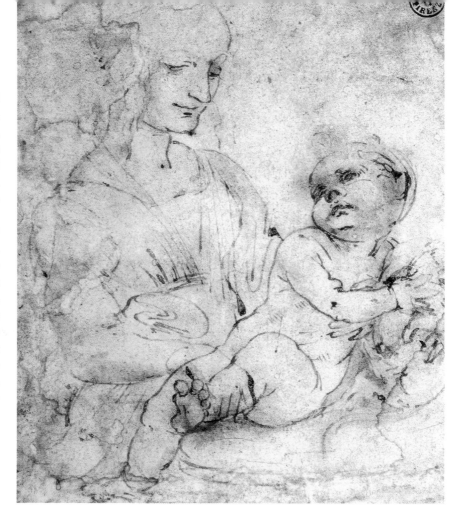

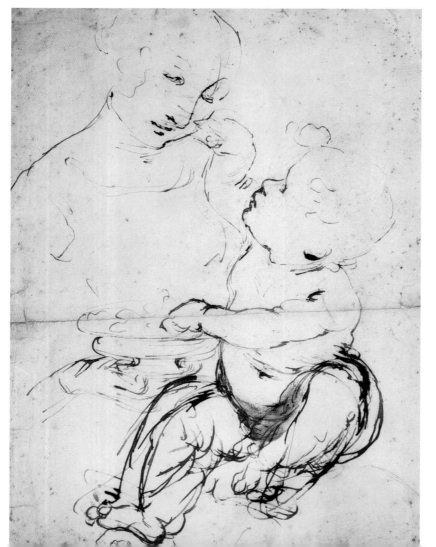

Study of Virgin and Child
with a bowl of fruit,
c.1478–80, pen and ink over
stylus underdrawing, Musée
du Louvre, Paris, France,
13.2 x 9.5cm (5.2 x 3.7in)

A pen and ink study of the
Virgin and Child. The Virgin
holds a shallow bowl of fruit
in her right hand. She offers
the fruit to the infant Christ.
The symbolism of fruit in
depictions of the Christ
Child is a possible reference
to the earthly 'Charity', one
of the three 'theological
virtues', or it might be a
reference to a future event,
when fruit is brought by
angels to the adult Christ,
during his temptation in the
wilderness (Matthew
4:1–11).

Study for an infant, c.1501, red chalk on tinted paper, Gallerie dell'Accademia, Venice, Italy, 28.5 x 19.8cm (11.2 x 7.8in)

The leg of an infant is drawn in finely observed detail. Leonardo was to paint several portrayals of the Madonna and Child, which, by tradition, illustrated a young infant in the arms or on the lap of the Virgin Mary, or at her feet. This drawing is a preparatory work.

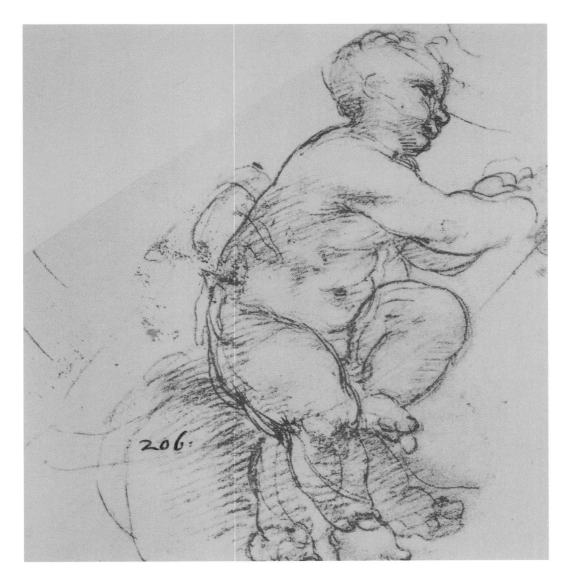

Drawing of a naked infant, c.1478–80, red chalk, Royal Library, Windsor Castle, UK, 13.8 x 19.5cm (5.4 x 7.7in)

Leonardo created many drawings and sketches of babies and young infants, most probably as preparatory drawings for Madonna and Child paintings. Looking at this drawing one can see Leonardo's skill in foreshortening the figure. He captures a relaxed baby in this freestyle depiction.

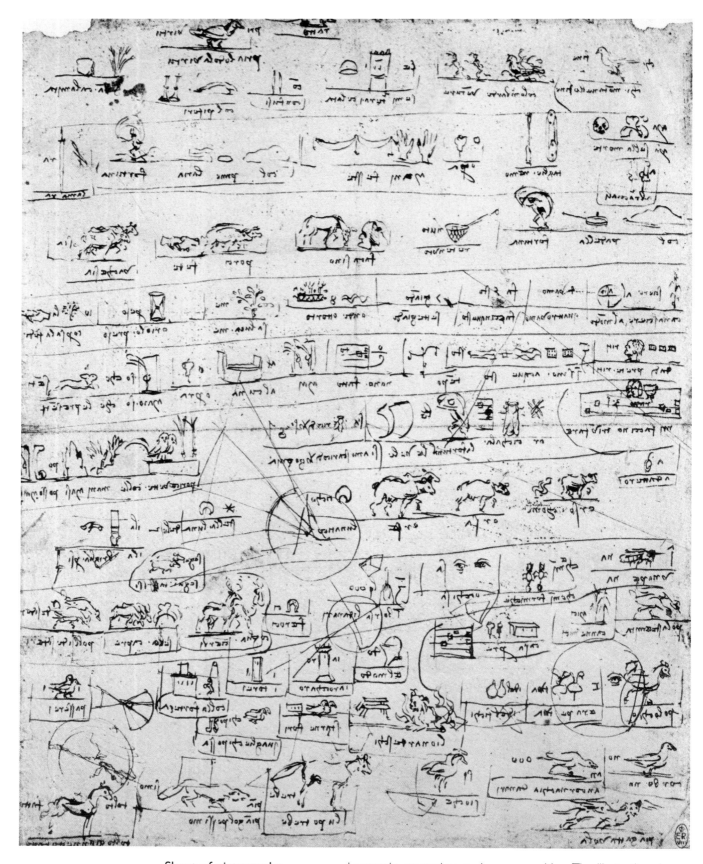

Sheet of pictographs, c.1487–90, pen and ink, Royal Library, Windsor Castle, UK, 30 x 25.3cm (11.8 x 10in)

Leonardo created several pages of pictographs. This sheet is mostly of animals. The drawings show him experimenting with pictorial writing. The illustrations have a text underneath. His own handwriting was famously achieved in mirror writing, created from right to left.

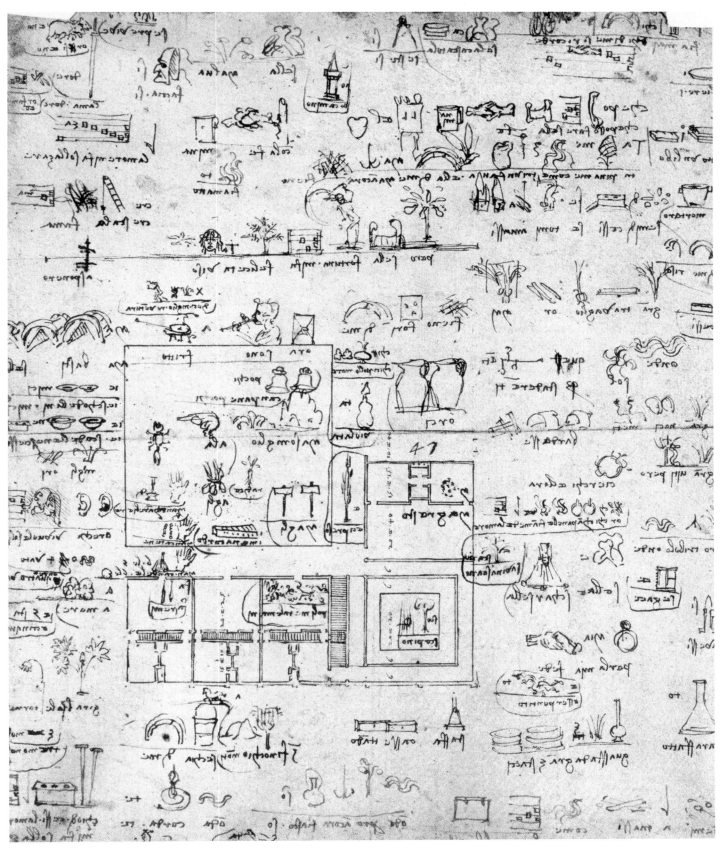

**Sheet of pictographs,
c.1487–90, pen and ink,
Royal Library, Windsor
Castle, England,
30 x 25.3cm (11.8 x 10in)**

This sheet of pictographs,
small illustrations combined
with text, includes a floor
plan, jugs, flower heads, a
water spout and a bird's wing.

Portrait of a woman in profile, *c.*1485–90, silverpoint on pale buff prepared paper, Royal Library, Windsor Castle, UK, 32 x 20cm (12.6 x 7.9in)

According to the Leonardo scholar Emeritus Professor Martin Kemp, this profile portrait bears a close resemblance to the chalk drawing of *La Bella Principessa* (*Young Girl in Profile in Renaissance Dress*), *c.*1496. It is possibly the same person, Bianca Sforza, the illegitimate daughter of Ludovico Sforza. In the portrait, the young woman wears her hair and her headscarf in a Florentine style. Professor Kemp points out the similarity of the forehead, nose, lips and eyes and the delicate subtlety of the drawing strokes, achieving a firm yet soft outline. However, it is also possible that this portrait is of a servant and was created during Leonardo's residence in Milan.

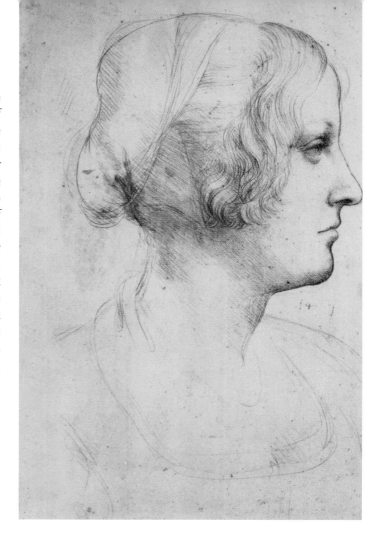

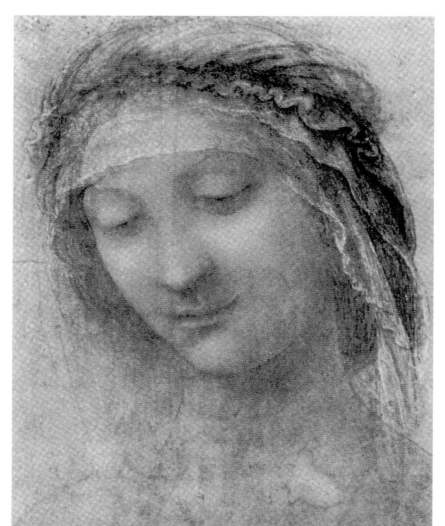

Head of a woman in three-quarter profile, *c.*1510–15, red and black chalk with touches of pen and white on the veil, on pale red prepared paper, Royal Library, Windsor Castle, UK, 24.4 x 18.7cm (9.6 x 7.4in)

Most probably intended to be an image of the Madonna, the headdress shows evidence of the hand of Leonardo, although the design is not typical of his work. The face of the woman has been stippled over by another artist at a later date, and only a small amount of the work can be traced to Leonardo.

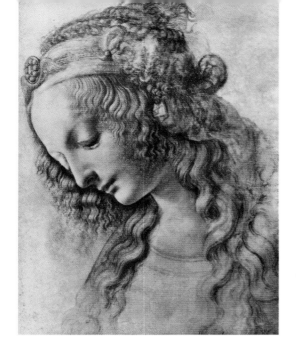

Head of a woman looking down, c.1468–75, black chalk or leadpoint, brown and grey-black wash, heightened with lead white (partly discoloured), Gabinetto dei Disegni e delle Stampe, Galleria degli Uffizi, Florence, Italy, 28 x 20cm (11 x 7.9in)

This drawing, attributed to Leonardo, depicts a beautiful young woman looking downward. Her distinctive headband highlights the hair braiding above it and the long tresses of hair below. The drawing closely resembles the head of the Virgin in Andrea del Verrocchio's *Virgin and Child*, c.1470. This is possibly a copy of the head by Leonardo. Close observation of the drawing reveals several changes and uses of different mediums, making it hard for experts to agree on authenticity.

La Bella Principessa, attributed to Leonardo da Vinci (formerly *Young Girl in Profile in Renaissance Dress*, German, early 19th century), c.1496, black, red and white chalk, pen and ink on vellum, private collection, 33 x 24cm (13 x 9in)

The small chalk drawing, formerly considered a 19th-century artwork of German origin, was attributed to Leonardo da Vinci in 2008 by Alessandro Vezzosi, director of the Museo Ideale in Vinci, and reconfirmed in late 2009 by Leonardo scholar Martin Kemp, Emeritus professor of History of Art at the University of Oxford. Professor Kemp has renamed it *La Bella Principessa* because he believes the young woman in the portrait is possibly Bianca Sforza, daughter of Ludovico Sforza, Il Moro, and his mistress Bernardina de Corradis. The drawing was found to have the imprint of a fingertip and palm print, which matches a fingertip imprint belonging to Leonardo da Vinci, found on the unfinished St Jerome painting, now in the Vatican Museum, Rome.

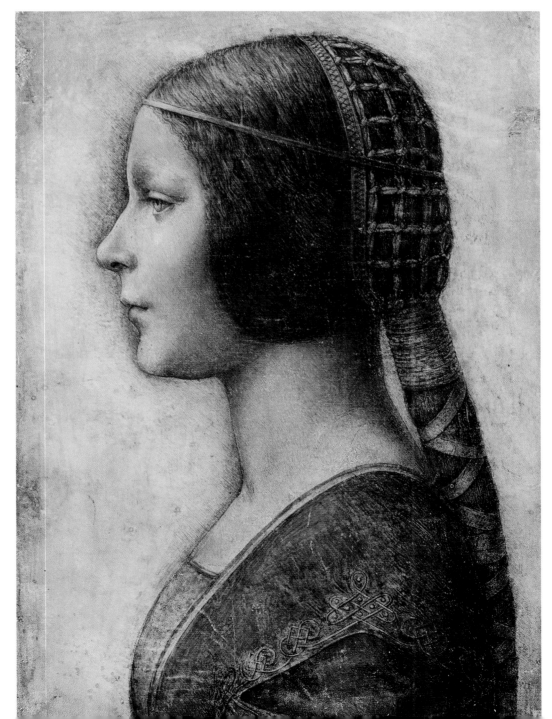

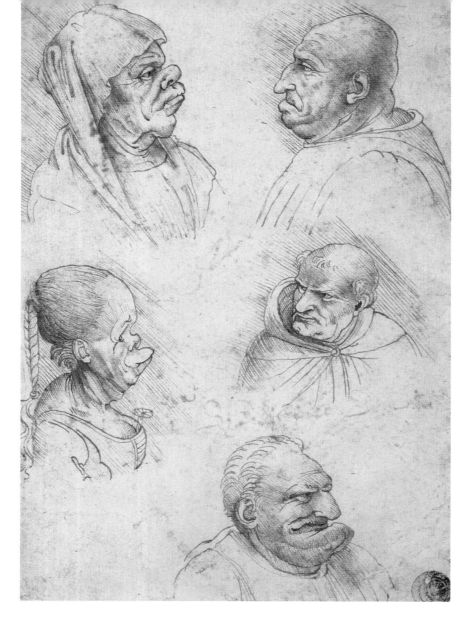

Studies of grotesque faces, caricatures, *c.*1485–90, pen and ink and watercolour, Royal Library, Windsor Castle, UK, 26.1 x 20.6cm (10.3 x 8.1in)

Leonardo spent much of his time on the streets of Milan finding people with interesting faces in order to draw them. For the painting of the 13 figures in the *Last Supper*, he felt it was vital to find a range of different faces with differing expressions. Here in these sketch drawings he has taken the figurative to the grotesque level.

Seven studies of grotesque faces, *c.*1485–90, red chalk on paper, Gallerie dell'Accademia, Venice, Italy, 18 x 12cm (7.1 x 4.7in)

Attributed to Leonardo da Vinci or Francesco Melzi, this page of sketches depicts seven profile studies of heads and faces, which are possibly life-drawn sketches. Some of the figures are direct copies of Leonardo's sketches shown on separate sheets of paper. Leonardo would combine the features of several different heads, noted in brief sketches, or committed to memory. His view was that a monstrous face was easily recalled. He explains his method in 'How to make a portrait in profile after seeing the subject only once', in his *Trattato della pittura (Treatise on Painting)*, 1492–1510.

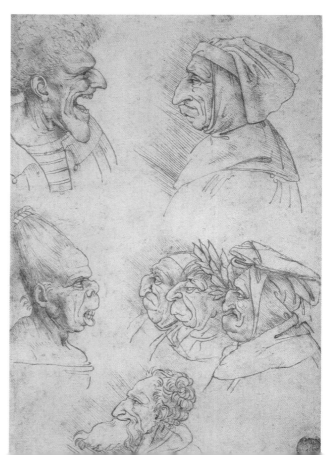

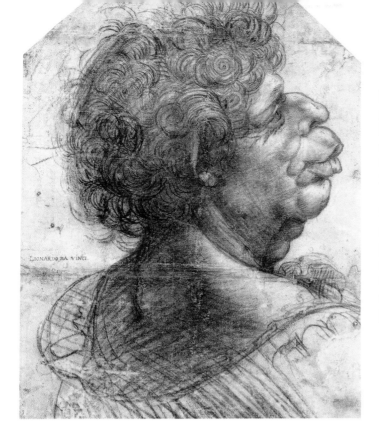

Portrait study of a grotesque head, *c.*1500–5, black chalk (pricked for transfer), Christ Church, Oxford, UK, 39 x 28cm (15.4 x 11in)

In his treatises, Leonardo's discussion of the physiological characteristics of the face related to capturing the expressive details. Later writers linked grotesque features to a person's mental disposition. Leonardo did not make this assumption. This drawing, according to historian and artist Giorgio Vasari, who owned it, is a portrait of 'Scaramuccia, king of the gypsies'. Others consider it a preparatory study for the head of an onlooker in a now lost painting of the Mocking of Christ. It is the largest of Leonardo's 'grotesque' heads.

Grotesque portrait study of two figures in profile, *c.*1487–90, pen and ink, Royal Library, Windsor Castle, UK, 16.3 x 14.3cm (6.4 x 5.6in)

The face of the man pictured left, in profile, bears a similarity to the face of the old man in another sketch, 'Head of an old man and a youth in profile', *c.*1495–9 (Galleria degli Uffizi, Florence, Italy). However, in this earlier portrait the face has many boils and facial deformities. The chin heavily protrudes, and the mouth is open to show the few teeth remaining. The study has been carefully worked to highlight facial expression. The figure pictured right, in profile, may be male or female. Leonardo captures the characteristics of the face etched with wrinkles, the hooked nose, and sucked-in closed mouth suggesting an absence of teeth.

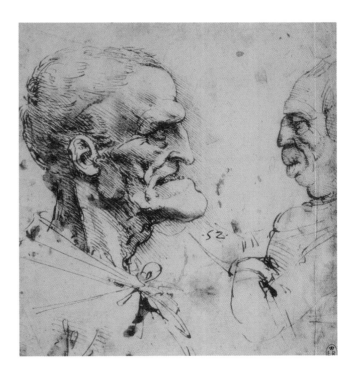

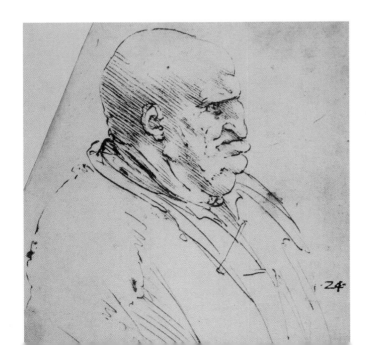

Portrait of a bald man in profile, *c.* 1485–90, pen and ink, Royal Library, Windsor Castle, UK, 16 x 13.5cm (6.3 x 5.3in)

While this was possibly a direct likeness of the person portrayed, Leonardo achieves a caricature of an obese, balding man whose extra weight is identified with a few strokes of the pen to outline his body size. The face, with distinctive inset eyes over a heavy brow, a hooked or broken nose, protruding chin and jowls, is linked to Leonardo's theory of creating many different faces through a redistribution of characteristics. This drawing is also linked to other profile sketches of ageing, balding men.

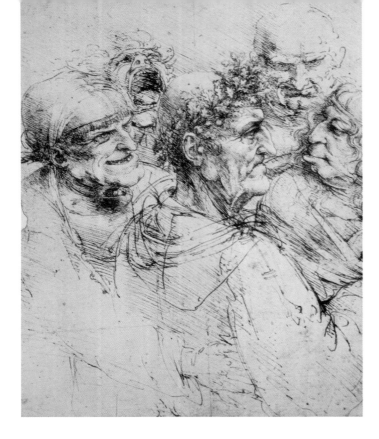

A man tricked by gypsies, c.1493, pen and ink, Royal Library, Windsor Castle, UK, 26 x 20.5cm (10.2 x 8.1in)

This drawing depicts a group of characters. The central character of the five grotesque faces wears a crown of oak leaves, in the fashion of a Roman emperor. Opinion differs on whether gypsies are surrounding the man. The facial expressions convey mischief. The group, through the diversion of laughter, might rob the man through duplicity. In Milan in April 1493 a decree ordered all gypsies to leave the city, due to petty thieving under the guise of fortune telling.

Sketch of the head of an old man in profile, c.1485–90, pen and ink, Biblioteca Ambrosiana, Milan, Italy, 7.8 x 5.6cm (3.1 x 2.2in)

A minute drawing of an old man in profile captures the characteristics and demeanour of the figure. Leonardo recommended artists to, 'commit to memory the four variations of the four different features… the nose, the mouth, the chin and the forehead'. In his notes, intended for publication, he advised the aspiring artist to pay attention to the contours on either side of the nose, which 'vary in three ways… straight, concave, or really convex'.

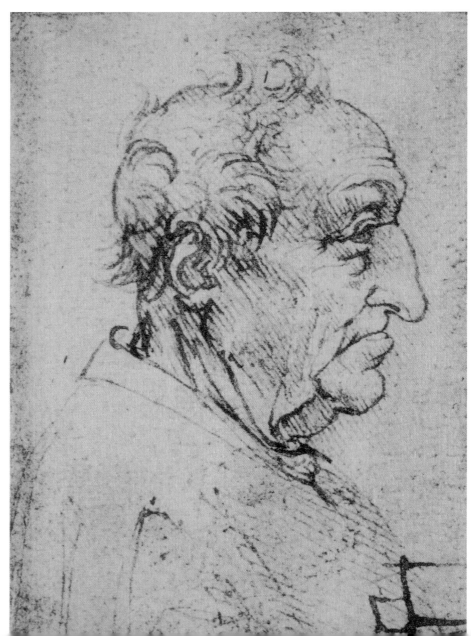

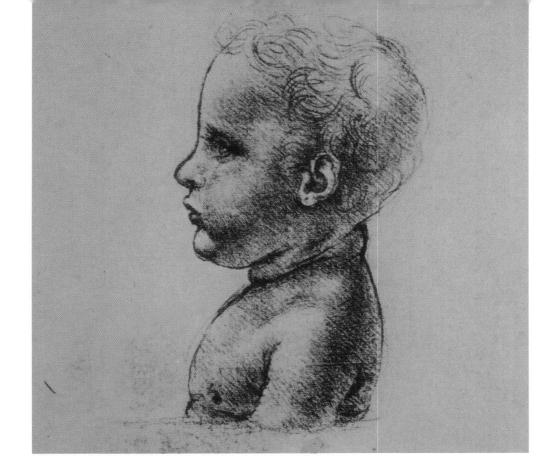

Profile bust of a child,
*c.*1497–9, red chalk,
Royal Library,
Windsor Castle, UK,
10 x 10cm (3.9 x 3.9in)

A delicate, closely observed
drawing of the head of a
child, seen in left profile,
facing right. This is possibly
a preparatory drawing for a
Madonna and Child painting.

Drawing of the back
and chest of a child,
*c.*1497–9, red chalk,
Royal Library,
Windsor Castle, UK,
15.5 x 13.6cm (6 x 5.4in)

A similar portrayal in red
chalk to the head of a child
in profile. This drawing
illustrates features of a young
infant's body, depicting the
chest and back. It is a closely
observed study and is
possibly a preparatory
drawing for a painting.

The Ermine as a Symbol of Purity, c.1494, pen and brown ink over slight traces of black chalk on paper, Fitzwilliam Museum, Cambridge, UK, diameter 9.1cm (3.6in)

The pastoral drawing shows a land worker and an ermine in the fields. It is intended to illustrate that the ermine would rather die than get its fur, a symbol of purity, dirty.

Head and shoulders of a figure of Christ, c.1490–5, metalpoint on grey prepared paper, Gallerie dell'Accademia, Venice, Italy, 11.6 x 9.1cm (4.6 x 3.6in)

A beautifully drawn study of the head and face of a male. The length of the hair and beard suggest a portrayal of the head of Christ.

Drawing after Michelangelo's *David,* and architectural sketches (detail), c.1504, pen and ink and black chalk on paper, Royal Library, Windsor Castle, UK, 27 x 20.1cm (10.6 x 7.9in).

This drawing is a detail from a larger page of sketches. It was created in 1504 at the time when Michelangelo Buonarroti's giant freestanding marble sculpture *David* (1501–4), had just been completed in Florence. On a sheet of architectural drawings, Leonardo sketched a figure in the stance of the David. However, at the feet of Leonardo's figure lies the outline of a lion, a possible reference to Hercules and the Nemean Lion. To the Florentines, David was seen as a modern-day 'Hercules'. Leonardo had been a member of the Florentine committee who had to choose where to place the sculpture, selecting a prime location outside the Palazzo della Signoria.

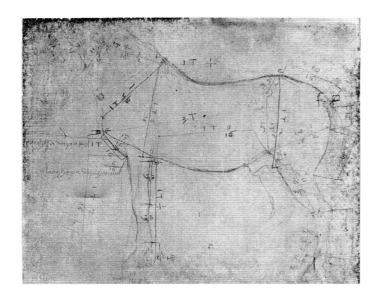

Study of a horse,
*c.*1489–90, metalpoint
on blue prepared
paper, Musée Bonnat,
Bayonne, France,
32.4 x 23.7cm (12.8 x 9.3in)

Leonardo made many
studies of the proportions
of the body of the horse.
He had taken great interest
in the making of the
equestrian statue of

Condottiere Bartolomeo
Colleoni, created by
Verrocchio, which was about
to be cast in bronze. He was
commissioned to create a
larger than life-size bronze
equestrian statue for
Francesco Sforza. This
drawing may be part of
a series for that purpose.
The project got under way
and a model was made but
it did not reach production.

**Study for the Sforza
monument,** *c.*1488–90,
metalpoint on blue prepared
paper, Royal Library,
Windsor Castle, UK,
14.8 x 18.5cm (5.8 x 7.3in)

In preparation for the Sforza
monument Leonardo created
a variety of equestrian
sketches. The earliest of
these reveal Leonardo's
interest in the creation of a
sculpture of a horse
rearing up with a rider
brandishing a sword.

This position was abandoned
due to the complicated
procedure of its construction.
In this drawing, the figure
rides the horse bareback.
Under the hooves of the
rearing horse, Leonardo has
drawn the figure of a man,
prostrate on the ground,
possibly a soldier fallen
captive. The image is similar
to Leonardo's later battle
sketches for the *Battle of
Anghiari* (*c.*1505), where
defeated soldiers lie under
the hooves of rearing horses.

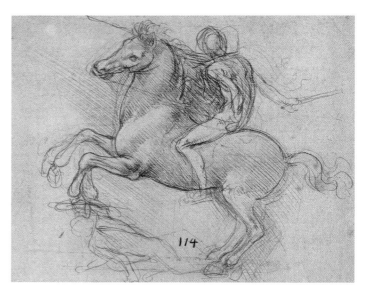

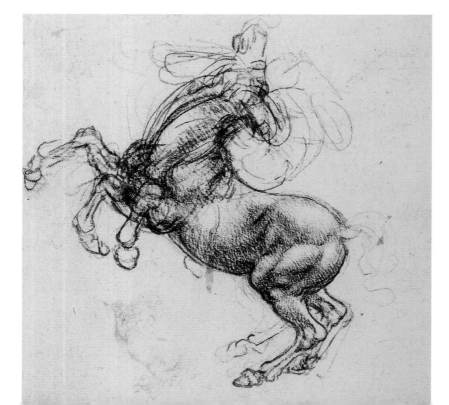

Sketch of a rearing horse,
*c.*1505, red chalk, pen and
ink, Royal Library,
Windsor Castle, UK,
15.3 x 14.2cm (6 x 5.6in)

One of several horse studies
created at the time of
Leonardo's commission for
the painting of the *Battle
of Anghiari*, in Florence.
The artist sublimely
captures the movement
of the animal. The drawing
shows several possible angles
for the head, which is
thrown back, and the
front and rear hooves.

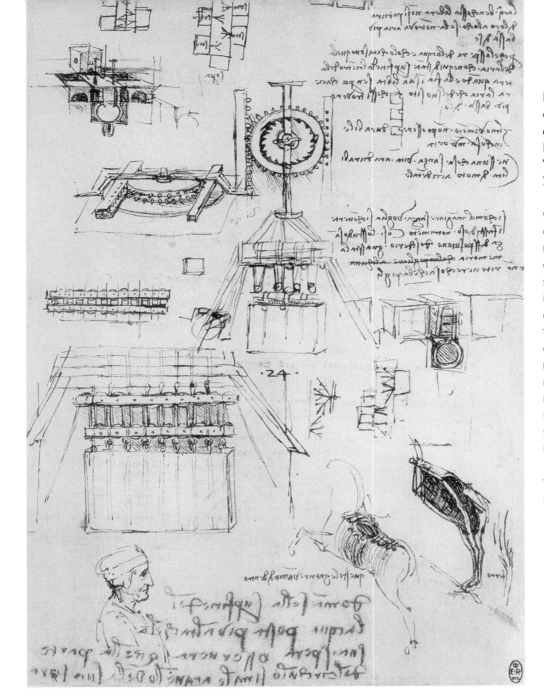

Drawing of components of the Sforza Monument, c.1491–3, pen and ink, Royal Library, Windsor Castle, UK, 27.8 x 19.1cm (10.9 x 7.5in)

One of many drawings created by Leonardo in relation to his creation of the Sforza equestrian statue. The drawings illustrate some of the components needed for the production and the casting of the Sforza monument. To bottom right are two small studies relating to the internal structure of the horse sculpture. Leonardo's notebook for 16 July 1493 mentions his need to find the right horse to model for the statue.

Study of the wooden framework with casting mould for the Sforza horse (Codex Madrid II, fol. 154v), c.1491–3, red chalk, pen and brown ink on paper, Biblioteca Nacional, Madrid, Spain, 21 x 14.3cm (8.3 x 5.6in)

This is a scaled drawing for the wooden framework – with casting mould in place – for the casting of the Sforza horse. The drawing is one in a series of several designs for the casting mould frame.

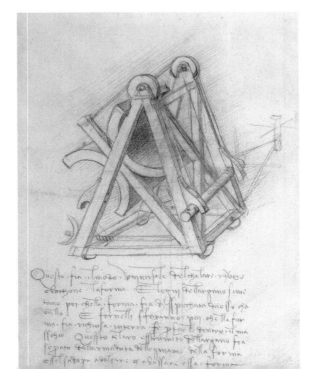

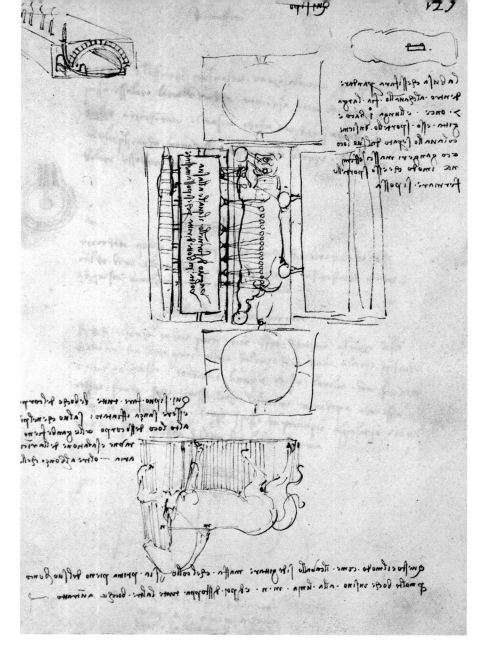

Sketch of the casting pit for the Sforza horse seen from above and the side (Codex Madrid II, fol. 149r), c.1493, pen and ink on paper, Biblioteca Nacional, Madrid, Spain, 21 x 14.4cm (8.3 x 5.7in)

The drawing illustrates the casting pit from above (top) and below (bottom). It was to be used to cast the Sforza bronze equestrian statue, to create a larger than life-size monument. The clay model for the horse was produced but the bronze intended for the equestrian statue was requisitioned for cannons. The vast clay model was later destroyed.

Drawing of ironwork casting mould for the head of the Sforza horse (Codex Madrid II, fol. 157r), c.1491–3, red chalk on paper, Biblioteca Nacional, Madrid, Spain, 21 x 29cm (8.3 x 11.4in)

This drawing details the hook and stay construction of the ironwork casting

mould, created for the larger than life-size head of the Sforza horse. Leonardo illustrates the piece-mould device. The equestrian sculpture was to be the largest monument ever cast in bronze. The size was to be 12 braccia (7.32m/24ft) from the horse's nape to the ground.

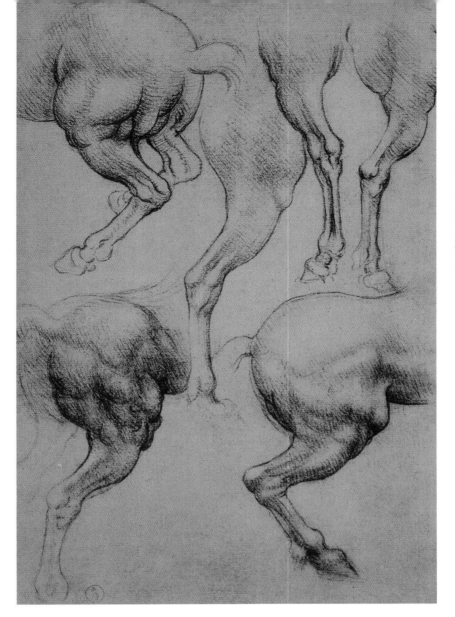

Studies of horses' hind legs, c.1490, red chalk on paper, Biblioteca Reale, Turin, Italy. 20.7 x 15.5cm (8.1 x 6.1 in)

This sheet contains six studies of horses' hind legs, created in preparation for the casting of the model of the Sforza horse.

Study of a horse and two figures, c.1517–18 sepia ink on linen paper, Galleria dell'Accademia, Venice, Italy, 17 x 14cm (6.7 x 5.5in)

One of a series of drawings, sketching the detailed movements of horses and people. Leonardo illustrated horses – a favourite subject – in fast movement, nostrils flared, mane and tail caught by the wind.

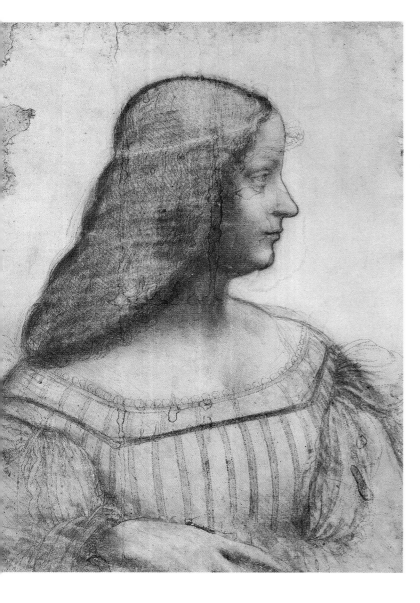

Portrait of Isabella d'Este,
*c.*1499–1500,
red chalk on paper, Musée
du Louvre, Paris, France,
63 x 46cm (24.8 x 18.1in)

Leonardo da Vinci visited
Isabella d'Este (1474–1539),
the Marchioness of Mantua,
after he left Milan in
December 1499. He stayed
in Mantua as her special
guest, for a few weeks, or
possibly longer. Records
place him in Venice in
March 1500. During his

stay he drew her portrait,
which was a preparatory
work, a cartoon drawing,
for a planned portrait in
oils. On his arrival in
Florence Leonardo deferred
and then dropped the
commission, much to
Isabella's disappointment.
Leonardo has depicted her
body in three-quarter profile
with her head turned to
face left in profile. Her hair
is dressed and is styled away
from her face, to highlight
her features.

Head of a bearded man
(self-portrait), *c.*1510–15,
red chalk on paper,
Biblioteca Reale, Turin, Italy,
33.3 x 21.5cm (13.1 x 8.5in)

This detailed drawing in
red chalk, of the head of a
heavily bearded man with
long hair, is considered

by many historians to
be a self-portrait of
Leonardo da Vinci.
In this depiction the
artist would be about
60 years of age. The study
illustrates a man with a
lined, thoughtful face,
bushy eyebrows and a
pronounced nose.

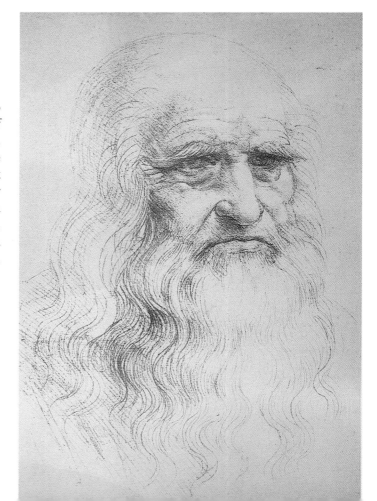

Study of the head of an older man, *c.*1505–10, red chalk with white heightening on paper, Royal Library, Windsor Castle, UK, 18.3 x 13.6cm (7.2 x 5.4in)

A detailed portrayal of an older man in frontal view. The head of hair is thickly curled, the eyes deep set and the mouth emphatically drawn in a downward turn. This model is used in other Leonardo drawings of faces and heads. To the lower right of the drawing Leonardo has sketched the head of a lion in three-quarter profile.

Study of the profile of a bearded man, *c.*1504–10, pen and ink on paper, Royal Library, Windsor Castle, UK, 15.4 x 20.5cm (6.1 x 8.1in)

A profile study of the head and shoulders of a bearded man in a turban. The study is probably linked to Leonardo's sketches of grotesques. He preferred to create heads and faces from life models and would then mix the characteristics. Here the face of the man is heavily lined and bearded. The nose is pronounced and the chin juts out beneath the beard.

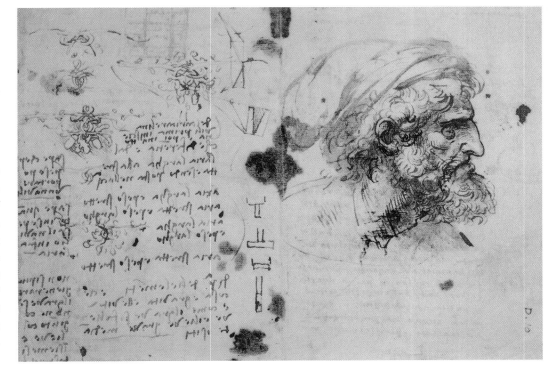

Studies of the head of Cesare Borgia from three points of view, *c.*1502, red chalk on yellow paper, Biblioteca Reale, Turin, Italy, 11.1 x 28.4cm (4.4 x 11.2in)

Studies of the tyrant Cesare Borgia, for whom Leonardo was working during 1502, are drawn from three different viewpoints. To the right, Borgia is in left profile, showing a defined beard, which juts out in front. The central study illustrates Borgia in three-quarter profile. To the left, a composed portrait of the man is illustrated facing forward with eyes cast down.

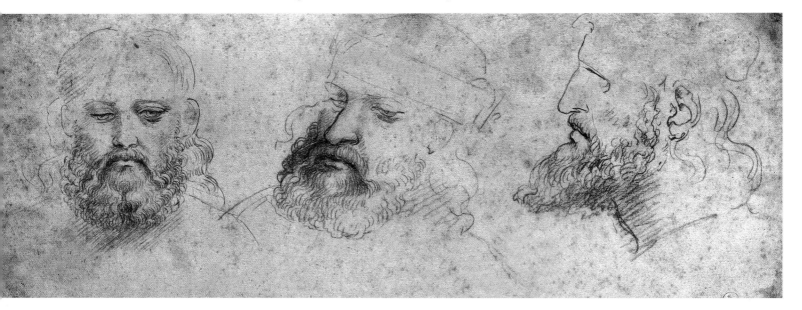

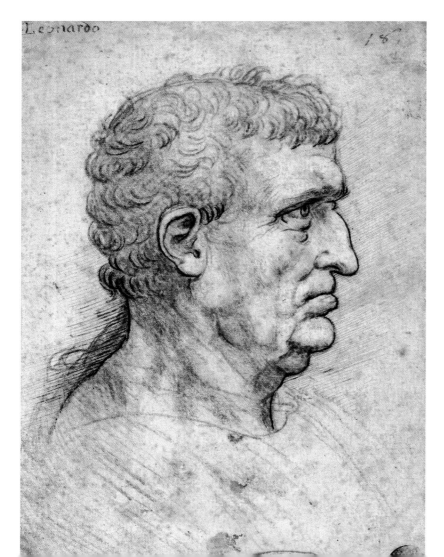

Head of a man in profile, *c.*1506–8, pencil and red chalk on paper, Galleria dell'Accademia, Venice, Italy, 14.7 x 10.4cm (5.8 x 4.1in)

A carefully drawn head of an older man in profile, one of several studies of this model drawn by Leonardo. The hair is short and the artist has paid attention to the style and cut. The profile illustrates a pronounced nose and a jutting chin with loose folds underneath.

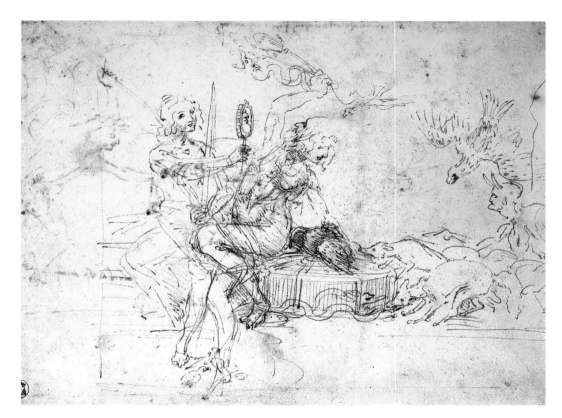

Allegory of Statecraft (Justice and Prudence), c.1490–4, pen and ink on paper, Christ Church, Oxford, 20.5 x 28.5cm (8.1 x 11.2in)

The virtues of Justice and Prudence represent Ludovico Sforza defending Milan. On the left 'Justice' holds a sword and a mirror. To her left, seated, is 'Prudence' with a double head and body, which is half male, half female. In her left arm she holds a cockerel, in her right, a serpent (an emblem of Milan). To the right, a pack of wild dogs (or wolves), unleashed by a satyr, hurtle toward the seated pair.

Allegory of River Navigation, 1508–16, red chalk on paper, Royal Library, Windsor Castle, UK, 17 x 28cm (6.7 x 11in)

This drawing may be an allegory of river navigation, a subject that intrigued Leonardo. He spent much time studying the waterways around Florence and Rome. In the drawing to the left sits a wolf steering a small boat with a wind-filled sail, being blown toward land. On the right a radiant eagle with a crown above its head stands on dry land perched on a globe of the world. The meaning of the allegory is unknown.

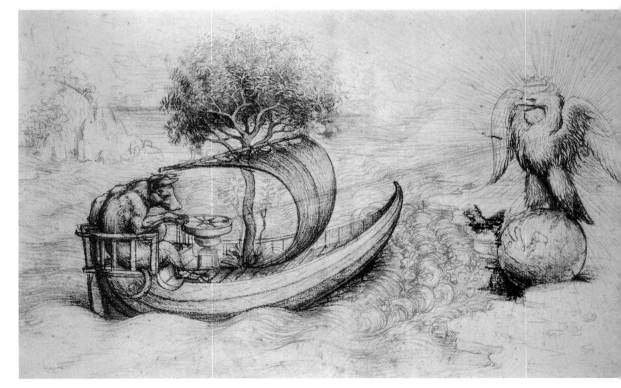

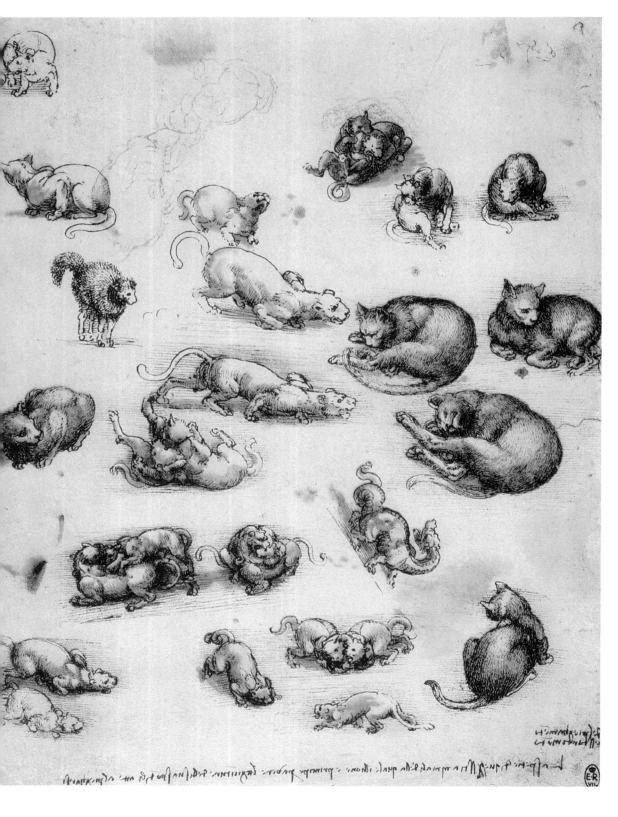

Studies of cats and lions, c.1513–14, pen and ink with wash over black chalk on paper, Royal Library, Windsor Castle, UK, 27.1 x 20.4cm (10.7 x 8in)

These drawings illustrate cats and lions in a variety of positions, from grooming to fighting, to resting and with hackles risen in response to an unseen prey or predator. The studies were probably one part of Leonardo's planned treatise on the nature of movement in animals and humans. The text at the base states, 'On bending and extension. This animal species of which the lion is the prince, because the joints of its spinal cord are bendable.'

Studies of horses, a cat, and a dragon fight, *c.*1513–14, pen and ink over black chalk on paper, Royal Library, Windsor Castle, UK, 29.8 x 21.2cm (11.7 x 8.3in)

The sheet of studies highlights Leonardo's expressive imagination and brings together favourite themes: the illustration of horses in action, Leonardo's passion; a drawing of a cat; and a variety of mythical combats between a dragon and a horseman. This is one of many of Leonardo's sheets of drawings of animals.

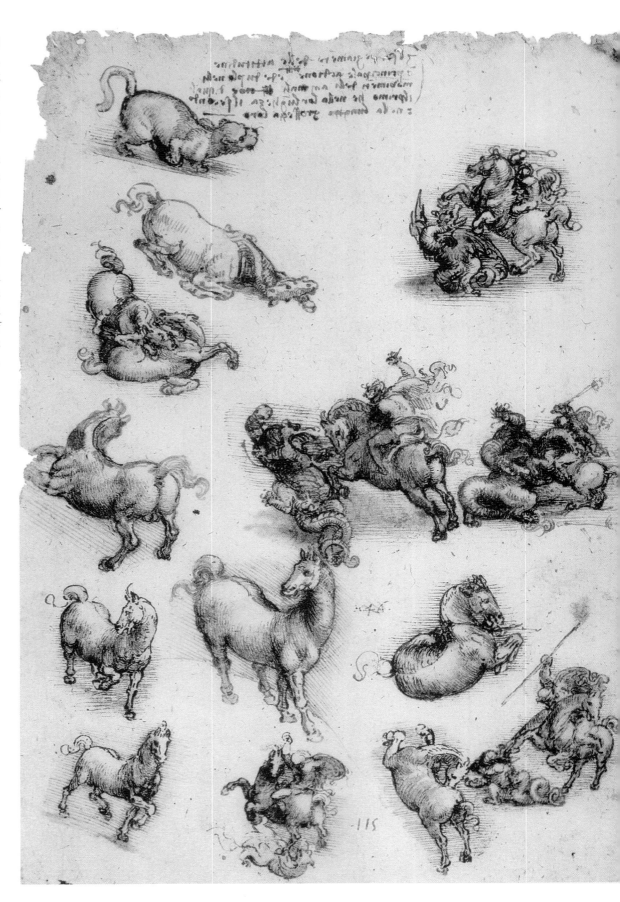

Studies for the Trivulzio monument, c.1508–11, pencil on paper, Royal Library, Windsor Castle, UK, 28 x 19.8cm (11 x 7.8in)

After the cancellation of the Sforza statue Leonardo was approached by Gian Giacomo Trivulzio, the leader of the victorious French troops in the siege of Milan in 1499, to create an equestrian funerary monument for him. Leonardo planned to adapt the Sforza model. The tomb was to be based on the equestrian statues of antiquity. Four nude sculptures were planned to stand at the base of each corner. The monument was never realized.

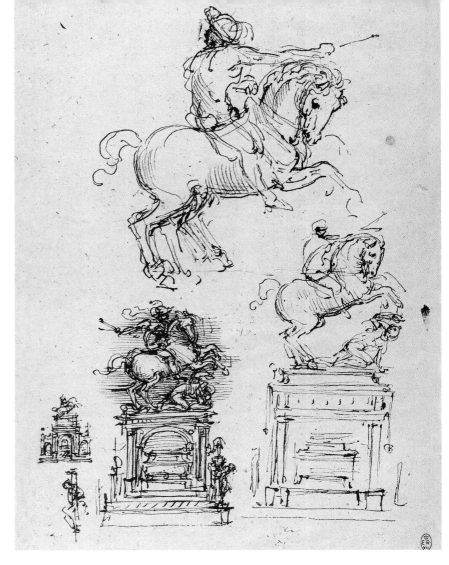

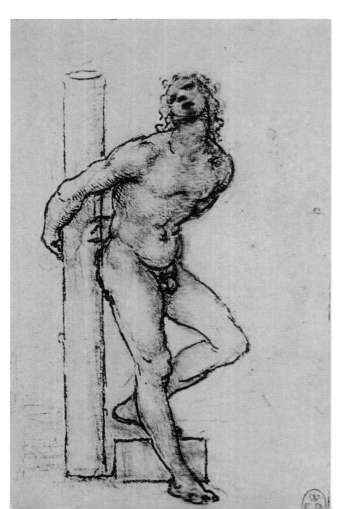

Study of a nude for the Trivulzio monument, c.1508–11, red chalk over metalpoint on paper, Royal Library, Windsor Castle, UK 11.0 x 6.8cm (4.3 x 2.7 in)

This study relates to a drawing of the martyr St Sebastian by Leonardo da Vinci. In addition, in 1505–6, Michelangelo Buonarroti designed a memorial tomb for Pope Julius II, decorated with 40 life-size marble sculptures, many of them nude, and based on the sculptures of classical antiquity. This study has a similar pose to Michelangelo's 'slave' sculptures for the tomb.

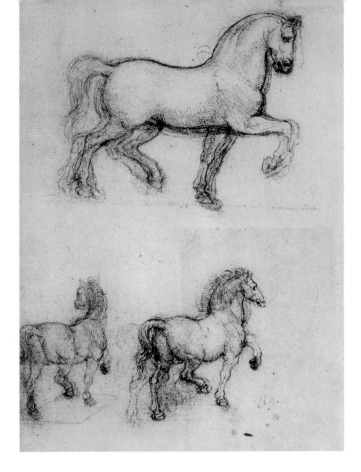

Three studies of horses, c.1508–11, pen and ink over black chalk on paper, Royal Library, Windsor Castle, UK, 20.3 x 14.3cm (8 x 5.6in)

Three studies of a prancing horse are preparatory sketches for the Trivulzio

equestrian funerary monument. The original design for the Sforza monument was to create a gigantic horse rearing up. Due to difficulties in casting it, the design was changed to a prancing horse, a design that was continued for the Trivulzio monument.

Study for an equestrian monument, c.1508–11, pen and ink and red chalk on paper, Royal Library, Windsor Castle, UK, 21.7 x 16.9cm (8.5 x 6.7in)

A study for an equestrian funerary monument to

Gian Giacomo Trivulzio, never realized. It is notable that at this time, Michelangelo, in Rome, had created a design for a monumental tomb for Pope Julius II with 40 life-size sculptures, including nude figures.

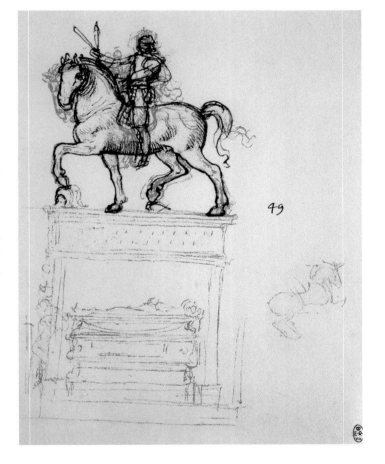

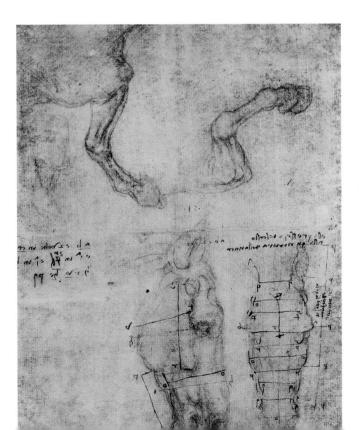

Study of the proportions of a horse's head, c.1508–11, black chalk on red prepared paper, Royal Library, Windsor Castle, UK, 27.5 x 19.7cm (10.8 x 7.8in)

A detailed page of drawings, showing, in the lower half, the front and side view of a horse's head with detailed

proportions marked in; and in the upper half, drawings of a horse's forelegs. The drawings are possibly linked to a commission for an equestrian monumental sculpture. The beautiful horse's head, one of several made at this time, is marked out, in mathematical proportions.

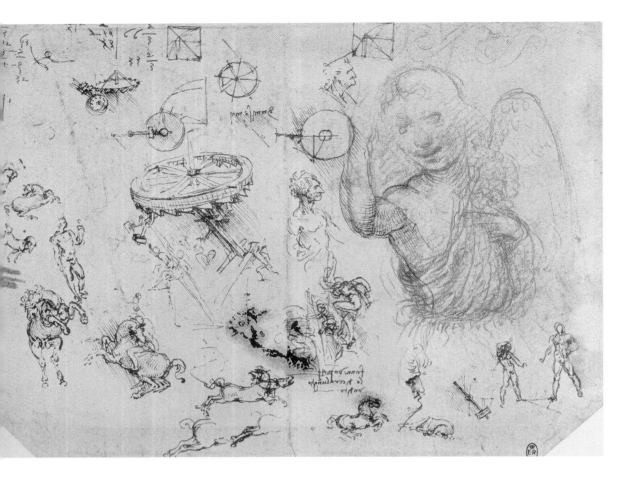

Studies of horses, figures and machines and an angel, pen and ink on paper, Royal Library, Windsor Castle, UK, 21 x 28.3cm (8.3 x 11.1in)

The figure that dominates this sheet of studies is of an angel, looking toward the viewer and pointing upward. Stylistically, historians consider it the work of an apprentice. Also on the sheet are Leonardo's small sketches of machines, horses, and male figures. Interest in the angel lies in its similarity to the pose in Leonardo's painting of *St John the Baptist, c.*1513–16 (or earlier), and the figure in the painting titled *Bacchus, c.*1513–16 (or earlier).

Sketch of Hercules and the Nemean lion, *c.*1504–8, pencil on paper, Palazzo Reale, Turin, Italy 18 x 19cm (7.1 x 7.5in)

A note written by Leonardo, dated 10 March 1500, on the obverse side of a drawing of Hadrian's mausoleum in Tivoli, simply states, 'A Roma. A Tivoli Vecchio, casa d'Adriano.' (*Codex Atlanticus*, fol. 618v). The journey may have been taken in 1501, in line with the Florentine calendar. Leonardo studied the ancient Roman monuments and sculptures.

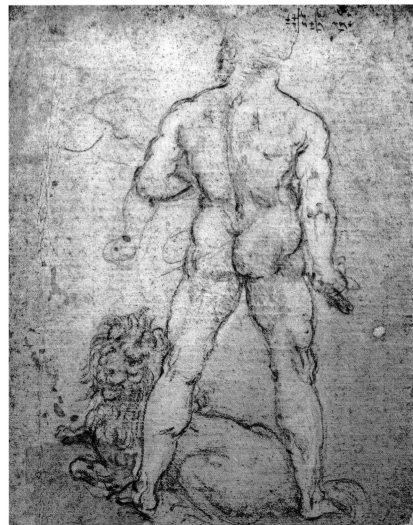

Study of a man shouting and of a profile, 1503–4, black and red chalk over metalpoint on paper, Szépmüvészeti Múzeum, Budapest, Hungary, 19.1 x 18.8cm (7.5 x 7.4in)

Two studies for the *Battle of Anghiari*, the drawing to the left possibly created for the head of Condottiere Niccolò Piccinino, the leader of the Milanese troops. In his notes on 'how to represent a battle' Leonardo wrote, 'Let the sides of the nose be wrinkled in an arch, starting at the nostrils and finishing where the eyes begin. [Show] the flared nostrils which cause these crease lines, and the lips arched to reveal the upper teeth, and the teeth parted, as if to wail…'

Head of a Warrior, after Leonardo da Vinci, black chalk on greyish paper, Ashmolean Museum, Oxford, UK, 50.5 x 37.5cm (19.9 x 14.8in)

A copy, after Leonardo da Vinci, which depicts the head of Condottiere Niccolò Piccinino (1386–1444), the mercenary leader of the Milanese troops, fighting for the Sforza family at the Battle of Anghiari, which he lost. Piccinino is depicted in full battle cry. He wears distinctive headwear. As the centrepiece of the painting, Leonardo placed the figure of Piccinino on horseback, raising his sword. This drawing is a copy of Leonardo's cartoon created for the *Battle of Anghiari* painting.

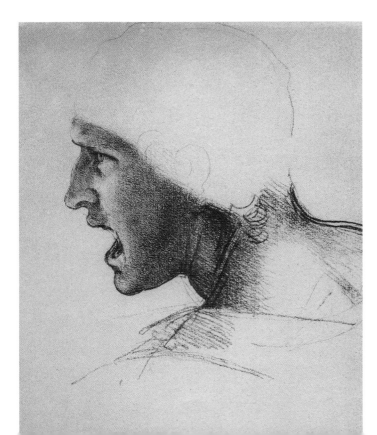

Study of a man shouting in profile to the left, 1503–4, red chalk on paper, Szépmüvészeti Múzeum, Budapest, Hungary, 22.7 x 18.6cm (8.9 x 7.3in)

A study for the *Battle of Anghiari* painting. The painting was Leonardo's recreation of a battle fought between soldiers of the Italian League, which included the Florentines, against Lombardy and the Milanese.

Studies of horsemen in combat, *c.*1503–4, pen and brown ink on paper, British Museum, London, UK, 8.2 x 12cm (3.2 x 4.7in)

Various equestrian studies for the *Battle of Anghiari,* including at the top of the page, one horseman charging with a spear. Leonardo was commissioned in late 1503 to paint a vast battle scene to commemorate a Florentine victory over the Milanese, at the battle of Anghiari, June 1440. It was painted in the Salone dei Cinquecento of the Palazzo della Signoria (now Palazzo Vecchio), Florence.

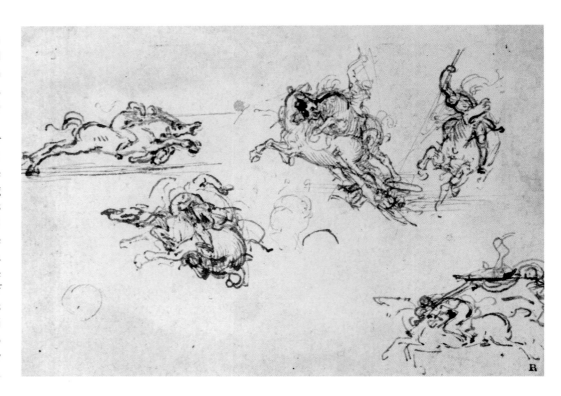

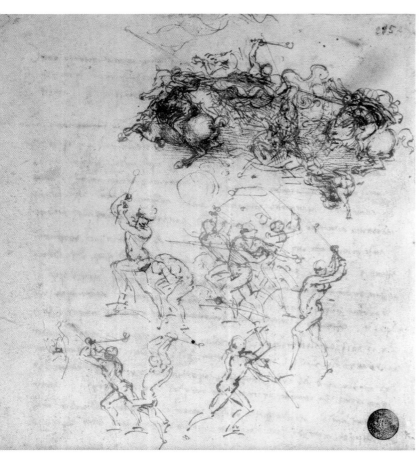

Study of horsemen in combat and foot soldiers, 1503, pen and ink on paper, Gallerie dell'Accademia, Venice, Italy, 10.1 x 14.2cm (4 x 5.6in)

The Battle of Anghiari, which involved troops of foot soldiers and horsemen from both sides, was fought on land between the walled city of Anghiari and San Sepolcro, on 29 June 1440. The Italian League (including Florentines) were victorious. The painting, commissioned by the Signoria of Florence, was to commemorate this victory. Another battle victory for the Florentines, the Battle of Cascina, was commissioned by the Signoria, to be painted by Michelangelo.

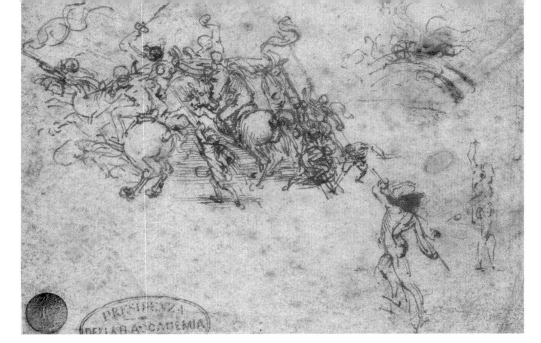

Study of horsemen in combat and foot soldiers, *c.*1503, sepia ink on linen paper, Gallerie dell'Accademia, Venice, Italy, 10.1 x 14.2cm (4 x 5.6in)

One of a series of preparatory sketches, probably for the *Battle of Anghiari* painting. The small drawing reveals a group of mounted horsemen engaged in combat, interspersed with foot soldiers. There is a separate sketch of a bridge.

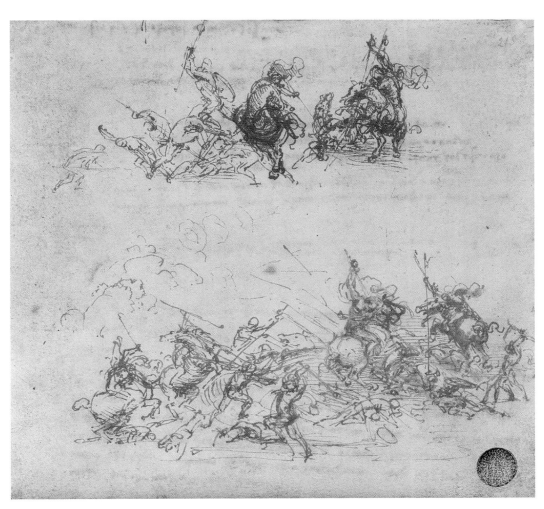

Study of horsemen in combat and foot soldiers, 1503, pen and ink on paper, Gallerie dell'Accademia, Venice, Italy, 14.5 x 15.2cm (5.7 x 6in)

A study for the *Battle of Anghiari* painting, illustrating foot soldiers and horsemen in combat. The unfinished painting of the battle remained on the wall of the Salone dei Cinquecento for 50 years. Its rapid deterioration, due to the paint materials used by Leonardo, finally saw the work replaced by a battle scene painted by Giorgio Vasari. There is a possibility that the *Battle of Anghiari* painting remains in a recessed space behind Vasari's painting.

Study of a male nude from the front, *c*.1503–7, red chalk, pen and ink on paper, Royal Library, Windsor Castle, UK, 23.6 x 14.6cm (9.3 x 5.7in)

A possible study for the male figures in the *Battle of Anghiari* painting. The muscular figure of the nude corresponds to Florentine interest in the statuary of ancient Rome, particularly pieces discovered and displayed during Pope Julius II's renovation of the Vatican Palace from 1503.

Study of a male nude from behind, *c*.1503–7, red chalk on paper, Royal Library, Windsor Castle, UK, 27 x 16cm (10.6 x 6.3in)

This drawing of a male nude seen from behind is thought possibly to be another of Leonardo's sketches for the *Battle of Anghiari*. At the time this drawing was created Michelangelo's giant freestanding marble sculpture *David* (1501–4) was the sensation of the city of Florence. Interest lay in the idealized human figure, based on the antique Greek and Roman sculptures.

Figure of a man in masquerade costume, *c.*1513–18, black chalk, pen with black and brown ink and wash on paper, Royal Library, Windsor Castle, UK, 27 x 18.1cm (10.6 x 7.1in)

The masquerade costume drawings created by Leonardo are difficult to date precisely. There is a possibility that some designs were created for a triumphal visit to Florence by Pope Leo X in 1515. However, after the artist's permanent move to France in 1516, he created designs for theatre scenery and costumes, and costumes for the many masquerade balls held by the French king, Francis I. This drawing illustrates a costume for a masquerader dressed as an exotic pikeman.

A study for the costume of a masquerader, *c.*1513–18, black chalk and pen and ink on paper, Royal Library, Windsor Castle, UK, 21.5 x 11.2cm (8.5 x 4.4in)

One of several costumes designed for masquerade balls held by the nobility.

In Leonardo's latter years he found it increasingly difficult to paint. He devoted his time to designing a new castle for King Francis I, and creating many designs for royal wedding celebration extravaganzas, costume balls and theatrical stage sets.

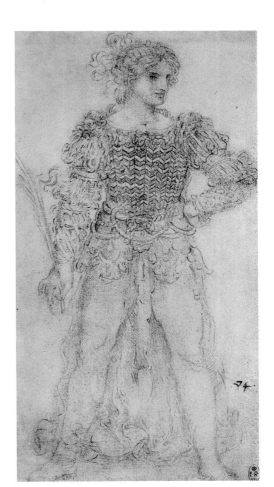

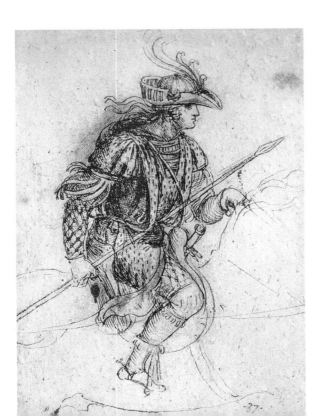

A masquerader on horseback, *c.*1513–18, pen and ink over black chalk on rough paper, Royal Library, Windsor Castle, UK, 24.0 x 15.2cm (9.4 x 6in)

Leonardo has devised a sensational costume for a masquerade rider. The costume is a combination of richly striped and checked fabrics, with quilting and decorative ribbons. It is unclear if Leonardo discussed the costume designs with the makers of the costumes.

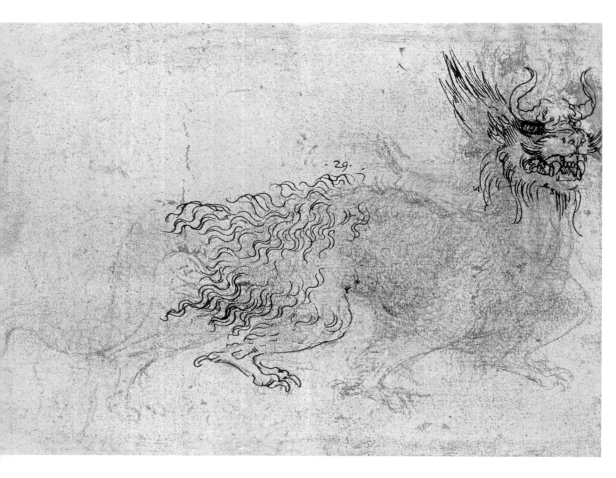

Drawing of a dragon,
c.1515–17, black chalk,
pen and ink on paper,
Royal Library,
Windsor Castle, UK,
18.8 x 27.1cm (7.4 x 10.7in)

A fabulous dragon, possibly
a drawing for one of the
celebratory festivities for
which Leonardo created set
decorations, costumes and
mechanical objects.

Bust of a masquerader
in right profile,
c.1517–18, black chalk,
rubbed with red chalk on
paper, Royal Library,
Windsor Castle, UK,
17 x 14.6cm (6.7 x 5.7in)

A drawing of a figure in
right profile, possibly a
masquerader. The costume is
a high-waisted dress. The
hair is worn up and dressed
with plaiting and braiding,
wound round the head and
tied. The gender of the
figure is ambiguous: although
pictured in a dress, the facial
features are mannish.

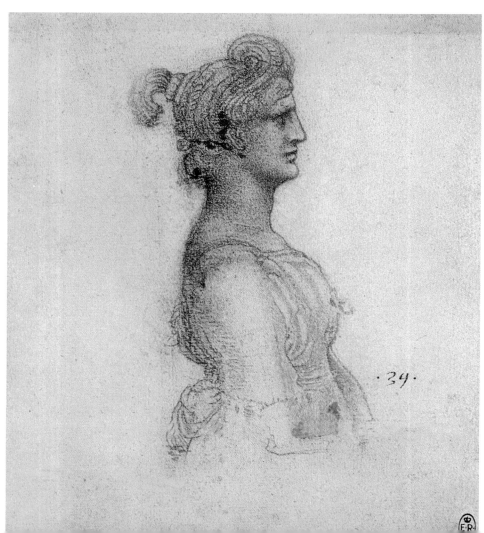

Drawing of three emblems, *c.*1508–10, pen and ink with wash, and blue body colour over black chalk on paper, Royal Library, Windsor Castle, UK, 26.9 x 19.5cm (10.6 x 7.7in)

During his second residency in Milan, as court artist to the French occupying the city, Leonardo was asked to design several emblems on the theme of constancy. The emblem at the top of the paper depicts a plough with the Latin words *hostinato rigore* ('obstinate rigour'). The middle emblem illustrates a compass placed on a permanently turning waterwheel. The lower emblem depicts a candle in a lantern. It remains aglow, in spite of the blowing winds, which come from all directions.

Studies of violets (Paris Manuscript B, fol. 14r), *c*.1487–90, pen and wash on paper, Bibliothèque de l'Institut, Paris, France, 23.3 x 16.8cm (9.2 x 6.6in)

A beautiful study of violas (*Viola bertolonii*) with possibly a drawing of *Viola canina*, a heath violet, too, both drawn on a page later filled with text.

St John the Baptist, *c*.1475–85, metalpoint with white heightening on blue prepared paper, Royal Library, Windsor Castle, UK, 17.8 x 12.2cm (7 x 4.8in)

This drawing is considered to be a preparatory study for a figure of St John the Baptist. The nude, most probably a life drawing, holds a staff in his left hand and points downward with his right hand. The youthful male looks out toward the viewer. Historians consider that his stance relates to the figure of St John the Baptist in an altarpiece, *Madonna di Piazza*, *c*.1475–85, in Pistoia cathedral, Italy, by Lorenzo di Credi, who worked for Andrea del Verrocchio alongside Leonardo.

Head of an old bearded man in right profile, *c.*1513–18, black chalk on paper, Royal Library, Windsor Castle, UK, 21.3 x 15.5cm (8.4 x 6in)

This detailed drawing of the head of an old man in right profile is possibly a self-portrait by Leonardo. The head of hair is thinning, but long strands of it are plaited and braided and tied at the nape of the neck, giving an exotic, eastern look to the sitter's demeanour. The profile reveals a man with a pronounced nose and bushy eyebrows. The neck is muscular, just glimpsed behind the lengthy, full beard.

Old man in right profile, seated, and water studies, *c.*1513–18, pen and ink, Royal Library, Windsor Castle, UK, 15.2 x 21.3cm (6 x 8.4in)

The facial features of the old man in right profile are similar to the formal portrait drawing 'Head of an old bearded man in right profile', *c.*1513–18 (above). He is seated with legs crossed at the knee, resting on a raised seat against a tree trunk. His left hand is raised to his face and the right hand leans on his walking stick. He looks ahead. To the right of the figure are three water studies, illustrating the flow of swirling water.

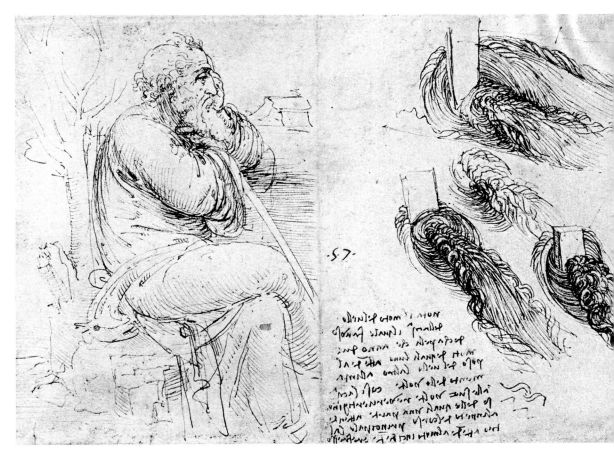

Study of a man, 1485–1518, pencil on paper, attributed to Leonardo da Vinci, Biblioteca Ambrosiana, Milan, Italy, 10.8 x 5.4cm (4.3 x 2.1 in)

Attributed to Leonardo, this nude figure study is of a man in left profile, bending from the waist. His left arm follows the line of the staff that he holds with his left hand. The weight of the staff rests on his left shoulder. The right arm is crooked, and the hand points toward an unseen person or object. Leonardo made many sketches of figures in a variety of poses. On the posing and depiction of limbs, he stated that 'limbs which are subject to labour must be muscular'. In this drawing the man is stooped and muscular, possibly to denote manual labour.

Studies of two heads in profile and studies of machines, December 1478, pen and ink on paper, Gabinetto dei Disegni e delle Stampe, Galleria degli Uffizi, Florence, Italy, 20.2 x 26.6cm (8 x 10.5in)

Dated December 1478, in Leonardo's right-to-left 'mirror-image' handwriting, the sketches of two heads, drawn in the midst of machinery designs, offer another comparison of old age and youth, a theme which continually appears in Leonardo's drawings. On the left, the use of dense shading adds realism to the lined face of the tousle-haired man, drawn in profile. In contrast, the profile of the youth is sketched in simple outline.

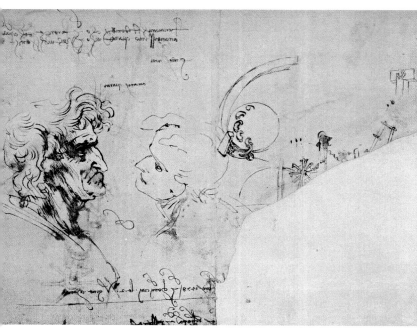

Study of a hand, c.1483–1503, red chalk on paper, Gallerie dell'Accademia, Venice, Italy, 22 x 13.9cm (8.7 x 5.5in)

Detailed in observation, this study of a hand with its long-jointed fingers is attributed to Leonardo. It links in style to his beautifully observed study of hands, c.1474–8, in the Royal Library, Windsor, and a preparatory work for the angel in the first version of the *Virgin of the Rocks*, 1483–6.

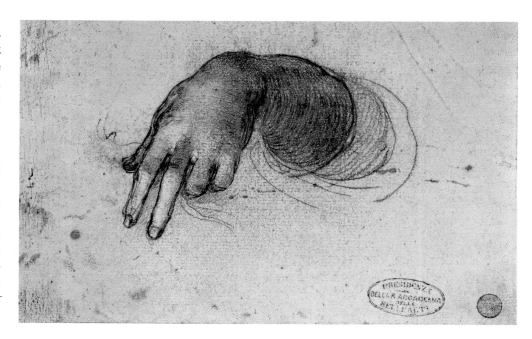

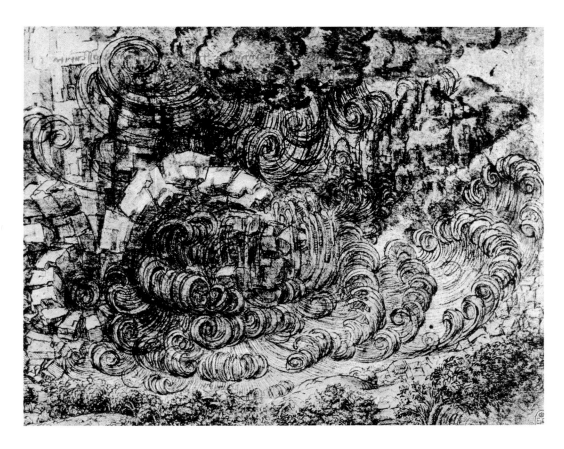

Mountain range burst open by water, c.1515–19, pen and brown and yellow ink, over black chalk on paper, Royal Library, Windsor Castle, UK, 16.2 x 20.3 cm (6.4 x 8in)

Leonardo made many studies of water, particularly when in forceful movement. In France, for King Francis I, one of his commissions was to look into the construction of canals and the diversion of canal waters. In this drawing the artist-engineer is studying the effect of a large volume of water, which has forced the rocks of a mountain range to burst open. The drawing includes the waves created by the boulders falling into a lake.

Storm clouds over a flooded landscape, c.1517–18, pen and ink and brown wash over black chalk, Royal Library, Windsor Castle, UK, 15.6 x 20.3cm (6 x 8in)

Leonardo's drawing depicts thunderous storm clouds releasing a deluge of water over a wooded hill. The strength of the rainwater bends trees in its pathway. The landscape and trees are submerged. This is one of many drawings created by the artist that illustrate cloud formation and deluges created by heavy storms, a continuing fascination for him.

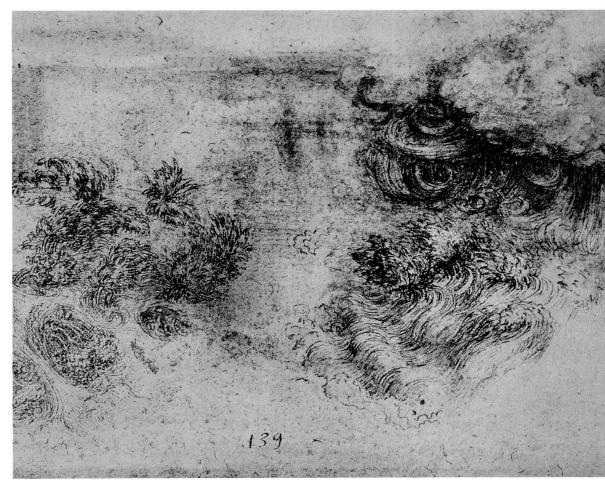

Stream running through a rocky ravine, *c.*1470–85, pen and ink on paper, Royal Library, Windsor Castle, UK, 22 × 15.8cm (8.6 × 6.2in)

This drawing depicts rock formations of eroded sandstone. Leonardo incorporated similar dramatic rock formations into several paintings including the *Virgin of the Rocks*, the portrait *Mona Lisa*, and the *Virgin and Child with St Anne*. From his earliest sketches we can see that Leonardo was greatly interested in the natural landscape. In this drawing, a stream is visible at the base of the rocks with two waterfowl in the foreground.

Study of the plant 'Job's Tears', *c.*1508–10, pen and ink over traces of black chalk on paper, Royal Library, Windsor Castle, UK, 21.2 × 23cm (8.3 × 9in)

This carefully detailed drawing of the plant known as 'Job's Tears' (*Coix lachrymal jobi*) is possibly a preparatory study for the wild plants that featured in Leonardo's now lost painting, *Leda and the Swan*. In this drawing Leonardo's great skills as a draughtsman are evident, in his close attention to detail and use of light and shade to create a vibrant sense of realism.

Study of a branch of blackberries, *c.*1505–8, red chalk with touches of white heightening on pink prepared paper, Royal Library, Windsor Castle, UK, 15.5 × 16.2cm (6.1 × 6.4in)

One of several detailed studies of wild plants and bushes created by Leonardo. Each drawing highlights his careful observation of natural plant life. This depiction of a spray of blackberries on a leafy branch was perhaps a study for a painting.

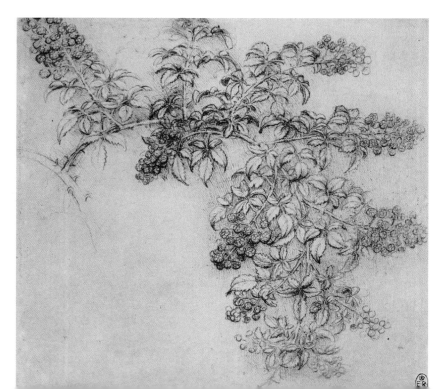

Study of a tree, c.1498–1508, red chalk on paper, Royal Library, Windsor Castle, UK, 19.1 x 15.3cm (7.5 x 6in)

Leonardo discussed the art of drawing trees in his treatise on painting, advising an artist to observe nature closely. The text under this drawing states, 'The part of a tree which has shadow for background is all of one tone, and wherever the trees or branches are thickest they will be darkest, because there are no little intervals of air. But where the boughs lie against a background of other boughs, the brighter parts are seen lightest and the leaves lustrous from the sunlight falling about them.'

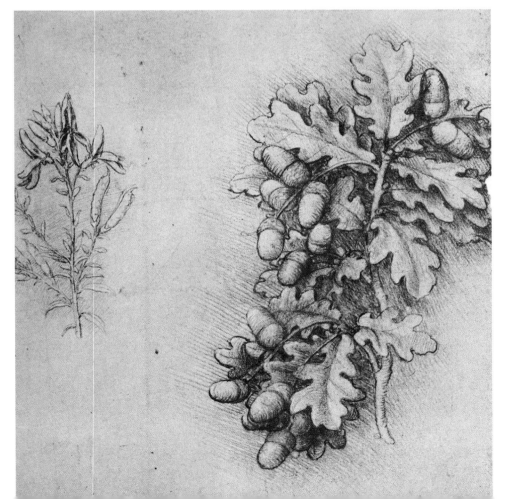

Fruiting branch of common oak and dyer's greenweed, c.1506–8, red chalk with traces of white heightening on pale red prepared paper, Royal Library, Windsor Castle, UK, 18.8 x 15.4cm (7.4 x 6.1in)

Leonardo's plant studies reveal a close observation of botanical differences between species. On the left, his study of dyer's greenweed (*Genista tinctoria*) highlights the sparsity of its leaves and fruit pods when compared to the robust foliage and fruit on a branch of common oak (*Quercus rober*), pictured right. Using a technique of red chalk on paper with an orange-red coating, Leonardo achieves a heightened sense of realism in his use of dense shading.

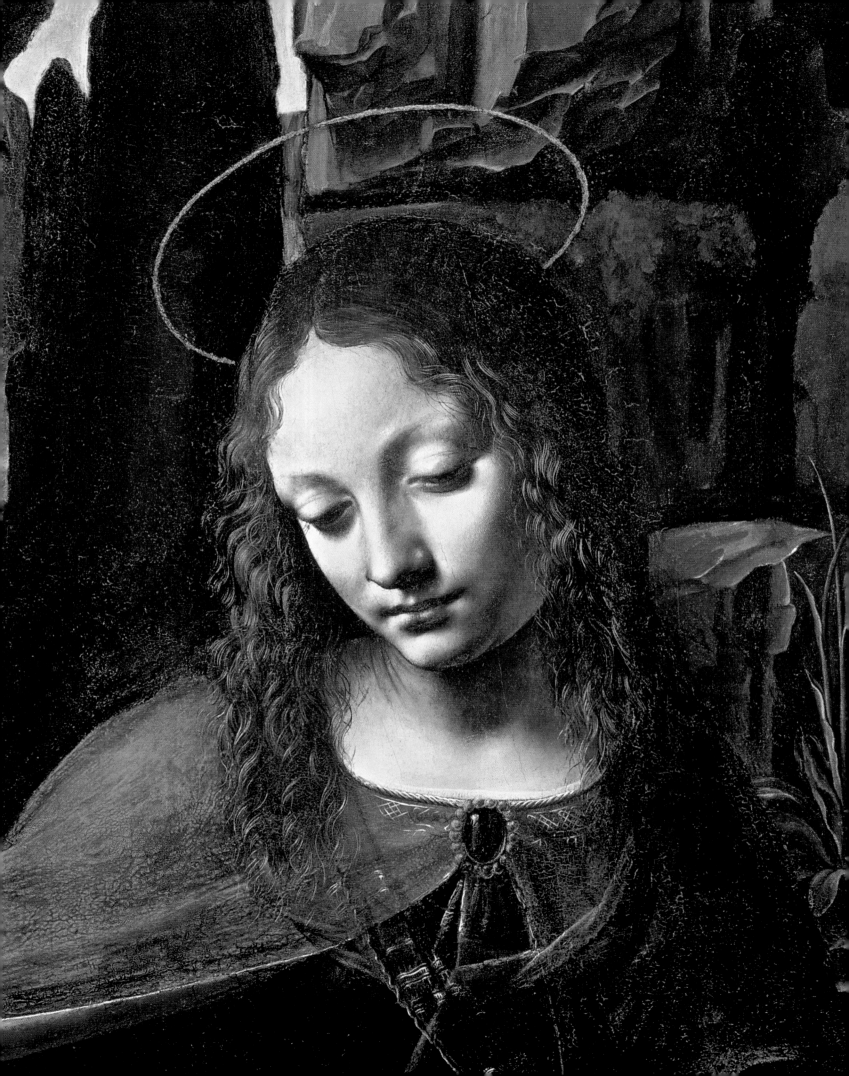

Paintings

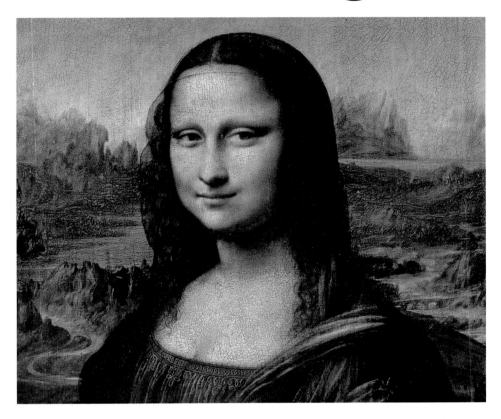

Scholars consider 22 paintings by Leonardo to be in existence, from a collection of about 30 works. The diverse subject matter of his paintings depended on his wealthy patrons. During a seventeen-year period living in Milan and working for Ludovico Sforza, Leonardo produced the *Virgin of the Rocks* in two versions, exquisite portraits of the Duke's mistresses, and the remarkable painting, *Last Supper*. Lost works, such as the vast painting of the Battle of Anghiari, and smaller works such as *Leda and the Swan*, are known to us through copies and Leonardo's own preparatory work. On his death in 1519, Leonardo's personal possessions included the *Mona Lisa*, possibly the most recognized artwork in the world.

Above: Mona Lisa, c.1503–6 (detail). *The Mona Lisa seems to gaze intimately at the viewer. The portrayal of Lisa Gherardini, 'Monna Lisa del Giocondo', is by far Leonardo's most famous work. Left:* Virgin of the Rocks, c.1508 (detail). *Leonardo sublimely portrays the demure face of the young Virgin Mary. A golden halo, missing from the first version of the painting, crowns her head.*

Dreyfus Madonna, Andrea del Verrocchio workshop, with Leonardo da Vinci, c.1469, oil on panel, Kress Collection, National Gallery of Art, Washington, DC, USA, 15.7 x 12.8cm (6.2 x 5in)

The *Dreyfus Madonna*, also known as The *Madonna with a Pomegranate*, is a tiny panel painting produced by Andrea del Verrocchio's workshop, which is thought to include work by the hand of Leonardo da Vinci. The question of attribution remains contentious as some historians believe it to be a sole work of Leonardo, others that is it is by another pupil, Lorenzo de Credi. The handling of the face and hands of the Madonna and Child is in Leonardo's style.

Dreyfus Madonna, detail

The hand of the Madonna holding the pomegranate is finely painted. The hand of the infant Christ touches the pomegranate. Both illustrate the style of Leonardo. The pomegranate fruit is a Christian symbol of the Resurrection of Christ, taken from the classical myth of Proserpine, who returned to Earth each spring, to regenerate the land. In religious iconography, as a symbol of the Resurrection, the pomegranate is held by the infant Christ.

Virgin and Child with Two Angels, **Andrea del Verrocchio workshop, with Leonardo da Vinci,** *c.*1470–3, oil on panel, National Gallery, London, UK, 96.5 x 70.5cm (38 x 27.8in)

This painting is attributed to Andrea del Verrocchio and his workshop. The depiction of the lily and stem held by the angel to the left is considered to have been painted by Leonardo. In addition, the rock formations in the background, above the head of the angel to the right, are probably the work of Leonardo.

Tobias and the Angel, by Andrea del Verrocchio workshop, with Leonardo da Vinci, 1470–80, tempera on poplar, National Gallery, London, UK, 83.6 x 66cm (32.9 x 26in)

A young boy, Tobias, is sent on an errand by his father to a distant town. He looks for a companion to walk with him and is accompanied by a guardian angel, in the guise of a young man. Along the way, the angel finds a cure for Tobias' father's blindness. This painting is thought to be the work of Andrea del Verrocchio's workshop, which included Leonardo da Vinci.

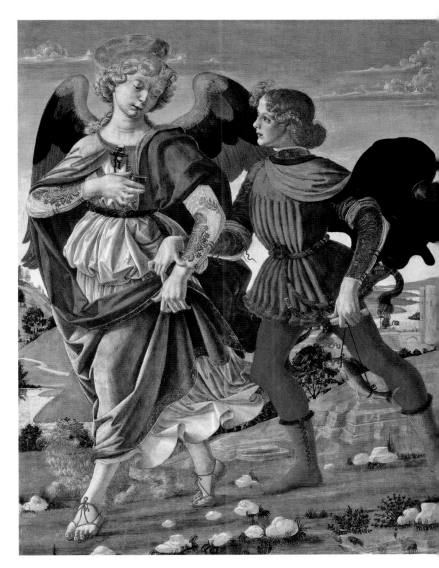

Tobias and the Angel, detail

Verrocchio's workshop would include artists who had finished their apprenticeship and continued to work for him, plus the apprentices with the most talent for painting.

Leonardo is considered to have contributed to this painting. The figure of the small fluffy dog, which runs alongside Tobias and the angel, displays characteristics of Leonardo's style and is considered to be his work.

Lady with a Bunch of Flowers,
Andrea del Verrocchio,
1475–80, marble, Museo
Nazionale del Bargello,
Florence, Italy,
height 61cm (24in)

This astonishingly life-like
portrayal of a young lady
holding a small posy of
flowers, possibly violets,
demands close comparison
with Leonardo da Vinci's
'Studies of hands and arms'.
It is possible that Leonardo
was involved with the
preparatory drawings for the
sculpture, or that the hands
of Verrocchio's sculpture
were copied by Leonardo.
Historians believe that the
marble sculpture might be a
portrayal of Ginevra de'
Benci, for whom Leonardo
painted a portrait.

Studies of hands and arms,
c.1478, metalpoint on
reddish prepared paper,
Royal Library,
Windsor Castle, UK,
21.5 x 15cm (8.5 x 5.9in)

Leonardo's portrait of
Ginevra de' Benci originally
included a portrayal of the
sitter's arms and hands in the
lower portion of the
painting, since removed.
These studies of beautiful
hands illustrate Leonardo's
attention to detail in his
preparatory drawings. The
placement of the hands
bears resemblance to
Andrea del Verrocchio's
marble bust sculpture,
Lady with a Bunch of Flowers,
on which his studies are
possibly based.

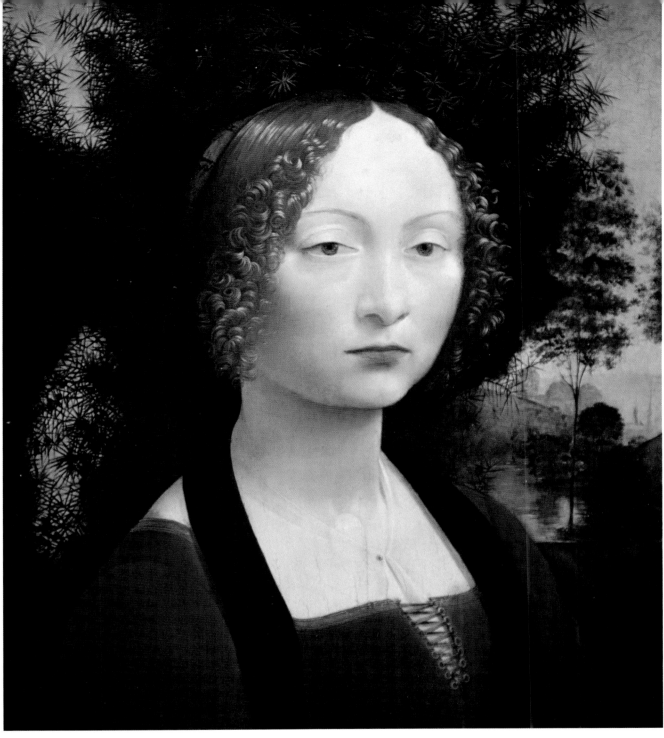

**Portrait of Ginevra de' Benci,
1480, tempera on panel,
National Gallery of Art,
Washington, DC, USA,
38.8 x 36.7cm (15.3 x 14.4in)**

Ginevra de' Benci (1457–
c.1520) was the daughter
of an important Florentine,
Amerigo de' Benci. This
portrait was Leonardo's first
secular commission, which
allowed him to capture the
essence of the sitter,
surrounding her with
personal symbols of her
name – Ginevra, relating to
the juniper bush (ginepro),
and family heritage. Ginevra's
head is portrayed in a halo
created by the juniper bush
behind her, a symbol of
female virtue. She looks
directly at the viewer, as
though she is observing
the observer with a short
distance between the viewer,
the sitter, and the landscape
beyond. The style of the
painting was a departure
from traditional marriage
portraits, which usually
portrayed the sitter in
profile. The documentation
for this portrait leads
historians to believe that the
portrait was a marriage gift
to Ginevra from a platonic
friend and admirer of the
bride, Bernardo Bembo. In
the background of the
painting is one of Leonardo's
signature serene landscapes,
drawn in precise detail.
Leonardo uses his *sfumato*
technique to add a haze of
blue to the hills, to create an
illusion of distance and light.

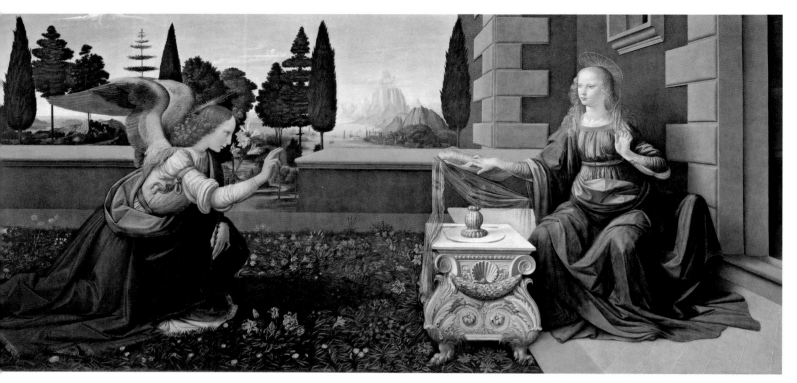

Annunciation, 1472–5, oil on panel, Galleria degli Uffizi, Florence, Italy, 98 x 217cm (38.6 x 85.4in)

The *Annunciation* was possibly created by Leonardo in Andrea del Verrocchio's workshop, on completion of his apprenticeship. The painting depicts the angel Gabriel, a messenger of God, bringing news that Mary, though a virgin, will conceive a son through the Holy Spirit (Luke I:28).

The awkwardness of the composition illustrates Leonardo in the process of learning to paint figures in perspective to objects and surroundings. The landscape is unusual in its inclusion of ships in a bay, which was not a scene Leonardo had depicted before.

The drapery on the figure of the Virgin is painted from a model. Careful attention has been paid to the clothing of the Virgin and the angel Gabriel, who wear contemporary Florentine dress. The fabric of the angel's sleeve is finely painted with attention to detail, including the tie of knotted silk tied around the upper arm.

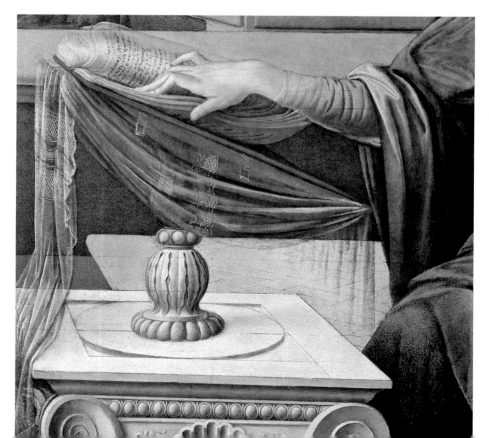

Annunciation, detail: table, stand and book

The fingers of the Virgin's right hand rest on an open page of the book she is reading. Leonardo uses this position as a device to show that the Virgin has been interrupted from her study. The text on the pages of her book is visible. The faux marble stand on which the lectern is placed is a direct copy of the decoration on Piero de' Medici's marble tomb in the church of San Lorenzo, Florence, carved by Leonardo's master, Andrea del Verrocchio.

Annunciation,
detail: the angel Gabriel

The figure of the angel Gabriel carries in his left hand a stem of the white lily flower, which is traditionally held by the angel Gabriel in depictions of the Annunciation. Alternatively, it is placed in a vase near to the figure of the Virgin. The wings of the angel illustrate Leonardo's close attention to naturalistic detail. He had cultivated a childhood interest and observation of birds and bird flight, to create a remarkable pair of feathered wings for the holy figure. The painting carries Leonardo's signature style of mixing and blurring the oil paint with his fingers and the palm of his hand, to create a soft, ambient effect.

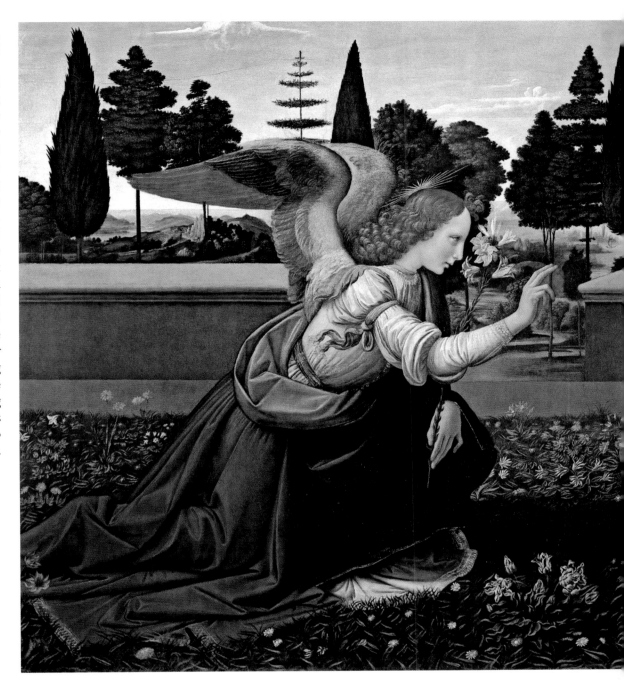

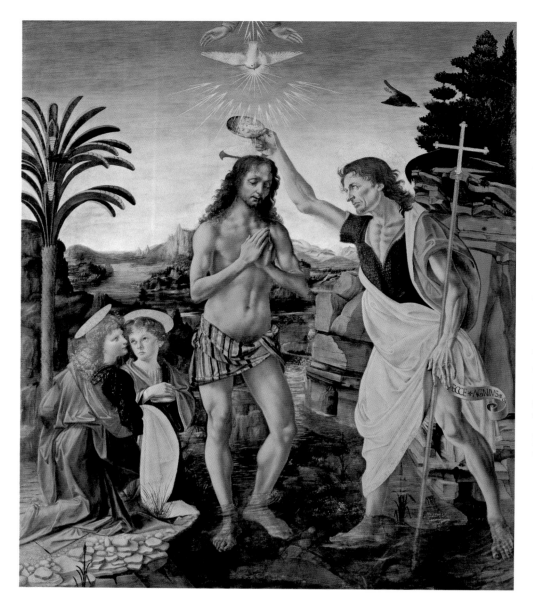

Baptism of Christ, Andrea del Verrocchio and Leonardo da Vinci, *c.*1475, oil and tempera on panel, Galleria degli Uffizi, Florence, Italy, 180 x 151.3cm (70.9 x 59.6in)

The *Baptism of Christ* is the work of Andrea del Verrocchio and his workshop. It is important in a history of Leonardo da Vinci due to his contribution of an angel, and possibly landscape too. Documentation refers to Verrocchio as the artist but states 'an angel by Leonardo'. It is the first work from the workshop where Leonardo is named and where one can see him break away from Verrocchio's style of painting to create his own signature style.

Baptism of Christ, detail

In Giorgio Vasari's 'Life' of the artist Andrea del Verrocchio, he comments on Leonardo's contribution to the painting of the *Baptism of Christ*, 'Leonardo… painted therein an angel with his own hand, which was much better than the other parts of the work, and for that reason, Andrea resolved never again to touch a brush, since Leonardo, young as he was, had acquitted himself in that art much better than he had done.' Leonardo's angel with back to the viewer kneels down and holds the clothes of Christ. The head is turned to reveal the young face in right profile. The angel looks toward the scene of Christ baptized by John the Baptist. The angel's face draws the viewer into the scene, to witness it also. Leonardo has paid careful attention to the face and long golden hair of the angel. The second angel, possibly painted by Sandro Botticelli, looks away from the scene.

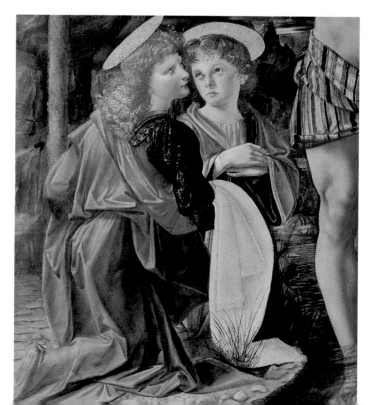

Madonna with the Carnation, c.1472–8, tempera and oil on poplar, Alte Pinakothek, Munich, Germany, 62 x 47.5cm (24.4 x 18.7in)

Verrocchio may have been the artist who created the original design for this work, but the painting is attributed to Leonardo by historians. The Madonna's hair is braided and styled in contemporary Florentine fashion away from her face, to accentuate her translucent skin and long neck, a symbol of beauty. She also wears contemporary Florentine clothing. The richness of the colours of the fabrics shows a close attention to detail, in the dress and undershirt, particularly the layered sleeve design. The infant Christ is portrayed as a rounded, quite chubby, active baby. Behind the figures the artist has painted four windows. Through each, one can glimpse the landscape beyond the room, creating perspective and the illusion of the world beyond the private space occupied by the Madonna and Child. Through the left window is a view of mountains. The haze of blue (*sfumato*) above them creates an aerial perspective of the far-distance. The landscape continues through the windows to the right.

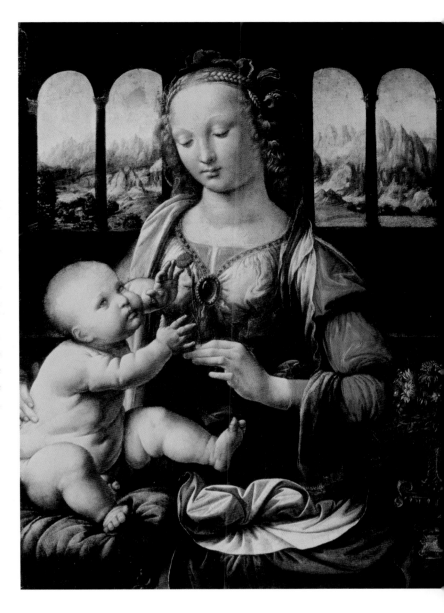

Madonna with the Carnation, detail

The carnation flower, particularly in the 15th and 16th centuries, was a symbol of betrothal when held in the sitter's left hand. In this painting it may be a reference to the marriage of Mary to Joseph, or a symbol of the Madonna's spiritual betrothal to God.

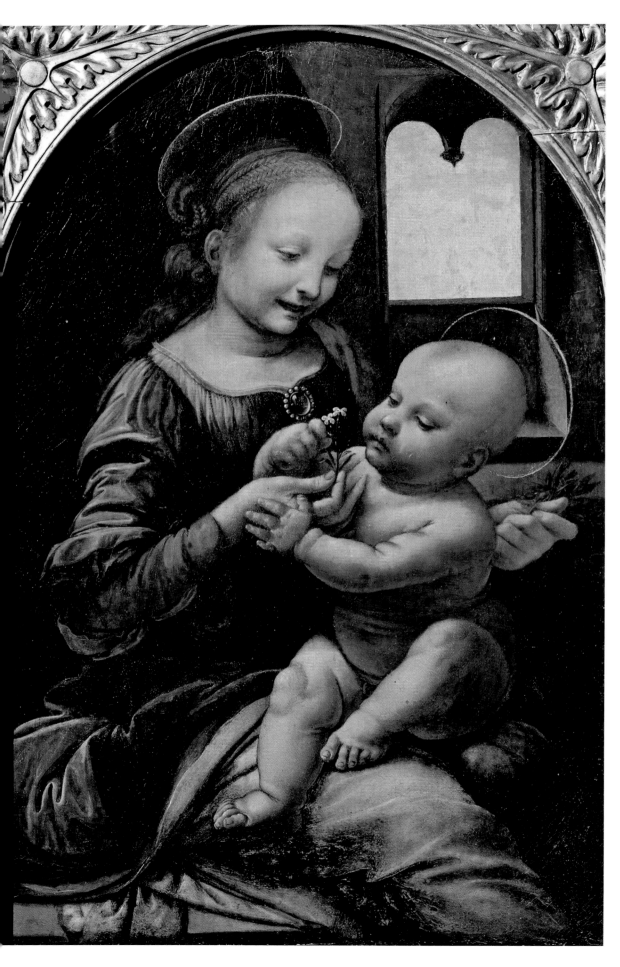

Madonna with a Flower ('Benois Madonna'), *c.*1478, oil on canvas, Hermitage Museum, St Petersburg, Russia, 49.5 x 31cm (19.5 x 12.2in)

Madonna with a Flower, also referred to as the 'Benois Madonna' after the name of the family who owned the painting in the early 20th century, is a portrait of the Madonna and Child in which the focus is on the symbolic flower held in the hand of the Madonna. Two sketch drawings, now in the British Museum, London, bear likeness to the composition of this portrayal, confirming to historians its status as a work by Leonardo. The youthful head of the Madonna, wreathed in a halo, looks down toward her infant son as he seeks to grasp the flower held in her hand. Her hair is worn braided, in contemporary Florentine fashion. Her face in three-quarter profile is smiling. Leonardo places the head of the Madonna close to the head of the infant Christ, illustrating a close bond between mother and child. The compact spacing relates to the arched frame of the painting. The infant Christ is seated on his mother's lap. The head of the baby, in three-quarter profile, is centre right of the picture plane.

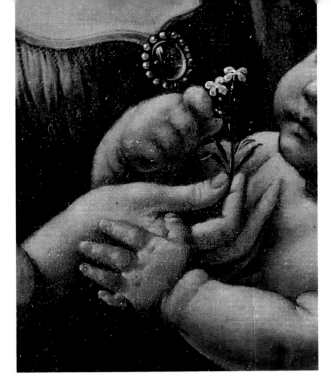

Madonna with a Flower ('Benois Madonna'), detail

The flower is lit by two sources of light, one from the window framed on the back wall of the painting and another light source above the group to the left. Surrounding the flower Leonardo groups the right hand of the Madonna grasped by the chubby hands and fingers of the infant. His gaze is focused on the flower that is held in his mother's hand. He reaches up with his right hand to take the flower. His left hand clutches his mother's hand to steady himself as he leans forward.

Virgin and Child, three heads in profile and other sketches, *c.*1478–80, metalpoint and leadpoint, with pen and brown ink, on pale salmon pink prepared paper, British Museum, London, UK, 20.3 x 15.6cm (8 x 6.1in)

This sketch of the Virgin and Child compares to three studies on the reverse side, and corresponds with the 'Benois Madonna' – it may be a study for that work. The faint leadpoint study of the Virgin in profile on the verso has been plausibly related to the *Madonna Litta* in the Hermitage Museum, which could relate to a 'Madonna' listed by Leonardo, which he drew up, soon after his arrival in Milan, '*un altra [nostra donna] qu(a)si [finita] ch_ proffilo*'.

Three studies of the Virgin and Child seated, *c.*1478–80, pen and brown ink on paper, over leadpoint, the lower sketch in leadpoint only, British Museum, London, UK, 20.3 x 15.6cm (8 x 6.1in)

This sketch with the arched top compares to that on the reverse side of the paper as a possible study for the 'Benois Madonna' in the Hermitage Museum, St Petersburg.

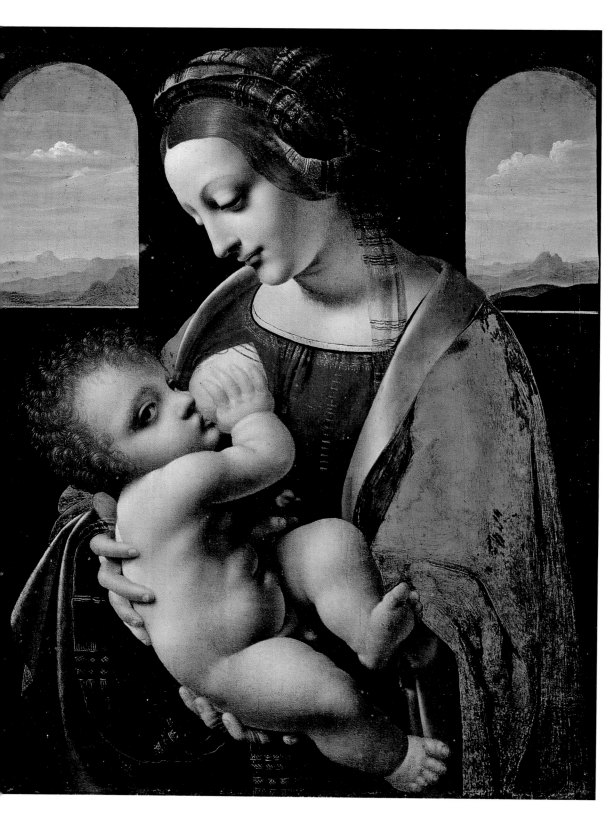

Madonna Litta (attributed to
Leonardo da Vinci), *c.*1490,
tempera and oil on wood,
transferred to canvas,
Hermitage Museum,
St Petersburg, Russia,
42 x 33cm (16.5 x 13in)

This small oil on panel
painting, of the Madonna and
Child, transferred to canvas,
is attributed to Leonardo da
Vinci by the Hermitage
Museum, where it hangs.
However, the attribution
remains contentious. The
title 'Madonna Litta' is taken
from the surname of Count
Antonio Litta of Milan, who
formerly owned the painting.
The style of the painting is
Leonardo's and the head of
the Madonna closely follows
a preparatory drawing,
created by Leonardo *c.*1490.
In the painting, she looks
down toward her infant son,
who suckles at her breast.
The depiction is traditional
for devotional paintings. She
wears a simple gown of red
and a loose cloak of blue
with gold reverse, colours
associated with the Virgin
Mary. The naked infant
Christ looks out toward the
spectator. 'Madonna del
Latte (Madonna of the Milk)'
was a popular image in the
Renaissance until banned
under laws instigated by the
Council of Trent (1543–63).

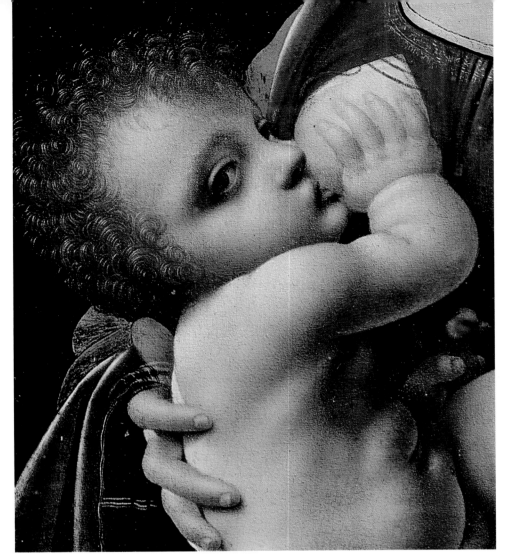

Madonna Litta, detail

The hair of the infant Christ is a mass of deep golden-red curls, a colour that mirrors the hair of his mother. His delicate face in three-quarter profile looks out to the onlooker as he lies contentedly in his mother's arms. The scene captures a normal everyday event for a mother with a newborn child and one that shows the Virgin Mary as a natural mother, caring for her baby.

Head of a young woman, *c.*1480, metalpoint highlighted with white on greenish-blue prepared paper, Musée du Louvre, Paris, France, 18 x 16.8cm (7.1 x 6.6in)

The finely drawn depiction of a young woman's head is a preparatory sketch for the virgin in the *Madonna Litta*, which leads scholars to consider that the painting is possibly by Leonardo da Vinci. The angle of the head and face and neck, and the outline of the young woman's dress, are closely aligned to the depiction of the Madonna in the Hermitage-owned painting.

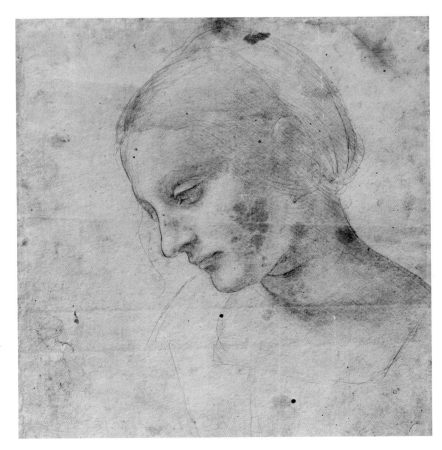

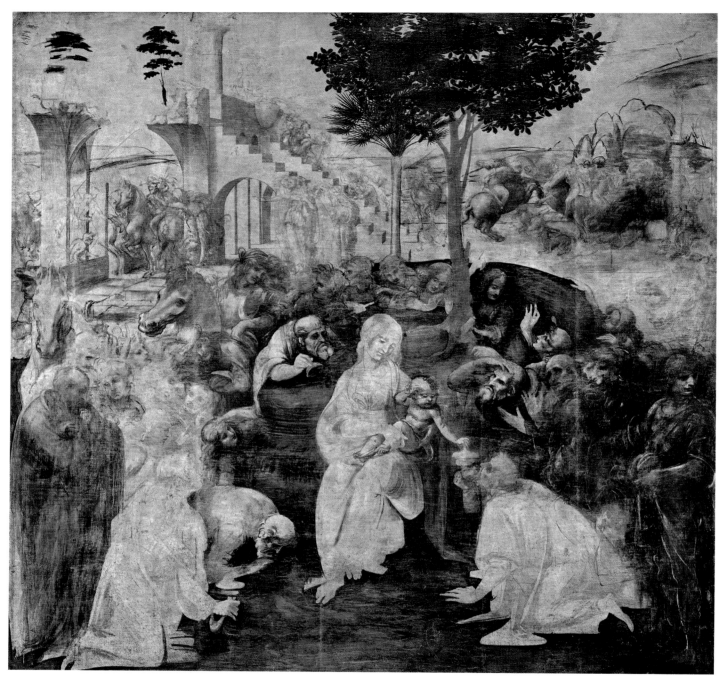

Adoration of the Magi, 1481–2, tempera mixed with oil with parts in red or greenish lacquer and white lead on wood, Galleria degli Uffizi, Florence, Italy, 243 x 246cm (95.7 x 96.9in)

Commissioned by the monks of San Donato at Scopeto in 1481, the painting was left unfinished when Leonardo left Florence for Milan. Through multispectral diagnostic imaging and analytical diagnostics, carried out by the Florentine professor Maurizio Seracini, it was discovered that the final layer of paint was added later and was not by Leonardo's hand. The focal point of the painting is the Madonna seated on a rocky outcrop in the foreground, holding the infant Christ on her lap. At her feet are three Magi, the wise men who followed the Star of Bethlehem to find the Holy Family. They kneel and offer gifts of gold, frankincense and myrrh to the newborn. Around the Madonna are grouped various onlookers who scratch their heads and look on in surprise and wonderment. Behind the figure group of the Holy Family, and above to the left, the arch of an ancient building is visible with a staircase rising up. Surrounding the building to left and right are groups of riders on horseback. The exact intention of the artist remains unclear. The building and horsemen may relate to a separate scene before the birth of Christ, or depict a narrative related to the visit of the three Magi.

Figural studies for the *Adoration of the Magi,* c.1481, pen and ink on paper, Wallraf-Richartz Museum, Cologne, Germany, 17.3 x 11.1cm (6.8 x 4.4in)

The numerous studies of individual figures illustrate Leonardo visualizing a large group of onlookers and followers, carefully positioned in a variety of poses.

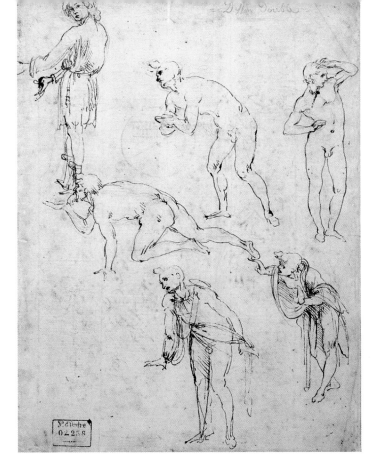

Figural studies for the *Adoration of the Magi,* c.1481, pen and ink and metalpoint on paper, Musée Bonnat, Bayonne, France, 17.3 x 11.1cm (6.8 x 4.4in)

Further figure studies show a variety of poses and different movements for individual figures and groups, who were to surround the Holy Family in the foreground or appear in the distant background. These studies show Leonardo's attention to detail prior to beginning work on the painting.

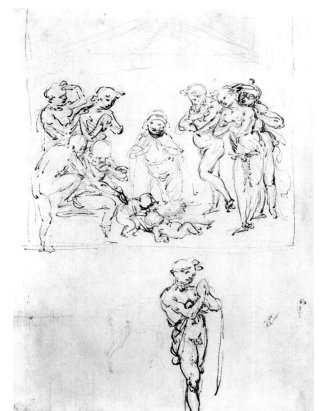

Figural studies for the *Adoration of the Magi,* c.1481 pen and ink over metalpoint on prepared paper, Hamburger Kunsthalle, Germany, 17.3 x 11.1cm (6.8 x 4.4in)

This figural study depicts Joseph, two shepherds and sketches for the Christ Child. Leonardo created many sketches, in which he altered the movement and positioning of the figures, prior to painting the *Adoration of the Magi.* Here one can see him testing different poses for various figures.

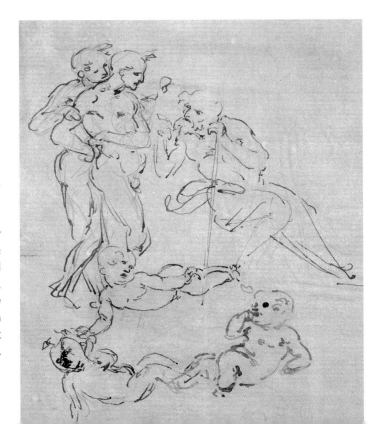

Compositional sketches for the *Adoration of the Magi*, *c.*1481, pen and ink over metalpoint on paper, Musée du Louvre, Paris, France, 27.8 x 20.8cm (10.9 x 8.2in)

This sketch reveals that the original composition of the *Adoration of the Magi* placed the Madonna and Child within a skeletal classical building complex with exposed stairways, arches and columns. The figures are in two distinct groups. The three Magi, with shepherds and animals, are in the foreground, centred on the Holy Family. In the background, framed within the classical building, are figures possibly connected to the entourage of the Magi.

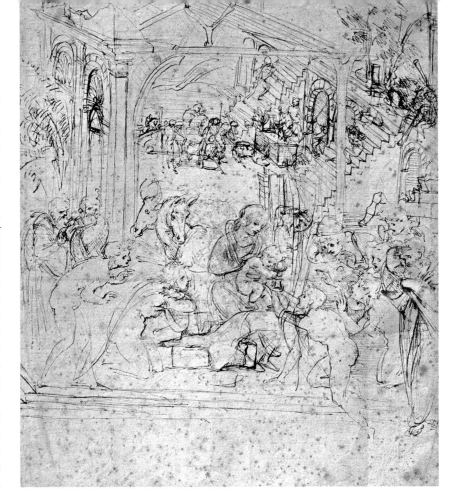

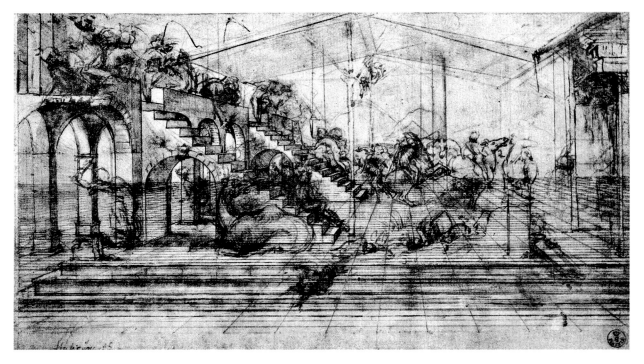

Perspective study for the background of the *Adoration of the Magi*, *c.*1480–1, pen and ink over metalpoint on paper, Galleria degli Uffizi, Florence, Italy, 16.5 x 29cm (6.5 x 11.4in)

A perspective study for the *Adoration of the Magi* gives a clearer indication of the planned depiction, which illustrates a classical roofed building with many arches and two vast staircases leading toward the upper level of the building. Various people, possibly the entourage of the three kings, are grouped on the stairs and near the archways. Riders on horseback cross the scene and in the far distance are mountains in a landscape.

Studies of horses, c.1480, metalpoint on prepared paper, Royal Library, Windsor Castle, UK, 11.4 x 19.6 cm (4.5 x 7.7in)

This finely drawn study of a rampant horse, among other studies on the paper, illustrates Leonardo's knowledge of the animal and its movement. The painting *Adoration of the Magi* carries many figures of horses in motion. This is possibly a preparatory sketch for the painting.

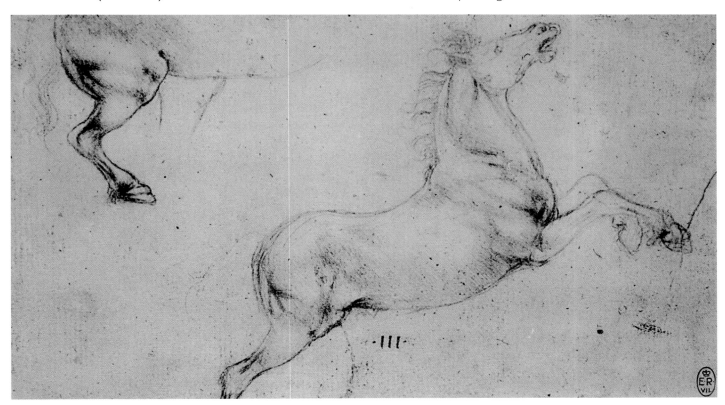

Sketch of a horseman fighting a dragon, c.1481, pen and brown ink with brown wash on paper, British Museum, London, UK, 138 x 190cm (54.3 x 74.8in)

A fantasy sketch of a horse and rider attacked by a mythological dragon. Leonardo captures the menacing lunge of the dragon, the bravery of the rider with sword in hand – a St George figure perhaps – and the understandable fear of the horse. A drawing of a horseman, similar to this depiction, appears in Leonardo's unfinished painting, *Adoration of the Magi*, which would date the drawing to c.1481.

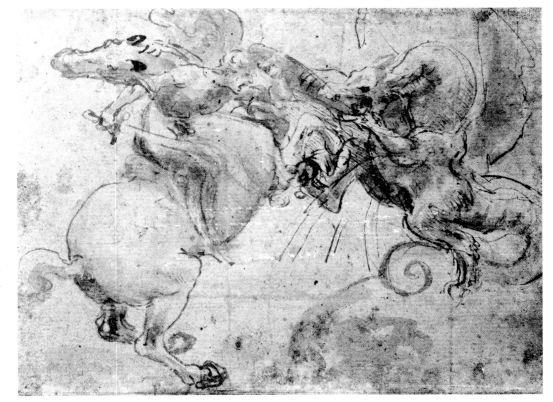

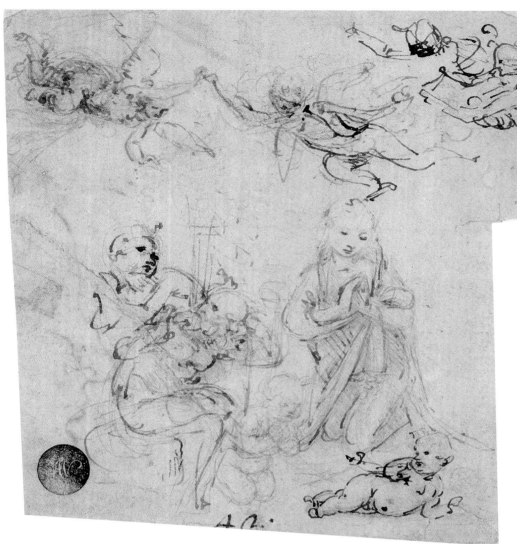

Studies for the Virgin Mary, angels and other figures, *c.*1481, pen and ink over metalpoint on paper, Galleria dell'Accademia, Venice, Italy, 11.9 x 13.5cm (4.7 x 5.3in)

These sketches of angels, the Virgin Mary and other figures are considered preparatory sketches for an Adoration painting.

Studies for angels and other figures, *c.*1481, pen and ink over metalpoint, Galleria dell'Accademia, Venice, Italy, 10.2 x 12.3cm (4 x 4.8in)

These quickly-drawn sketches of angels and other figures are possibly part of the preparatory work for the *Adoration of the Magi* painting. The sketches include a Christ Child, angels kneeling and angels flying.

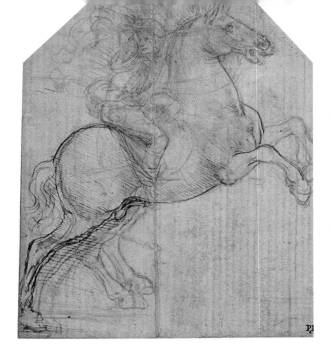

Rider on a rearing horse, c.1481–2, metalpoint reinforced with pen and brown ink on a pinkish prepared paper, Fitzwilliam Museum, Cambridge, UK, 14.1 x 11.9cm (5.6 x 4.7in)

This sketch for a rider on a rearing horse appears, slightly adapted, in the final composition of the *Adoration of the Magi* painting. The horse, moving from left to right across the picture plane, rears up and tilts its head back as if frightened by something or someone. The rider, undisturbed, looks toward the horse and rider coming toward him.

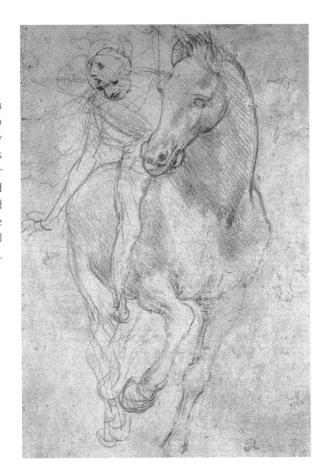

Study of a horse and rider, c.1481, metalpoint on pale pink prepared paper, private collection, 12.8 x 7.8cm (5 x 3.1in)

A beautiful study of a horse and rider, this is a sketch for the *Adoration of the Magi* painting. In the final composition the head of a horse and rider appears to the left of the Holy Family group. Other horses with riders appear in the background behind the trees to the right and within the frame of the ruins of a classical building to the left.

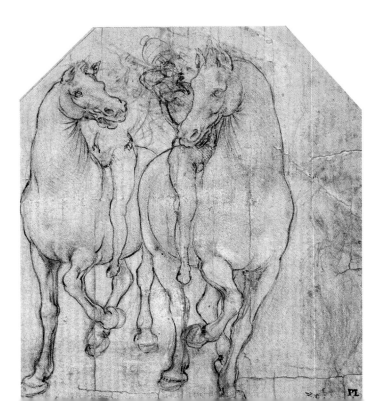

Studies of horses and riders, c.1480, metalpoint on prepared paper, Fitzwilliam Museum, Cambridge, UK, 14.2 x 12.8cm (5.6 x 5in)

Two studies of horses and riders, possibly for the *Adoration of the Magi*. Leonardo closely studied the anatomy of horses, birds, lizards, dogs and cats to be able to draw their bodies accurately and capture on paper an animal's particular characteristics.

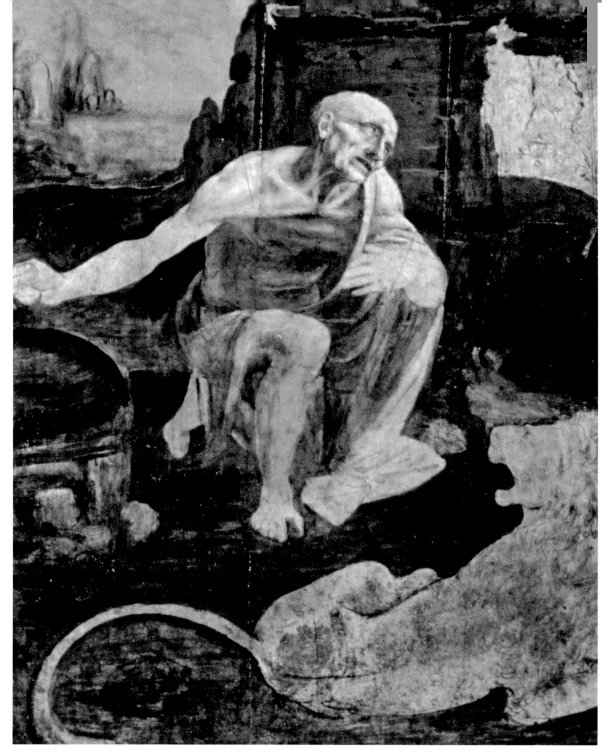

*St Jerome, c.*1480–2, oil and
tempera on walnut, Vatican
Museums and Galleries,
Rome, Italy,
102.8 x 73.5cm
(40.5 x 28.9in)

St Jerome (*c.* 340–420), a
Christian theologian, is
recognized for his translation
of the Bible into Latin (known
as the Vulgate). For a period
of time he lived as a penitent
on retreat in the desert
of Chalcis, south-west of
Antioch, where he studied
and wrote. Leonardo paints
the figure of St Jerome in
the act of beating his chest
with a rock, in penance. His
head has the sculptural
quality of an ancient Roman
bust. The fine detail of the
head and upper body of
St Jerome illustrates
Leonardo's attention to
anatomy. He portrays the
saint as a skeletal figure. A
lion with its mouth open lies
at St Jerome's feet, facing
him with its back to the
onlooker. The painting
of the lion remains
unfinished. In the story of St
Jerome, he heals the lion's
injured paw and the lion
lives with him thereafter. An
imprint of Leonardo's
fingertip was found on this
painting. It confirms the
artist's preference for
working paints into the
surface with his fingers to
soften and meld colours
and outlines.

Virgin of the Rocks, c.1483–6, oil on panel, transferred to canvas, Musée du Louvre, Paris, France, 197.3 x 120cm (77.7 x 47.2in)

Leonardo painted two versions of the *Virgin of the Rocks.* Historians agree that this painting was the original, the central panel of a triptych altar painting commissioned by the Confraternity of the Immaculate Conception. The title of the painting refers to the rock formations in the near background, which follow through to the mountainous landscape and water glimpsed behind the Virgin's right shoulder. Using aerial perspective, the distant rocky landscape and waters lie in a mist of hazy blue (*sfumato*), signifying distance and the density of the air. Leonardo invites the onlooker to the rocky grotto to witness a meeting of the Virgin and Christ Child with the infant St John the Baptist and a youthful Angel Gabriel.

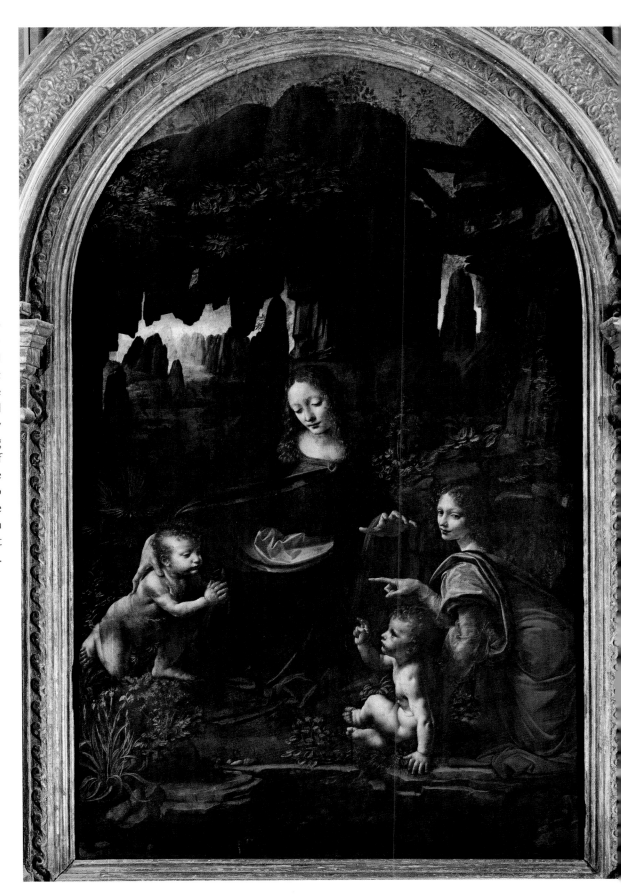

Virgin of the Rocks, detail

Mary, the young mother of
Christ, is placed in a central
position in the painting. She
kneels and looks down at
those gathered around her.
She places her right arm
around the naked infant John
the Baptist, resting her hand
in a protective gesture on his
shoulder. Her left hand
stretches out and hovers
protectively over the head of
the infant Christ, seated in
front of her to her left.

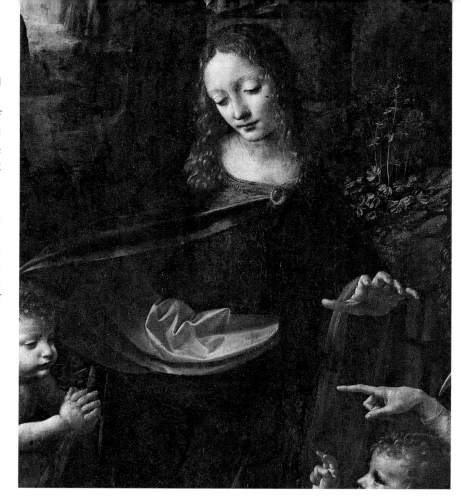

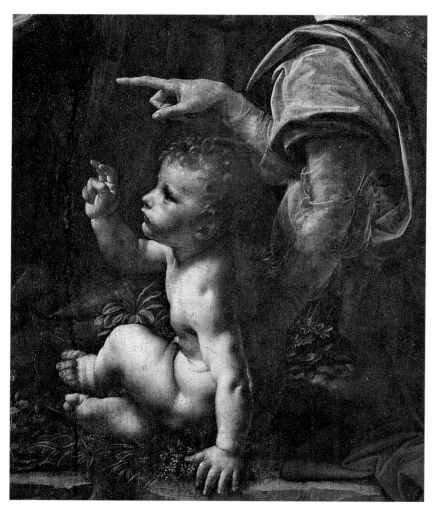

Virgin of the Rocks, detail

The naked infant Christ is
seated centre right in the
foreground. In profile he
looks right, toward the figure
of the infant St John the
Baptist, and holds up his tiny
right hand in blessing.
Leonardo has envisaged the
infant with dimpled arms and
legs and a fleshy rounded
body, which capture the
essence of the physique of
a non-idealized earthly
young child. The Angel
Gabriel is next to the infant
Christ and supports the
baby's back with his left
hand. Above the head of
Christ the angel points
his finger toward the infant
John, his cousin, and blesses
him with hand and fingers
outstretched.

Studies of flowers, *c.*1481–3, pencil on paper, Gallerie dell'Accademia, Venice, Italy

Leonardo da Vinci created many studies of plants, flowers and rushes in preparation for paintings. A close observation of the *Virgin of the Rocks* shows the artist's minute attention to each detail, including the illustration of the plants and flowers.

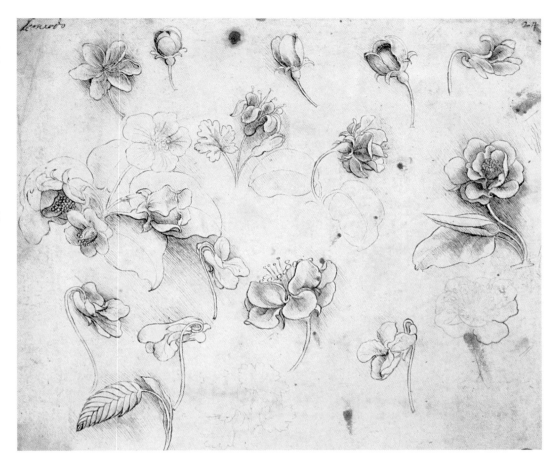

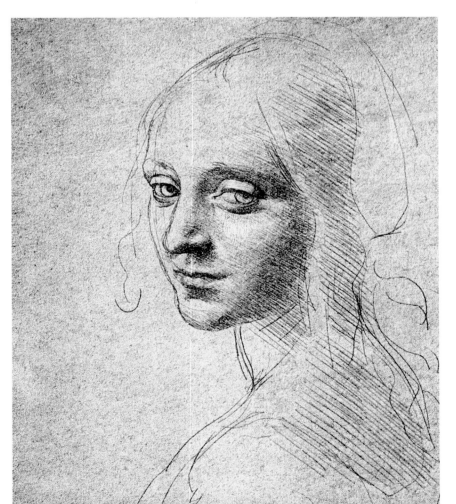

Study for the Angel in the *Virgin of the Rocks*, 1483, silverpoint on brown prepared paper, Biblioteca Reale, Turin, Italy, 18.2 × 15.9cm (7.2 × 6.3in)

This study shows the image of the angel to be based on a female portrait, illustrated in Leonardo's detailed drawing of the face. A close examination of the eyes, nose and lips of the girl in this portrayal matches the Angel, and possibly the face of the Virgin Mary, in both versions of the painting.

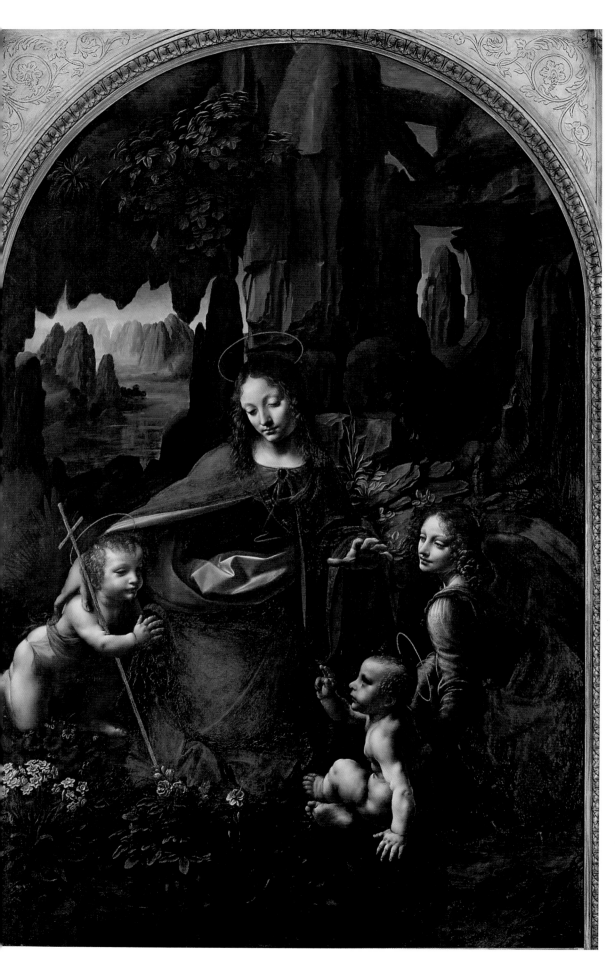

Virgin of the Rocks (Virgin with the Infant St John Adoring the Infant Christ Accompanied by an Angel), c.1508, oil on poplar, National Gallery, London, UK, 189.5 x 120cm (74.6 x 47.2in)

Problems of payment and delay surrounding the first painting of the *Virgin of the Rocks* (now in the Musée du Louvre, Paris) led to a second version being painted (now in the National Gallery, London). It has been confirmed that this version was, on completion, installed in the church of San Francesco in Milan. This painting differs slightly in its composition. During the time that the first version of the painting was produced, records show that a golden necklace was ordered by the Confraternity. Historians believe that the intention was to attach it to the wooden panel to adorn the Virgin. With the first version of the painting rejected by the Confraternity, the second version may have had the addition of the necklace. An unusual factor of this painting's iconography is the absence of reference to the Immaculate Conception of the Virgin, which one would have expected for a commission by the Confraternity of the Immaculate Conception. However, Leonardo has painted the face of the Virgin with the most devout, serene expression, full of tender affection for the young children.

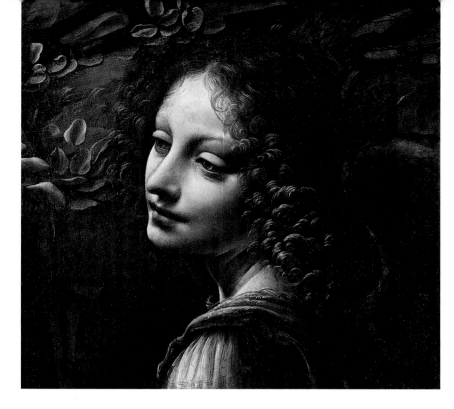

Virgin of the Rocks, detail

In this version of the *Virgin of the Rocks* the figure of the Angel Gabriel is slightly altered, looking toward the group and not toward the spectator. The angel does not point toward the infant St John. Instead, the angel's passive presence leads the viewer to gaze on the Christ Child's action of blessing the infant St John.

Study of the head of a child, *c.*1483–1508, pencil on paper, Musée du Louvre, Paris, France, 17 x 14cm (6.7 x 5.5in)

The delicate drawing of the head of a child corresponds to depictions of the infant St John the Baptist and the infant Christ. The head is taken from a life-model.

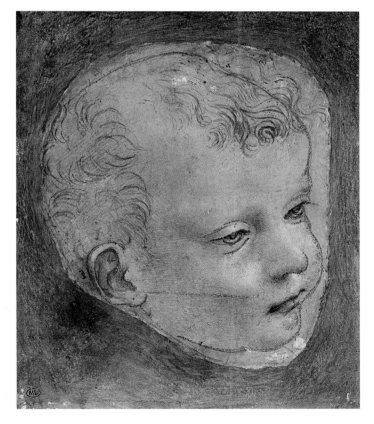

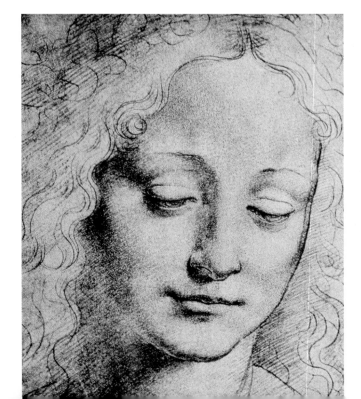

Head of a young girl, *c.*1508, pencil on paper, Galleria degli Uffizi, Florence, Italy, 21 x 15cm (8.3 x 5.9in)

This pencil on paper drawing is a possible study for the face of the Virgin.

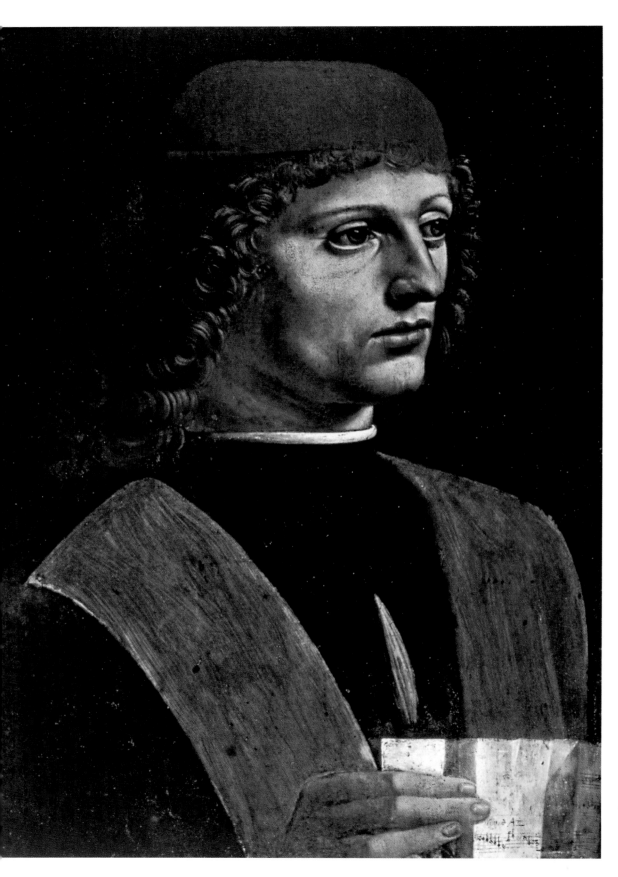

Portrait of a Musician,
*c.*1485, oil on wood panel,
Pinacoteca Ambrosiana,
Milan, Italy,
43 x 31cm (16.9 x 12.2in)

This painting has been
attributed to Leonardo da
Vinci by many Leonardo
scholars. Some suggest that
the head was painted by
Leonardo, while the body was
painted by Giovanni Antonio
Boltraffio (*c.*1466–1514).
The sitter is difficult to identify.
Suggested persons include
Franchino Gaffurio
(1451–1522), who was
choirmaster at Milan cathedral
and a musician at the Sforza
court, the Franco-Flemish
composer Josquin des Prez
(*c.*1450– 1521), at court in
Milan, or Leonardo's friend
Atalante Migliorati. That the
head of the musician is the
work of Leonardo has been
confirmed stylistically and
through X-radiography
exploration of the paint
surface and layers beneath.
The strong features and head
of the young man are painted
in three-quarter profile, which
resembles a later composition
and lighting effect in *Portrait of*
*Cecilia Gallerani, c.*1489–90.
The sitter holds in his right
hand a sheet of music on
which is inscribed 'CANT[OR]
ANG [ELICUM]'. Historians
consider that this might be a
reference to a musical work
by Antonio Gaffurio,
choirmaster of Milan
cathedral, which is titled
Angelicum ac Divinum Opus.

*Portrait of Cecilia Gallerani
(Lady with an Ermine),*
c.1489–90, oil on panel,
Czartoryski Museum,
Krakow, Poland,
54.8 x 40.3cm (21.6 x 15.9in)

The portrait of a young
woman holding an ermine
is considered to be that
of Cecilia Gallerani, a
much-loved mistress of Il
Moro, Ludovico Sforza,
Duke of Milan. A text at
the top of the painting
to the left reads 'LA BELE
FERONIERE LEONARD
DA VINCI', which has led
to confusion between this
painting and the portrait of
Lucrezia Crivelli, another
of Ludovico's mistresses,
now understood to be the
sitter for *La Belle Ferronnière.*

Leonardo portrays the
young woman as her head
momentarily turns away
from the viewer, distracted
by something or someone
that has entered the space
to her left. The action
brilliantly captures a moment
in time. It gives life to the
portrayal of Cecilia Gallerani,
whose head and hair are
styled in the latest Milanese
fashion. Leonardo has
captured the quizzical look
of the young woman's pet
ermine as it swivels its head
in unison with its owner.
Leonardo has painted the
ermine's head, body and feet
with precise attention to
detail. The exquisitely
painted detail follows a
preparatory drawing created
by Leonardo for this work.

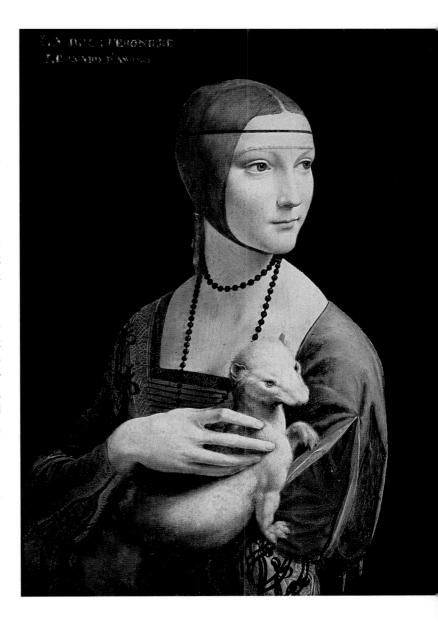

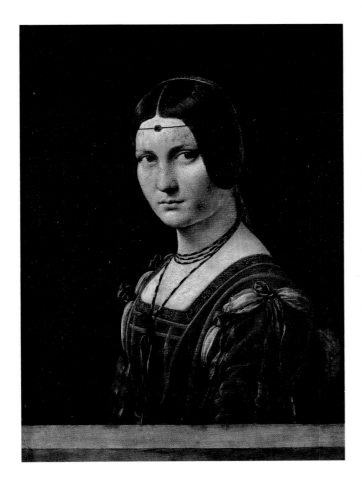

*Portrait of a Lady
(La Belle Ferronnière),*
c.1490, oil on wood,
Musée du Louvre, Paris,
62 x 44cm (24.4 x 17.3in)

This painting has been given
many titles, including *Portrait
of a Woman at the Court* of
Milan and *Portrait of a Lady,*
but the title *La Belle
Ferronnière* is that most
associated with it. The title
refers to Lucrezia Crivelli, a
mistress of Il Moro, Ludovico
Sforza, at the court in Milan.

Leonardo was the court
artist, and here he portrays
a beautiful lady of the court
in three-quarter profile.
A text written in Latin
(Codex Atlanticus, fol. 456v)
is said to describe the
woman in the portrait:
'She whom you see, whose
name is Lucrezia/ To whom
the gods have given all with
a generous hand/ Was given
rare beauty. Leonardo first
among painters/ Painted her;
Moro, first among princes,
loved her.'

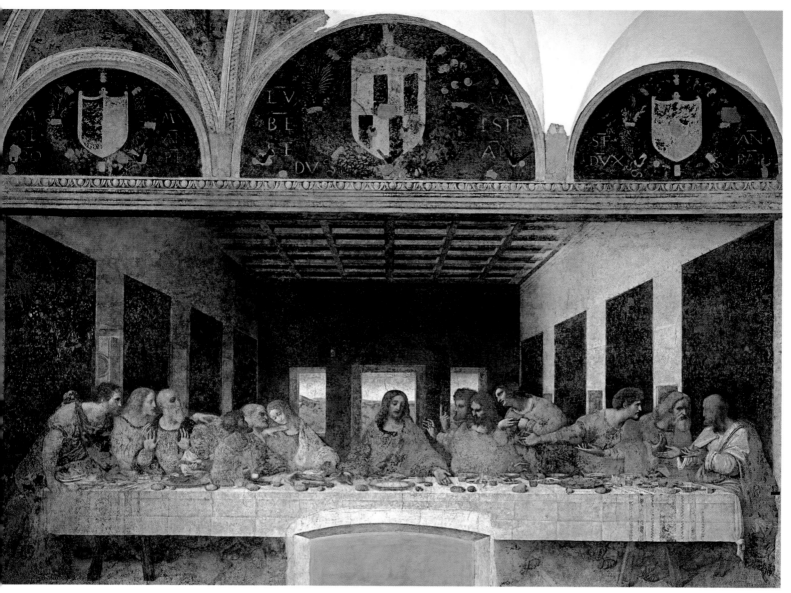

Last Supper, 1495–7, tempera on plaster, Refectory of the Monastery of Santa Maria delle Grazie, Milan, Italy, 460 x 880cm (181.1 x 346.5in)

Leonardo received the commission to paint a vast fresco depicting the *Last Supper (L'Ultima Cena)* in the refectory of the Convent of Santa Maria della Grazie, in Milan. It is understood that Ludovico Sforza was the patron behind the commission, a generous gift to the Dominican monks of the fraternity. The Sforza family coats of arms can be seen in the lunettes painted above the 'room' where the Last Supper is taking place. The central lunette illustrates the coat of arms of Ludovico Sforza and his wife and reads: LU(dovicus) MA(ria) BE(atrix) EST(ensis) SF(ortia) AN(glus) DUX (mediolani). The left-hand lunette has the coat of arms of Ludovico's son Massimiliano with text. The right-hand lunette with text refers to the coat of arms of the duchy of Bari, belonging to Ludovico's second son, Francesco. Work began on the fresco in 1495. The painting shows Christ sharing a final supper with his 12 disciples or apostles. From left to right: Bartholomew, James the Less, Andrew, Judas Iscariot, Peter, John, Jesus Christ, Thomas, James the Greater, Philip, Matthew, Jude Thaddeus and Simon. The 'supper room' is depicted with space behind the table, leading to three 'windows' which look out on the surrounding countryside. Leonardo deftly paints distant trees and hills, a local landscape familiar to the Milanese. He has created a magnificent *trompe l'oeil*, making the table a part of the real refectory space. According to the biblical narrative (Matthew 26: 17–29), the table for the Last Supper was laid with unleavened bread for Passover, fruit and wine. In Leonardo's depiction of the meal, he includes eel and oranges, his own favourite foods. Every apostle is placed on the far side of the table, which allows the onlooker to view the array of footwear underneath the trestle table, and to see the tablecloth and its contents. To the far left and to the far right the tablecloth has a geometric blue-tinged pattern.

Last Supper, detail: Christ

The figure of Christ is central to every depiction of the Last Supper. Here, Leonardo depicts a youthful man. His calm expression acknowledges the shock and disbelief of his friends, when he announces that one of the group gathered at the table will betray him. Leonardo captures that moment and starkly contrasts the composed appearance of the Christ figure with his followers, who twist and turn, shout and gesticulate on hearing the news, registering dismay in their faces. Leonardo places the figure of Christ at the centre of the table. The orthogonal lines of the work converge on the head of Christ, creating centred perspective.

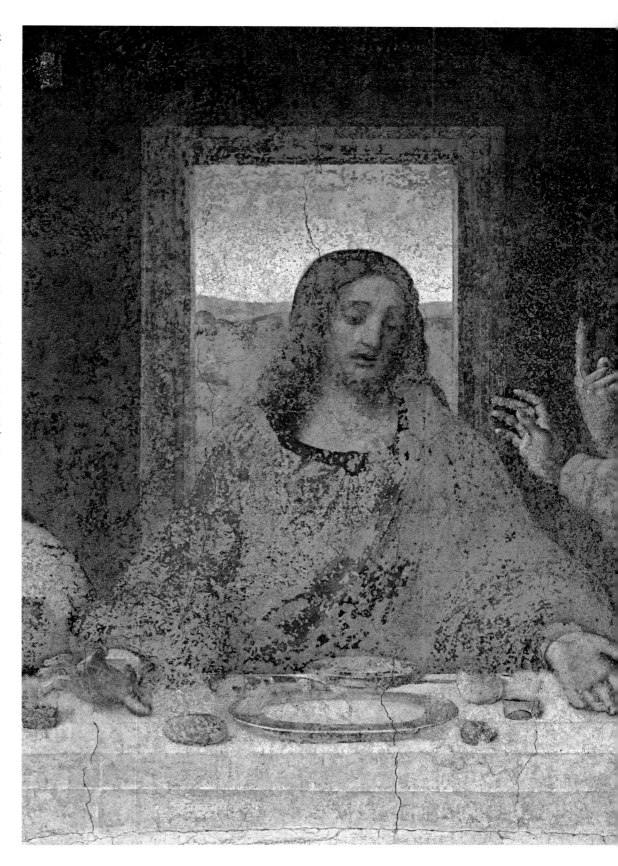

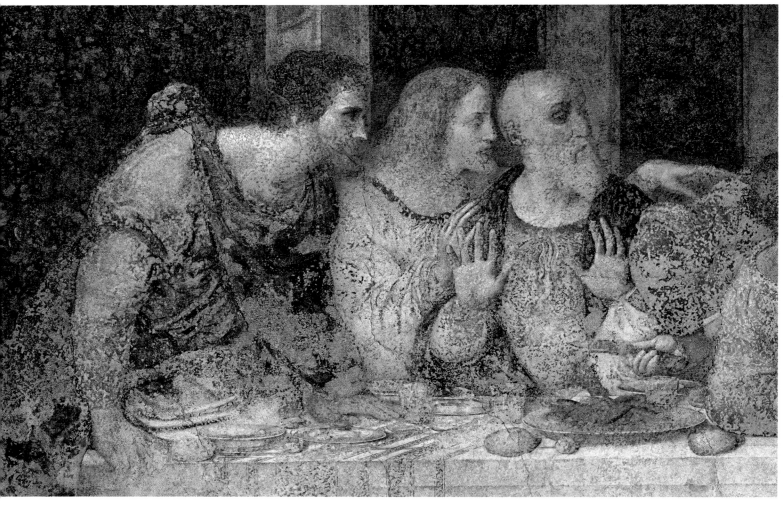

Last Supper, detail:
Bartholomew, James
and Andrew

Leonardo has placed the 12 figures of the apostles in four groups of three. Here the group placed at the far left of the table are (left to right) Bartholomew, James the Less, and Andrew. Bartholomew is one of the 12 apostles, or disciples, mentioned sixth in the three Gospel lists (Matthew 10:3; Mark 3:18; Luke 6:14), and seventh in the list of Acts (1:13). Leonardo places him at the supper table on the extreme left. He stands and leans forward. His face is in right profile, which leads the viewer toward the object of his gaze, the central figure of Jesus Christ. James the Less (James=Jacobus in Greek), another apostle, is related to James, son of Alphaeus. In this depiction of the *Last Supper* he is placed between Andrew and Bartholomew. Seated slightly behind Andrew, he rests his hand on the shoulder of Judas Iscariot, who is speaking to John. Andrew, a fisherman by trade, became a follower of John the Baptist. Later he became an apostle of Christ. Here he is placed third left. He sits upright looking toward his left, his hands raised as if in surprise.

Last Supper, detail: Judas
Iscariot, Peter and John

Here the group placed
at the left of centre are
(left to right) Judas
Iscariot, Peter and John.
Judas Iscariot, the betrayer
of Christ, is placed fourth
left on the supper table.
He is depicted with
receding grey hair and a
beard. He leans across
behind the figure of Peter
toward John, with whom
he is in conversation. Peter
turns his head around to
listen to the conversation.
Peter, known as the boldest
member of the apostolic
group, turns his head to
look over his shoulder
toward the figure of Judas
Iscariot who leans across
with fingers pointing toward
the central figure of Christ.
Leonardo depicts him
as a wiry figure, and with a
head and beard of dark
hair. John the apostle and
his brother James were
called the 'sons of thunder'
in the biblical narrative.
John is seated between
Peter and the figure of
Christ. He is depicted full
face, head to one side,
looking down. He listens to
Judas Iscariot who leans
across the back of Peter,
to speak to John. Between
the figures of John and
Christ, Leonardo has
created a v-shape, which
separates the table into
two separate spheres and
each sphere into two
smaller groups. The gap
leads the onlooker toward
the large 'windows' at the
rear of the 'room', to view
the distant landscape.

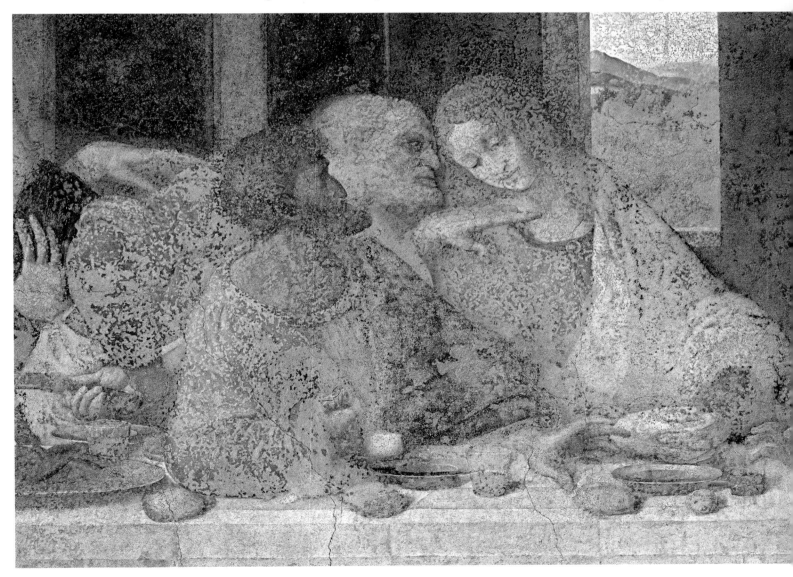

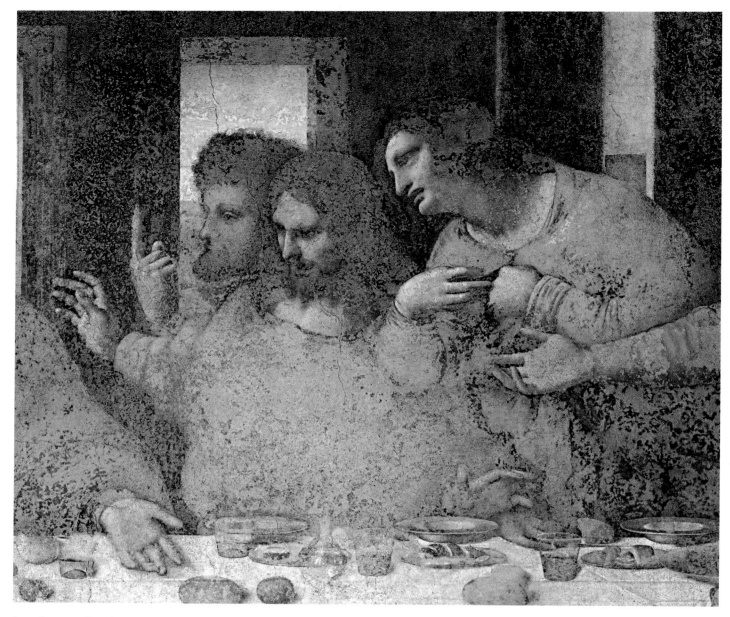

Last Supper, detail:
Thomas, James the Greater
and Philip

Here the group placed
directly left of the figure of
Christ are (left to right)
Thomas, James the Greater
and Philip. Thomas, known
as Doubting Thomas, is
depicted with a full beard
and head of hair. He is
shown in profile, standing
behind the figure of James
the Greater. His hand and
lengthy forefinger points
upward, possibly a reference
to the Ascension of Christ.
The figure of James, seated
next to Christ's left side,
holds out his arms in a
gesture of disbelief at
Christ's statement that
someone would betray him
before the night was over.
Leonardo captures the
individual gestures of each
disciple as they ask, according
to Matthew 26:22, 'Is it I,
Lord?' Leonardo depicts
the figure of Philip standing
and leaning his body into
the group of Christ, Thomas,
James and John, to hear
the words of Christ.
The stance of Philip's figure
breaks this group away
from the final three figures
of Matthew, Jude Thaddeus
and Simon.

Last Supper, detail: Matthew, Jude Thaddeus and Simon

Here the group placed at the far end of the table to the viewer's right are (left to right) Matthew, Jude Thaddeus and Simon. Leonardo gives the figure of Matthew a strong persona; he looks toward Jude Thaddeus and Simon, and gestures with the open palms of his hands, which are directed toward the figure of Christ. This gesture adds to the questioning face of Matthew, which registers incredulity at Christ's statement. The head of Jude Thaddeus in three-quarter profile mirrors the outline of the head of Matthew to his immediate right. Both look toward Simon, in disbelief at the sorrowful news that one among them will betray Christ. Leonardo, through gesture and facial expression, has created a table of animated characters who speak and shout, twist and turn to each other, in sorrow and bewilderment. The figure seated to the far right on the table is Simon. He is depicted in left profile, looking toward Jude Thaddeus and Matthew, his face animated in discussion with the palms of his hands turned upward, gesturing surprise and confusion. The figure of Simon, with short hair and cropped grey beard, is depicted in left profile. He mirrors the figure of Bartholomew depicted in right profile at the end of the table to the far left.

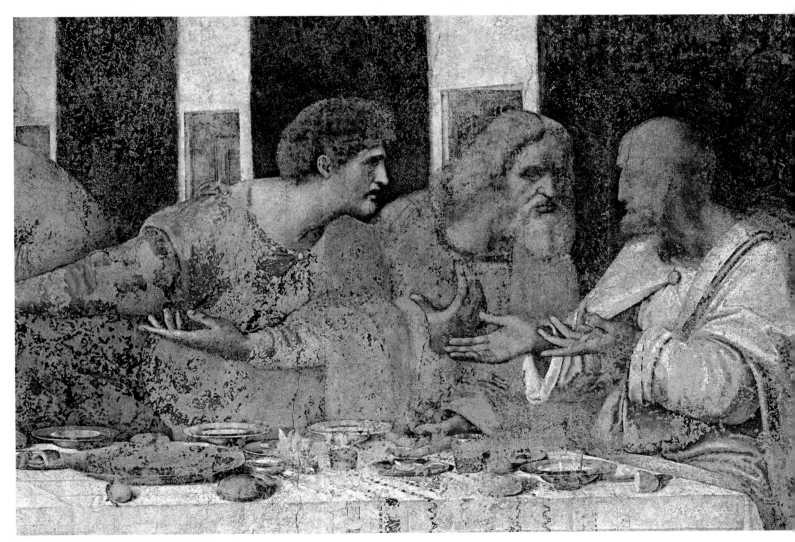

Preparatory drawing for the *Last Supper*, c.1495, red chalk, pen and ink on paper, Gallerie dell'Accademia, Venice, Italy, 26 x 39cm (10.2 x 15.4in)

A preparatory drawing by Leonardo depicting the table seating arrangement with a name formation of the figures for the *Last Supper*. One figure, not realized in the painting, rests his head on the table. The Bible does not state exactly who sat where and in which position. It is left to the artist, with knowledge of the biblical narrative, to assign hierarchy and placement.

Preliminary sketch for the *Last Supper*, c.1495, pen and ink on paper, Royal Library, Windsor Castle, UK, 26.6 x 21.5cm (10.5 x 8.5in)

One of Leonardo's first sketches for the *Last Supper*. In the drawing he places one disciple on the near side of the table, which is often, in versions of the *Last Supper*, the position of the traitor Judas Iscariot. The table in the sketch is depicted within an architectural framework. Beneath the sketch is a geometric drawing and Leonardo's handwritten text.

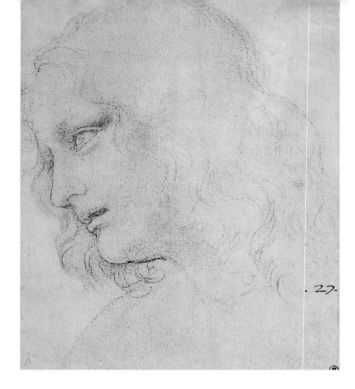

Study for the *Last Supper* (Philip), *c.*1497, black chalk on paper, Royal Library, Windsor Castle, UK, 19 x 15cm (7.5 x 5.9in)

The head of the apostle Philip is drawn in near profile. It is a youthful figure with long hair. The final depiction of Philip, placed standing next to the seated figure of James the Greater, to the near left of the figure of Christ, is replicated clearly. Leonardo wanted each figure to have a different facial expression to convey their reactions to Christ's news of his coming betrayal by one of the group.

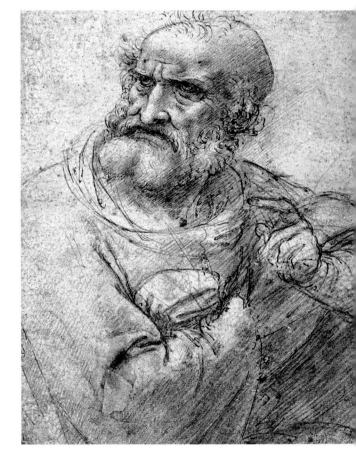

Study for an apostle from *Last Supper*, *c.*1495, pen and ink and metal point on blue prepared paper, Graphische Sammlung Albertina, Vienna, Austria, 14.5 x 11.3cm (5.7 x 4.4in)

This small pen and ink drawing is a preparatory study for one of the apostles of the *Last Supper*, possibly the figure of Peter. Leonardo made many preparatory drawings and notes, which included remarks on the actions of the figures. One 'wrings his fingers and turns with a frown', another '…who was drinking, has left his glass in its place and turned his head toward the speaker.' In this drawing the figure leans back in his seat and gestures with his raised hand, to make a point.

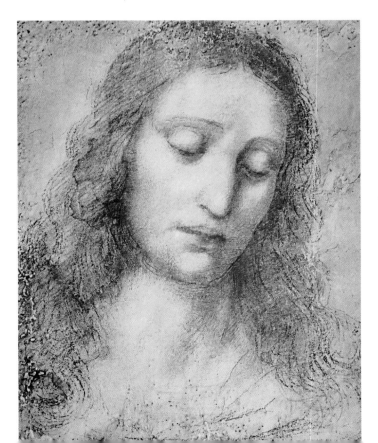

Study for the head of Christ, *c.*1495, red chalk, pen and ink on prepared paper, private collection, 11.6 x 9.1cm (4.6 x 3.6in)

This drawing is a preparatory study, attributed to Leonardo da Vinci, for the head of Christ, for the *Last Supper*, Santa Maria delle Grazie, Milan. The head closely resembles Leonardo's finished figure painting.

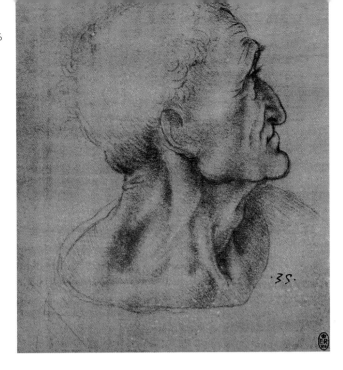

Study for the *Last Supper* (Judas Iscariot), *c.*1495, red chalk on red prepared paper, Royal Library, Windsor Castle, UK, 18 x 15cm (7.1 x 5.9in)

The head of Judas Iscariot is depicted in profile. The muscles of the neck protrude. The high cheekbone and defined nose, mouth and chin are copied to the painting of Judas, who is placed third left, standing behind the seated figure of Peter, leaning forward toward the figure of John.

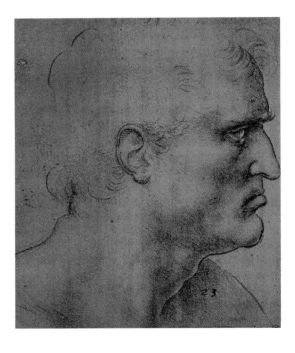

Study for the *Last Supper* (Bartholomew), *c.*1495, red chalk on red prepared paper, Royal Library, Windsor Castle, UK, 19.3 x 14.8cm (7.6 x 5.8in)

This drawing of the head of St Bartholomew in profile matches the final depiction of the Apostle. His figure, standing, looking to his left, was placed at the end of the table to the far left.

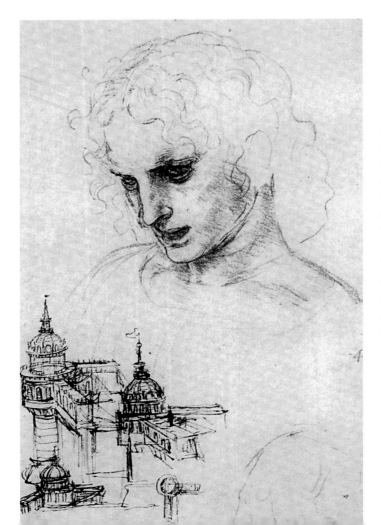

Study for the *Last Supper* (James the Greater) and architectural sketches, *c.*1495, red chalk, pen and ink, Royal Library, Windsor Castle, UK, 25.2 x 17.2cm (9.8 x 6.7in)

The figure is a study for the apostle James the Greater, seated to Christ's left in the *Last Supper.* Leonardo spent much time searching for models with expressive facial characteristics, to portray a variety of emotions in the *Last Supper.* The face of St James the Greater drew much attention for its beauty. One observer asked how Leonardo would surpass it to depict the head of Christ. Beneath the figure is drawn an architectural sketch of a castle.

Sale delle Asse (room of pikes), *c.*1498–9, tempera on plaster, Castello Sforzesco, Milan, Italy, dimensions unknown

In 1498, Leonardo, as court artist to Ludovico Sforza, was commissioned to decorate a ground floor vaulted room of Castello Sforza in Milan. The room was formerly used to store pikes. Leonardo – with assistants – was to paint a scenic forest of trees with a pergola, shrubs and fruit, depicting an ancient grove brought to life. The Sforza coat of arms was painted at the centre of the ceiling. The concept of the Sala delle Asse was innovative, a brilliantly designed total work of art. It was also laborious, time-consuming and repetitive and the work often tested Leonardo's patience.

Sala delle Asse, detail

For the wall decoration of an ancient shady grove Leonardo chose to depict a forest of mulberry trees in reference to Ludovico Sforza's nickname, 'Il Moro'. (The Italian word for mulberry is *gelsomoro*.) The secondary purpose for the decoration of the room with *trompe l'oeil* trees, branches and leaves was the symbolism of the 'ancient grove' by its association with the Sforza family tree, which was inscribed on four tablets painted on the walls.

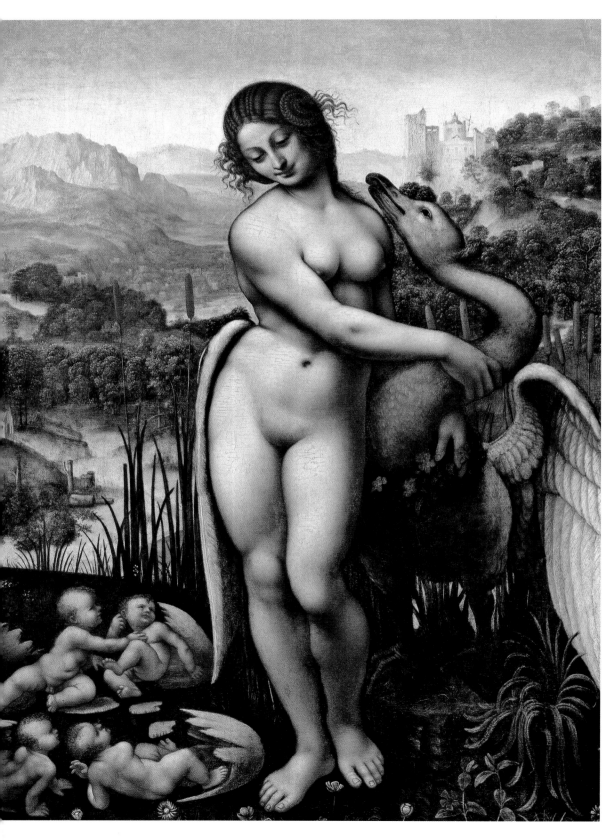

Leda and the Swan, by Cesare da Sesto (*c*.1477–1523) after Leonardo da Vinci, *c*.1505–10, oil on wood, Wilton House Collection, Salisbury, Wiltshire, UK 96.5 x 73.7cm (38 x 29in)

It is Cesare da Sesto's copy that allows us to envisage Leonardo's lost painting. Following the text of the Greek (and Roman) myth, Leonardo painted Leda, the beautiful wife of Tyndareus, King of Sparta, with a swan, the Olympian god Zeus (Roman: Jupiter) in disguise. The myth relates that Zeus came to her by a river disguised as a swan and lay with her. The naked Leda is depicted standing in a *contrapposto* position. Zeus, the swan, stands on a small base to her left. He wears a celebratory garland of flowers around his lower neck. He places his right wing seductively around Leda's waist and cranes his neck toward her face. She encircles his neck with her arms but modestly looks away from his gaze. In the myth, the results of the union of Leda and the swan are eggs that hatch the 'heavenly twins', mortal Castor and immortal Polydeuces, and the immortal Helen and mortal Clytemnestra. In the painting, four lively babies, naked and newly hatched from the eggshells, lie on the ground in a carpet of wild flowers, at the feet of their mother.

Study for kneeling Leda, c.1504–6, pen and ink over black chalk on paper, Museum Boijmans-van Beuningen, Rotterdam, Netherlands, 12.5 x 11cm (4.9 x 4.3in)

Cassiano dal Pozzo (1588–1657), secretary to Cardinal Francesco Barbarini, and nephew of Pope Urban VIII, saw Leonardo's painting of *Leda and the Swan* on a visit to Fontainebleau in 1625. His description included the detail of a 'standing figure of Leda, almost entirely naked, with the swan at her feet, and two eggs, from whose shells come forth four babies'. During the preparatory work for the painting, Leonardo changed the form of Leda from kneeling to standing and gave the swan a more prominent position.

Study for *Leda and the Swan*, c.1504–6, pen and ink over black chalk, Collection of the Duke of Devonshire, Chatsworth, UK, 16 x 13.9cm (6.3 x 5.5in)

Leonardo's sketches for *Leda and the Swan* give clues to the content of the original painting, now lost. In this drawing, the figure of Leda is kneeling by a waterbank surrounded by aquatic plants. Her right arm points down to reveal four babies lying among the plants, the result of her union with a swan (the god Zeus in disguise). He, by her side, embraces her with one wing as his head leans toward hers.

Sketch for *Leda and the Swan* (detail from larger sheet of sketches), c.1504–6, pen and ink and black chalk on paper, Royal Library, Windsor Castle, UK, 28.7 x 40.5cm (11.3 x 15.9in)

Sketches of *Leda and the Swan*, with Leda both kneeling and standing next to the swan, date from 1504, when Leonardo was working also on sketches for the *Battle of Anghiari*, for the Salone dei Cinquecento in the Palazzo Signoria. Here, this small sketch of Leda, the pose possibly informed by ancient Roman statuary, is one of two on a large sheet of drawings, which includes a rearing horse, possibly a sketch for the Anghiari painting.

Study for the head of Leda,
c.1504–6, pen and ink over
black chalk on paper,
Royal Library,
Windsor Castle, UK,
17.7 x 14.7cm (7 x 5.8 in)

The studies for the head *of*
Leda, c.1504–6, are
preparatory drawings
for Leonardo's painting
Leda and the Swan, now lost.
The painting was recorded in
the estate of Leonardo's
assistant Salaì in 1525.
The work is known through
several studies created
by Leonardo, and a close
copy of the painting made
by Cesare da Sesto
(c.1477–1523), painted
c.1505–10. Other copies
also exist.

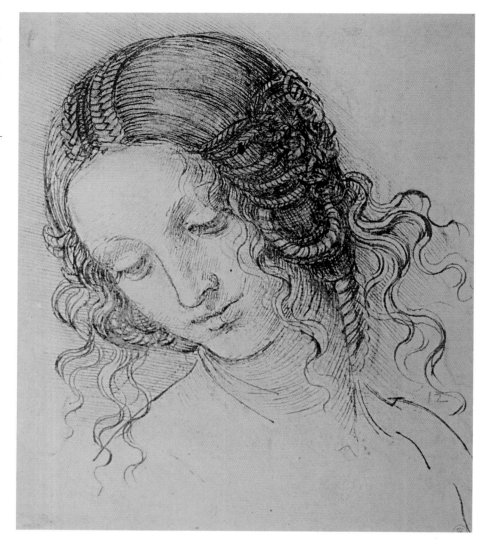

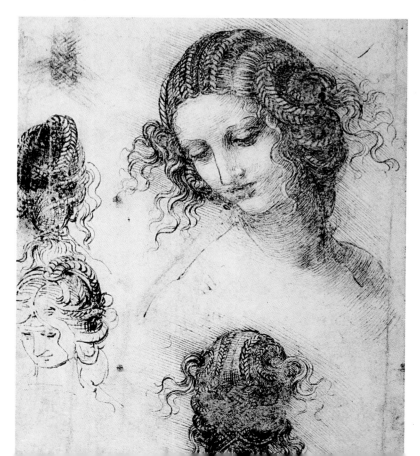

Studies for the head
of Leda, c.1505–10, pen
and ink over black chalk on
paper, Royal Library,
Windsor Castle, UK,
20 x 16.2cm (7.9 x 6.4in)

In these studies the hair of
Leda is exquisitely styled and
illustrated, from the front of
the head, the back of the
head and the crown.
The hair is intricately
braided. The whorls and
wisps of hair, according to
Leonardo, mimic water in
circular motion.

Study for the head of Leda, c.1503–6, pen and ink on paper, Royal Library, Windsor Castle, UK, 9.2 x 11. 4 cm (3.6 x 4.5 in)

This drawing is inscribed by Leonardo da Vinci, 'questo sipo/ levare eppo/ re sanza gu/ asstarrsi' ('this can be removed and put on without hurting it'). This might be in reference to the hair being a wig, which the model could put on for Leonardo's preparatory sketches of Leda, and then for the actual painting. The hair in Cesare da Sesto's painting Leda and the Swan, after Leonardo da Vinci, bears a close resemblance to Leonardo's preparatory drawings.

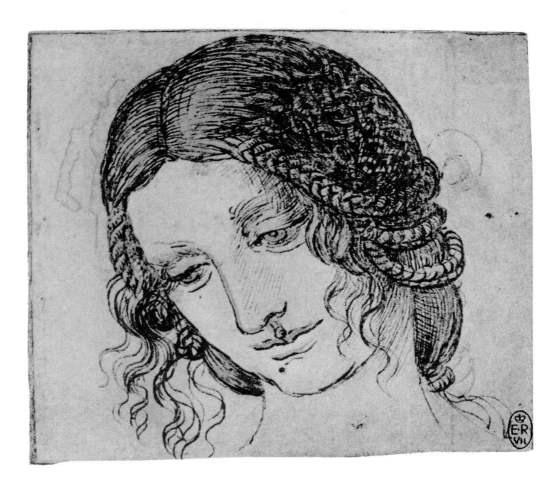

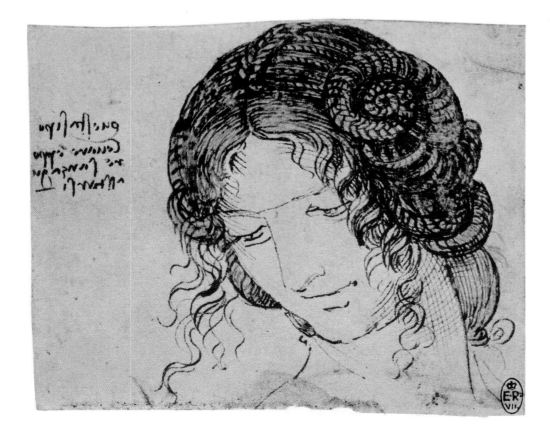

Study for the head of Leda, c.1503–6, pen and ink over black chalk on paper, Royal Library, Windsor Castle, UK, 9.3 x 10.4cm (3.7 x 4.1in)

A study for the head of Leda that focuses on the intricate styling of the young woman's hair. The elaborately plaited hair styled into whorls of braiding, according to Leonardo's notes, may relate to the eddying whirls created in moving water, and possibly a link to the river habitat of the swan (the mythical god Zeus in disguise).

Two studies of rush in seed,
*c.*1505–10, pen and ink
over black chalk on paper,
Royal Library,
Windsor Castle, UK,
19.5 x 14.5cm (7.7 x 5.7in)

A study of two rush plants,
Scirpus lacustris and *Cyperus
monti,* with notes. The
studies may possibly have
been for the *Leda and the
Swan* painting or intended
for Leonardo's planned
publication on drawing and
painting. The notes to the
top of the page explain the
plant above: 'This is
the flower of the fourth
type of rush and is the
principal of them, growing
three or four *braccia*
high…' To the left of the
lower plant, he writes, 'This
is the flower of the third
type, or rather species of
rush, and its height is about
one *braccio*…'. (One
Florentine *braccio* is equal
to about 58.4cm/23in.)

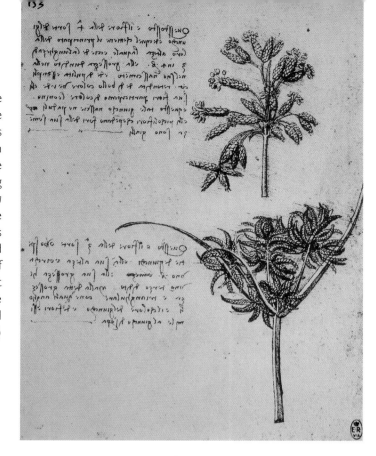

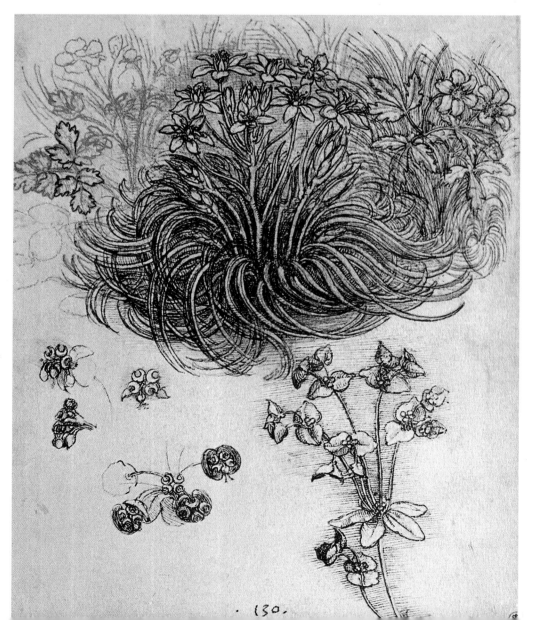

Star of Bethlehem and
other plants, c.1504–6, red
chalk, pen and ink,
Royal Library,
Windsor Castle, UK,
19.8 x 16cm (7.8 x 6.3in)

A detailed study of the Star
of Bethlehem (*Ornithogalum
umbellatum*), a spring plant,
and other flowers, was
preparatory work for
Leonardo da Vinci's painting
of Leda and the Swan.
He produced several
drawings of plants and
flowers to use in the
painting. The observation
and sketching of wild flowers
at his childhood home in
Vinci would have informed
his knowledge of variant
species of flowers and plants.

*Mona Lisa, c.*1503–6, oil on panel, Musée du Louvre, Paris, France, 77 x 53cm (30.3 x 20.9in)

The sitter for the *Mona Lisa* painting is considered to be Lisa Gherardini (1479–c.1551), Monna Lisa del Giocondo, the wife of wealthy Florentine silk merchant Francesco del Giocondo (1460–1539). The portrait of Francesco's wife was possibly commissioned to commemorate the birth of the couple's second son in December 1502. The three-quarter length portrait depicts the sitter looking directly at the viewer in near full-profile. Leonardo has paid great attention to the fine skin of the delicate hands of Monna Lisa. The enigmatic smile of Monna Lisa is well documented. The soft half-smile was a favourite of Leonardo and can be seen in his other works, particularly the cartoon of the *Virgin and Child with St Anne and the Infant John the Baptist, c.*1499–1500. Painting a portrait in oils was a time-consuming project for an artist and an expensive one for the patron. Unusually, the *Mona Lisa* painting remained with Leonardo until he died and did not become the property of the sitter. The reason for this remains unknown. Leonardo's signature landscape is glimpsed behind the *Mona Lisa.* Beyond her right shoulder a winding road snakes through the valley toward a rocky formation of mountains.

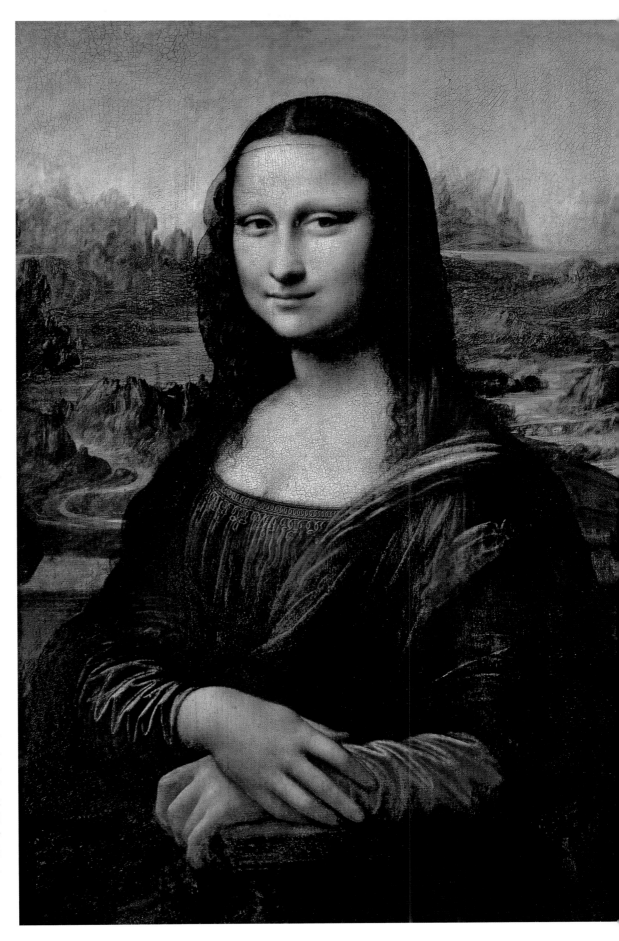

Studies for the infant
Christ, *c.*1501–10,
red chalk with
white heightening
on tinted paper,
Galleriadell'Accademia,
Venice, Italy,
28.5 x 19.8cm
(11.2 x 7.8in)

These studies for the
infant Christ may be
preparatory studies for
the *Virgin and Child
with St Anne and the
Infant St John the
Baptist.* It has not been
possible to date the
drawing with precise
accuracy. Stylistically it
is dated between
1501 and 1510.

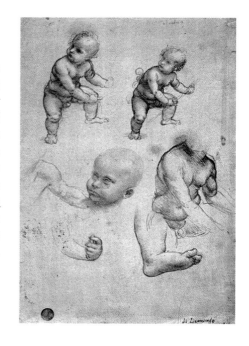

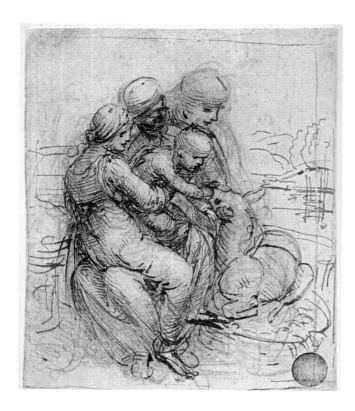

Study for the *Virgin and
Child with St Anne,*
*c.*1501–10, pen and ink
on paper, Galleria
dell'Accademia, Venice, Italy,
12.1 x 10cm (4.8 x 3.9in)

The pen and ink drawing is a
preparatory study for the
Virgin and Child with St Anne,
which shows the Christ
Child reaching out to touch
a young animal.

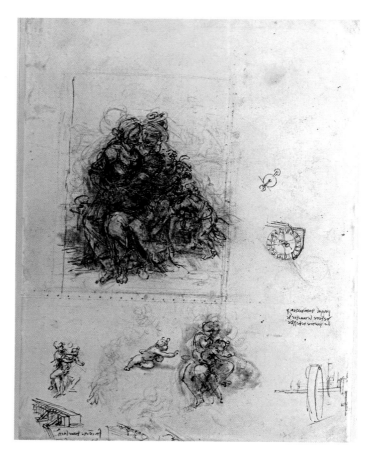

Studies for the *Virgin and
Child with St Anne and the
Infant St John the Baptist,*
*c.*1501–3, pen and brown
ink, with grey wash,
heightened with white, over
black chalk, indented for
transfer, British Museum,
London, UK,
26.5 x 19.9cm
(10.4 x 7.8in)

The larger study, enclosed in
a frame, depicts the Virgin
seated to the left, seemingly

perched on the lap of
St Anne, while holding the
infant Christ, who reaches
out to the infant St John
standing on the right.
The study is related to a
cartoon of the Virgin and
Child with St Anne and St
John. Four cartoons were
created by Leonardo but
only one survives (now in
the National Gallery,
London). This sheet of
sketches also contains
some studies of machinery.

Virgin and Child with St Anne and the Infant St John the Baptist, 1499–1500, black chalk and touches of white chalk on brownish paper, mounted on canvas, National Gallery, London, UK, 141.5 x 104.6cm (55.7 x 41.2in)

This full-size cartoon is a preparatory study for a painting. The cartoon has not been used – it lacks the pricking through or incising method of transferring cartoon to canvas. The dating of the work places it toward the end of Leonardo's residence in Milan and his move to Florence. Leonardo may have been commissioned in Milan by the French king, Louis XII, at the time French troops were entering the city, or contacted by a member of the king's entourage. The painting of the work was carried out later in 1508.

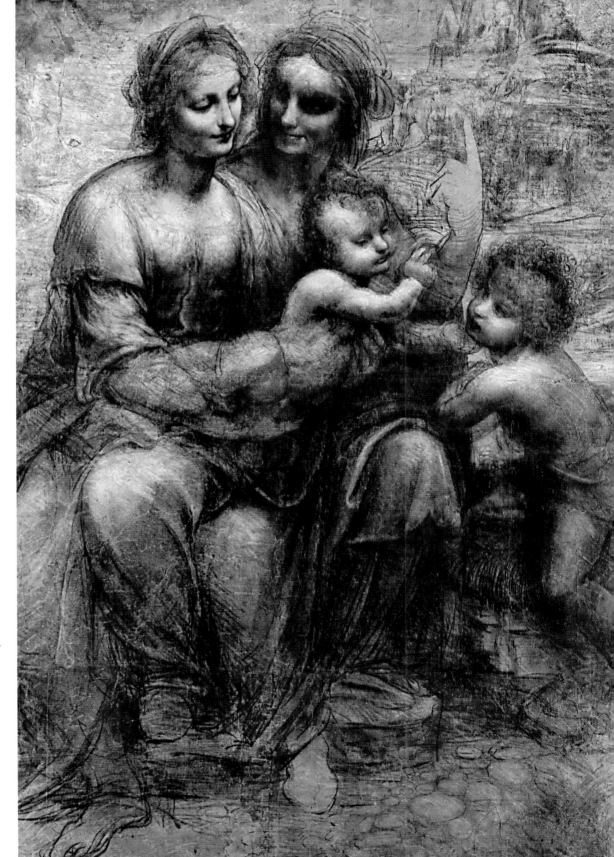

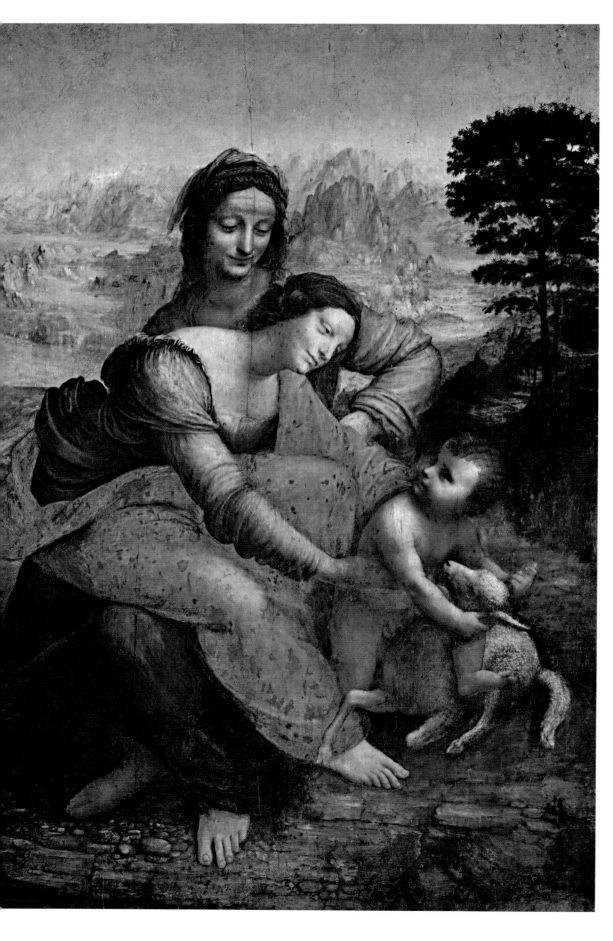

Virgin and Child with St Anne,
*c.*1502–16, oil on poplar,
Musée du Louvre, Paris,
France, 168.5 x 130cm
(66.3 x 51.2 in)

The composition of the *Virgin and Child with St Anne* contains some similarities to the cartoon of the *Virgin and Child with St Anne and St John the Baptist,* 1499–1500. The figures of the Virgin and St Anne remain closely connected. The Virgin leans forward and across the body of St Anne to allow her son to stroke a lamb. St Anne gazes at them with a serene smile. The Christ Child is held by his mother close to the ground in order to stroke a lamb, which has replaced the figure of the infant John the Baptist. St Anne and the Virgin, mother and daughter, are both smiling as they look toward the figure of the infant Christ. Leonardo has captured a tender private moment between three generations of a family. The setting for the family group is outdoors. Both the Virgin and St Anne wear long robes and their feet are bare. The landscape behind the figures of the Virgin and St Anne features Leonardo's favoured rocky mountains. The pale colour of the mountains serves to focus attention on the heads of the two women. The landscape gradation of colour, from dark to pale, creates an aerial perspective and the illusion of distance.

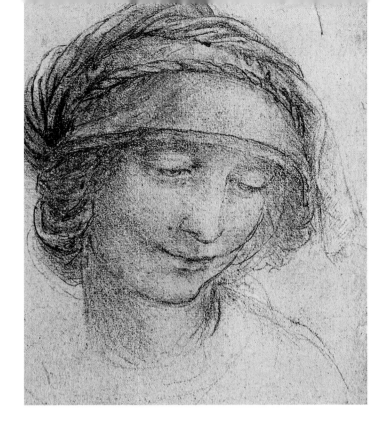

Study of the head of a woman looking down to the right, c.1501–10, black chalk on paper, Royal Library, Windsor Castle, UK, 18.8 x 13cm (7.4 x 5.1in)

This detailed study of the head of a woman looking down is considered by historians to be a preparatory drawing for the head of St Anne in *The Virgin and Child with St Anne*, 1502–16. The facial expression bears a likeness to the image of the Virgin in Leonardo's cartoon of *The Virgin and Child with St Anne and St John the Baptist*, 1499–1500.

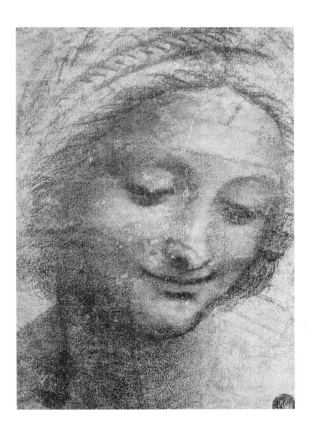

Study for the head of St Anne, c.1501–8, charcoal on paper, Gallerie dell'Accademia, Venice, Italy, 15 x 21cm (5.9 x 8.3in)

This is a preparatory study for the head of St Anne. The drawing depicts her not as a saint but as mother and grandmother. She looks down at the Virgin and Christ Child with a loving, serene expression.

Study for the sleeve of the Virgin's arm, c.1501–10, red, black and white chalk on reddish prepared paper, Royal Library, Windsor Castle, UK, 8.6 x 17cm (3.4 x 6.7in)

A detailed preparatory study of the right arm, hand and sleeve of the figure of the Virgin for the painting of the *Virgin and Child with St Anne*.

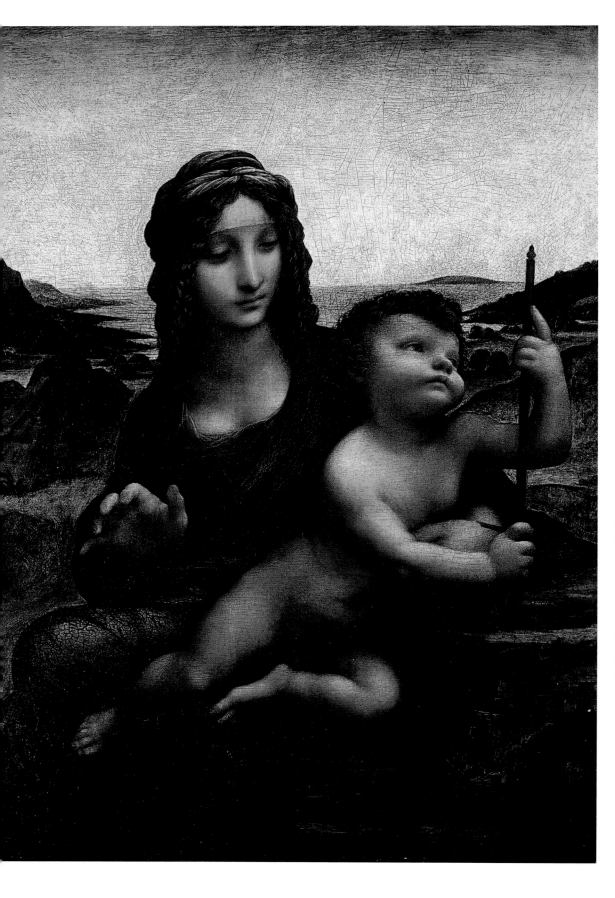

Madonna of the Yarnwinder (Buccleuch Madonna), by Leonardo da Vinci and workshop, *c.*1501–7, oil on panel, private collection (Duke of Buccleuch and Queensberry, KT), 48.3 x 36.9cm (19 x 14.5in)

The small panel painting is from an original design by Leonardo da Vinci and painted by members of his workshop with some evidence of his participation. The painting depicts the Virgin and Child in a landscape. The naked Christ Child stretches out across his mother's lap to hold a yarnwinder or spindle, reminiscent of a crucifix, in his left hand. He steadies the base of it with his right hand. The sweet face of the Virgin mother looks down to her infant son. She places her left arm around his body to steady him. The infant Christ looks away from his mother; his gaze is fixed on the top part of the yarnwinder, which resembles the shape of a crucifix. The landscape depicts water surrounded by hills below a clear sky. Historians believe that the painting of the sky, hills and surface water was retouched (not by Leonardo).

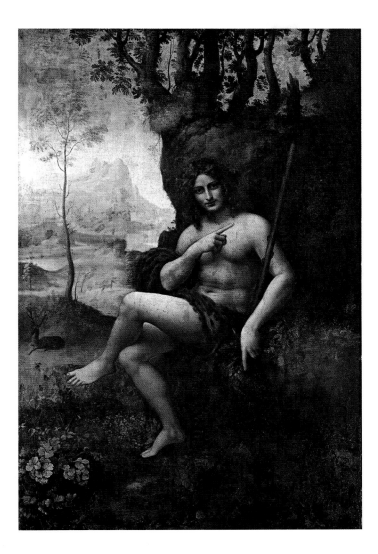

Bacchus (controversial attribution to Leonardo da Vinci), *c.*1513–19, tempera and oil on panel, transferred to canvas, Musée du Louvre, Paris, France, 177 x 115cm (69.7 x 45.3in)

The painting *Bacchus* holds a contentious attribution to Leonardo da Vinci. It is possibly the product of Leonardo with help from assistants. Similarities can be found in Leonardo's painting of *St John the Baptist, c.*1513–16, below. This painting *Bacchus* was in fact begun as a St John the Baptist depiction but was changed to a Bacchus.

In this painting the young Roman god Bacchus sits in a shady grove. He is naked except for a draped animal skin across his lower body. His left arm enfolds a thrysos stick (a staff), a symbol of Bacchus and the Bacchanalian rites. His eyes look out toward the viewer. His features bear a resemblance to Leonardo's *St John the Baptist*. Leonardo creates a pastoral landscape for the figure of Bacchus, which would work equally well for a portrayal of St John the Baptist. To the left of the figure of Bacchus a distant landscape includes hills, mountains and lakes.

St John the Baptist, *c.*1513–16, oil on canvas, Musée du Louvre, Paris, France, 69 x 57cm (27.2 x 22.4in)

Leonardo depicts an idealized figure of St John the Baptist in a half-length portrait. The darkened background highlights the naked upper body of St John; his right arm is raised, and his index finger points upward. His lower body is wrapped in animal fur. The dating of the portrait of St John the Baptist to 1513–16 places its creation during Leonardo's stay in Rome, prior to moving permanently to France. The painting was in the artist's possession when he died. John the Baptist is the last of the Old Testament prophets, a forerunner of Christ. He was a preacher who lived much of his life in the desert. The right arm of St John the Baptist is held across his body to draw attention to the upward movement of the hand and the index finger raised and pointing toward heaven. A light source directed from above the head illuminates the face, the raised arm and hand. The eyes of St John focus on the viewer. His head is covered in a mass of curls. The facial expression of the saint resembles the enigmatic smile of the *Mona Lisa*.

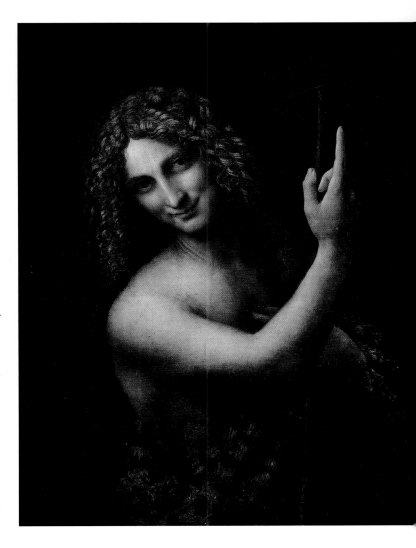

The Art of Science

As well as being an accomplished painter and draughtsman, Leonardo also made a unique contribution to science, as anatomist, geographer, astronomer and engineer. Each field of study reveals the phenomenal scope of Leonardo's inventive mind. An introductory letter from Leonardo to Ludovico Sforza outlined his ambitions to build fortifications, temporary bridges, scaling ladders and machines for warfare; it was but a small part of his portfolio. In his lifetime, he sought to understand the luminosity of the moon; he immersed himself in human and animal anatomy, in order to understand the body's construction and organ functions; and he produced extraordinary maps, to plot the landscape.

Above: Anatomical study of the human skull in sagittal section, seen from the front (detail), 1489.
Leonardo accurately identifies and illustrates the maxillary sinus in the cheekbone of the skull.
He illustrates the arrangement of the teeth, each identified in individual drawings to the left.
Left: Sheet of notes, and drawings of the sun and moon (detail), Codex Arundel, 1508.

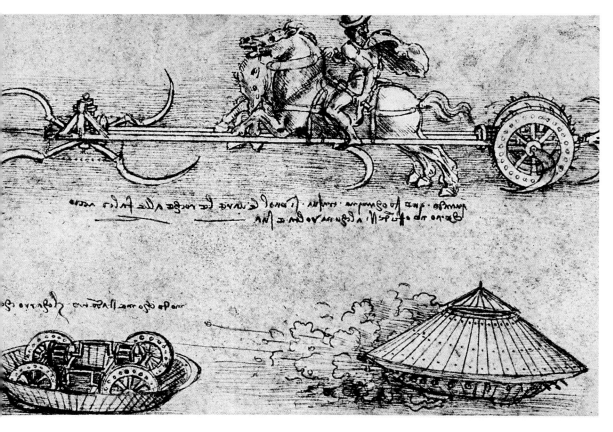

Designs for a scythed chariot and an armoured car, *c.*1485–8, pen and ink on paper (ref. B.B.1030), British Museum, London, UK, 17.3 x 26.6cm (6.8 x 10.5in)

Two designs are illustrated here, one for a scythed chariot (one of several Leonardo designed) and the other for a prototype armoured car, circular in shape. The drawing to the lower left of the paper illustrates the internal workings of the car, shown upside down with the wheel mechanism clearly drawn. Underneath the drawing he wrote, '8 men to operate it, and the same men turn the car and pursue the enemy'.

Model of an armoured car, *c.*1485, Museo Leonardiano di Vinci, Castello dei Conti Guidi, Vinci, Italy, dimensions unknown

A modern reproduction, created to scale in wood, of the armoured car designed by Leonardo da Vinci, *c.*1485–8. Leonardo enjoyed working as a design engineer; it absorbed his interest. For Ludovico Sforza he produced many designs for war machines, none of which were ever put into production.

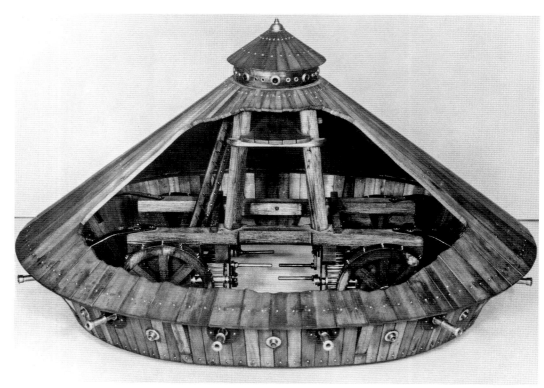

Study with a battle chariot, a soldier with a shield, and a horseman, c.1485–8, pen and ink on paper, British Museum, London, UK, 17.3 x 24.6cm (6.8 x 9.7in)

One of a series of studies of war machines by Leonardo da Vinci. The sketches show a soldier armed with a bow and arrow and a shield, a horse at full gallop with the rider in position holding a lance, with two further lances attached to the horse and two battle chariots with a variety of menacing weapons attached. It was Leonardo's desire to be in the service of Ludovico Sforza as an engineer and architect, not a painter.

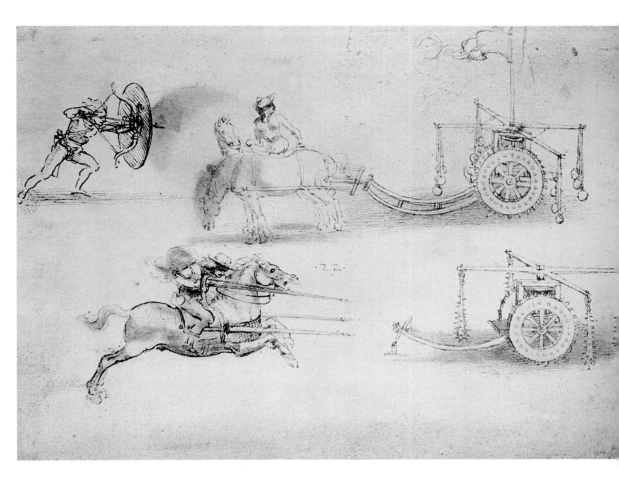

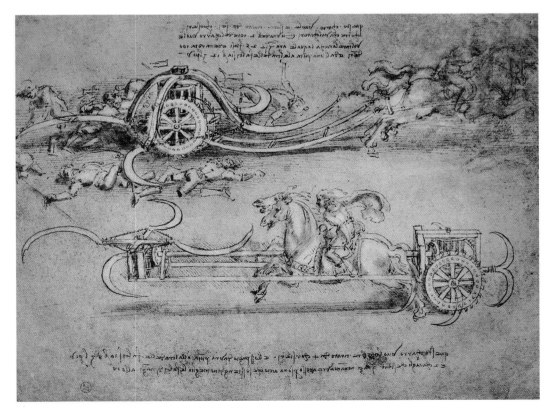

Scythed chariots, c.1485–8, pen and ink, Biblioteca Reale, Turin, Italy, 21 x 29cm (8.3 x 11.4in)

Two chariots are illustrated here, each with a variation of Leonardo's scythe action blades, aimed to kill or maim enemy troops. The upper illustration shows the machine blades in action, scattering dismembered bodies in the wake of the human threshing machine. The lower illustration depicts a chariot with shorter blades. The horseman controlling the chariot horses wears a scarf-like item of clothing. It flutters in the wind, to represent the high speed at which the machine is travelling.

Drawing of a large cannon
raised on to a gun carriage,
c.1487, pen and ink on
paper, Royal Library,
Windsor Castle, UK,
25 x 18.3cm (9.8 x 7.2in)

This drawing shows a busy
munitions yard with stores of
cannon barrels, gun carriages
and cannon balls. Central to
the drawing is a vast
armature, used to winch
a colossal cannon barrel on
to a gun carriage. Helping to
achieve this is an army of
men, all illustrated naked.
To the foreground the
cannon barrel cradle is
shown, where it has been
left. Leonardo had hoped to
spend his time in Milan
creating machines, for peace
or war, but none were
brought to production.

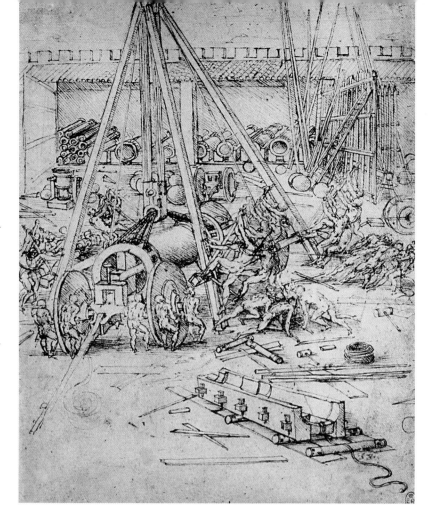

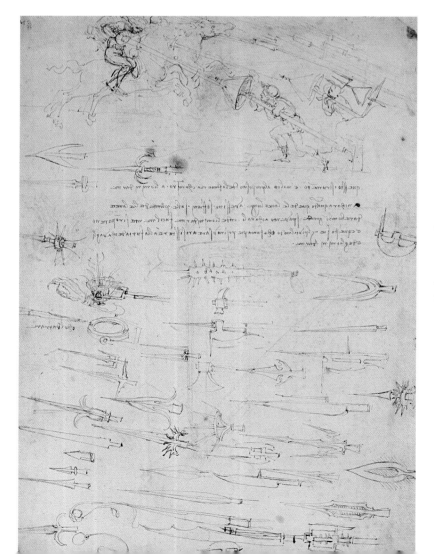

Sheet of studies of foot
soldiers and horsemen in
combat, and halberds,
1485–8, pen and ink
on paper, Gallerie
dell'Accademia, Venice, Italy,
24.7 x 17.5cm (9.7 x 6.9in)

A sheet of studies, one in a
series, illustrating military
halberds. These are
constructions used from
the Middle Ages that
combine a spear and a
battle-axe on a long handle.
At the top of the paper are
sketches of foot soldiers and
horsemen in combat.

Studies of attack cart and war machines (Codex Atlanticus, fol. 0049r), c.1480–2, pen and ink on paper, Biblioteca Ambrosiana, Milan, Italy, 26.8 x 19.4cm (10.6 x 7.6in)

These studies illustrate a covered bridge design, enabling attackers to get close to enemy walls and raise the mechanism to cross. To the lower right is a design for a siege machine.

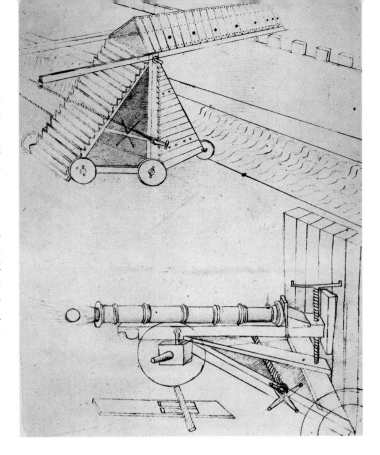

War machines, c.1485, pen and ink on paper, Codex Atlanticus (fol. 4v; 235v), Gallerie dell'Accademia, Venice, Italy, 21.3 x 15cm (8.4 x 5.9in)

An outline sketch of war machines, including a giant catapult and its fixings, devised by Leonardo. Studies of war machinery created during Leonardo's stay in Milan point to workable technology. In a letter of his own recommendation to Leonardo Sforza, Leonardo described himself as a 'military engineer', offering designs for instruments of war: 'I will lay before your Lordship my secret inventions, and then offer to carry them into execution at your pleasure.'

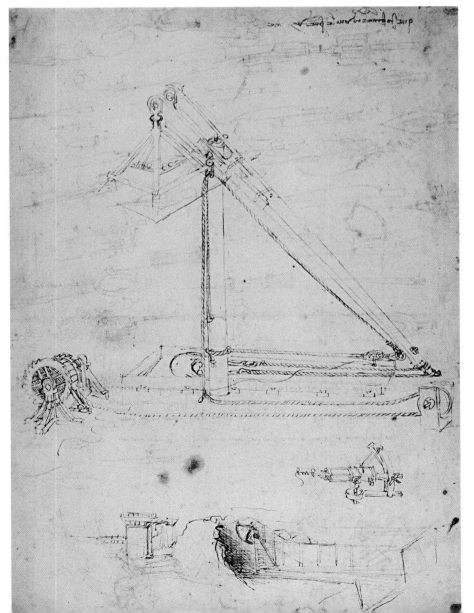

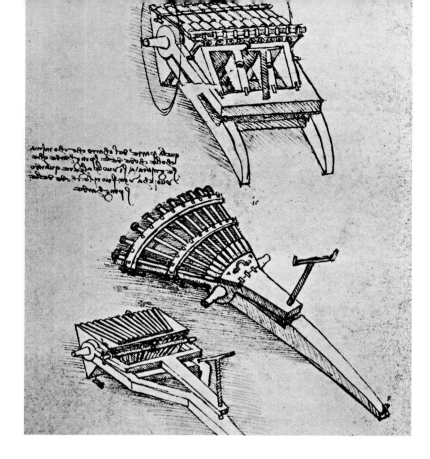

Studies of multi-barrelled guns (Codex Atlanticus, fol. 0157r), c.1480–2, pen and ink on paper, Biblioteca Ambrosiana, Milan, 27 x 18.8cm (10.6 x 7.4in)

This sheet of studies illustrates three designs for multi-barrelled guns. Leonardo created a series of designs for warfare machines, including giant crossbows and treadwheels, and intricate machines for simultaneously hurling stones using mechanized catapults.

Model of multi-barrelled gun, Château du Clos Lucé, Amboise, France

This is a scale model of one of Leonardo da Vinci's designs for a multi-barrelled gun, a forerunner of the machine gun.

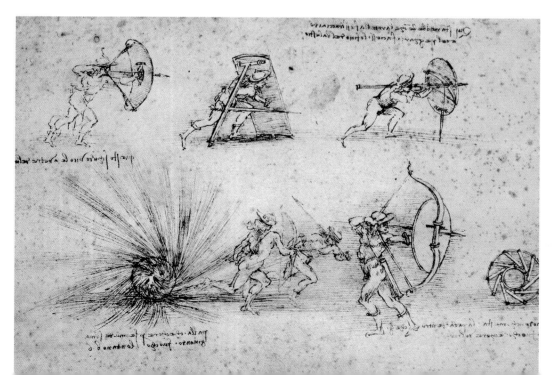

Drawings of shields for foot soldiers and an exploding bomb, c.1485–8, pen and ink on paper, École Nationale Supérieure des Beaux-Arts, Paris, France, 20 x 27.3cm (7.9 x 10.7in)

A fascinating sketch that reveals a variety of inventive shield types, and their mode of use by foot soldiers in combat. At lower left, an exploding bomb is illustrated, showing the ineffectiveness of soldiers, shields or arrows to interrupt its path.

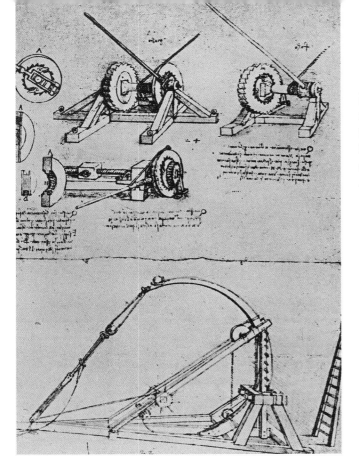

Design for a catapult machine (Codex Atlanticus, fol. 148r, a–above/ b–below), c.1490, pen and ink on paper, Biblioteca Ambrosiana, Milan, Italy, 16.2 x 29cm (6.4 x 11.4in)

The mechanism of a giant catapult is fully explored in Leonardo's detailed drawing, which diagrammatically demonstrates the formation and working parts of the war machine.

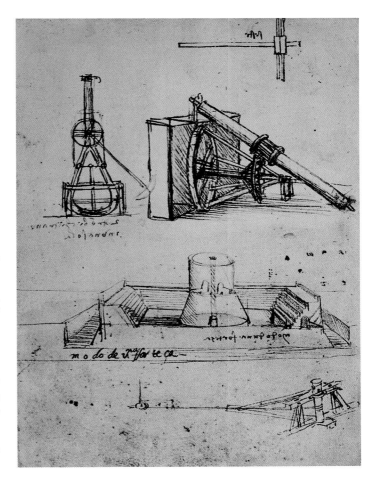

Designs for defensive weapons (Paris Manuscript B, fol. 52v), c.1487–90, pen and ink on paper, Bibliothèque de l'Institut de France, Paris, 23 x 16cm (9.1 x 6.3in)

This sheet is part of Leonardo's earliest recorded manuscript, dating to his last years in the service of Ludovico Sforza in Milan. The need for defensive weapons, to protect Milan from an invasion by the French, is reflected in this drawing, one of many designs for military and civil engineering equipment.

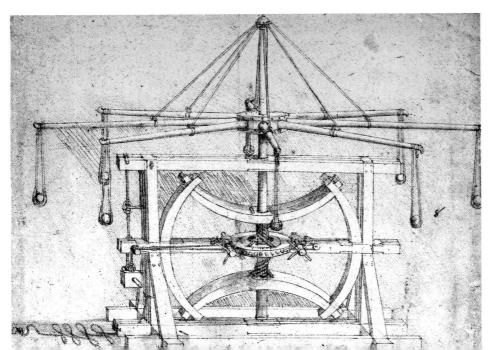

A military machine to catapult stones, c.1485, pen and ink on paper, Biblioteca Ambrosiana, Milan, Italy, 20.8 x 26.5cm (8.2 x 10.4in)

The detail of the drawing reveals a complicated mechanism for catapulting stones, to engage a systemized line of attack. The idea of the machine, perhaps not practical to produce, demonstrates Leonardo's inventive logic.

Design for a giant crossbow (Codex Atlanticus, fol. 149r–b), 1485, pen and ink on paper, Biblioteca Ambrosiana, Milan, Italy, 20.3 x 27.5cm (8 x 10.8in)

Leonardo made several drawings of this prototype giant crossbow. The structure is colossal – the width of the bow is 13m (42.6ft) – and can be gauged by the size of the tiny figure of the man, standing on its shaft, ready to release the screw mechanism that was intended to fire heavy balls. The crossbow was to be made of wood with six wheels. The design was one of many created for Ludovico Sforza.

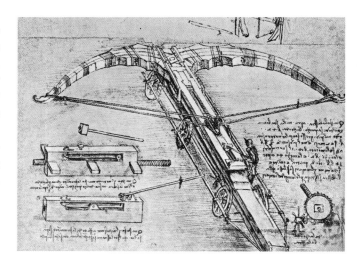

Mortars bombarding a fortress, c.1503–4, pen and ink with brown wash over black chalk on paper, Royal Library, Windsor Castle, UK, 32.9 x 48cm (13 x 18.9in)

A large drawing of a military machine in action. The spectacular illustration depicts a row of four mortars firing stones over a wall and into the courtyard of a castle or fort. The shower of ammunition is illustrated in the continuous arch of falling stones.

Designs for a treadwheel with four crossbows (Codex Atlanticus, fol. 1070r), c.1485, pen and ink on paper, Biblioteca Ambrosiana, Milan, Italy, 22 x 30cm (8.7 x 11.8in)

A prototype for a war machine designed by Leonardo da Vinci for Ludovico Sforza. The mechanism of the treadwheel in action triggers the revolving crossbows to fire.

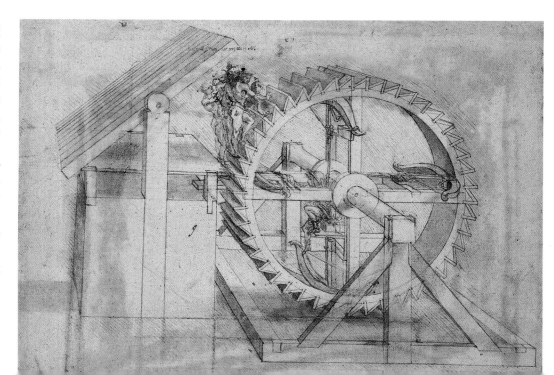

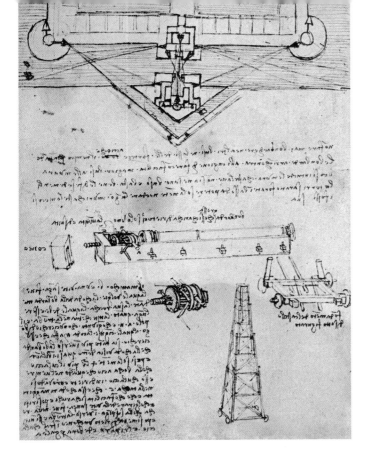

Drawing of a bombard and its placement on ramparts (Paris Manuscript B, fol.24r), c.1487–90, pen and ink on paper, Bibliothèque de l'Institut de France, Paris, 23 x 16cm (9.1 x 6.3in)

A bombard was a type of cannon, which fired stone cannonballs.

The text accompanying the drawing explains how the machine will defend the fortress, and how it can be loaded. Leonardo created several different types of bombard, illustrating the firing mechanisms and the effects of their use. In this drawing, the bombard is placed on the ramparts of the fortification.

Design for a ladder for scaling fortifications and other drawings (Paris Manuscript B, fol. 50r), c.1487–90, pen and ink on paper, Bibliothèque de l'Institut de France, Paris, 23 x 16cm (9.1 x 6.3in)

The central illustration depicts a soldier scaling the walls of a fortification, using a flexible rope ladder that can be attached to the building for quick access. Below it, Leonardo details a section of the design of the ladder. Many of his military drawings feature equipment for the scaling of fortresses, using a variety of ladders, created for different defence systems.

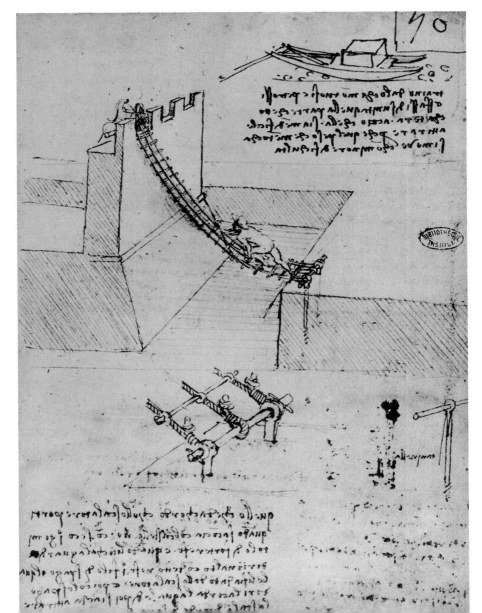

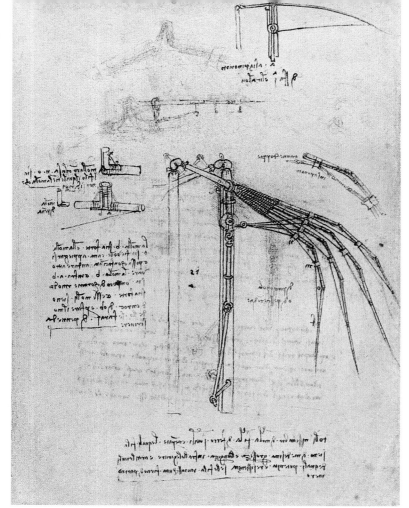

Study of articulated wings, c.1490–3, pen and ink on paper, Biblioteca Ambrosiana, Milan, Italy, 29 x 21.8cm (11.4 x 8.6in)

After initial research into a flying machine powered solely by human muscle, Leonardo altered his approach to consider a machine powered by mechanical means, incorporating power derived from the pilot's leg muscles. It was an assumption that muscle power would be enough that delayed Leonardo's progress.

Design for a device for rotating a wing, c.1505, pen and ink on paper, Biblioteca Reale, Turin, Italy, 21.3 x 15.4cm (8.4 x 6.1in)

The drawings show a design for a device for rotating a wing (Turin, Codex on flight, 17r), which relates to the study of flight, a constant source of exploration for Leonardo. The drawing details the 'nuts and bolts' of its mechanism with accompanying text.

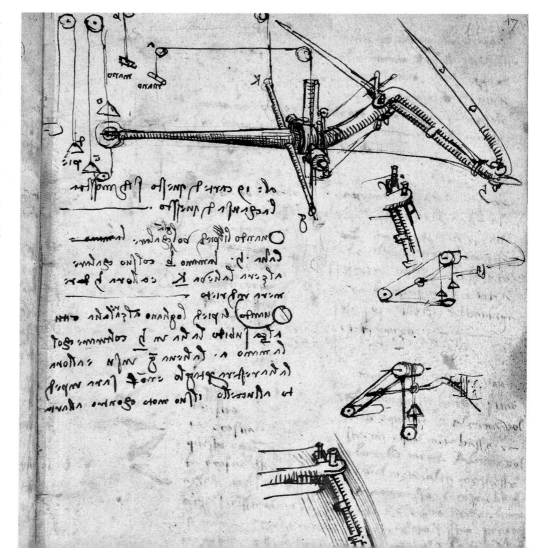

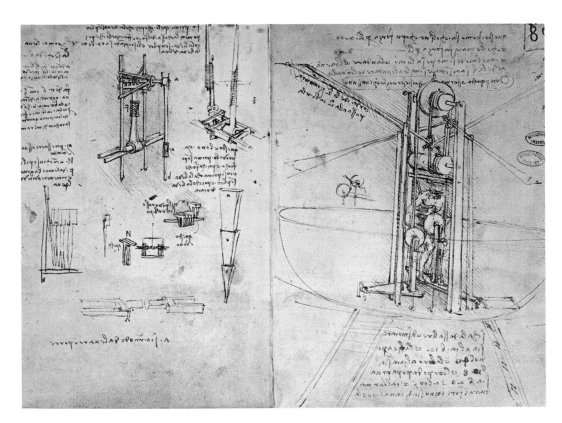

Design for a vertically standing bird's-winged flying machine (Paris Manuscript B, fol. 80r), 1488–90, pen and ink on paper, Bibliothèque de l'Institut de France, Paris, 23.2 × 16.5cm (9.1 × 6.5in)

A vertical ornithopter, a standing bird's-winged flying machine. This is one of a series of machines designed for mechanical flight. Leonardo closely studied the flight of birds, particularly wing structure, to ascertain the process and science of flight. Of the most interest on this sheet is the image of a man, to the right, operating the 'helicopter' from within the machinery.

Take-off and landing equipment for a flying machine (Paris Manuscript B, fol. 89r), c.1488–90, pen and ink on paper, Bibliothèque de l'Institut de France, 23.2 × 16.5cm (9.1 × 6.5in)

The intricacies of Leonardo's design for take-off and landing equipment for a flying machine include a ladder at the base to reach the mechanical parts.

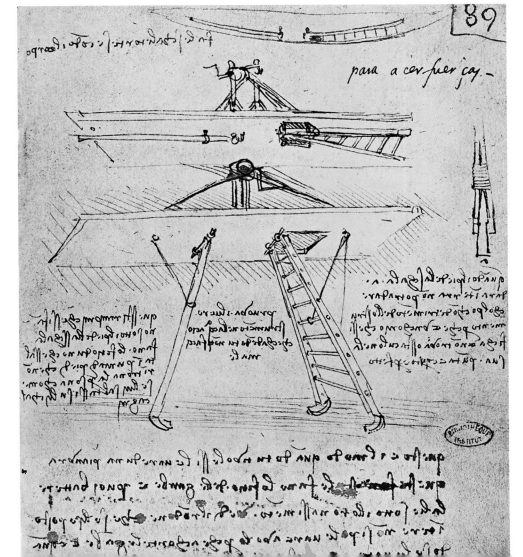

Sketch of a design for a flying machine (Paris Manuscript B, fol. 74v), c.1487–90, pen and ink on paper, Bibliothèque de l'Institut de Paris, 23.2 x 16.5cm (9.1 x 6.5in)

Leonardo was intensely interested in flight. He observed the flight of birds and transferred his explorations to the study of machines, which could enable human flight. The designs of his machines were based on the wing mechanism of birds.

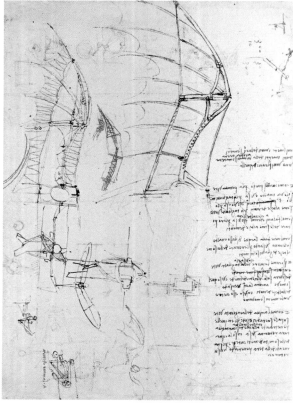

Bird's wing apparatus with partly rigid wings (Codex Atlanticus, fol. 858r), c.1488–90, pen and ink and red chalk on paper, Biblioteca Ambrosiana, Milan, Italy, 28.9 x 20.5cm (11.4 x 8.1in)

The wings of Leonardo's aircraft were modelled on bird and bat wing structures. To remain stable in flight, Leonardo placed the pilot at the centre of the machine below the wing mechanism.

Study of a flying machine, 1487–90, pen and ink on paper, Bibliothèque de l'Institut de France, Paris, 23.2 x 16.7cm (9.1 x 6.6in)

A lifetime interest in the mechanism of the flight of birds, with close attention to wing span and movement, was transferred to the study of flight by machines.

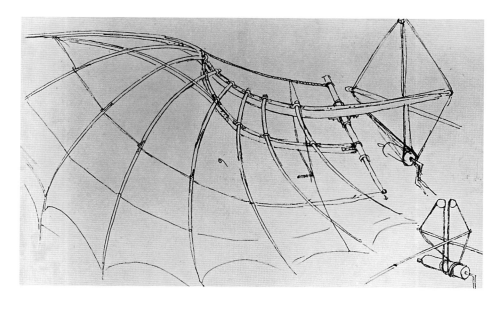

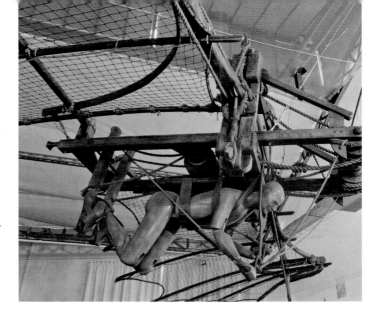

Reconstruction of a Leonardo da Vinci flying machine, Château du Clos Lucé, Amboise, France

At the location of Leonardo's last residence, in Cloux, a museum of Leonardo inventions demonstrates, through large-scale models, the inventiveness and ingenuity of its illustrious former resident. A flying machine model, scaled up from Leonardo's drawing, reveals the intricacy of the mechanics and the plausibility of its design, looking much like the microlight aircraft of the 21st century.

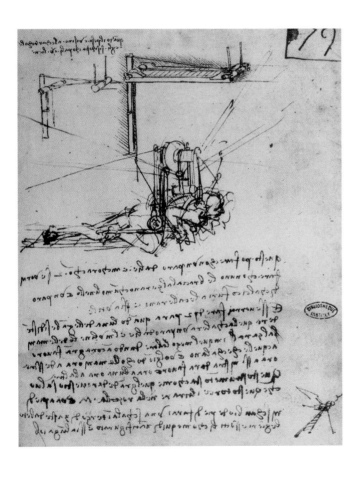

Studies of a flying machine with a hand- and foot-powered mechanism (Paris Manuscript B, fol. 79r), 1487–90, pen and ink on paper, Bibliothèque de l'Institut de France, Paris, France, 23.2 x 16.7cm (9.1 x 6.6in)

In some of Leonardo's drawings of flying machines, he illustrates the pilot lying prone, manipulating the craft's wing mechanism through arm and leg power. The arm power is articulated through a series of diagonal rods that are cranked by hand.

Design for a flying machine (Paris Manuscript B, fol. 83v), c.1488–90, pen and ink on paper, Bibliothèque de l'Institut de France, Paris, 23.2 x 16.5cm (9.1 x 6.5in)

Designs and notes relating to mechanical flight, with illustrations for a flying machine, the so-called 'helicopter' (Paris Manuscript B, fol 83v). Also included in the series of drawings created at this time were inventions for submarines and personal flight carriers.

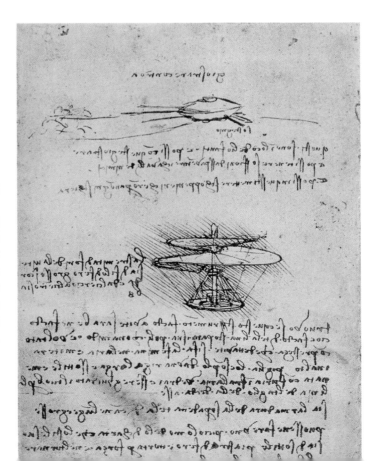

Cross-section of a building (Paris Manuscript B, fol. 36r), 1488–90, pen and ink on paper, Bibliothèque de l'Institut de France, Paris, 23.3 x 16.5cm (9.2 x 6.5in)

Designs for the 'ideal city' abounded in the 15th century in Italy, and Leonardo produced his own drawings for sucha city.

A seminal treatise, written by Leon Battista Alberti (1404–72), *De re aedificatoria* (*On the Art of Building*), 1452, was an early modern revision of the ancient Roman treatise, *De architectura libri decem* (*Ten Books on Architecture*), a handbook written by the Roman architect and engineer Vitruvius (*c.*80BC–15BC). Both were known to Leonardo.

Design for stables (Paris Manuscript B, fol. 39r), c.1487–90, pen and ink on paper, Bibliothèque de l'Institut de France, Paris, 23.3 x 16.5cm (9.2 x 6.5in)

A small number of Leonardo's drawings refer to architectural designs for palaces. This elaborate drawing belies the intended use of the buildings as a stable block. The text states that for stables one should 'divide its width in three parts… and let these three divisions be equal… the middle part shall be for the stable masters; the two side ones for the horses.' Leonardo explained that the hay, brought to the upper level by machine, was to be stored in the central area. The outer areas of this floor were for servants and stable hands.

Designs for bridge construction (Paris Manuscript B, fol. 23r), pen and ink on paper, Bibliothèque de l'Institut de France, Paris, 23 x 16cm (9.1 x 6.3in)

The text on this page discusses different designs for bridge construction. At the centre, one is illustrated with water flowing through, the text adding that the bridge could have two transits, one above the other.

Drawings of compass dividers (Codex Atlanticus, fol. 696r), 1514–15, pen and ink on paper, Biblioteca Ambrosiana, Milan, Italy, 28.4 x 22.2cm (11.2 x 8.7in)

This sheet illustrates over 30 drawings of opening mechanisms and compasses. The larger illustration depicts a compass with a pivotless ring and a spring on each pointer. The page highlights Leonardo's continuous interest in geometry, and his use of mathematical proportion for his engineering designs.

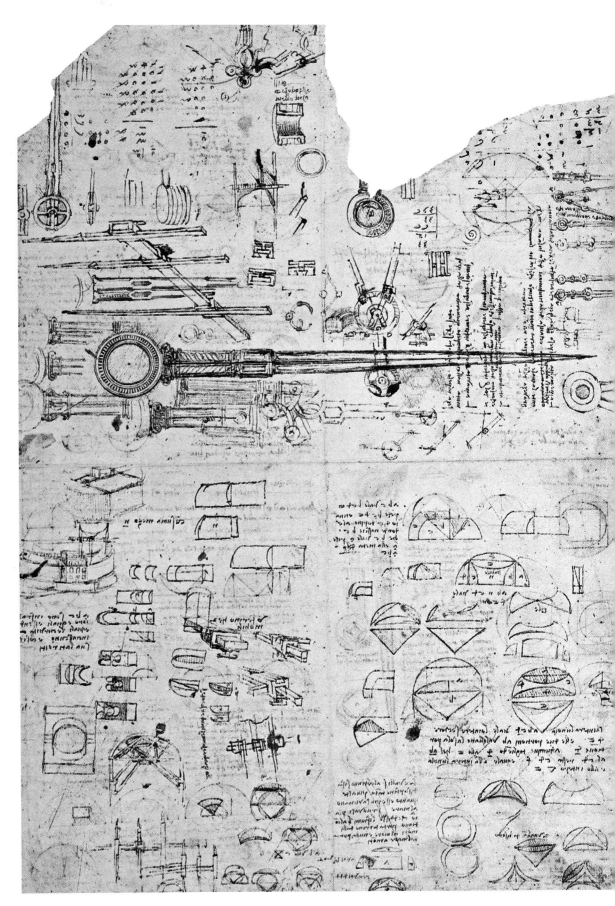

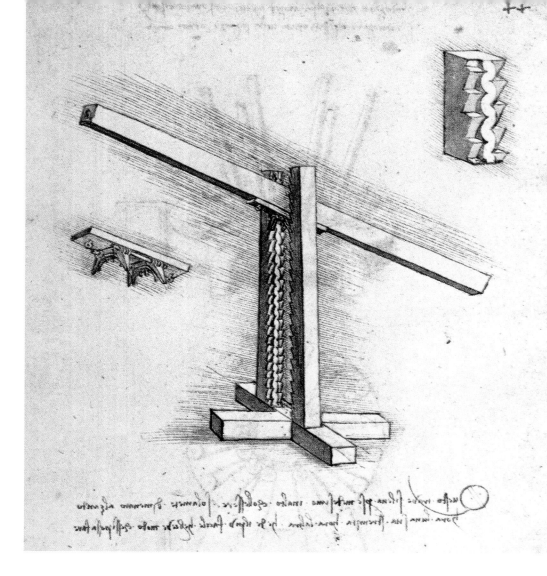

Hoist for a beam (Codex Madrid I, fol. 44r), 1493–7, pen and ink on paper, Biblioteca Nacional, Madrid, Spain 21.3 x 15cm (8.4 x 5.9in)

An early engineering study that illustrates a mechanism for a hoisting a beam. Leonardo's inventive designs for hoisting equipment follow other Italian contemporaries in this field, Filippo Brunelleschi (1377–1446), Francesco di Giorgio Martini (1439–1502) and Mariano Taccola (1382–c.1458).

Designs for machines to lift weights (Codex Atlanticus fol. 0138r), 1478–1518, pen and ink on paper, Biblioteca Ambrosiana, Milan, Italy, 27.8 x 38.5cm (10.9 x 15.2in)

These drawings depict machinery for lifting heavy weights, part of a series of engineering designs, showing the mechanism of innovative equipment and its construction.

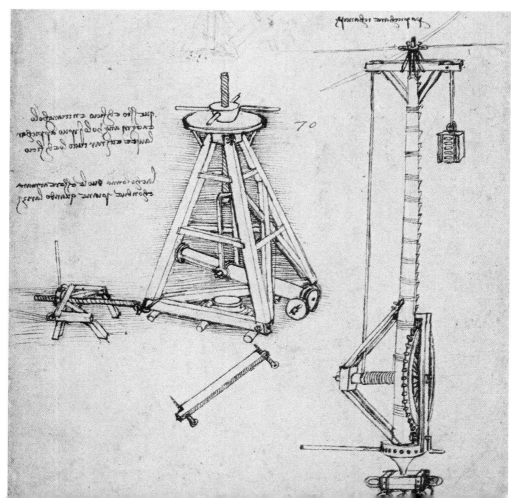

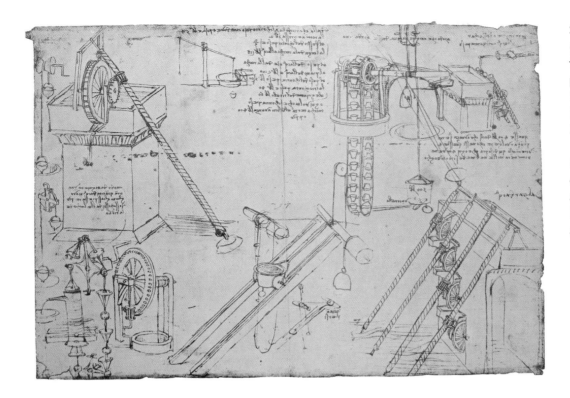

Studies of hydraulic devices
(Codex Atlanticus
fol. 386v-b), c.1478–80,
pen and ink on paper,
Biblioteca Ambrosiana,
Milan, Italy,
39.7 x 28.5cm (15.6 x 11.2in)

In the drawings of hydraulic
devices, hoisting equipment
and lifting mechanisms,
Leonardo establishes himself
as engineer.

Designs for water devices
(Paris Manuscript B, fol. 53v),
c.1487–90, pen and ink on
paper, Bibliothèque de
l'Institut de France, Paris,
23.1 x 16.5cm (8.4 x 6.5in)

The text on this page
refers to the mechanism
of machines designed for
pumping water and the
water ratio that can be
expected from the water
shower pictured.

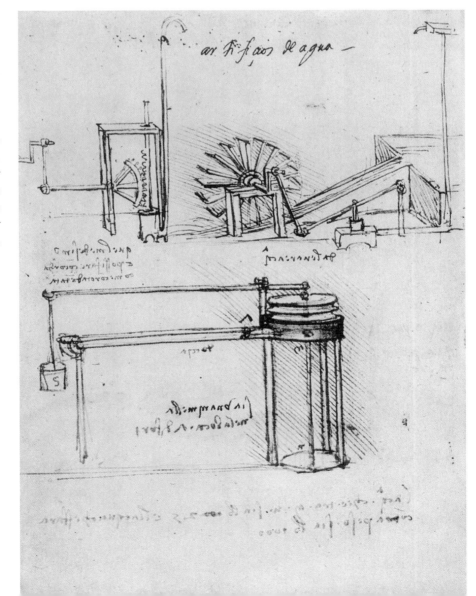

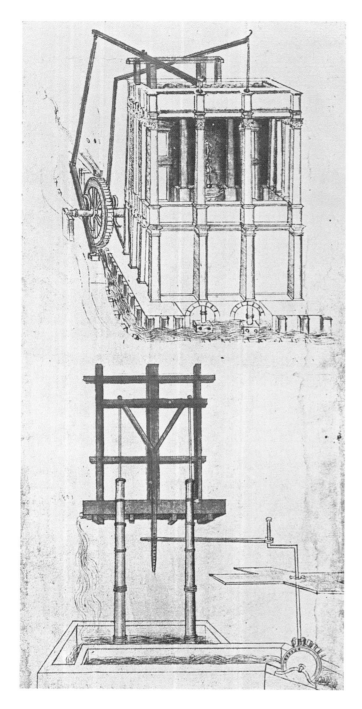

Tower-shaped loggia above a fountain (Codex Atlanticus, fol. 1099r), 1478–1518, pen and ink on paper, Biblioteca Ambrosiana, Milan, Italy, 23 x 39cm (9.1 x 15.4in)

In the palace section of Leonardo's treatise on the ideal design for palaces, castles and villas, he includes a loggia with fountain below. This detailed drawing illustrates a hydraulic water pump for the fountain, which is carefully concealed from view.

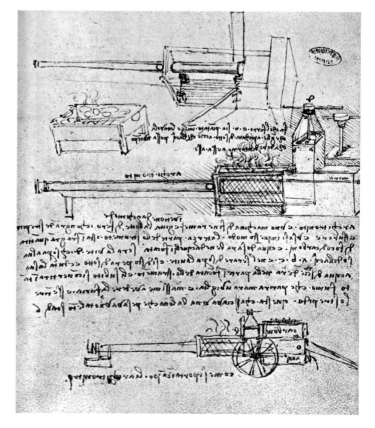

Designs for a steam cannon, 1488–97, pen and ink on paper, Bibliothèque de l'Institut de France, Paris, 23.1 x 16.5cm (8.4 x 6.5in)

A sheet of innovative designs for a warfare machine, which shows a cannon, activated by steam, to shoot missiles. The mechanics of the machine and operating method are illustrated.

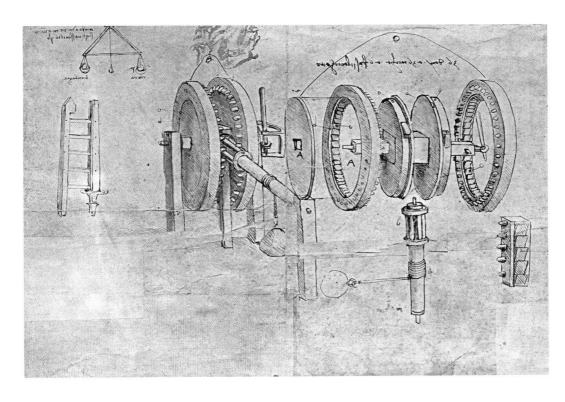

Machine with reciprocating motion (Codex Atlanticus, fol. 08v-b), c.1485, pen and ink on paper, Biblioteca Ambrosiana, Milan, Italy, 27.8 x 38.5cm (10.9 x 15.2in)

A skilful drawing that highlights Leonardo's remarkable ability to create a working drawing, and a work of art, from a series of wheels. The components of the machine, when put together, make a two-wheel hoist. The arrangement of the wheels on the paper aims to instruct on how to put the machine together.

Sketch of a rolling mill (Codex Atlanticus, fol.10r/2r-a), c.1500–10, pen and ink on paper, Biblioteca Ambrosiana, Milan, Italy, 30 x 22.5cm (11.8 x 8.9in)

One of a series of studies focusing on industrial machinery. This design for a rolling mill links to others in a series of designs for a spinning machine, textile processing equipment and cloth cutting machine.

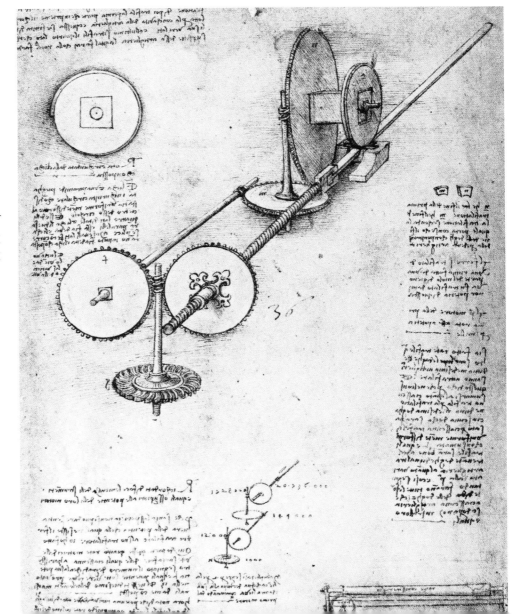

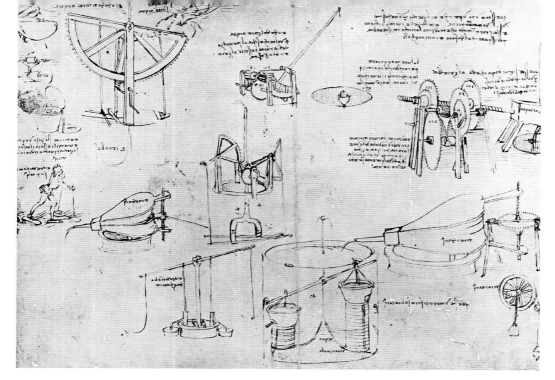

Designs for devices for diving and other studies (Codex Atlanticus, fol. 26r/7r-a), c.1480–2, pen and ink on paper, Biblioteca Ambrosiana, Milan, Italy, 29.1 x 40cm (11.5 x 15.7in)

This sheet, depicting hydraulic equipment, includes a small figure sketch of a man walking on water wearing the 15th-century equivalent of skis on his feet. Other devices, including bellows and breathing apparatus, are also illustrated.

Excavating machine (Codex Atlanticus, fol. 3r), c.1503, pen and ink on paper, Biblioteca Ambrosiana, Milan, Italy, 23 x 39cm (9.1 x 15.4in)

The Codex Atlanticus contains 1,119 pages of Leonardo's notes and drawings, from studies of bird flight, to sketches of machinery for bridge buildings, waterways and engineering equipment, dating from 1478 to 1519. Leonardo included engineering projects in his hydrographical and cartographic surveys of land. This design is of an excavating machine for canal construction, possibly in relation to plans to divert the course of the River Arno.

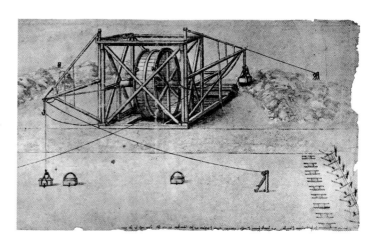

Designs for a hinge valve and bellows (Paris Manuscript E, fol. 34r), 1513–15, pen and ink on paper, Bibliothèque de l'Institut de France, Paris, 14.5 x 10cm (5.7 x 4in)

Manuscript E consists of 80 pages, dating from 1513–15. One part of the 'notebook' is titled 'Order of the first book of water'. The larger drawing illustrates a salt-water valve; beneath it is a bellows device. The sheets of notes and drawings include the study of weights, and water projects with machinery for canal dredging.

Chemical distillation oven (Codex Atlanticus, fol. 912r), 1480, pen and ink on paper, Biblioteca Ambrosiana, Milan, Italy, 21 x 30cm (8.3 x 11.8in)

The text beneath the drawing, in Leonardo's mirror writing, states that this is a sketch of 'fornello da stillare acque forti', an oven for distilling strong waters. In another notebook (Codex Forster), Leonardo gives the chemical recipe for 'acque forti', using equal parts of 'Roman vitriol, saltpetre, cinnabar and verdigris', which would create a nitric acid, for dissolving metals.

Designs for an underwater breathing device, c.1507–8, (Codex Arundel 263, fol. 24v), pen and ink on paper, British Library, London, UK, 21 x 14.3cm (8.3 x 5.6in)

It is known that in 1507–8 Leonardo, working for the French governor of Milan, Charles d'Amboise, was involved in the design of various ingenious water devices. His sheets of notes and drawings from this period include a water clock linked to an automaton and designs for underwater breathing apparatuses. The drawing here illustrates a floater, a valve that controls the intake and outlet tubes, to avoid water entering the breathing apparatus.

Diver with oxygen tube, carried above water (Codex Atlanticus, fol. 386r–b), c.1478–80, (detail), pen and ink on paper, Biblioteca Ambrosiana, Milan, Italy, 39.7 x 28.5cm (15.6 x 11.2 in)

A profile drawing of a diver with an oxygen tube in his mouth, which is carried above water level using a cork disc. In addition, the drawing illustrates the mechanics of a well pump.

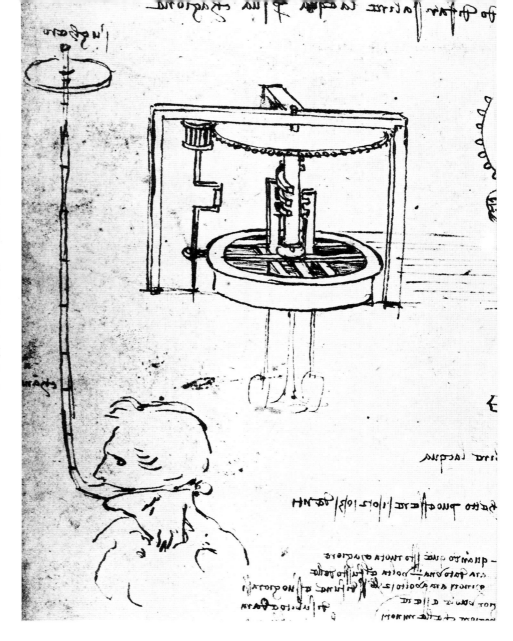

Design for a bastion with double moat (Codex Atlanticus, fol. 116r), c.1504–8, pen and ink on paper, Biblioteca Ambrosiana, Milan, Italy, 44 x 29cm (17.3 x 11.4in)

One of a series of designs for a bastion, this model has a double moat. Leonardo's continued interest in fortified architecture is identified in many sketches and detailed drawings for fortresses, and discussed at length in his notes.

Design for an odometer
(Codex Atlanticus, fol. 1r),
1478–1518, pen and ink on
paper, Biblioteca Ambrosiana,
Milan, Italy,
26.5 x 19.5cm (10.4 x 7.7in)

Here, Leonardo gives a
concise account of the
odometer (a machine which
counts the mileage travelled
by a vehicle), explaining the
workings of the machinery
and its purpose.

Pulley system for the
construction of a staircase
(Codex Atlanticus, fol.
1012v), 1478–1518,
pen and ink on
paper, Biblioteca
Ambrosiana, Milan, Italy,
26.5 x 19.5cm (10.4 x 7.7in)

In the text which
accompanies this drawing,
Leonardo explains that
with the aid of a pulley
system, a staircase can be
constructed and positioned
where required next to
a raised platform of
earth. This may have
been a design for
scaling fortifications in
warfare or for civil
engineering projects.

Tempered spring with gear mechanism, 1493–7, pen and ink on paper, Biblioteca Nacional, Madrid, Spain, 21.3 x 15cm (8.4 x 5.9in)

Leonardo illustrates a volute or helical gear that is used to regulate the force of the clock-drive spring. One of a series of designs for springs, pinions and spindles, aimed to harness the force generated by springs.

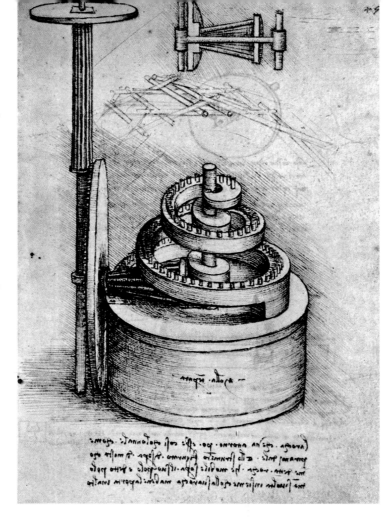

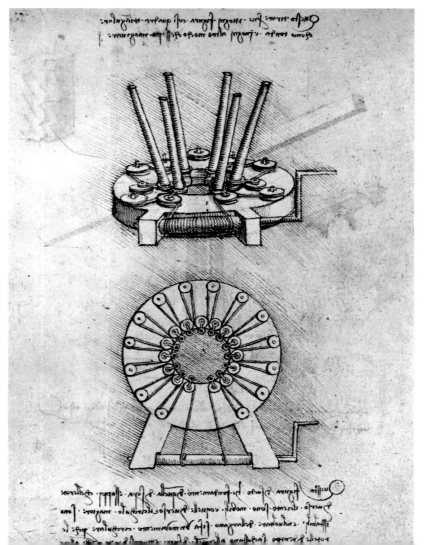

Designs for 'machine elements' of levers and springs (Codex Madrid I, Ms 8937, fol. 44v), 1495–9, pen and ink on paper, Biblioteca Nacional, Madrid, Spain, 21 x 15cm (8.3 x 6in)

These drawings, illustrating the mechanical elements of levers and springs, are on a page from the Codex Madrid I, which relates to the time of Leonardo's residence in Milan, at the court of the Sforza family, in 1490–9. Drawings in this codex focus on mechanical devices, hydraulic engineering and clockwork mechanisms.

Equipment for scaling a wall (Paris Manuscript B, fol. 59v), c.1480–1515, pen and ink on paper, Bibliothèque de l'Institut de France, Paris, 23.1 x 16.5cm (8.4 x 6.5in)

This is one in a series of drawings that illustrate different methods of scaling walls. Leonardo devised a variety of equipment for scaling walls with wood or rope ladders or grappling hooks. In his introductory letter to Ludovico Sforza, Leonardo stated his interest in engineering, bridge design and machinery for warfare: 'When a place is besieged I know how to cut off water from the trenches, and how to construct an infinite number of bridges, battering rams, scaling ladders, and other instruments which have to do with the same enterprise.'

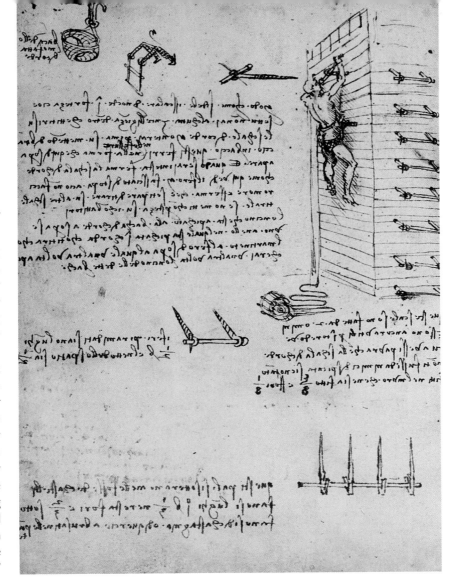

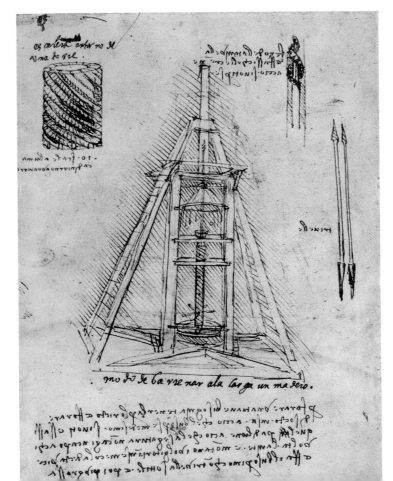

Design for a drill (Paris Manuscript B, fol. 47v), c.1487–90, pen and ink, Bibliothèque de l'Institut de France, Paris, 23.1 x 16.5cm (8.4 x 6.5in)

The larger drawing is a design for a drilling machine, showing the position of the mechanism of the vertical drill. At the top left of the page is an illustration of a truncated tower with ten helical staircases on the exterior.

Side view of human skull in sagittal section with cranial nerves, c.1489, pen and brown ink, Royal Library, Windsor Castle, UK, 19 x 15.7cm (7.5 x 6.2in)

A stunning observation of the human skull, illustrating a side view in sagittal section with cranial nerves and cavities. (A sagittal section is a cross-section obtained by slicing through the body, or part of the body, in a vertical plane.) Leonardo's drawing is as much a work of art as his religious paintings and portraits for patrons. The drawing shows the halved skull in detail, revealing the interior space.

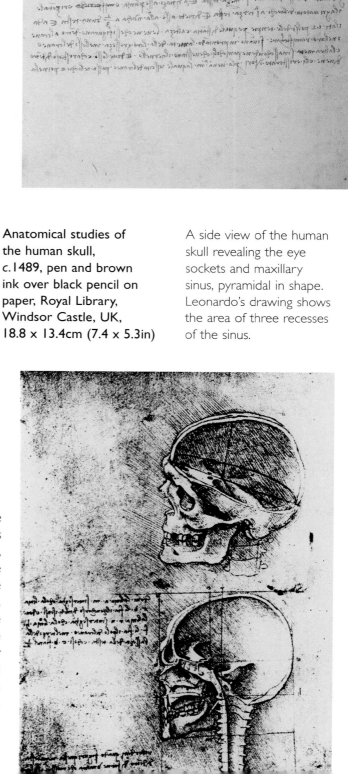

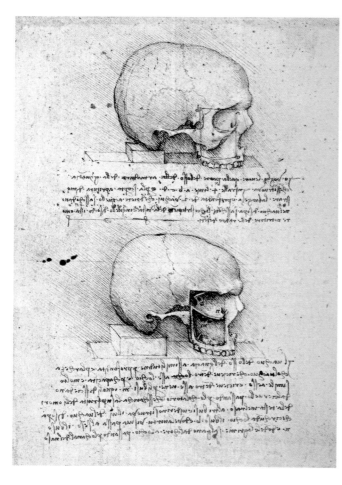

Anatomical studies of the human skull, c.1489, pen and brown ink over black pencil on paper, Royal Library, Windsor Castle, UK, 18.8 x 13.4cm (7.4 x 5.3in)

A side view of the human skull revealing the eye sockets and maxillary sinus, pyramidal in shape. Leonardo's drawing shows the area of three recesses of the sinus.

Anatomical drawings of two skulls in profile, c.1489, pen and brown ink over black chalk on paper, Royal Library, Windsor Castle, UK, 18.1 x 12.9cm (7.1 x 5.1in)

The many anatomical drawings created by Leonardo illustrate his knowledge of anatomy and his attention to fine detail. This study shows the human skull in profile, halved to expose the cavities of the brain, eye socket, nose and mouth. The illustration of the sectioned skull at the bottom of the paper includes the upper spinal cord and its connection to the head.

The reproductive organs of a man and a woman, c.1490, pen and brown ink on paper, Royal Library, Windsor Castle, UK, 27.6 x 20.4cm (10.9 x 8in)

In this drawing, Leonardo illustrates, through the use of a vertical section, the sexual act in process, based on knowledge of the external and internal organs of males and females. Later anatomical drawings, created through Leonardo's dissection of cadavers, illustrate his increased understanding of the reproductive organs and the capacity of the womb to produce a baby.

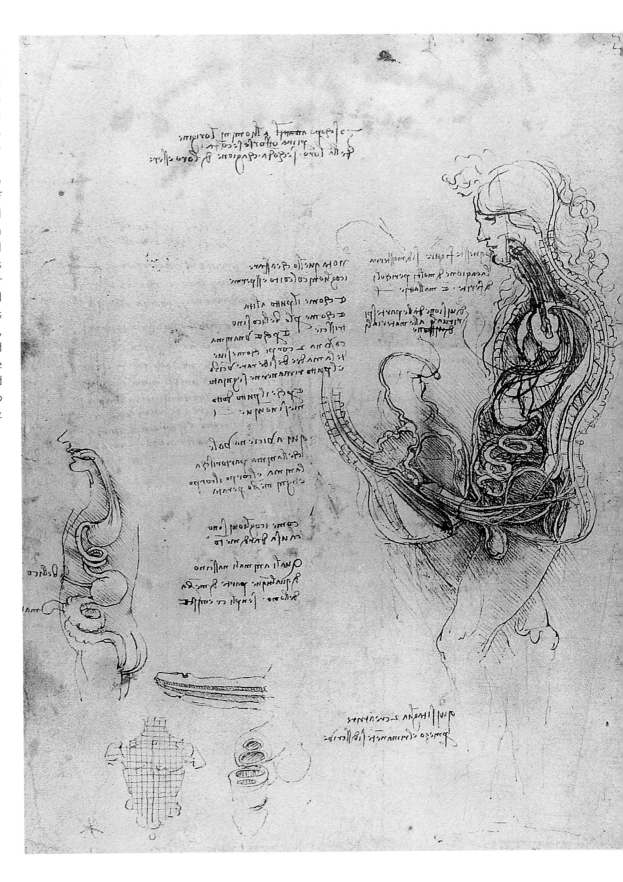

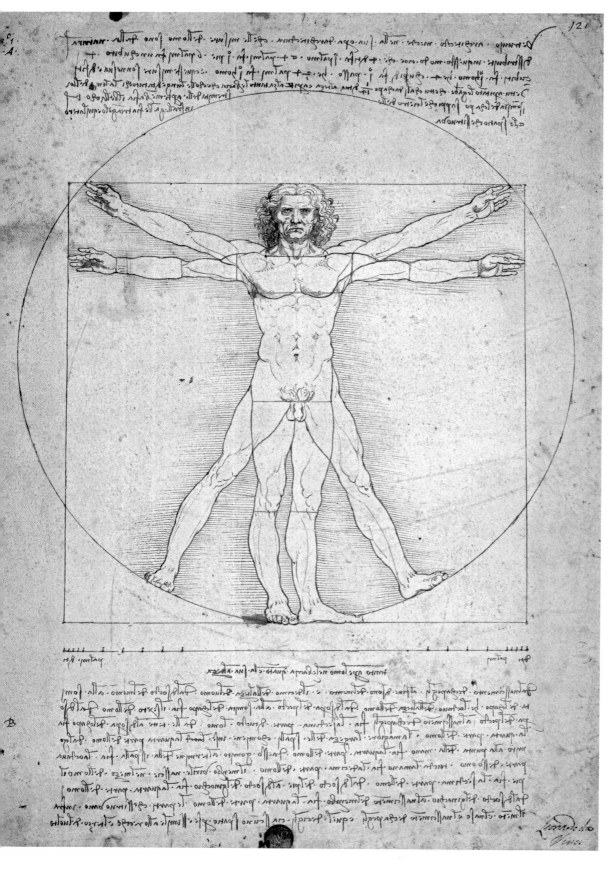

The Proportions of the Human Figure ('Vitruvian Man'), *c.*1492, pen and ink over metalpoint on paper, Gallerie dell'Accademia, Venice, Italy, 34.4 x 24.5cm (13.5 x 9.6in)

The drawing of 'Vitruvian Man' is so named after a description of the human body by the Roman architect and engineer, Vitruvius (*c.*80–15BC), in his architectural work *De architectura* (*c.*30BC), the only extant ancient treatise on architecture. In the third volume, Vitruvius discusses the ratio measurements of the body in relation to beauty and harmony in building design. Leonardo produced an analytical drawing based on Vitruvius' text. Using the perfect forms of the circle and the square he placed the figure of a man with arms and legs outstretched within the two forms: *homo ad circulum* and *homo quadratum*. Leonardo's illustrated analysis, in his geometric drawing of man at the centre of the cosmos, relates to his contemporaries' Humanist ideals and Neo-Platonic debate. In a text entitled 'Of squaring the circle and who it was who first happened to discover it', Leonardo wrote his own analysis. This drawing elucidates Leonardo's text as well as Vitruvius' own. Leonardo's drawing outclassed all other attempts to draw the 'Vitruvian Man'. It has become an iconic symbol of the Renaissance in Italy.

Studies of the proportions of three figures ('Vitruvian Man'), c.1490, pen and ink on paper, Royal Library, Windsor Castle, UK, 15.9 x 11.5cm (6.3 x 4.5in)

Leonardo's study and drawings of the mathematical proportions of the three figures of a man, kneeling, standing and sitting, emulated contemporaries such as Michelangelo, who had also studied Vitruvius' treatise. Leonardo wrote his own analysis, which began: 'When a man kneels down he will diminish by a quarter of his height. When a man kneels with his hands to his breast, the navel will be at the midpoint of his height…'.

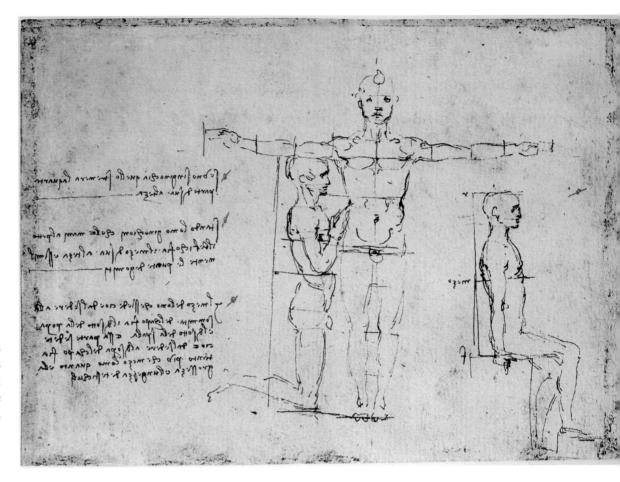

Studies of the proportions of the face and eye, c.1489–90, pen and ink over metalpoint on prepared paper, Biblioteca Nazionale, Turin, Italy, 14 x 27.7cm (5.5 x 10.9in)

This is a drawing that illustrates Leonardo's exploration of the measurements of the face and eye and the proportions of each in relation to the head and neck. Leonardo's measurements were taken from two male models, Caravaggio and Trezzo, whom he employed for the purpose of measuring and drawing the human body.

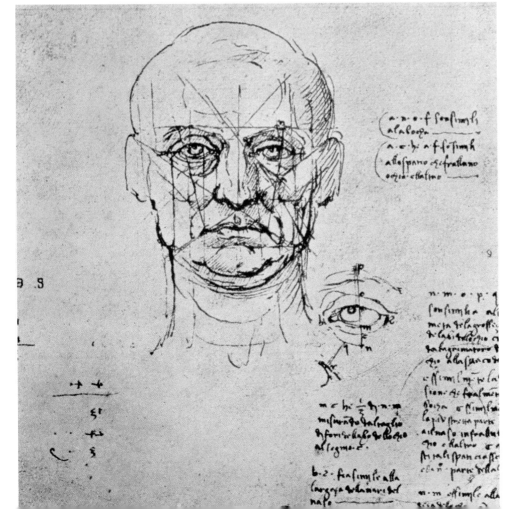

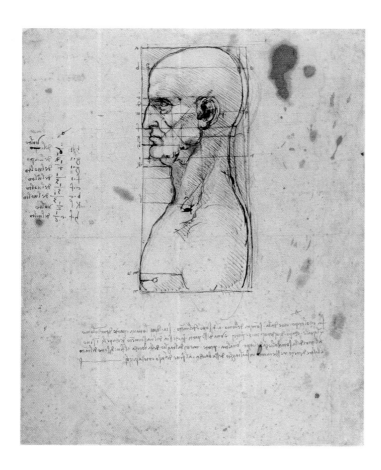

Drawing of the bust
of a man in profile,
c.1489–90, pen and two
shades of brown inks
on paper, Gallerie
dell'Accademia, Venice, Italy,
28 × 22.2cm (11 × 8.7in)

Leonardo created many
analytical drawings based on
the measurements and
proportions of the human
figure. In this drawing, the
left profile of a male is
squared up on paper to
measure proportion.
The paper contains jottings
and written notes, relating
to Leonardo's findings.

Torso of a man in profile,
the head squared for
proportion, and sketches of
two horsemen, c.1490 and
c.1504, pen and ink and
red chalk over metalpoint
on paper, Gallerie
dell'Accademia, Venice, Italy,
28 × 22.2cm (11 × 8.7in)

One of many analytical
drawings created by
Leonardo, demonstrating the
proportions of the human
figure. The measurements
were taken from a
life model. In this drawing
of a male torso the right
profile of a man shows
eye-to-ear-to-mouth
measurement, squared up
on the paper. In addition,
the paper contains drawings
of two horsemen, perhaps
added at a later
date, c.1504, possibly
preparatory sketches
for the Battle of Anghiari.

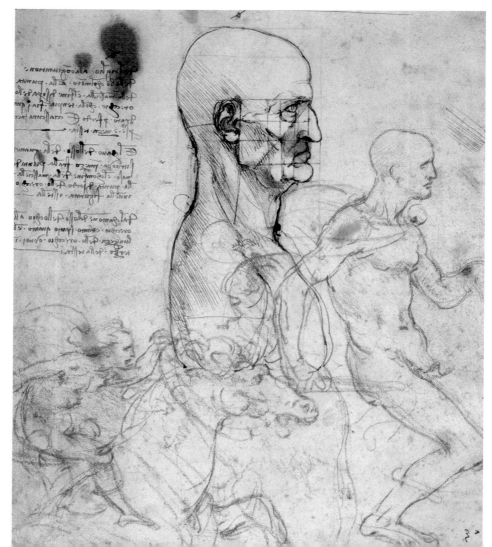

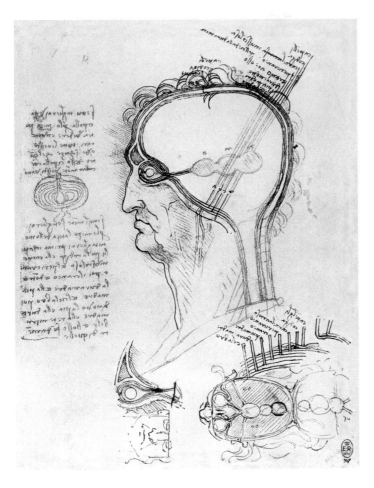

Anatomical studies of layers of the brain and scalp, *c.*1490–3, red chalk, pen and brown ink on paper, Royal Library, Windsor Castle, UK, 20.3 x 15.3cm (8 x 6in)

A study showing the head in profile, revealing the brain and layers of the scalp. The large drawing shows the outer layers of the brain and the skull. The smaller drawings to the lower right show the head, halved, to reveal the nerve system from the eyes and ears to the brain core.

Anatomical study of a bear's foot, *c.*1490, metalpoint with pen and brown ink, heightened with white, on blue prepared paper, Royal Library, Windsor Castle, UK, 16.1 x 13.7cm (6.3 x 5.4in)

Leonardo supplemented his knowledge of human anatomy with anatomical studies of animals. The foot and lower leg of a bear, was possibly not drawn from a dissected bear limb but was Leonardo's summation of the bone structure, as an observation of the exterior of the hind leg in close-up. Another drawing: A bear walking, *c.*1490 (Metropolitan Museum of Art, New York, NY), illustrates a bear walking on four paws. In his notebooks, Leonardo refers to the presence of bears in the environs of Milan.

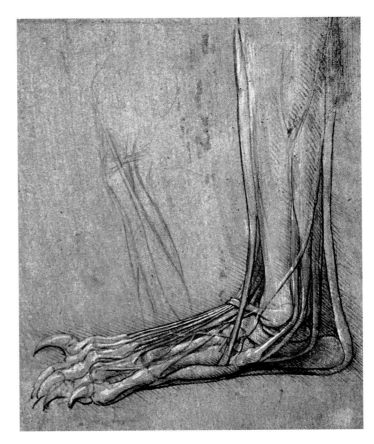

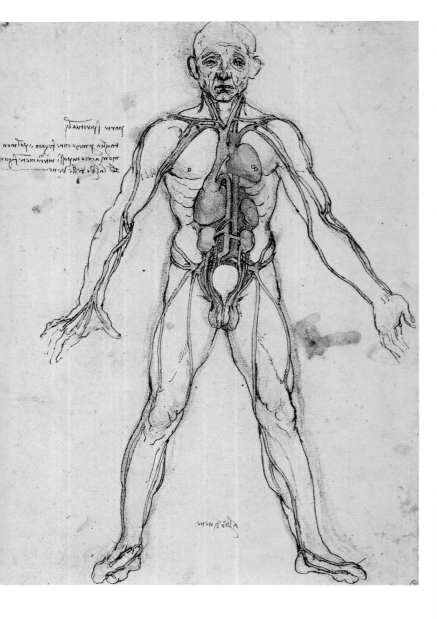

The 'Tree of Vessels', c.1490, pen and brown ink and watercolour over black chalk on paper, Royal Library, Windsor Castle, UK, 28 x 19.8cm (11 x 7.8in)

An anatomical study of a male figure, illustrating the 'tree' of major blood vessels and placement of the heart, liver and kidneys. Leonardo's study of human anatomy and physiology was supported by the theories of the Greek-born Roman physician Galen (AD129–c.200/217) who, as a medical researcher, dissected the bodies of monkeys to increase his knowledge. His treatises dominated anatomical research, including his findings on the function and actions of the heart, veins and arteries, liver and kidneys.

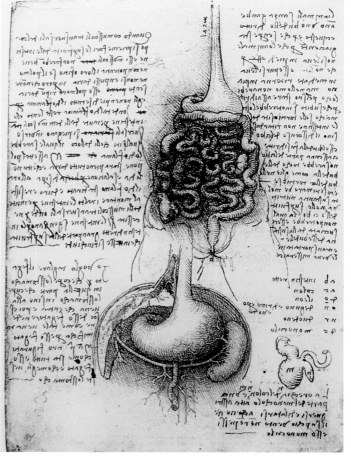

Anatomical study of the stomach and intestines, c.1506, pen and brown ink over traces of black chalk on paper, Royal Library, Windsor Castle, UK, 19.2 x 13.8cm (7.6 x 5.4in)

Leonardo da Vinci's anatomical studies are spread over a 30-year period.

His early studies, c.1485, were carried out during his residence in Milan. Studies from his second period, c.1506–10, illustrate his increased knowledge of the form and structure of the human body. Here he illustrates the stomach and the intestines.

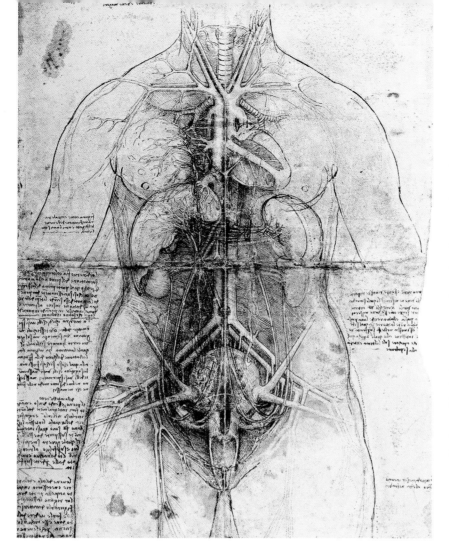

The organs of the chest, abdomen and vascular system of females, *c.*1508, pen, brown ink and wash, with traces of red and black chalk and yellow wash, on yellow washed paper (pricked for transfer), Royal Library, Windsor Castle, UK, 47.6 x 33.2cm (18.7 x 13.1in)

This anatomical drawing reveals Leonardo's knowledge and understanding of the internal organs of the body, obtained through his presence at the dissection of mortuary cadavers. Here he illustrates the anatomical structure of the female body, including the vascular system.

Anatomical study of male urinary tract and genital organs, *c.*1506–8, pen and brown ink on paper, Schlossmuseum, Kunstsammlungen zu Weimar, Germany, 19.2 x 13.5cm (7.6 x 5.3in)

Leonardo began his studies of human anatomy in 1485. His drawings from that time until the curtailment of his research in 1515 reveal how his knowledge of human anatomy progressed over the years.

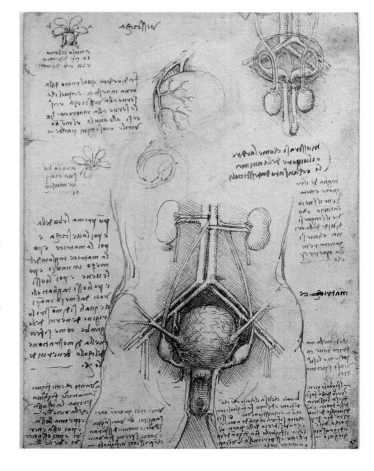

Study of the lungs, heart and abdominal organs of a pig, *c.*1508, pen and brown ink over traces of black chalk on paper, Royal Library, Windsor Castle, UK, 19.4 x 14.2cm (7.6 x 5.6in)

This drawing illustrates the internal organs of a pig, highlighting the lungs, heart and abdominal organs. Leonardo opted to study animals, including pigs, in addition to human anatomy, in order to compare the internal structure of the bodies.

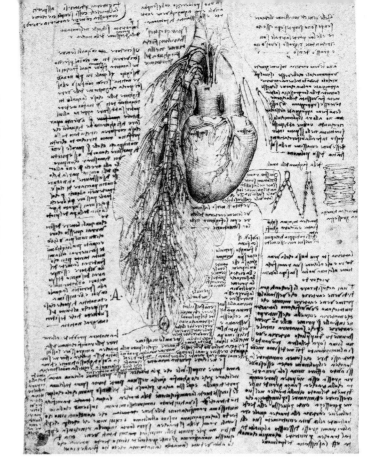

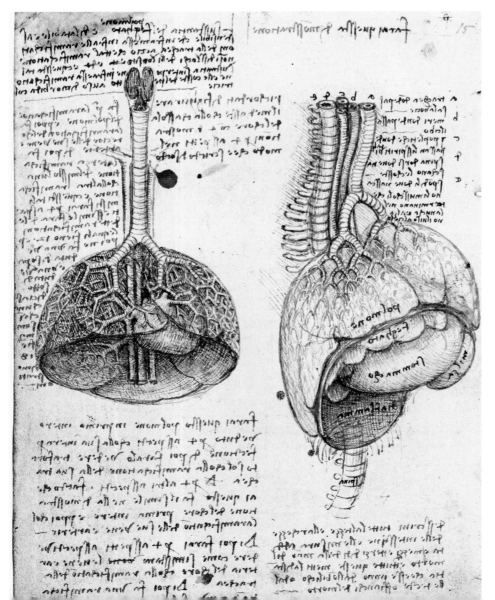

Study of the lungs, heart and abdominal organs of a pig, *c.*1508, pen and three shades of brown ink, over traces of black chalk on paper, Royal Library, Windsor Castle, UK, 19.4 x 14.2cm (7.6 x 5.6in)

Leonardo considered that the anatomy of certain animals, such as the ox and pig, was related to human anatomy, and as such could be explored to discover more about the human body and its functions. In this exquisite drawing – a work of art in its own right – Leonardo examines the lungs, heart and abdominal organ structure of the pig.

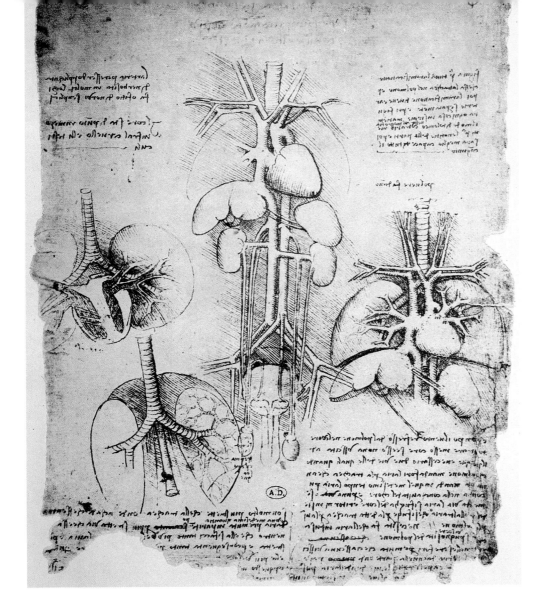

Study of the internal organs of the chest and abdomen, c.1508–9, pen and brown inks and black chalk on paper, Royal Library, Windsor Castle, UK, 28.3 x 21.9cm (11.1 x 8.6in)

A study of the chest and abdomen with attention to the heart, the vascular system and the lungs. In 1510, Leonardo visited Pavia to see Marcantonio della Torre (d.1511), a doctor and anatomist by profession at the university. There, Leonardo's study of the dissection of corpses gave him further scientific knowledge of the human body. His understanding of human bone structures, muscle and tendon formation, the heart and its blood vessels, is visible in his drawings.

Anatomical drawing of an ox heart and blood vessels, 1513, pen and brown ink on blue paper, Royal Library, Windsor Castle, UK, 28.8 x 41.3cm (11.3 x 16.3in)

Leonardo closely studied dissections of human and animal bodies. This drawing, one half of a larger sheet of drawings of the heart, shows the thorax and diaphragm of an ox. The pulmonary artery of the heart is illustrated with its interventricular septum. The drawing is dated 9 January 1513.

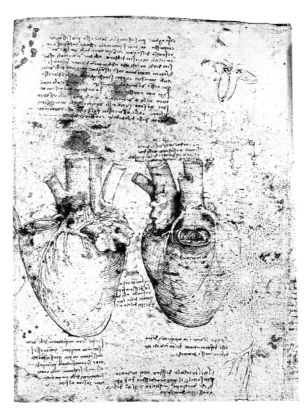

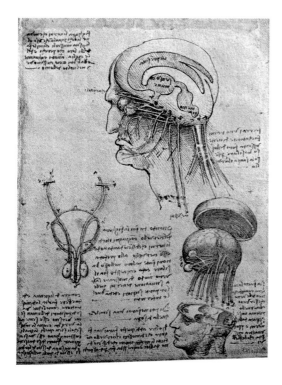

Study of the anatomy of the brain, c.1506–8, pen and ink on paper, Schlossmuseum, Kunstsammlungen zu Weimar, Germany, 19.2 x 13.5cm (7.6 x 5.3in)

A study, with notes, detailing the brain, its cavities and nerve system.

Leonardo's access to the dissection of human corpses allowed him to closely study every part of the body, including the skull and the brain. In this study, also included, to the lower left, is a drawing of male urogenital apparatus.

Anatomical study: stomach, liver, spleen and intestines, with notes, c.1506, pen and two shades of brown ink over traces of chalk on paper, Royal Library, Windsor Castle, UK, 19.2 x 14.1cm (7.6 x 5.6in)

The finely executed drawing explores the innards of the stomach, highlighting the position of the liver, spleen and intestines. Leonardo's written notes refer to his understanding of the separate organs, and how they worked together. He attended cadaver dissections, encouraged by a friend, Marcantonio della Torre (d.1511), a professor of Anatomy, who taught at the universities of Pavia and Padua.

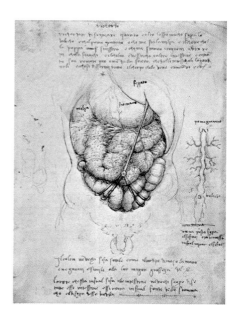

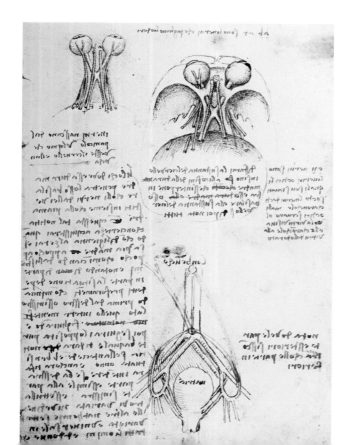

The optic chiasma and the cranial nerves, c.1506–8, pen and three shades of brown ink with traces of black chalk on paper, Royal Library, Windsor Castle, UK, 19 x 13.6cm (7.5 x 5.4in)

One of a series of studies of the optic and cranial nerve system. Other drawings reveal the extent of Leonardo's studies of dissected brains.

Five views of a foetus in the womb, c.1510, pen and ink on paper, Bibliothèque des Arts Décoratifs, Paris, France, 30.4 x 21.3cm (12 x 8.4in)

Leonardo was present at dissections of human corpses, but his study of the foetus in the human womb was based on the dissection and study of the wombs of animals. He transferred this knowledge to the female body and its organs, which he has outlined here.

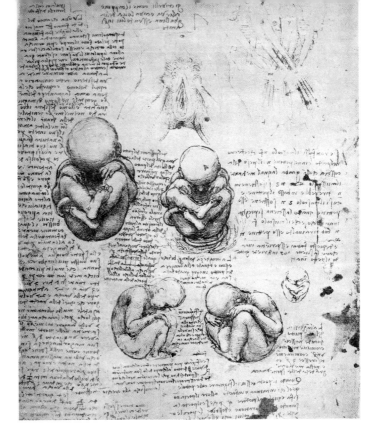

Anatomical studies of embryonic development, c.1510, red chalk, pen and brown inks with wash on paper, Royal Library, Windsor Castle, UK, 30.4 x 22cm (12 x 8.7in)

A detailed drawing with notes, to illustrate the creation and growth of the foetus in the womb. This is one of a series of drawings to show the progress of the foetus from conception to birth. Leonardo noted that the foetus in this drawing was about four months old. To illustrate the progress of the foetus, he studied dissections of pregnant cows and pigs. His drawings show his understanding of the purpose of the placenta and auxiliary vessels.

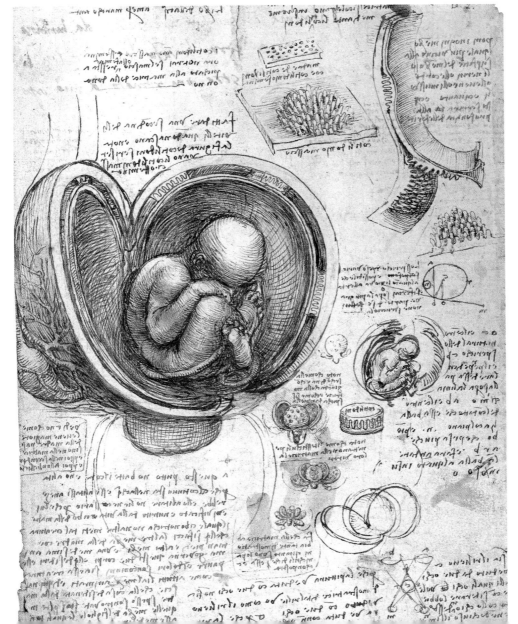

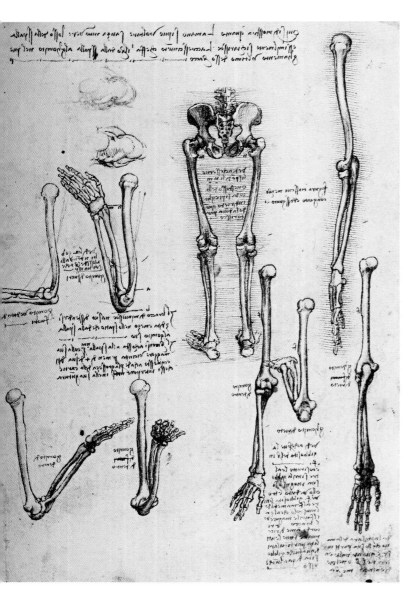

Anatomical studies of the female pelvis, the coccyx and the lower limbs, and the rotation of the lower arm, *c.*1509–10, pen and brown inks on paper, wash and black chalk on paper, Royal Library, Windsor Castle, UK, 28.6 x 19.3cm (11.3 x 7.6in)

This sheet shows several skeletal studies of the female pelvis, the coccyx and the lower limbs, plus details of the rotation – pronation and supination – of the arm.

Anatomical studies of the human skeleton, *c.*1509–10, pen and ink and wash over black chalk on paper, Royal Library, Windsor Castle, UK, 28.8 x 20cm (11.3 x 7.9in)

Leonardo creates an art form from his study of the human skeleton. Access to corpses undergoing autopsy allowed him to closely study the structure of the bones.

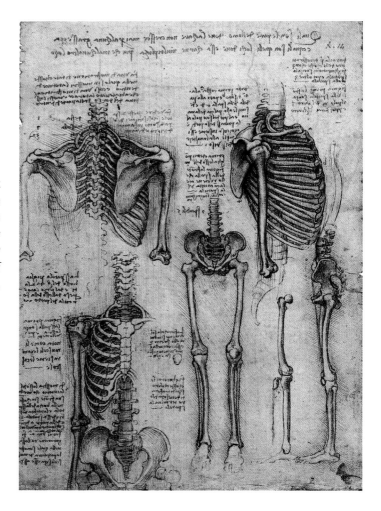

Anatomical studies of hanging skeletons, c.1509–16, pen and ink with wash on paper, Gabinetto dei Disegni e delle Stampe, Galleria degli Uffizi, Florence, Italy 28 x 22.2cm (11 x 8.7in)

Two studies of hanging skeletons reveal Leonardo's method of careful observation. However, in his text on anatomy, Leonardo advises the aspiring artist that to understand the human body it would be 'better to watch an anatomist at work' than to solely view his drawings.

Anatomical study of the neck muscles, c.1516, pen and ink on blue coloured paper, Royal Library, Windsor Castle, UK, 27.6 x 20.7cm (10.9 x 8.1in)

Leonardo's third period of study of the human body occurred around c.1513–15. At this time his knowledge of human anatomy had been enhanced by careful study of dissected corpses, over many years. In this drawing Leonardo observes the formation of the neck muscles.

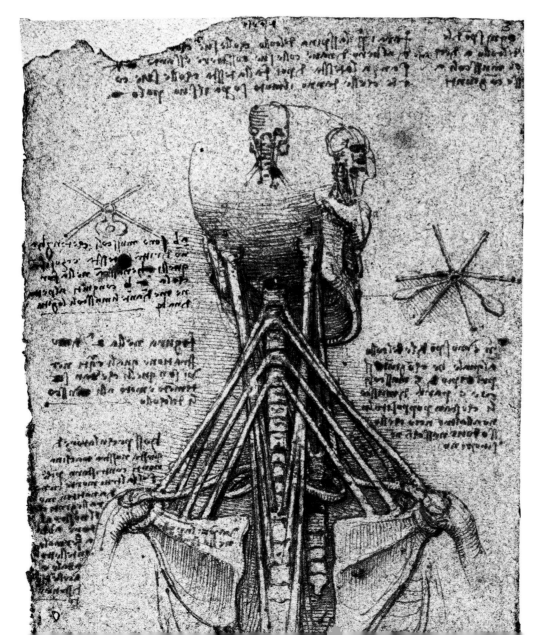

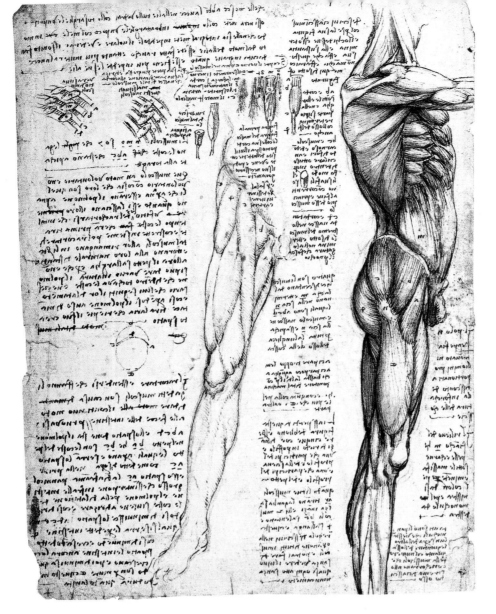

Anatomical studies of the torso and lower leg (detail), *c.*1509–10, pen and brown ink on paper, Royal Library, Windsor Castle, UK, 28.6 x 20.7cm (11.3 x 8.1in)

An anatomical study of the muscle formation of the torso and leg, a detail of a page, which also shows a frontal view of the muscles of the leg.

Anatomical study of the muscles of the side of the torso, *c.*1507, pen and brown ink over black chalk on paper, Royal Library, Windsor Castle, UK, 19.3 x 14cm (7.6 x 5.5in)

Leonardo advised apprentices of art not to portray the muscles of the human body bulging out too much. While the study of human corpses and bodies for artistic purposes was not universal during Leonardo's professional life, it was made a stipulation for all apprentices soon after his death. Here a close study of the dissected corpse reveals the muscle system of the side of the torso.

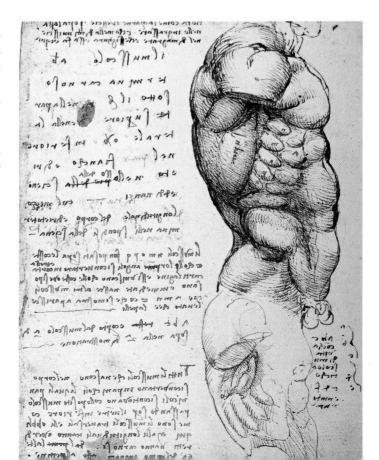

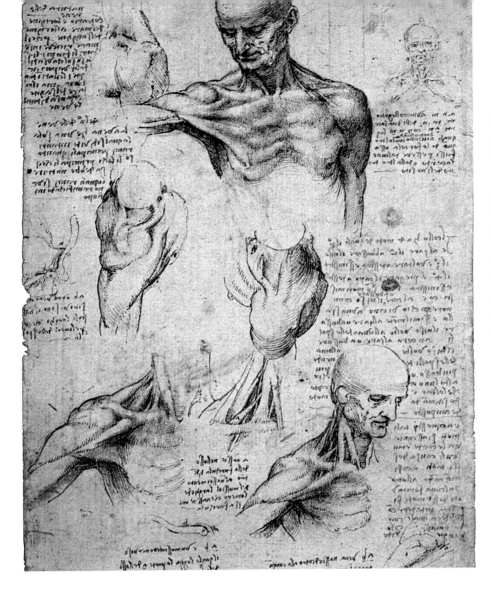

Anatomical studies of the muscles of the shoulder and mechanics of the clavicle joint, c.1509–10, pen and two shades of brown ink and wash over black chalk on paper, Royal Library, Windsor Castle, UK, 29.2 x 19.8cm (11.5 x 7.8in)

These detailed drawings from life-study show the movement of the muscles of the shoulder and the way the clavicle joint is stabilized.

Anatomical studies of the muscles of the shoulder and arm, and the bones of the leg and foot, c.1509–10, pen and brown ink on paper, Royal Library, Windsor Castle, UK, 28.9 x 20.1cm (11.4 x 7.9in)

These studies show the position of the muscles relative to the bones and joints, and the way they are attached.

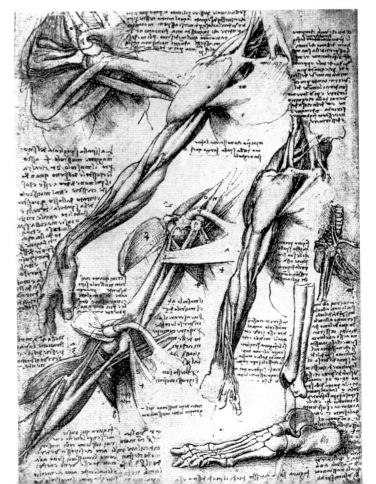

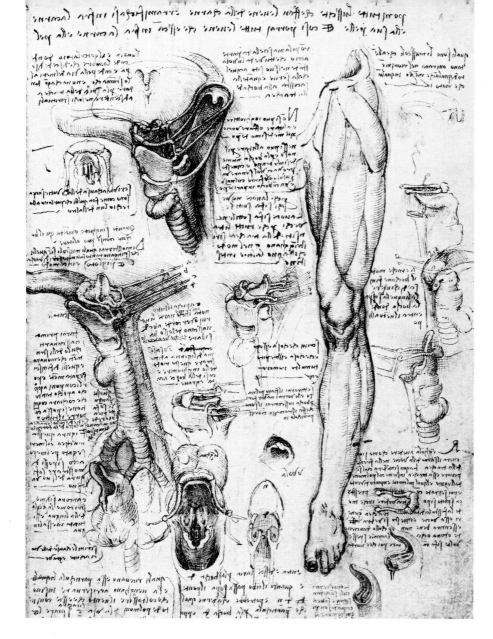

Drawing of the instruments of breathing, swallowing and speaking, and an external view of the leg and foot, c.1509–10, pen and brown ink and wash over black chalk on paper, Royal Library, Windsor Castle, UK, 29 x 19.6cm (11.4 x 7.7in)

Leonardo draws the uvula, pharynx, tongue with trachea, larynx and oesophagus – the 'instruments' of breathing, swallowing and speaking. A drawing of the muscle formation of a human leg is illustrated on the same page. In the collection of Leonardo da Vinci drawings in the Royal Library, Windsor Castle, around 200 folio papers document the artist's close observation of human anatomy.

Anatomical studies of the muscles of the back, c.1509–10, pen and three shades of brown ink and wash over black chalk on paper, Royal Library, Windsor Castle, UK, 28.9 x 20.5cm (11.4 x 8.1in)

One of a series of studies of muscle formation in the human body. Leonardo was one of the first artists during the Renaissance in Italy to seek to further his knowledge of human anatomy through the observed dissection of corpses. In Della pittura (On Painting), 1436, Leon Battista Alberti promoted the idea that the artist should begin with the skeleton, and then add to it muscles and flesh. Leonardo was familiar with Alberti's treatise.

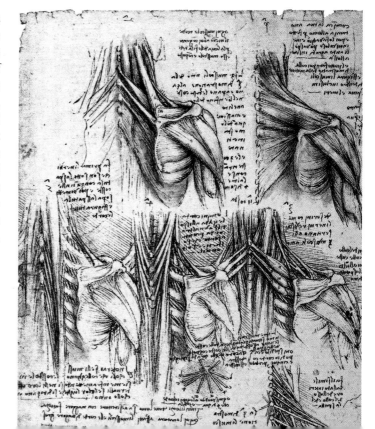

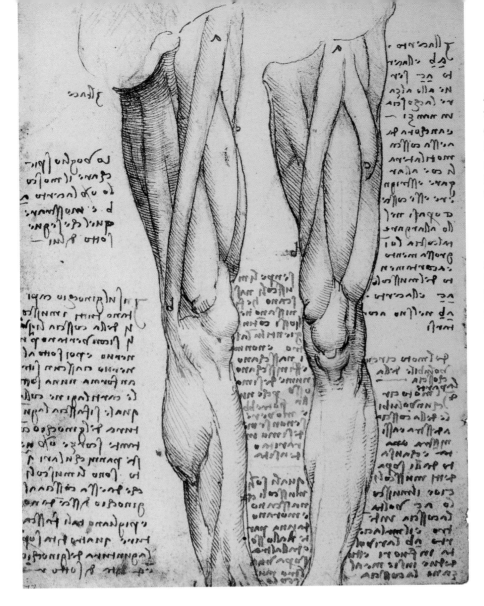

Anatomical study of
the muscles of the legs,
*c.*1507–10, pen and
brown ink and wash
over black chalk on paper,
Royal Library,
Windsor Castle, UK,
19.2 × 14cm (7.6 × 5.5in)

This detailed drawing
shows the way in which
Leonardo carries through
his observation of leg
muscle formation and
development, highlighting
his findings in many studies
of the subject. Here he
illustrates the upper and
lower leg and calf muscles,
from a frontal and side
view. The text discusses
his analysis.

Study of arms, *c.*1509–10,
attributed to Leonardo da
Vinci, pen and ink on paper,
Musée du Louvre,
Paris, France,
28.6 × 20cm (11.3 × 7.9in)

This is one of several of
Leonardo's anatomical
studies of the muscular
formation of human arms.

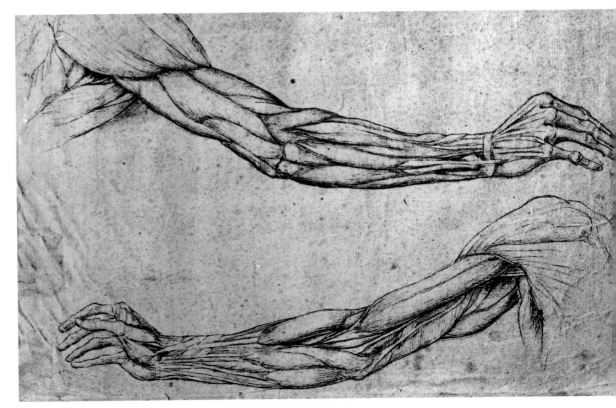

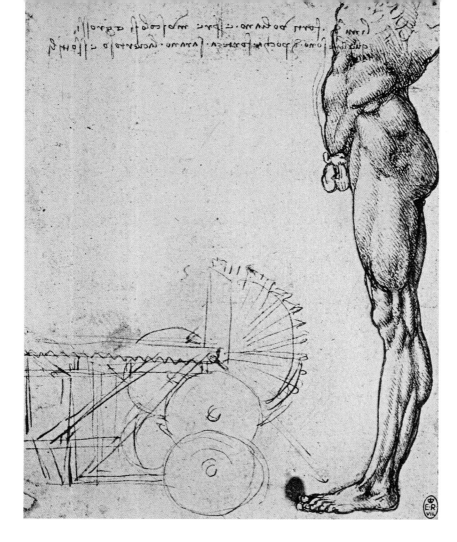

Abdomen and left leg of a male nude, c.1490, pen and brown ink over black chalk on paper, Royal Library, Windsor Castle, UK, 19.6 x 31.3cm (7.7 x 12.3in)

One of many anatomical studies, which focus attention on the muscular formations of the male body. This example, with its side view of a male nude, observes the external appearance of tensed muscle in the lower abdomen and leg. On the same sheet, to the lower left of the figure, is a sketch of a piece of machinery.

Study of the proportions of the head, c.1492–1510, (Codex Urbinate lat.1270), Biblioteca Apostolica Vaticana, Rome, 16 x 22cm (6.3 x 8.7in)

On the depiction of shadow and light, Leonardo explained that 'it has been proved that every definite light has – or appears to have – its origins in a single point…on to which the radiant lines fall at equal angles' (*Treatise on Painting*). The letters and numbers relate to his further discourse on the subject.

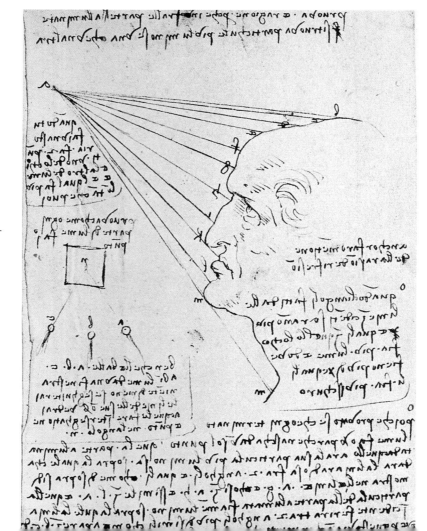

Dodecahedron (illustration for *De divina proportione*) by Luca Pacioli and Leonardo da Vinci, 1509, engraving, Bibliothèque Nationale, Paris, France, 15 x 22cm (5.9 x 8.7in)

Leonardo da Vinci met Luca Pacioli at the Sforza court during the revered Pacioli's visit to Milan. It was Pacioli who gave Leonardo instruction in mathematics. They became good friends. In return, Leonardo, while in Milan, illustrated Pacioli's book on geometry, *De divina proportione*. It was published in 1509, after they had both left the Sforza court.

Anatomy studies of the upper leg, the sciatic nerve and femoral nerve, with notes, *c.*1508, pen and brown ink over traces of chalk on paper, Royal Library, Windsor Castle, UK, 19 x 14cm (7.6 x 5.5in)

The majority of Leonardo's anatomical drawings are accompanied by neatly written notes, added in after the drawing was completed. 'Give the anatomy of the upper leg up to the hip, in all views and in every section and every state: veins, arteries, nerves, sinews and muscles, skin and bones; then the bones in sections to show the thickness of the bones.'

Dodecahedron (illustration for *De divina proportione*) by Luca Pacioli and Leonardo da Vinci, 1509, engraving, Bibliothèque Nationale, Paris, France, 15 x 22cm (5.9 x 8.7in)

After the siege of Milan in 1499, Pacioli and Leonardo travelled together when Leonardo left for his journeys to Mantua, Venice and Florence.

Studies of the Moon (Codex Leicester, Sheet 1A, fol. 1r), 1508–12, sepia ink on linen paper, Collection of Bill and Melinda Gates, Seattle, WA, USA, 29.3 x 22.1cm (11.5 x 8.7in)

This is the most famous page of the collection of notes and drawings known as the Codex Leicester. It is an exploration of astronomy and geometry. The diagrams illustrate the Moon, to explain why the light from the Moon is less bright than the Sun. At the bottom of the page the drawing illustrates waves of light bouncing off the 'waves' of the moon's surface, to show that the light rays are singular and do not blend together.

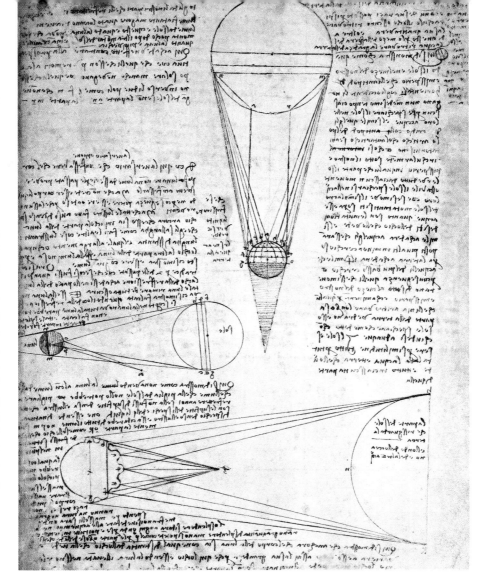

The movement of the Earth (Codex Leicester, Sheet 3B, fol. 34r), 1508–12, sepia ink on linen paper, Collection of Bill and Melinda Gates, Seattle, WA, USA, 29.3 x 22.1cm (11.5 x 8.7in)

This page contains Leonardo's observations on the circulation of water in the body of the Earth, 'Nothing grows in a spot where there is neither sentient, vegetal or rational life…'. He considers two explanations for water rising to the summits of mountains and relates his findings to Ristoro d'Arezzo's treatise on the composition of the Earth.

'Of the Moon' (Codex Leicester, fol. 2r), (detail), *c.*1508–10, pen and ink on paper, Collection of Bill and Melinda Gates, Seattle, WA, USA, 29.3 x 22.1cm (11.5 x 8.7in)

This page is titled 'Of the Moon; no dense body is lighter than air'. The text and illustrations show how the Sun and Earth are contributing factors of the Moon's light – the rays from the Sun are reflected back from the oceans of the Earth. The elements of the Moon and the indirect causes of its luminosity are discussed. The detail shown here depicts the Sun's rays reflecting back from the Earth to the dark side of the Moon, described by Leonardo as an 'ashen surface' (*lumen cinereum*).

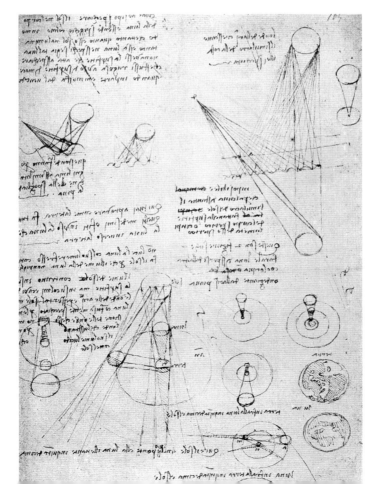

Drawings and notes on the Moon's reflection (Codex Leicester, fols. 103v-04), *c.*1508–10, pen and ink on paper, Collection of Bill and Melinda Gates, Seattle, WA, USA, 29.3 x 22.1cm (11.5 x 8.7in)

On this page Leonardo argues that the Moon has water and the rays of the Sun are reflected from the Moon to the Earth and back. The drawing in the lower part of the page, centre left, illustrates the theory that the Sun and Moon revolve around the Earth. However, in notes elsewhere, he does consider the possibility that the Sun is static, and the Earth and Moon are planets that revolve around it.

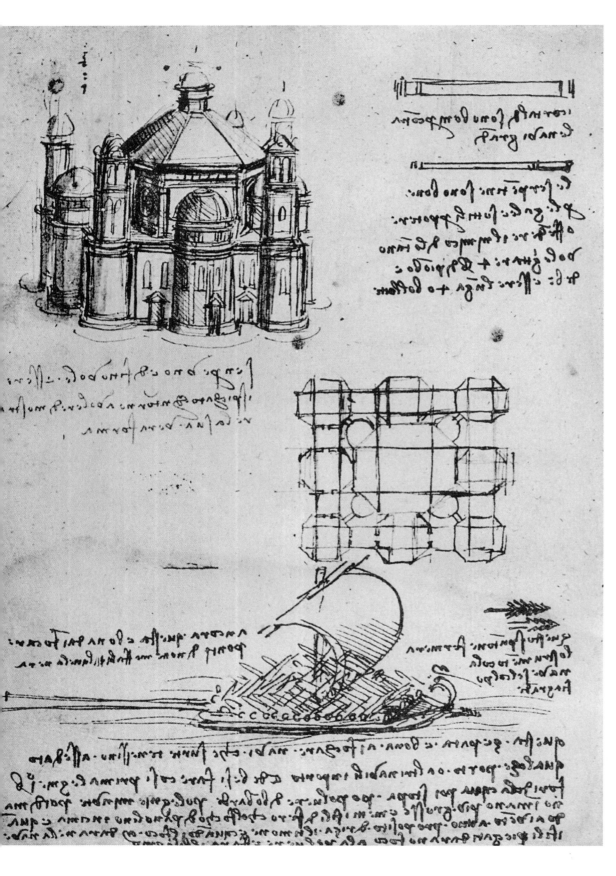

Design for a centrally planned church (Paris Manuscript B, fol. 39v), and a sketch of a ship, c.1487–90, pen and ink on paper, Bibliothèque de l'Institut de France, Paris, 23.3 x 16.5cm (9.2 x 6.5in)

One of a series of drawings depicting plans and elevations on the theme of a centrally planned church. Leonardo was familiar with Leon Battista Alberti's treatise *De re aedificatoria*, (*c.*1450), which discusses the use of two perfect forms, the circle and the square, to achieve spiritual harmony in religious building design. In his own treatise, *Trattato del cupole*, Leonardo states that a building 'should always be detached on all sides so that its form may be seen'. He argues for churches based on circular and square plans with a central dome, and churches of a Latin cross design. He personally favoured the Greek cross plan. In his treatise he groups dome-types into four classes: rising from a circular base; a square base; a square base with four pillars; and an octagonal base. In Leonardo's drawings, the decorative detail and fluidity of the exterior design anticipates the Baroque interpretation of classical architecture. In the lower section of this sheet, Leonardo illustrates a ship in full sail.

Studies for a building on a centralized plan (Codex Ashburnham, 1875, I and II, formerly part of Manuscript B (2184), fol. 3v), c.1487–92, pen and ink on paper, Bibliothèque de l'Institut de France, Paris, 23.3 x 16.3cm (9.2 x 6.4in)

Interest in Vitruvius' treatise on the proportions of the human body in relation to beauty and harmony in architectural design led to a revival of interest in circular buildings, using the perfect forms of the circle and the square. In Leonardo's era, the use of the centrally planned building was focused on church architecture. In Leonardo's drawing, one of many that explore centrally planned buildings, he illustrates the floor plan, a study of the completed building, and different aspects of it.

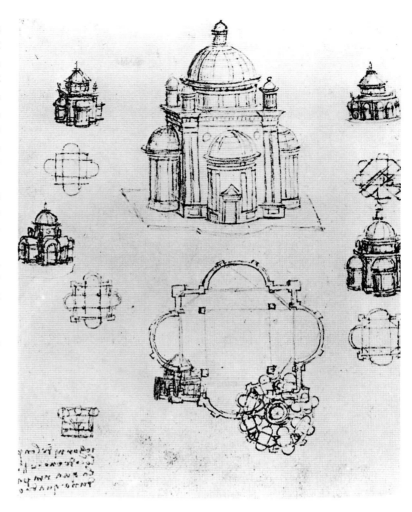

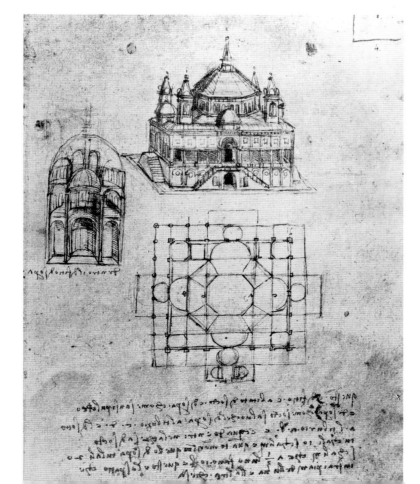

Studies for a building on a centralized plan (Codex Ashburnham, 1875, I and II, formerly part of Manuscript B (2184), fol. 4r), c.1487–90, Bibliothèque de l'Institut de France, Paris, 23.3 x 16.3cm (9.2 x 6.4in)

One of several drawings executed by Leonardo that explore the form of the centrally planned building, using the perfect forms of the circle and square to create an idealized church architecture.

Drawing of centralized churches (Paris Manuscript B, fol. 25v), Bibliotheque de l'Institute de France, Paris, 23.3 x 16.2cm (9.2 x 6.4 in)

Another drawing that explores the centrally planned building, using the perfect forms of the circle and square.

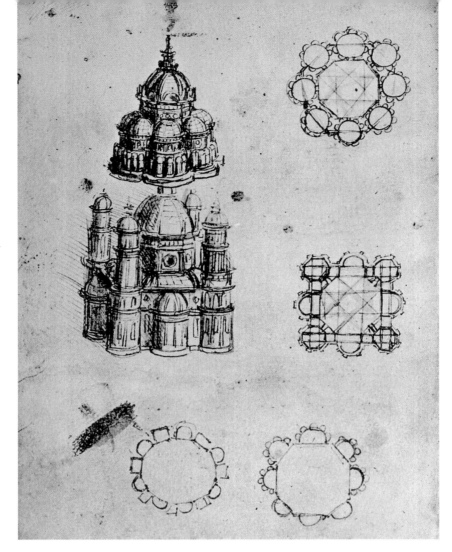

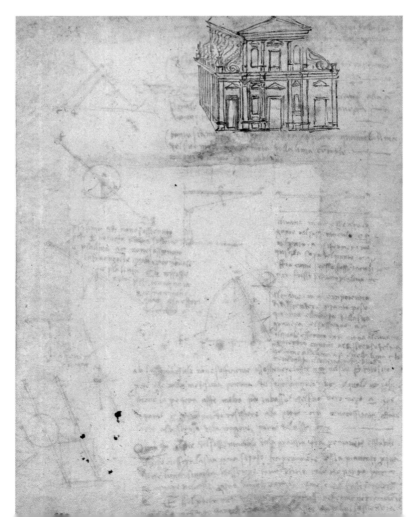

Design for a church façade, c.1495–7, pen and ink over metalpoint on linen paper, Galleria dell'Accademia, Venice, Italy, 21.3 x 15.2cm (8.4 x 6in)

A building in the style of classical temple architecture is drawn at the top of the page. The façade of the building bears a resemblance to those of the churches of San Miniato and Santa Maria Novella in Florence.

A stretch of the River Arno from the Mugnone outlet to the area around Peretola, *c.*1504, pen and ink with green and blue washes on paper, Royal Library, Windsor Castle, UK, 39.5 x 22.2cm (15.6 x 8.7in)

This map of the River Arno shows a section of the river from the Mugnone outlet to the area around Peretola. In the summer of 1504, Leonardo made a serious study of the river, creating several maps and sketches. The section shows a weir, and he may have studied the erosion caused by water flow, with regard to maintenance of the river bank.

The River Arno from the Mugnone outlet, *c.*1504, pen and ink over black chalk on paper, Royal Library, Windsor Castle, UK, 41 x 25.7cm (16.1 x 10.1in)

A topographical map, which plots the Arno and Mugnone rivers, at the Peretola outlet, situated to the west of Florence. Leonardo wanted to draw up plans for creating a waterway from Florence to the sea. Other plans were for the creation of a canal and a new watercourse.

Bird's eye map of western Tuscany, *c.*1503–4, pen and ink and watercolour on paper, Royal Library, Windsor Castle, UK, 27.5 x 40cm (10.8 x 15.8in)

This map is a detailed overview of western Tuscany from Lucca to Campigli. It shows Pisa in the north-west and Volterra in the south-east and includes over 100km (60 miles) of coastline.

Map of Tuscany and neighbouring regions, *c.*1502–3, pen, ink and watercolour on paper, Royal Library, Windsor Castle, UK, 31.7 x 44.9cm (12.5 x 17.7in)

The map shows the region of Tuscany on the west coast, from the mouth of the River Magra to Toscanella and Corneto. During Leonardo's service to Cesare Borgia, he was contracted to create maps of Tuscany and surrounding areas and regions. This was carried out through studies of the terrain and distances catalogued, in order to draw scale maps of different areas.

Map of the Val di Chiana, *c.*1502, pen and ink and colour washes on paper, Royal Library, Windsor Castle, UK, 33.8 x 48.8cm (13.3 x 19.2in)

The delicately coloured map shows a view of the landscape dominated by Lake Trasimeno and the Val di Chiana. It identifies the cities of Arezzo, Perugia, Siena and Chiusi.

Map of the city of Imola, I
*c.*1502, pen and ink and
watercolour on paper,
Royal Library,
Windsor Castle, UK,
44 x 60.2cm (17.3 x 23.7in)

The map of Imola was
drawn up from direct
measurements during
Leonardo's service for
Cesare Borgia. On 18 May
1502, Leonardo had been
enlisted in Borgia's retinue
as 'familiar architect and
general engineer'. As chief
military engineer, he
was in charge of the
design of machines,
warfare equipment and
fortifications, as well as land
surveys and map making.

Map of a river bed,
*c.*1506–7, pen and ink,
Royal Library,
Windsor Castle, UK,
28.6 x 19.9cm (11.3 x 7.8in)

Leonardo's interest in the
flow of the River Arno and
its tributaries through the
Arno valley led him to
undertake a feasibility study
of diverting the river, digging
a canal, and connecting
Florence to the coast.
During his research he
made several drawings of
the valley and the river bed,
its tributaries, and various
points where silting of the
river occurred.

INDEX

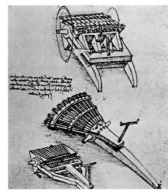

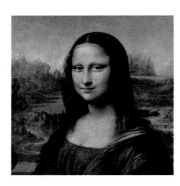

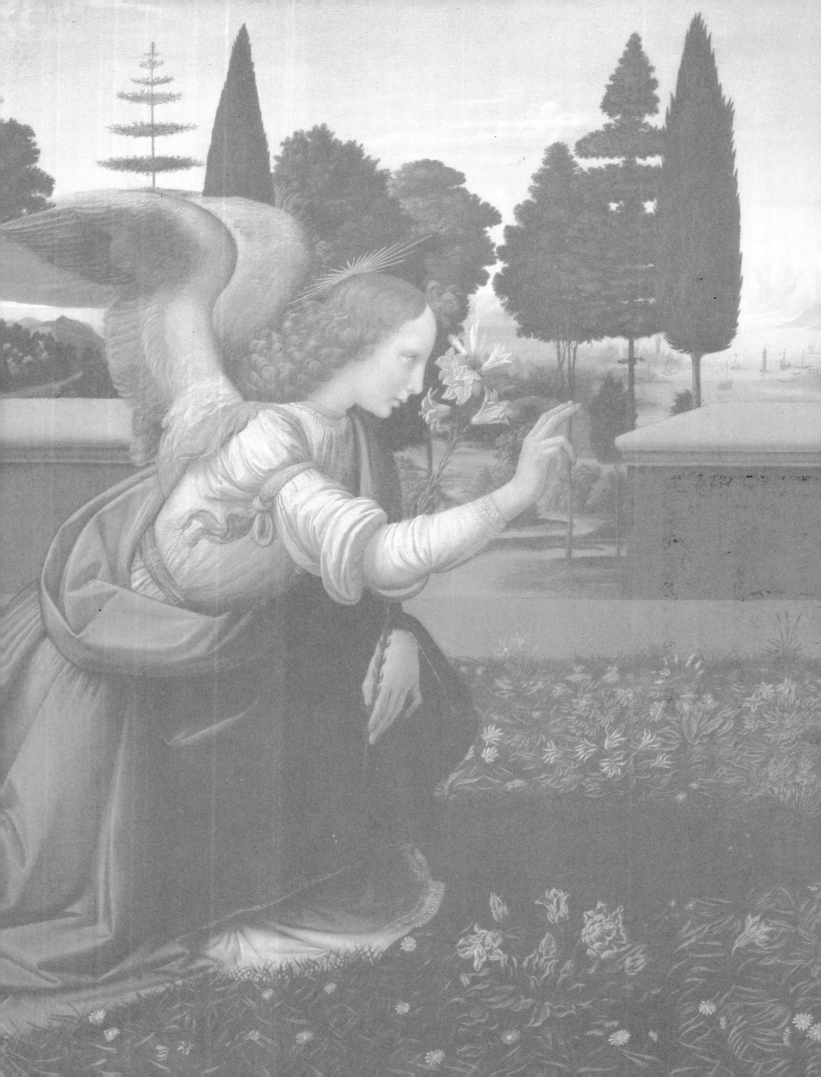